$10.95

Photography

Reproduced on the cover: **David Vine.** *Still Life.* 1973.
Elizabeth and Charles Swedlund. "Posterizations" of
Still Life made from high-contrast negatives and positives
printed interchangeably with Kwik Proof. 1973.

Charles Swedlund

Southern Illinois University, Carbondale

Photography

A Handbook of History, Materials, and Processes

Holt, Rinehart and Winston, Inc.

New York Chicago San Francisco Atlanta
Dallas Montreal Toronto London Sydney

To Elizabeth, from whom I received a new life

Acknowledgments My first acknowledgment must be to the students whose questions prompted me to undertake this project. Their comments and reactions helped both directly and indirectly to structure the presentation, which first appeared in two earlier versions of the book, under the title *A Guide to Photography*. Critiques of the material given to me by Thomas Baird of the University of California Extension in Berkeley, Marie Czach at the Art Institute of Chicago, and Jerry Uelsmann at the University of Florida proved enormously beneficial in my attempts to bring the book to its present form. I received, in addition, useful criticism from Ken Abel and John D. Lindstrom. All must be held exempt from responsibility for whatever error may have been left undetected in the volume now published.

Elinor White and Janet Wood helped prepare and present the text in its preliminary versions, and Ford Gilbreath, William Kociecki, and Gordon Richardson facilitated the production of the illustrations. I am grateful to all.

I must also cite with gratitude the many photographers, museums, galleries, libraries, and agencies that lent us both their support and their resources. Particularly helpful were Doris Bry, Paul Strand, and Cole Weston; Rex Anderson, David Holtz, and Donald Ryon of the Eastman Kodak Company in Rochester, N.Y.; Ann McCabe of the Photographic Print Service at George Eastman House in Rochester; the entire staff of the Department of Photography at New York's Museum of Modern Art; Grace Mayer, director of the Steichen Archives of the Museum of Modern Art; Miles Barth at the Art Institute of Chicago; Harold Jones of the Light Gallery in New York; and Paul H. Bonner, Jr., at Condé Nast Publications. Without them, we would have had fewer ideas and even less illustration.

The book's ultimate production, with the great program of illustrations and substantial text, proved a herculean task, borne mainly by Dan Wheeler of Holt, Rinehart and Winston, as well as by Joan Curtis and Pat Kearney, who collected the halftone illustrations and cleared the permissions to use them. Rita Gilbert and Pat Kearney also did much editorial work, while Marlene Rothkin Vine executed the book's striking and appropriate design. It is the work of Felix Cooper and Lennie Shur that has given the black-and-white line art its clarity and elegance. For their expertise and personal enthusiasm throughout the enormous undertaking, these thorough professionals have my sincere thanks.

To honor the special place she occupies in my life, I direct these last expressions of gratitude to Elizabeth, who pacified my tantrums, typed the manuscript, prepared the sketches for many illustrations, and generally caused reason to prevail whenever chaos threatened. CS

The author and the editors are happy to make a special acknowledgment of Time-Life Books' *Life Library of Photography* (1970–71), a beautiful and authoritative series of sixteen volumes that should prove invaluable to any serious student of photography, just as it did in the preparation of the present work. The entire series is listed title by title at the head of the bibliography that commences on page 352.

Editor Dan W. Wheeler
Production editors Francis W. Bilodeau, Hermine Chivian, Margot Cutter,
 Barbara Gibbons, Rita Gilbert, Patricia Kearney, and Marie Lonning
Picture editors Joan Curtis and Patricia Kearney
Designer Marlene Rothkin Vine
Line drawings Felix Cooper, Lennie Shur, and Dominic Troiani

Preface

In 1839, not long after the first image had been recorded and made permanent by photographic processes, Sir John Herschel, the English chemist and astronomer, declared "It is a miracle!" upon seeing photography done for the first time. Almost 150 years later, when photography has come to provide, after spoken discourse, the principal means of communication and expression for the whole spectrum of modern life, Jerry Uelsmann, a preeminent photographer of our time, confirms that photography "has been and will always be alchemy." Just as the crude products of a pioneering effort caused a 19th-century scientist to exclaim in the terminology of medieval mysticism, the contemporary person, whether child or adult and already acculturated to life viewed through the lens, almost invariably experiences rapture whenever his first attempt at taking pictures with a camera produces so much as a single image, however poorly focused and randomly framed. The thrill is that of life itself, for no other medium ever devised by man has the capability of photography to record with perfect fidelity the image of life in the fleeting moments of its occurrence in time and space. The miracle of photography is that a child can do it, so thoroughly has the underlying technology been simplified; yet the medium offers such range and power that a sensitive and knowing technician can use it to achieve images whose revisualizations of the world have the profound beauty of great art. Most of us aspire to a competence somewhere in between, and it is to this purpose that the present volume has been addressed, for mysterious and magical though the processes and effects of photography may be, they are in fact all the more wondrous by virtue of the logic and simplicity in the principles that make photography possible. The book's objective is educational, to reveal in a clear and practical way, for beginners of all ages, the fundamental logic in the magic of photography, to demonstrate the grammar and syntax of a language whose visual idiom has become the expressive vehicle of modern communication. Its point of departure was indicated by László Moholy-Nagy, who estimated that "...the knowledge of photography is just as important as that of the alphabet. The illiterate of the future will be a person ignorant of the use of the camera as well as the pen."

To see the world and see it intensely and perceptively is to know and understand life and to be gratified by one's participation in it. Used with competence and imagination, the camera can supplement the eyes and extend man's ability to see and enrich his vision to encompass the submicroscopic as well as the outer limits of the planetary system. The human eye can focus on objects both large and small and distinguish their actual and relative sizes, discern movement and distance, and differentiate among colors. Superb as this instrument may be, however, the human eye has limitations. It can see energy from that part of the electromagnetic spectrum called *visible light,* but not the shorter wavelengths of X rays nor the longer ones for infrared, both of which the camera includes in its range of seeing. Human sight perceives the movement of a duck in full flight, but the camera can register in a still, frozen image the high-velocity beating of a hummingbird's wings, to which the naked eye would remain blind. Attached to man himself, the eye can go only where man goes, which may well be the greatest limitation placed upon man's unaided ability to see. Photographs have been taken of the interior chambers of the heart and pictures snapped at 1/200,000,000 of a second to reveal the effects of a nuclear explosion. Indeed, the mechanical eye of a camera and sensitized film have together made it possible for man to know by sight virtually every form of life or matter. Quite possibly their most startling revelations are those produced by photographic candor from scenes in everyday life,

discovering there unsuspected textures, details, and depths of feeling and personality, even in the image of one's own face.

To develop meaningfully in the medium, the beginning photographer should attempt to acquire not only proficiency in the techniques of using photographic equipment and materials and in the processing of film and prints but also a good and tasteful eye for the special qualities of photographs and the type of imagery they produce. Photographs themselves—in great numbers and the best —are the most effective teachers of taste and discernment, and for this reason the book commences with a historical survey of the genesis and development of photography from the early 19th century to the present. The historical review is then followed by a survey of the major means that photography has provided for visual expression. In these two chapters, as everywhere else in the book, the illustration program is dense and rich and the examples selected for quality, in the sense of both visual excellence and the demonstration of possibilities unique to the photographic medium. The objective guiding the selection of the photographs reproduced has been to achieve a blend of the historical and the contemporary, so as to reveal how photography has grown through the process of exploration on the part of individual photographers.

Thereafter, the narrative advances through a sequence of chapters arranged to present with clarity and logic, moving from the simple to the complex, the elements, principles, and functions of cameras, exposure, light, lenses, depth of field, film, photographic print-making, and color photography. Supplementing the main body of the text are appendices on artificial light, closeup photography, copying, view camera movements, filters, toning, presentation, color temperature, and a chart for notations on the relationships of time and temperature variables in development processes.

Throughout these units every effort has been made to speak of photography in basic English, freed insofar as the subject matter would permit of all unnecessary technical jargon. Also to serve the interests of clarity and directness, the illustrations, which total almost 800 in number, have been prepared so that the photographs reproduced are indeed photographs in every sense of the word, while the demonstrations of equipment, materials, techniques, and processes take the graphic form of line drawings. In the hope of causing the presentation to proceed systematically from broad and basic concerns to higher levels of distillation and concision, the book has been arranged to function fully in its several different but closely interrelated elements. The prose text and the visual illustrations recapitulate each other one for one, with every point in the text being reproduced either in a photograph or in a line drawing. Meanwhile, the legends provide in brief the information given both in the text and in its accompanying illustration. Finally, a key word or phrase at the beginning of each legend cites in bold-face type the fundamental significance of the related text, illustration, and legend. At the same time, the various parts make a coherent whole by virtue of the layout, which brings together on the same page or on facing pages all related elements, even in the chapter on color, where well over 100 full-color plates have been integrated with the text. For those who have read and studied the book, the illustrations and their explanatory legends alone should provide entirely adequate information for purposes of quick reference and review.

Concluding the book are the substantial features of a bibliography, a glossary, and an index. Beginning it is a portfolio of photographs, placed just after the table of contents and before Chapter 1. These represent some of the most imaginative and compelling work done by contemporary photographers. All together, they establish the book's theme, which is that the gleaming technology of photography exists to serve the expressive purposes of those who see with sensitivity, preception, wit, and intellect, and such is the expressive potential of photography that the modern person could well afford to master and control the techniques of photography as a means of pursuing his vision of life.

Cobden, Ill. CS
January 1974

Contents

7 DEPTH OF FIELD

8 FILM

9 THE PRINT

10 COLOR

Picture-taking is a trap of images — serious, fleeting, funny, tragic, fanciful, rare, human, irreplaceable.

Jacques Henri Lartigue

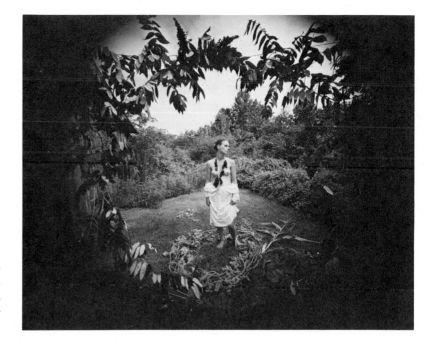

right: **Emmet Gowin.** *Edith (Wildberry Necklace).* 1971. Courtesy Light Gallery, New York.

below: **Leslie Krims.** *Untitled,* from the portfolio *Mom's Snaps.* 1971. Courtesy the photographer.

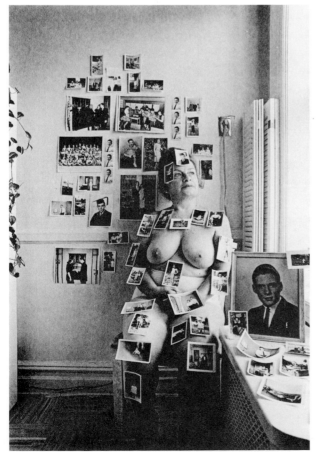

The family portrait almost invariably has offered the photographer his first opportunity, and some have developed this subject matter into highly charged and intensely affecting statements. Such a photographer is Emmet Gowin, who achieved the circular image of his wife reproduced here by exposing through a lens too small to cover fully the film size in his 8×10 camera. The shape of the image suggests something of the intimacy of the relationship between the photographer and his subject. Of Les Krims' work, represented here by a portrait of his mother, Robert A. Sobieszak has written that "confrontation with any of Les Krims' photographs is at best a very difficult yet exquisite proposition."

The social landscape offers a rich source of imagery for the photographer eager
to isolate the details, textures, and specific qualities of life. Usually, such
photographs illustrate a natural or commonplace scene, event, or situation,
but transformed by the photographer's selective treatment from mere documentation
into symbol, myth, or metaphor. To photograph the life of New York's Harlem,
Bruce Davidson did not dart about stealthily with a 35mm camera but worked with
a large view camera and concentrated on a single block in East Harlem.
This yielded photographs characterized by quiet dignity and great, sincere respect.

Bruce Davidson. *East Harlem.* 1966. Courtesy Magnum, New York.

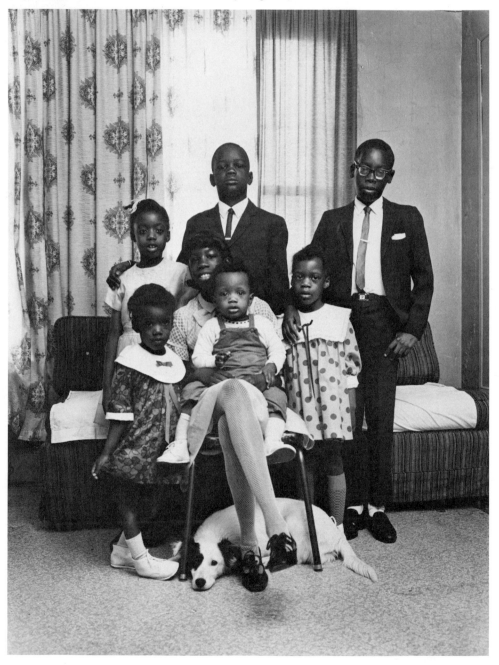

Charles Swedlund. *Elizabeth's Family.* 1972. Courtesy the photographer.

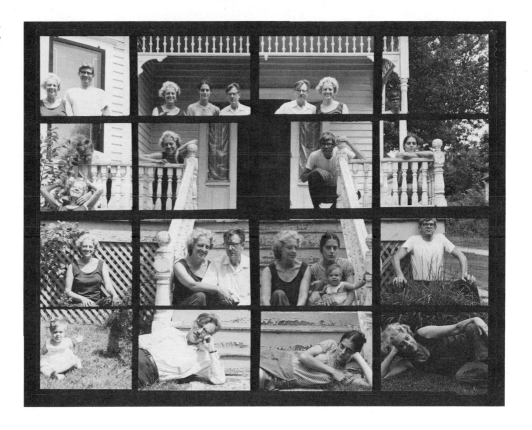

Sequences develop from separate photographs or from separate and isolated parts of a single photograph in which the pictorial impact derives from the significance of the whole rather than from the importance of the individual elements. The separate images, however, hold together by virtue of relationships in subject matter, ideas, or even the piece of film common to all the units. Swedlund made the photograph reproduced here by exposing a sheet of 8 × 10 film sixteen different times, for each of which he moved a mask at the back of the camera so as to uncover the film sequentially. The camera session lasted about two hours, which is apparent in the way the quality of the light varies from cell to cell throughout the grid of images.

Long photographs can be created by a variety of means, the result of which is a negative with one dimension very much exaggerated relative to the other and, often, an image distorted equilaterally on the long axis. Here, William Larson made a narrow slit in the back of his camera and used an electric motor to advance the film, causing it to pass the slit for exposure. At the same time, he had the model rotate throughout the exposure duration.

William G. Larson. Plate 1 from *Portfolio: Human Figure in Motion.* 1969. Courtesy the photographer.

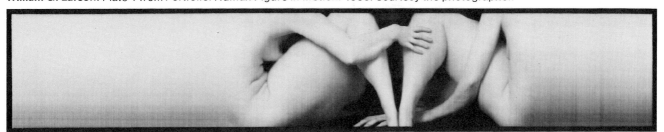

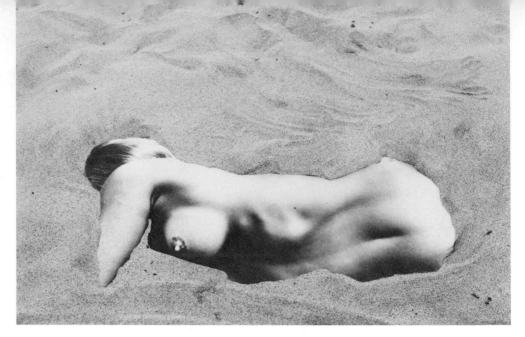

Ellen Brooks. *Beach Piece.*
1971. Over lifesize. Courtesy
the photographer.

Photographs on cloth were popular years ago when the imagery served the need for sentimental souvenir or memento of a holiday or family scene reproduced on a pillow. Today, photographers explore this possibility by using a light-sensitive cloth called Photo Linen or by sensitizing cloth with applications of gum bichromate or Quick Proof. Ellen Brooks arranges cloth photographs in sand and then rephotographs them to create new, marvelously surreal images.

Photographic printmakers employ the mechanical eye and light-sensitive film to create designs for multiple reproduction by techniques traditional to lithography, intaglio, and silk screen. As a consequence, photographers have become printmakers at the same time that printmakers have adopted the methods of photography. Such cross-fertilization is a hallmark of contemporary art. About the work reproduced here, Naomi Savage writes that *"Contradiction* is a linecut, photoengraved in copper, and then silver-plated, oxidized, and lacquered. It is made from a photograph of a wooden hanger-head and a rubber band. Contrary to the usual procedure of making a photoengraved plate as a means of reproduction, it is used out of context as the finished object."

Naomi Savage. *Contradiction.* 1972.
Courtesy the photographer.

Photographic sculpture extends photography into the actual third dimension, which makes possible an interesting visual exchange between the illusion of solid form set in deep space and its actual presence. It also involves the viewer with photography in a different way, requiring him to consider more than a single surface in order to see the whole of the work. Of the photographic sculpture reproduced here, Heinecken has written that "all of the 9 'slices' have images on all 4 sides and are manually rotated about a central axis creating various mutations and combinations of the figure. This particular item allows for mixtures of the anatomy and organic natural images from a particular beach environment. It is one of a series of similar objects utilizing this basic form and idea but made up of a variety of subject matter and in different scales." Dale Quarterman's piece is much larger, and to experience its image fully, the spectator must examine all surfaces both inside and out.

left: Robert Heinecken. *Figure Sections Beach.* 1966. Photographic paper, adhered to nine separate walnut blocks, plus base; height 8½". Courtesy the photographer.

right: Dale Quarterman. *Marvella.* 1969. Photographic paper prints, mounted on a built-up styrofoam form; height 25", depth 3½". Courtesy the photographer.

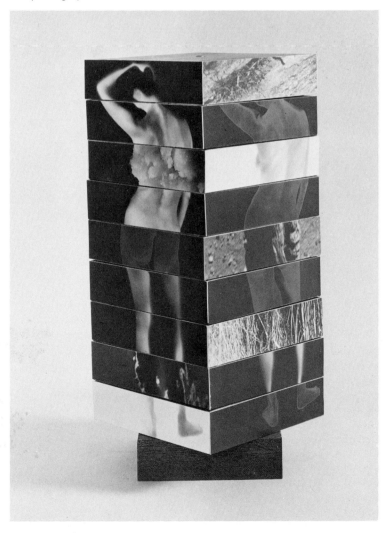

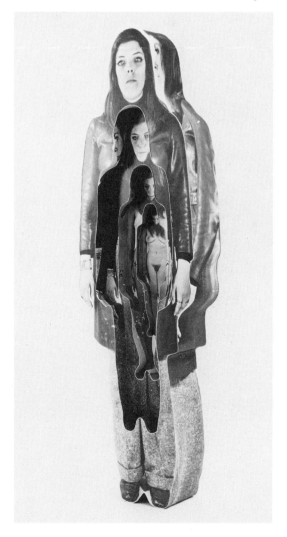

Charles Arnold, Jr. *Untitled.* 1973. Direct xerograph. Courtesy the photographer.

Technology continues to provide the photographer with new means of image making. Some photographers have been immensely successful in their experiments with Xerox, Itek, Thermofax, CopyMate, 3M Color, etc. Charles Arnold creates what he terms *xerographs* by exposing electronically charged selenium plates in a view camera, employing the same techniques evolved for film. He writes: "I have used xerography as a creative image-producing process since 1966. For these reasons: A. No darkroom time (I have been involved with photography all my life and for the last 20 years have hated darkrooms); B. The images can be transferred to beautiful papers (photographic paper is ugly); C. The process is quick and full of surprises (I can make a finished image from exposure to vapor fixer in 5 to 7 minutes); D. I enjoy exploring and expanding relationships of things in a controlled environment. By making many finished images in a day and using them to provoke changes in each successive transfer, I see a growth and structure develop."

History of Photography

THE EARLIEST PHOTOGRAPHIC IMAGES

Of all the major visual arts, photography has perhaps the shortest history. Whereas sculpture, architecture, drawing, and even painting can be traced back thousands of years, the technique of creating a durable photograph was mastered only in the 19th century. Nevertheless, in the more than one hundred thirty years since Daguerre photographed a corner of his studio (Fig. 5), astonishing technical advances have brought photography to a very high level of sophistication. And, while scientists have continued to expand the mechanical potential of the camera and related equipment, sensitive practitioners have explored the aesthetic possibilities of the medium. Any discussion of photography's early history must consider the two areas—scientific and aesthetic—as parallel developments, for they are closely interrelated. Without mechanical advances, the artistic achievements would not have been practicable, and at the same time, if the more imaginative photographers had not been constantly seeking new ways to expand the horizons of their craft, the mechanical improvements would not have been stimulated. In many cases it is just as interesting to know *how* a photographer made a certain image as it is to know *what* he photographed.

The term *photography* is derived from two Greek words meaning "light" (*phos*) and "writing" (*graphein*). Light is the essential element in photography, for it possesses two properties that combine to create a permanent image. The first is that light, when passed through a lens and focused upon some field, such as paper or glass, can produce an image. The second is the ability of light to alter certain materials. The latter property is well known from one's daily experience. For example, some pigments, such as those used in making fabric dyes, fade after prolonged exposure to light. Many chemical compounds are light-sensitive; they may darken when merely subjected to light or when exposed to light and then to other chemicals. This phenomenon is the principle upon which modern photography is based, for it serves to render the recorded image durable. Both properties of light had been understood for several centuries, but not until 1837 were they combined successfully in a way that made a photographic image possible.

Despite the enormous complexity of some modern equipment, all cameras rely on the same essential features (Fig. 1). Light enters a darkened enclosure (the *camera,* from the Latin word for "room") through a small *aperture,* the size of which can often be controlled mechanically. A *shutter* is opened and then closed to admit light for a specified period of time, varying potentially from hours or days to tiny fractions of a second. Inside the camera, a ground-glass *lens* gathers and concentrates the light, throwing it onto a light-sensitive field at the back of the camera—the *film.*

No one knows when man first constructed a device that would record images

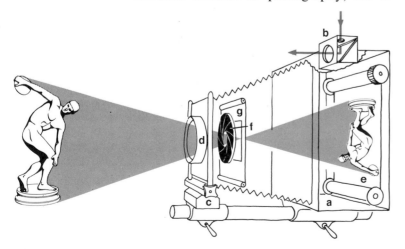

1. The essential elements of the camera, a *light-tight box* (a), are the *viewing system* (b), through which the photographer can see his subject; the *focusing system* (c), which works mechanically to shift the *lens* (d) back and forth until it gathers light in such a way as to project an image in focus upon the light-sensitive surface of the *film* (e). The *aperture* (f) and *shutter* (g) control the amount of light entering the camera, the first by the size of its opening and the second by the length of time during which light is admitted into the camera.

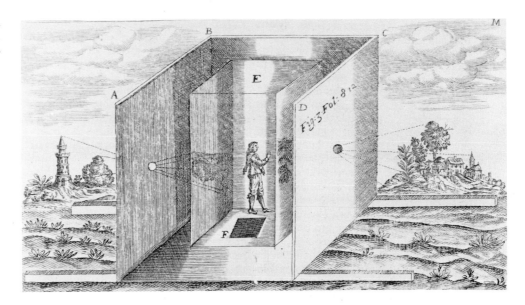

2. Camera obscura, a "cutaway" view. 1646. Engraving. George Eastman House, Rochester, N.Y.

by means of light. An old legend tells of a certain Arab who awoke one morning to find a miraculous vision on the wall of his tent. After his first astonishment had passed, he realized that the "vision" was actually an inverted image of a group of people outside. Because of a perfect coincidence of factors, a tiny hole in the opposite wall of the tent had acted as a crude lens.

This principle was exploited during the Renaissance, not as an end unto itself, but as a means to an end—that end being the realization of correct perspective in painting. In that period artists were much concerned with painting a scene "realistically" and therefore became preoccupied with questions of vanishing points and true perspective. The *camera obscura* (Fig. 2) solved many of their problems. Leonardo da Vinci described the principles underlying the camera obscura (literally, "dark room") and made sketches detailing its implementation. In essence, light would be admitted through a tiny pinhole in one wall of a darkened room, whereupon the scene outside the room would appear, upside down, on the opposite wall. One had only to place a sheet of translucent paper over the image and trace its outlines. In 1568 Danielo Barbaro of Padua recommended substituting a lens for the pinhole, because the image produced would thereby be much brighter.

Over the years the camera obscura gradually shrank, until by the 18th century it consisted of a box, perhaps 2 feet square, fitted with a lens to trap the light and a sheet of ground glass to receive the image. The device, in many variations, was extremely popular with artists of the period.

The earliest research in light-sensitive materials was conducted by Heinrich Schulze (1687–1744), a German physicist who in 1727 discovered this property in silver salts. At first Schulze thought the *heat* of the sun had caused the salts to darken, but when other sources of heat failed to duplicate the results, he realized that the *light* must be responsible. To verify, he wrapped a stencil of opaque paper around a jar of silver salts and placed this in bright sunlight. After a while, the exposed areas turned black, while the portions covered by paper remained unchanged.

Similar work was undertaken by Thomas Wedgwood (1771–1805), son of the British potter. In 1802 Wedgwood published the results of his experiments with paper that had been soaked in nitrate of silver. By setting a piece of lace over the light-sensitive paper, he produced a negative image of the lace, for all portions of the paper that were not covered had turned black. Unfortunately, Wedgwood could find no way to *de*sensitize the paper once a satisfactory

image had been created, so he had either to squint at his pictures in almost total darkness or permit them to disappear as normal daylight gradually turned the paper a uniform shade of black. In spite of this drawback, Wedgwood's research is important, for he had attempted to combine the phenomenon of light-sensitive materials with the image-producing capability of the camera obscura. At this point, then, the two basic ingredients of photography had been formulated: the Italians had developed a method to capture images; a German and an Englishman had suggested a way to preserve them. It remained for two Frenchmen to pull the elements together.

Joseph Nicéphore Niépce (1765–1833) had developed a method of rendering photographic images permanent at least by 1826 and probably several years earlier. Niépce's first experiments centered around an attempt to reproduce engravings, since he could thus concentrate on black and white and avoid the complication introduced by many shades of gray. He found that a certain type of bitumen became insoluble in lavender oil after it had been exposed to light, whereas the same substance could be dissolved in lavender oil if light were prevented from striking it. Through the action of these chemicals, Niépce was able to transfer the engraving to a pewter plate—an accomplishment that paved the way for lithographic reproduction. Next, he turned his attention to the images of nature, or as he called them, "view points." A thin pewter plate coated with light-sensitive material was exposed in the camera obscura, then placed in an acid solution that allowed the unexposed areas to be etched. After some of the lines had been further incised by hand, the plate was inked and printed. Niépce's first successful experiment in what he termed *heliography* was apparently a view from the photographer's window at Gras, made in 1826 with an exposure of eight hours (Fig. 3). The image is very blurred, partly because the long exposure recorded constantly shifting shadows.

In 1826 Niépce entered into a correspondence with Louis Jacques Mandé Daguerre (1787–1851), a French painter and entrepreneur who had also experimented with the camera obscura. At that time, Daguerre's main occupation was the Diorama (Fig. 4), an extraordinary Paris attraction of which he was the inventor and coproprietor. In a large theater were displayed immense landscapes painted on semitransparent theatrical gauze. A system of shutters and screens behind the paintings allowed light to be projected on first one section and then another, thereby changing the mood and even giving the impression of movement. In order to make the paintings as meticulously detailed, as impeccably "realistic" as possible, Daguerre and his partner executed numerous studies with the camera obscura. As a final touch, the entire theater could be revolved, enabling the audience to view the paintings in sequence.

Daguerre's experience with the camera obscura led him to investigate light-sensitive materials. He initiated the contact with Niépce after their mutual lens maker, Chevalier of Paris, suggested that Niépce was working along similar lines. The letters

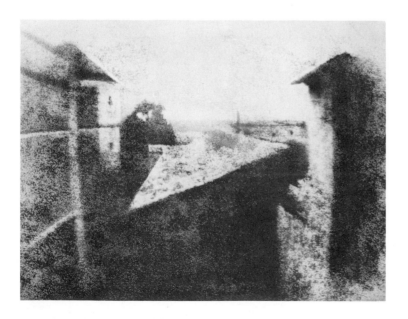

3. **Joseph Nicéphore Niépce.** *View from Window at Gras.* 1826. Heliograph. Gernsheim Collection, Humanities Research Center, University of Texas, Austin.

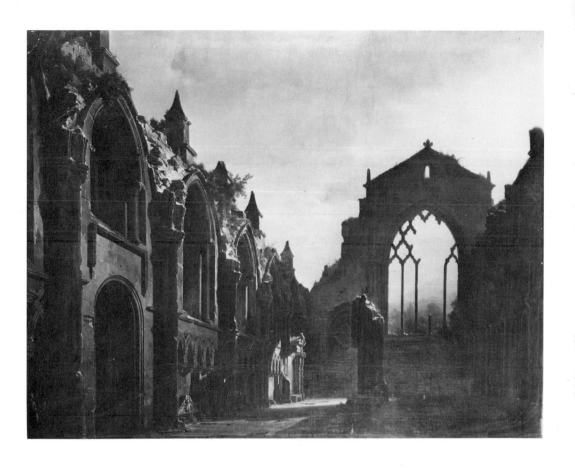

that passed between the two men were cordial but extremely guarded, for each was jealous of his secret research and hesitated to reveal details for fear the other would claim credit for the discoveries. For three years Niépce and Daguerre thrust and parried, each always holding back the one bit of information he thought the other needed. Finally, in 1829 ill health and discouraging results forced Niépce to suggest a partnership, to which Daguerre agreed. But the collaboration lasted only a short time, for in 1833 Niépce died, two years before his research was publicly reported.

Daguerre persevered in his experiments, continuing his partnership with Niépce's son Isidore. In 1835 the Paris *Journal des artistes* reported that Daguerre had hit upon a method of preserving images made by the camera obscura. However, evidence indicates that the first successful photograph was actually *The Artist's Studio* (Fig. 5), signed and dated 1837. Convinced

above: **4. Louis Jacques Mandé Daguerre.** *Ruins of Holyrood Chapel.* Exhibited 1824 (Diorama of same subject, 1823). Canvas, 6′11″ × 8′5″. Walker Art Gallery, Liverpool.

below: **5. Louis Jacques Mandé Daguerre.** *The Artist's Studio.* 1837. Daguerreotype. Société Française de Photographie, Paris.

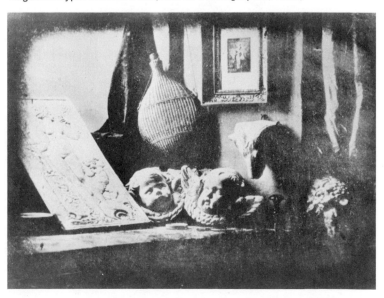

that his methods were sufficiently different from Niépce's, Daguerre called his efforts *daguerreotypes*. Shortly after the French government bought the invention in 1839, details of the procedure were made public.

As demonstrated by the inventor, the daguerreotype process involved a sheet of copper that had been silverplated on one side. After buffing with pumice, the plate was subjected to the fumes of iodine and then exposed in the camera obscura. When the required exposure time had elapsed, the plate was removed and developed with fumes from heated mercury, which gradually brought out the image (to the astonishment of assembled spectators). Finally, the image was made permanent by soaking in hyposulphite of soda (sodium thiosulphate, still known universally as *hypo*). The resulting photograph was difficult to look at, because the mirrorlike surface reflected the viewer's own features, and from certain angles the image appeared in negative.

Moreover, the daguerreotype was extremely fragile; thus, it had to be mounted behind glass and sealed.

By 1839 Daguerre had so perfected the process that he could record more complicated scenes, but the long exposure time — from 5 to 40 minutes — precluded photographing people. *Paris Boulevard* (Fig. 6) is the only one of Daguerre's pictures that includes a human being, and even that occurred by pure chance. The man barely visible in the lower left corner had stopped to have his shoes shined and remained motionless throughout the exposure period. The hard-working shine boy is a mere blur, while other pedestrians as well as passing carriages have vanished. Although there was considerable demand for portrait photographs, even Daguerre despaired of reducing the exposure time sufficiently to make such pictures feasible. By the time of his death he had all but abandoned photography and returned to painting.

6. **Louis Jacques Mandé Daguerre.** *Paris Boulevard.* 1839. Daguerreotype. Bayerisches Nationalmuseum, Munich.

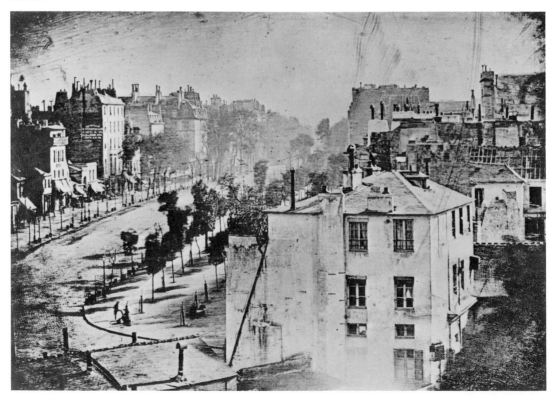

The Era of Portrait Photography

Within a few months after Daguerre's original announcement, word of his invention had spread throughout Europe and the United States. The initial excitement soon passed, however, when the public realized the daguerreotype was not a quick and easy substitute for portrait painting. One enterprising publisher established a business based on daguerreotype reproductions into which figures, horses, carriages, and other normally mobile items had been drawn by hand. More farsighted individuals, at the same time, were attempting to perfect the basic daguerreotype process. By 1841 improved lenses and better methods of preparing the light-sensitive plate had reduced the necessary exposure time to less than a minute. The experience of having oneself photographed was therefore possible, if not particularly comfortable.

The first American "daguerreotype gallery for portraits" was opened in New York in 1840; by the mid-fifties that city boasted 86 such studios, and there was at least one in every major city and town across the United States. People of all kinds flocked to have their portraits made, and long lines formed outside the more popular studios. So inexpensive were the daguerreotypes — at the height of competition the price dropped to two-for-a-quarter, including the frame — that subjects were willing to endure sitting, motionless and unblinking, for half a minute or more. For modern viewers, the rigid, stilted postures and forced countenances have acquired a timeless, noble, almost classical quality. Too, the old photographs express quite accurately the serious vision that photographers and their subjects had of their lives and times and of the significance of photography itself. Unfortunately, children made rather poor subjects, for their normally restless nature precluded adequate self-control.

The daguerreotype had two serious flaws. First of all, the surface was extremely delicate, and without the protective frame it was subject to damage or destruction. Sec-

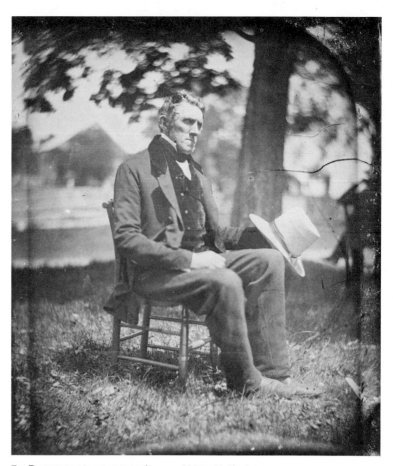

7. Daguerreotype portrait. c. 1850. Half-plate. Collection the author.

ond, its mirrorlike face made duplication very difficult, so each photograph was unique. For these reasons, the process was destined to be replaced by more efficient methods. By the 1850s, the time of the image reproduced in Figure 7, daguerreotype portraiture was already on the wane.

Meanwhile, in England the scientist and mathematician William Henry Fox Talbot (1800–77) had perfected a method he first called *calotype* (from the Greek, meaning "beautiful pictures") but was persuaded by his friends to rename *talbotype*. Talbot began his researches in 1833, two years before Daguerre's original announcement, and he later claimed to have been taken totally by surprise when he learned of the Frenchman's work. Hoping to share the fame (and, of course, the recompense),

8. David Octavius Hill and Robert Adamson. *Portrait of a Minister.* c. 1845. Calotype. George Eastman House, Rochester, N.Y.

(Fig. 538). In 1844 Talbot began publication of a work entitled *The Pencil of Nature,* which contained 24 calotypes—the first book ever to be illustrated with photographs.

Among the few who employed the calotype process for portraits were the team of David Octavius Hill (1802–70) and Robert Adamson (1821–48). Hill was a painter who in 1843 was commissioned to execute a canvas that would include a grand total of 450 individual portraits! He enlisted the aid of Adamson in making calotype studies for the work, and for five years the seemingly endless train of sitters made their way to Hill and Adamson's outdoor studio. Moreover, the two did not confine themselves to subjects for the painting; all manner of people came to be photographed, and many of these penetrating, sensitive portraits survive (Fig. 8).

Both the daguerreotype and the calotype had good and bad points. The former was sharp and clear but could not be duplicated; the latter could be reproduced any number of times but possessed what a contemporary observer referred to as "nothing but mistiness." The solution to both problems appeared to be a glass plate, which, lacking the coarseness of paper, would permit sharp imagery and easy duplication. However, little progress was made in finding a substance that would cause the silver salts to adhere to a glass surface. Various materials were tried, perhaps the most bizarre being the slime from snails. A qualified success was attained by Claude Félix Abel Niépce de St. Victor (1805–70), cousin of Daguerre's partner, who used a compound made from egg albumen to coat his glass plates. The resultant negatives were brilliant and much sharper in detail than the calotypes, but the plates' relatively low sensitivity necessitated long exposures.

A completely new chemical substance was needed in order to overcome the several deficiencies of the daguerreotype and calotype methods. That substance proved to be *collodion,* a gluey mixture of guncotton, alcohol, and ether that had been developed in 1847 as a means of protecting wounds. In 1851 Frederick Scott Archer

Talbot made his invention known to the public in 1839.

Calotypes were made on light-sensitive paper, rather than on the silver-coated copper plates Daguerre had employed. Talbot early discovered the negative-positive relationship—that a reversed image from the camera, which he himself named a *negative,* could again be reversed to make any number of *positive* prints. Consequently, the major drawback of the daguerreotype was eliminated. But the calotypes were neither as bright nor as sharp as daguerreotypes, so the technique was never commercially successful for portrait photography. It did, however, lend itself well to recording architecture and landscapes

right: **9. Ambrotype.** c. 1860. One-sixth plate, presented against a dark ground (left) and a white ground (right). Collection the author.

below right: 10. Tintype of a Civil War soldier by an unknown photographer from the 1860s. Collection the author.

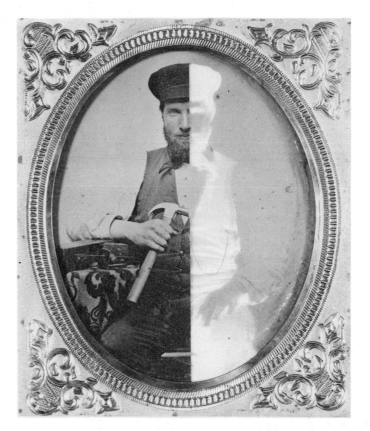

(1813–57), a British sculptor, devised a process in which glass plates coated with collodion were dipped in light-sensitive chemicals (silver nitrate solution), then exposed, while wet, in the camera. Three variations of collodion or "wet plate" photography were invented; together they managed to conquer the daguerreotype.

Archer had published his invention with no restrictions, and after James Ambrose Cutting of Boston patented the technique in 1854, his name was associated with it. The *ambrotype* became very popular in the United States because of the great demand for inexpensive portraits. Like the daguerreotype, each ambrotype was unique. It consisted of a sheet of glass coated with collodion emulsion, purposely underexposed (or normally exposed and then bleached). When viewed against white, the resultant image resembled a pale negative (Fig. 9), but a backing of black material or, occasionally, dark red (amber) glass revealed a properly exposed positive. Ambrotype portraits were fast and relatively cheap. They were often mounted in pressed-paper or leather cases for display.

A second variation of collodion photography was the *tintype*, which utilized a black or dark-brown metal plate instead of glass. The process was introduced in 1856 and immediately embraced by an enthusiastic public. Tintypes were even cheaper than ambrotypes; they could be developed very quickly, so the sitter could carry his portrait away with him. In addition, because the tintypes were not fragile, they could be sent through the mail, mounted in albums, or casually exchanged among friends. Most of the portraits made by this process were quite informal, even delightfully naïve (Fig. 10). Their quality was not as high as the products of other collodion methods, because the dark backgrounds

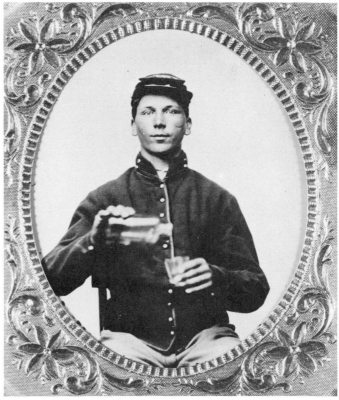

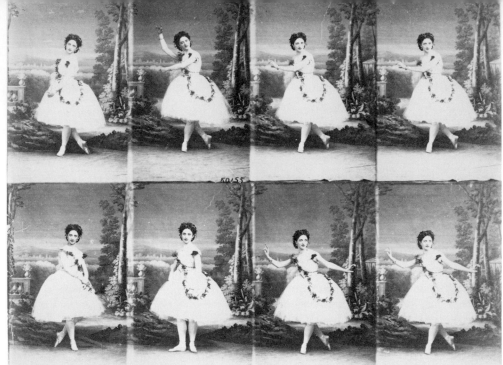

right: 11. **Adolphe Eugène Disdéri.** Sheet of uncut *carte-de-visite* photographs of Martha Muravieva, Paris Opéra dancer, in poses from the ballet *Neméa.* 1864. George Eastman House, Rochester, N.Y.

below: 12. **Nadar (Gaspard Félix Tournachon).** *Sarah Bernhardt.* 1859. Collodion plate. Bibliothèque Nationale, Paris.

cut down brilliance and made a pure white impossible. Nevertheless, an astonishing number of tintypes were made between the early sixties and the late eighties, usually by the less fashionable portrait photographers. Toward the end of its vogue, the tintype became associated with the penny arcade.

The tintype's even more prolific cousin was the *carte-de-visite* (Fig. 11), so called because each paper print was mounted on a card 4 × 2½ inches—the standard size for calling cards. This process, patented in 1854 by Adolphe Eugène Disdéri, differed in several respects from both the ambrotype and the tintype. First of all, the camera used for making carte-de-visite photographs was equipped with a multiple lens, so that eight or twelve different exposures could be obtained from a single glass plate. The plate was then contact-printed on paper, which was cut apart into individual photographs. However, more important for the development of photography, the product of the camera was a *negative,* which could be duplicated in an infinite number of positives. Portraits of kings, queens, presidents, and military heroes were reproduced and sold by the thousands. (When

Prince Albert, consort to Queen Victoria, died in 1861, seventy thousand portraits of him were snapped up inside a week.) Like the tintypes, carte-de-visite portraits were eagerly sought by the general public, and the exchange of photographs among family and friends became quite common. About 1860 elaborately bound albums made with slots to accept the uniform cards were introduced, and the family photo album became a fixture in Victorian parlors.

The ambrotype, tintype, and carte-de-visite portraits were not as a rule distinguished by their artistry, their sensitivity of lighting or pose, their revelation of character. They are the popular art of 19th-century photography, often comical in their attempts to be elegant or to resemble paintings and engravings. But even in those pioneering days of the craft, there existed a "fine art," practiced by serious photographers, both amateur and professional. Foremost among them was Nadar (Gaspard Félix Tournachon, 1820–1910), whose famous portrait of the actress Sarah Bernhardt is reproduced as Figure 12. Working with photographic plates that were larger than the common variety, Nadar posed his subjects in a simple, straightforward manner against plain backgrounds under the soft illumination of a skylight. He dispensed entirely with artificial props and other devices that might distract from the sitter. Thus he managed to capture an intimate record of the subject's personality. Although he became the most sought-after portrait photographer in Paris, Nadar did not confine himself to that field. A true Renaissance man, he continued to experiment, becoming one of the first to make photographs by artificial light. Nadar also took the first aerial photograph, swinging precariously in the basket of his balloon, *Le Géant.*

Julia Margaret Cameron (1815–79) had the unique advantage of presiding over a salon attended by most of the illustrious men and women in the London of her time. Among her subjects were Alfred, Lord Tennyson, Charles Darwin, Henry Wadsworth Longfellow, Robert Browning, and Sir John Herschel (Fig. 13). Cameron was not intimidated by the complexities of the photographic process; instead, she simply ignored them, cheerfully using whatever methods occurred to her to obtain the desired effect—the permanent recording of her sitter's essential spirit, his innate character. Unconcerned if her subject moved, thus destroying the focus, she deliberately employed faulty lenses to soften details and photographed her subjects from very close range—their heads often filling most of the composition. Much of her success depended upon a sympathetic interaction between her own forceful personality and that of the sitter.

The popularity of the carte-de-visite fostered a desire for larger images that could be produced just as readily. To meet this demand, the *cabinet* photograph was introduced in 1866. Printed from an individual negative that measured $6\frac{1}{2} \times 4\frac{1}{2}$ inches, the cabinet photo could be retouched to elimi-

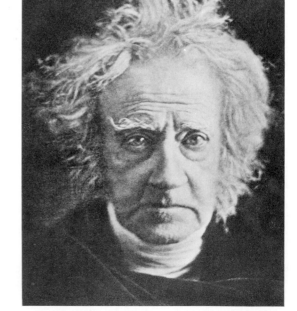

13. Julia Margaret Cameron. *Sir John Herschel.* 1867. Collodion plate. Art Institute of Chicago (Alfred Stieglitz Collection).

nate imperfections, such as freckles, moles, wrinkles, and the like. The cabinet photograph was also grander than its predecessors; often, the subject would be posed with fake scenery, elaborate drapery, and other studio props (Fig. 14). It was the ultimate step in idealized portraiture.

Within a few decades of its introduction, then, photography had more than gratified the desires of those who could not afford a painted portrait but who nonetheless longed to have their images recorded for posterity. This accomplished, photographers turned their attention to other ways in which they could beat painting at its own game.

In Search of Allegory

The collodion plate was not equally sensitive to all colors. In particular, it was overly sensitive to blue, which presented a problem in photographing landscapes. By the

left: 14. Cabinet photograph of an actor. Late 19th century. Collection the author.

below: 15. Oscar G. Rejlander. *The Two Ways of Life.* 1857. Composite photograph. Royal Photographic Society. London.

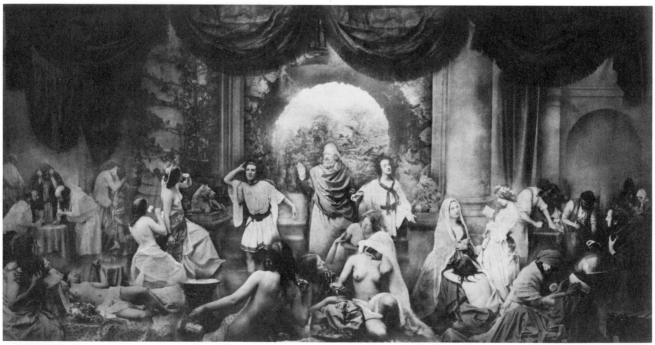

time the plate had been exposed long enough to record trees, buildings, mountains, or whatever, the sky above would be imprinted on the negative as a solid dark mass, blocking out clouds or any color variation. Photographers overcame the difficulty by exposing two negatives—one for the sky and one for the ground. After developing, the negative for the sky had its ground area masked, the other the reverse. Carefully registered on the same paper, the images made by *combination printing* suggested quite another possibility for photographers eager to make their work emulate painting.

In 1857 Oscar G. Rejlander (1813–75) exhibited an allegorical photograph called *The Two Ways of Life* (Fig. 15), which depicted on the one hand Religion, Charity, and Industry, on the other Gambling, Wine, and Licentiousness (leading inevitably to Suicide, Insanity, and Death). At the center of the composition is a figure symbolizing Repentance, accompanied by Hope. Rather than attempting to pose, as a unit, the thirty different models required by the composition—to say nothing of the massive props that would necessitate a huge studio—

Rejlander made the photograph in sections, recording each figure group and each portion of the background individually. When he had finished, he masked the negatives together to produce a single composite print that measured 16 × 31 inches. Although to our eyes the picture seems forced and absurdly melodramatic in its symbolism, it existed within the aesthetic—if not the caliber—of contemporary paintings, such as Gustave Courbet's *Interior of My Studio, a Real Allegory Summing Up Seven Years of My Life as an Artist* (Fig. 16), completed just two years earlier. The photograph was generally well received, its original actually purchased by Queen Victoria.

Less favorable notice was accorded *Fading Away* (Fig. 17), a composite photograph made by Henry Peach Robinson (1830–1901). Printed from five separate negatives, the scene portrayed the death of a young girl—acted by a professional model

16. Gustave Courbet. *Interior of My Studio, a Real Allegory Summing Up Seven Years of My Life as an Artist.* 1854–55. Oil on canvas, 11′ 10″ × 19′ 7″. Louvre, Paris.

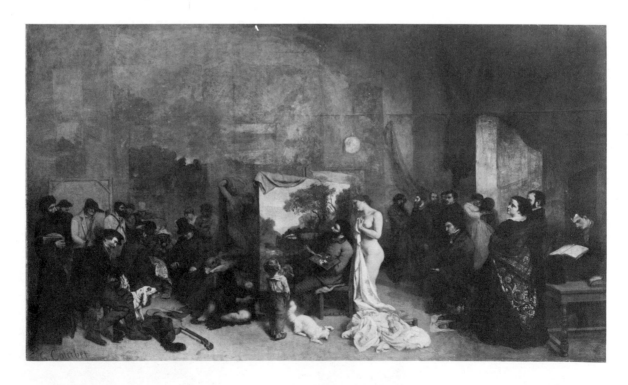

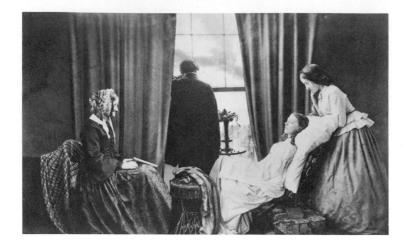

The Photographer in the Field

The first accredited war photographer was an Englishman, Roger Fenton (1819–69), who in 1855, backed by Agnew Brothers of Manchester, set out to cover the Crimean War. Although some daguerreotypes had been made of officers and men in the Mexican War, Fenton was the first to actually focus on scenes of battle (Fig. 18). He had outfitted a "photographic van" to serve as a portable darkroom, for the wet-plate collodion process required that each negative be processed as soon as it had been exposed. Despite his complaints that he could scarcely concentrate on the war itself in the face of so many pressing demands for portraits, Fenton managed to bring back to England more than three hundred negatives, showing battlefields, fortifications, and soldiers (although little real action). The photos were exhibited in London and Paris, and while the public found them dull compared to the heroic battle scenes of painting, it was generally conceded that the element of truth they contained made up for the lack of drama. Even *The Times* of London allowed that "whatever he represents from the field must be real."

—and was accompanied by a rather maudlin poem written on the mat. Critics protested that the photograph was too artificial, while the general public found it all too real, its deathbed scene excessively morbid for photography. Of course, such subjects were common in painting, but the camera's testimony of "this really happened" had a shocking effect upon its Victorian audience.

As long as photographers felt they must imitate the forms and conventions of painting, their craft was doomed to second-rate status. Only when the inherent potential of the medium was exploited—when it began to do things well that painting could not do at all—did photography come into its own as a forceful medium of visual expression.

The American Civil War presented a much more tempting invitation to photojournalism. At the outbreak of hostilities,

top: **17. Henry Peach Robinson.** *Fading Away.* 1858. Composite photograph printed from five negatives. Royal Photographic Society, London.

right: **18. Roger Fenton.** *The Tombs on Cathcarts Hill.* 1855. Gernsheim Collection, Humanities Research Center, University of Texas, Austin.

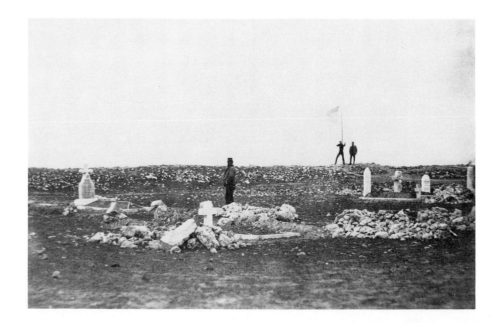

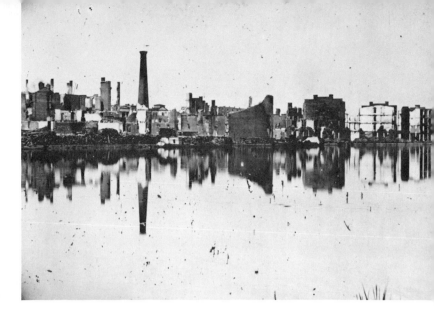

Mathew Brady (1823–96), an extremely successful New York photographer, abandoned his lucrative portrait business and obtained clearance to travel through the war zone. With his team of assistants, he took his photographic buggy straight into the thick of the conflict to record battlefields littered with dead, exhausted soldiers, ships, wrecked railroads, and ruined cities (Fig. 19). For his photographs, Brady ignored the very real dangers; at Bull Run he was nearly killed. Nevertheless, by the end of the war he and his associates had produced more than seven thousand negatives. News of Brady's enterprise encouraged other photographers to join him, and by 1865 some three hundred men had been granted clearance by the Army of the Potomac. The public, however, was not so willing to embrace war photography. To a nation eager to forget the horrors of civil conflict, Brady's stark, often brutal scenes were too painful. The public preferred the somewhat romanticized engravings prepared for *Harper's Weekly* by such artists as Winslow Homer, and Brady never realized much profit from his venture.

Many of the photographers who took their training during the war set out afterward to record the vast, largely unexplored regions of the American West. Often attached to geological survey groups, these men carried their unwieldy cameras and portable darkrooms over rough, precipitous terrain to capture on film the natural wonders of which most Americans were ignorant. In 1870 William Henry Jackson (1843–1942) joined an expeditionary party led by the explorer-scientist Ferdinand Vandiveer Hayden, and the following year he made the first photographs of the area now known as Yellowstone Park. Jackson's stunning photos of the unspoiled magnificence of the Western landscape (Fig. 20)

top right: 19. Mathew Brady. *Ruins of Richmond, Viewed Across the Basin.* c. 1865. National Archives (Brady Collection), Washington, D.C.

right: 20. William Henry Jackson. *Glacier Point, Yosemite.* c. 1895. Denver Public Library (Western History Department).

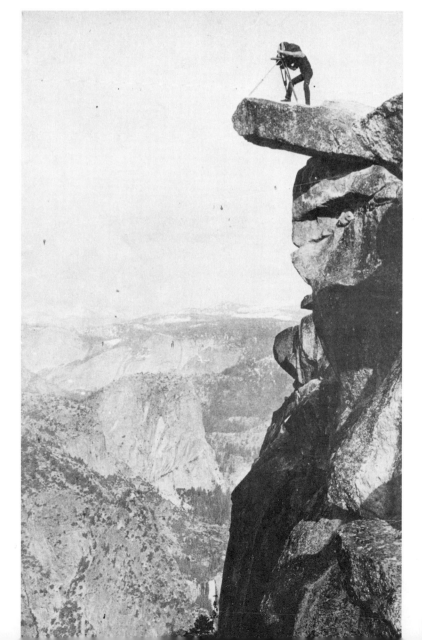

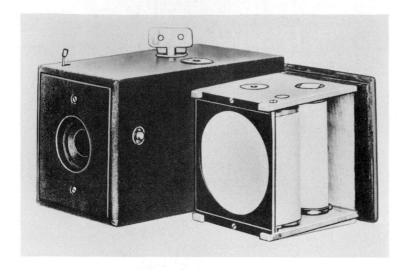

inches! In that period, enlarging was still a very difficult matter, seldom attempted, so the size of the print was determined by the size of the negative. Moreover, since the wet plates had to be processed immediately, the darkroom traveled wherever the photographer went. Jackson's darkroom consisted of a "canvas tent lined with orange calico about six feet square at base with center pole," transported on horseback or by mule train. One expedition failed to yield a single negative, because a horse carrying the camera fell off a cliff.

Enlarging did not become really practical until the 1920s, but the other problem was eliminated in the late 1870s. By 1867 the Liverpool Dry Plate and Photographic Printing Company had begun to market readymade collodion plates that could be processed at the photographer's convenience. However, these first dry plates had such low sensitivity that most professionals refused to accept them. Four years later an English physician, Richard Leach Maddox, described a dry process that depended on gelatin emulsion into which light-sensitive chemicals had been dissolved. A perfected version of this method was introduced in 1879, and it proved so far superior to wet-plate photography that it was almost universally adopted at once. The dry plates could be purchased in stores, exposed at leisure, and developed within any reasonable time—either by the photographer himself or by a commercial processing firm. The first dry plates were oversensitive to blue and almost completely insensitive to red, orange, and yellow. Gradually, these inconsistencies were corrected. (Modern film is equally sensitive to all colors.)

Until the last decade of the 19th century photography remained largely the province of sturdy individuals willing to cope with all the inherent problems just described. But in 1888 George Eastman (1854–1932),

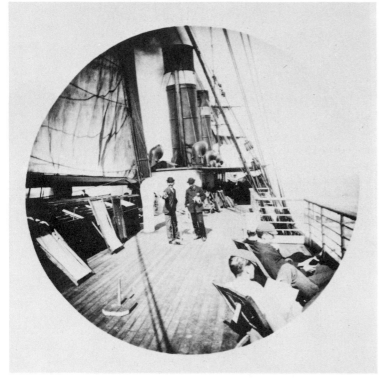

were an essential factor in Congress' controversial decision to set aside certain regions as national parks.

The intrepidity of men like Fenton, Brady, and Jackson can be fully comprehended only when one realizes the limitations of their equipment. For example, the camera that Jackson lugged up and down the Rocky Mountains measured 20 × 24

an American dry-plate manufacturer, did for the camera what Henry Ford would do for the automobile a generation later: he made it possible for almost anybody to own one. In that year Eastman introduced the box camera (Fig. 21), which he called a *Kodak* (because the name was easy to pronounce and remember). The Kodak box camera was small, relatively lightweight, and not at all difficult to operate; its faster shutter speed eliminated the need for a tripod. Essential to the success of the box camera was another Eastman invention, the so-called "American film"—flexible paper (later transparent nitrocellulose) coated with a gelatin emulsion. As purchased, the camera was equipped with a roll of this material capable of taking one hundred round negatives each $2\frac{1}{2}$ inches in diameter (Fig. 22). When the roll was completed, the whole camera was shipped back to Rochester, where the film was removed and processed. The customer received back in the mail his hundred individually mounted prints and the camera, reloaded with a new roll of film. A nation of amateur photographers sprang up overnight in response to the Eastman company's slogan: "You press the button, we do the rest."

From the earliest days of photography there had been an interest in stereographic pictures—two nearly identical views of the same scene taken from vantage points about 2 inches apart. By this device photographers hoped to imitate the stereo vision of the human eyes, a major factor in the perception of three-dimensional space. In the early 1900s stereographic photographs of scenic points, architectural wonders, and street scenes became all the rage. They were made either by moving the camera laterally a short distance between shots or with a double-lens camera, then the results were viewed through a *stereoscope* (Fig. 23), a device that blended the two images to produce the illusion of spatial depth. Stereoscopes were the "home movies" of early 20th-century America.

Not only were Americans looking at pictures of faraway places, they were going out and taking such pictures themselves.

Turn-of-the-century tourists carried their new box cameras along with them on their travels and brought back snapshots to prove to the folks at home that they had really visited such-and-such a marvelous place (Fig. 24). The slightly more ambitious amateur could purchase a kit that included a tripod, a developing tank, and all the necessary chemicals.

While the Sunday photographer was out busily recording on film the images of family, friends, and environment—with what

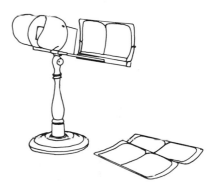

right: 23. A stereoscope.

below: 24. Fred Church. *George Eastman on the S.S. Gallia.* 1890. Photograph made with a Kodak No. 2 camera, like that held by Eastman. George Eastman House, Rochester, N.Y.

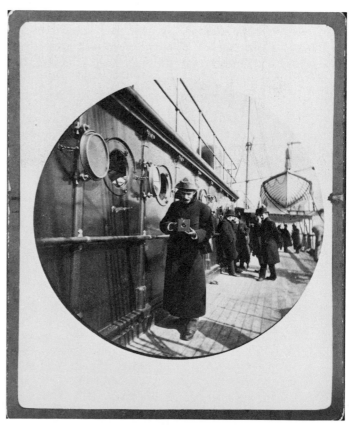

degree of success one can only speculate—serious professionals were beginning to explore the aesthetic potential of the camera. The 20th century saw a new era of "art" photography quite different from that of Messrs. Rejlander and Robinson.

20TH-CENTURY PHOTOGRAPHY
The Photographer as Artist

Throughout the history of photography two basic but conflicting views concerning the photographic image have coexisted. In one camp are the photographers and critics who feel that a photograph must be a work of art, and that the human hand should play a more decisive role than merely pointing the camera in order for the results to be as "artistic" as possible. Photographs of this kind frequently rely upon the photographer's intervention *after* the negative has been exposed. They often resemble paintings in both subject matter and effect. Clearly, both Rejlander and Robinson (Figs. 15, 17) adhered to this school of thought. This approach is challenged by the proponents of *straight photography,* who maintain that all decisions affecting the nature of a particular shot must be made *before* the shutter is opened. Processing and printing merely serve to record those decisions. Perhaps the first champion of straight photography was Daguerre himself, who wrote: "Nature has the artlessness which must not be destroyed." In the latter part of the 19th century, photographic exhibitions tended to feature sentimental genre scenes, idealized landscapes, and rather artificial portraits—the antithesis of straight photography. The most adamant foe of this salon aesthetic was the Englishman Peter Emerson.

An established photographer, Emerson (1856–1936) set forth his aesthetic theories in a textbook, *Naturalistic Photography,* published in 1889. Among other things, he was vehemently opposed to enlarging, retouching, combination printing, and, in general, any manipulation of the photographic image. He did not approve of hand cameras and frowned upon prints that were made large for the sake of size alone, claiming that one small but artistic plate was worth a hundred large commonplace ones. The most controversial of Emerson's ideas was his contention that only the principal elements in a photograph should be in sharp focus, with the background and other subsidiary areas somewhat blurred. By this device he hoped to imitate the vision of the human eye, which does not focus with

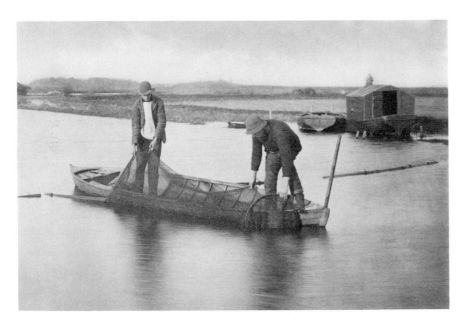

25. Peter Emerson. *Taking Up the Eel-net.* 1885. George Eastman House, Rochester, N.Y.

26. Alfred Stieglitz. *The Terminal.* 1892. San Francisco Museum of Art (Alfred Stieglitz Collection).

equal clarity upon all portions of a scene. Emerson's theory of graduated focus is evident in *Taking Up the Eel-net* (Fig. 25), in which only the foreground figures and the boat are sharply defined. In later years Emerson recanted some of his ideas, but the spirit he had instigated did not falter.

In an effort to establish photography as an art medium unto itself—free of its ties to science and technology, as well as its connection with salon painting—several London photographers banded together in 1892 to form the Linked Ring. The group's exhibits differed radically from the typical photographic show, in that the pictures were displayed in a pleasing arrangement at eye level, rather than being crammed haphazardly from floor to ceiling. Sponsors of the new "Photographic Salons" hoped they would become sufficiently prestigious that any photographer would be honored to have his work included. By the midnineties the exhibits had assumed an international character, and entries were submitted from the United States and several European countries. Among the most honored was an American whose name has become virtually synonymous with early 20th-century photography and avant-garde patronage in the United States.

As a boy of seventeen, Alfred Stieglitz (1864–1946) left New York to study mechanical engineering in Germany. One day, as he was walking through the streets of Berlin, he noticed a camera displayed in a shop window and immediately bought it. Gradually, Stieglitz' growing interest in photography blotted out any thoughts of engineering, and he launched upon a career that would absorb him for the rest of his life. His earliest photographs were genre scenes, a bit sentimental but nonetheless evidencing a fresh, personal point of view and a sincere desire for perfection.

When he returned to New York, Stieglitz was dismayed to find that the local camera clubs were interested in photography only as a hobby, rather than as a serious art form. Moreover, they disdained the new Eastman hand cameras that had become so popular. Stieglitz set out to prove that the hand camera was perfectly capable of achieving professional results. With borrowed equipment, he began to photograph deliberately under adverse conditions—in the snow, in the rain, at night—and made a highly successful lantern slide from a negative showing steaming horses in a downtown streetcar terminal (Fig. 26). In 1896 the Society of Amateur Photog-

raphers and the New York Camera Club merged to form the Camera Club. Stieglitz was elected vice-president of the joint organization and also supervised the publication of *Camera Notes,* a periodical that featured the work of outstanding American photographers.

Stieglitz became an ardent propagandist for photography as an art medium. He arranged a number of photographic salons and lectured widely, illustrating the talks with his own lantern slides. In *Camera Notes* he attempted to present the very best work available, regardless of the fact that in so doing he slighted many of his own club members. This zeal for quality soon alienated him from the rest of the Camera Club, and he was forced to resign the editorship of *Camera Notes.* By 1902, however, Stieglitz had become involved with Photo-Secession, a loosely structured group dedicated to advancing photography "as applied to pictorial expression." *Camera Work,* a handsome new quarterly of which Stieglitz assumed full charge, helped to further this goal. In the fifteen years of its publication, *Camera Work* adhered to the highest possible standards of excellence, both in the works selected for presentation and in the quality of reproduction.

Led by Stieglitz, the Photo-Secession group mounted exhibitions in the United States and sent out loan collections all over the world. In 1905 they opened the Little Galleries at 291 Fifth Avenue in New York (Fig. 27). The "291" gallery became famous for presenting the most daring, innovative work in the visual arts—not only photography but painting, sculpture, and drawing as well. Through "291" Stieglitz introduced to the United States such European masters as Pablo Picasso, Paul Cézanne, Henri Matisse, Georges Braque, and Auguste Rodin. The work of many progressive young American artists was also featured.

Although Stieglitz often presented photographs made by the soft-focus "gum" process—and even experimented with a few such prints himself—in later years he turned more and more to straight photography. The introduction of the gum bichromate method, which permitted a high degree of control over the resulting photographic image, stirred a new controversy between those who championed such "painterly" modes and the proponents of straight (nonmanipulative) photography. The latter term was applied to photographs in which everything appeared in sharp focus and the subjects had not been posed or otherwise ordered. Normally, a large negative was used, with the diaphragm of the camera nearly closed. *Steerage,* in Figure 28, is a very "straight" photograph, having been shot hurriedly when Stieglitz noticed the striking composition of human figures and bold diagonal forms on the lower decks of the S.S. *Kaiser Wilhelm II.* Stieglitz himself considered it to be his finest photograph.

In the late twenties Stieglitz began work on an extensive series of photographs all featuring clouds (Fig. 29). By choosing a subject that was "there for everyone," he hoped to silence those who maintained that his success with portraits, for example, was attributable to his own forceful personality. In addition, Stieglitz intended to demonstrate what he had "learned in forty years

about photography." He used an ordinary camera and had all the film processed in the same manner as that available to amateurs. The resulting photographs are indeed "straight," yet they illustrate Stieglitz' mastery of form in the sensitive relationships of twisting and swirling clouds with the horizon, the trees, or the circular shape of the sun. Each photo could be viewed as an independent image or as part of the whole series.

Stieglitz' contribution to photography goes far beyond his own efforts; in *Camera Work* and at "291" he introduced many previously unknown photographers who later earned international recognition.

Stieglitz made a fortuitous discovery in the talent of Edward Steichen (1879–1973), a painter and apprentice lithographer from Milwaukee who matured to become not only one of the most illustrious photographers of his time but also an influence of vast significance for the development of modern art in the United States. A founding member of Photo-Secession, Steichen urged Stieglitz to establish the Little Galleries at 291 Fifth Avenue, and it was he who designed the rooms and mounted the first exhibition, a survey of the photography

above: 28. Alfred Stieglitz. *Steerage.* 1907. Philadelphia Museum of Art (Alfred Stieglitz Collection).

left: 29. Alfred Stieglitz. *Lake George—Landscape.* 1931. Courtesy Georgia O'Keeffe for the Estate of Alfred Stieglitz.

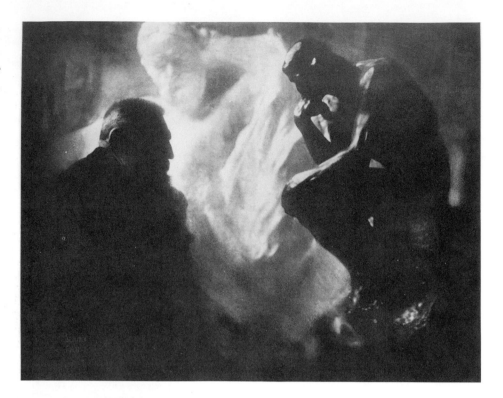

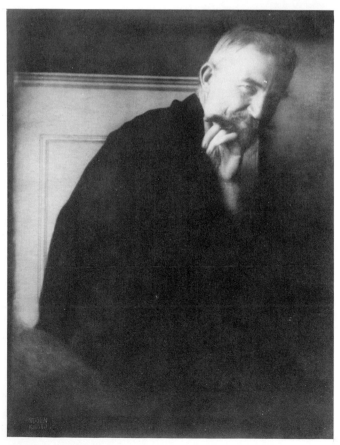

of Gertrude Käsebier. For the second show Stieglitz exhibited the work of Steichen himself. As a practicing painter, Steichen quite naturally drew photography toward the alignment that Stieglitz sought with the fine arts. Subsequent to a one-man show in Paris, Steichen settled there to paint and to make photographs—and to scout the work of young American artists and modern French masters for exhibition at "291" in New York. The first such show consisted of drawings by Auguste Rodin. Figure 30 reproduces Steichen's portrait of the great sculptor seated in a striking profile relationship with *The Thinker,* one of his masterworks. Already present are Steichen's special genius for directness of vision, strong design, and dramatic lighting.

Assigned during World War I to the American Air Services and charged with making battle photographs of maximum clarity, detail, and definition, Steichen found direct photography so full of potential that he abandoned both painting and the gum prints of his early photography. He achieved an extraordinary mastery over the photographic processes, and this, com-

bined with his gift for design and for the characterization of personality in portraiture, enabled him to turn magazine illustration into a high art. Working for Condé Nast, the publisher of *Vogue* and *Vanity Fair,* Steichen succeeded again and again in recording on film the moment of most revealing insight into such complicated personalities as the playwright George Bernard Shaw (Fig. 31).

The last issue of *Camera Work* featured Paul Strand (b. 1890), a young American who pushed straight photography to a point that Stieglitz called "brutally direct." Many of Strand's early photographs were closeup abstractions of fruit, machines, rocks, and kitchen equipment (Fig. 32). He combines an extraordinary perception of subject matter with a sincere respect for the photographic process. Strand's meticulous attention to craftsmanship has contributed much to the development of photography as a respected art form.

By the 1920s photography had, for the most part, cast off its image as a device to enhance the range of painting. It is, therefore, altogether fitting that in the same

left: 32. Paul Strand. *Abstraction — Bowls.* 1915. Courtesy the photographer.

right: 33. Alvin Langdon Coburn. *Vortograph.* 1917. George Eastman House, Rochester, N.Y.

period serious painters began to use their art to expand the aesthetic possibilities of photography.

The Artist as Photographer

In 1917 Alvin Langdon Coburn (1882–1966), a member of Photo-Secession, exhibited a series of totally nonobjective photographs made by focusing his camera through a triangle of mirrors onto small objects. He called his experiments *Vortographs* (Fig. 33). Coburn had set out to prove that the camera could be just as abstract as the paint brush. He wrote that the patterns he had created "amazed and fascinated" him. In the next several years a number of men known primarily as painters produced abstract images by photographic means, often dispensing with the camera altogether.

In the early twenties Man Ray (b. 1890), an American painter, was connected with the Dada circle in New York and Paris, a group of artists who, appalled by the brutal mass killings in World War I, preached that all moral and aesthetic values were dead. The Hungarian László Moholy-Nagy (1895–1946) was instructor at the Bauhaus School of Design in Germany. About 1921 the two men began independently to make photographic images by placing three-dimensional objects on light-sensitive paper and then exposing the whole to light. They called their efforts *rayographs* and *photograms,* respectively (Figs. 34, 35). (Yet another artist, Christian Schad of Zurich, had earlier made photographic abstractions without the camera, naming his experiments *schadographs.* In his 1947 book *Vision in Motion,* Moholy-Nagy rather testily remarked that the name "photogram" has "been adopted since by most people.") The resultant image revealed the contours of the object as well as its cast shadows. When translucent or transparent objects were employed, their textures were reproduced in various tones of gray. Moholy-Nagy wrote that the photogram "exploits the unique characteristics of the photographic process—the ability to record with delicate fidelity a great range of tonal values. The almost endless range of gradations, subtlest differences in the gray values, belongs to the fundamental properties of photographic expression."

Many different experimental techniques were investigated during this same period. Some photographers made negative prints, which reverse all the tones (Figs. 58, 59); others diffused their images mechanically to produce a deliberate reduction in sharpness. One technique called for a negative and a positive of the same subject to be sandwiched together slightly out of register. A print made from this combination has a linear quality reminiscent of bas-

left: **34. Man Ray.** *Rayograph.* 1924. Collection Arnold H. Crane, Chicago.

right: **35. László Moholy-Nagy.** *Photogram.* 1926. Museum of Modern Art, New York (anonymous gift, 1940).

relief sculpture. A method known as *reticulation* involves the actual destruction of the gelatin emulsion by its subjection to rapid changes in temperature during the processing. Treated in this way, the emulsion literally shrivels to produce a fragmented image (Figs. 322, 323).

Both Man Ray and Francis Bruguière (1880–1945) created many abstract photographs by means of a technique commonly (but inaccurately) known as *solarization.* When either a negative or a print is momentarily reexposed to light part way through the processing, the result is a partial reversal of tones, especially of sharp edges or lines. Such negative-positive photos have an exciting visual quality (Fig. 36).

While artist-photographers like Moholy-Nagy, Ray, and Bruguière were experimenting with distortions of the photographic image, other practitioners focused their attention on recording the unembellished, often painful, image of reality. The camera as an instrument of social conscience came into its own in the late 19th century.

The Social Commentators

The camera has an unparalleled ability to document scenes of poverty, cruelty, brutality, and despair. While the viewer may shrug off painted or sketched representations of the same subjects as being the artist's invention, he cannot deny the evidence of a photographic image. For this very reason Mathew Brady's photos of the Civil War (Fig. 19) were so unpopular with a public that hoped to remember only the glory of battle and forget the horrors.

In the late 1880s Jacob Riis (1849–1914), a Danish immigrant in New York, set out to prove to an indifferent nation that intolerable living conditions *did* exist for many among the "huddled masses" who had recently arrived in the United States. Riis had worked for a time as a police reporter, which occupation regularly took him into the worst sections of the city. His pictures of tenement slums and of a disreputable alley known as Bandits' Roost (Fig. 37) evoke a sordid reality that is far

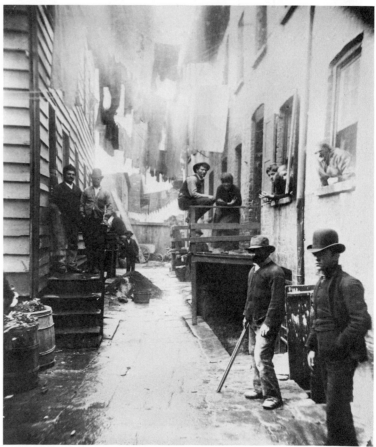

top: 36. Francis Bruguière. *Abstraction: Il est rare. . . .* c. 1927. Museum of Modern Art, New York (gift of J.J. Sweeney).

above: 37. Jacob Riis. *Bandits' Roost, Mulberry Street.* c. 1888. Museum of the City of New York (Jacob A. Riis Collection).

right: **38. Lewis W. Hine.** *Little Spinner in Carolina Cotton Mill.* 1909. George Eastman House, Rochester, N.Y.

below: **39. Dorothea Lange.** *Migrant Mother, Nipomi, Calif.* 1936. Photographed for the Farm Security Administration. Oakland Museum, Calif.

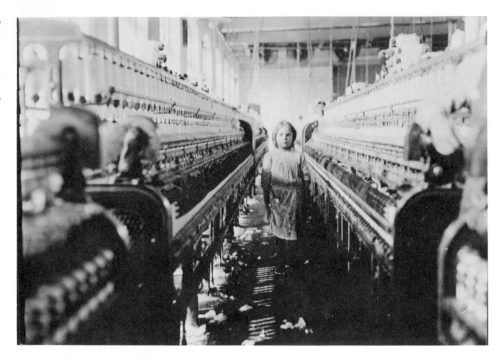

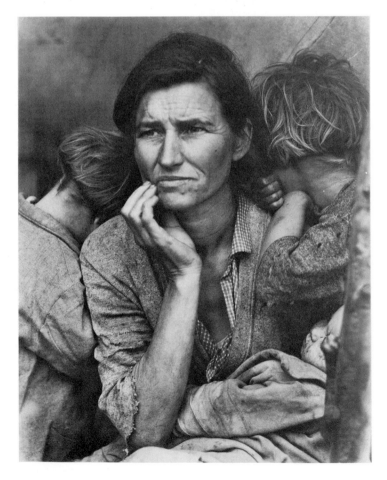

removed from the genteel image of late 19th-century New York. Unfortunately, photographic reproduction was still in its infancy, and Riis' pictures appeared in the newspapers as facsimile drawings. His 1890 book *How the Other Half Lives,* which contained seventeen photographic reproductions, had greater impact, and ultimately Riis' campaign led to many housing reforms.

Similar motivations inspired Lewis W. Hine (1874–1940), a sociologist, to carry his camera along on field trips into the factories, the sweatshops, and the slums. Photographs like *Little Spinner in Carolina Cotton Mill* (Fig. 38) were carefully calculated in terms of scale to prove that the factory workers were actually quite small children. In 1900 nearly two million children under the age of sixteen were employed, often in wretched conditions. Hine's photographs helped to create a climate for the child labor laws that were passed after 1911.

Social conscience on a governmental level blossomed during the years of the Great Depression. In the hope that photographic documentation would serve an educational purpose, the U.S. Government,

through the Farm Security Administration, sent out photographers to record conditions in rural areas brought about by the Depression and the severe drought of the mid-thirties. Dorothea Lange (1895–1965) concentrated on the plight of migrant farm workers who traveled back and forth across the country trying to find enough work to feed their families (Fig. 39). Walker Evans (b. 1903) lived among sharecroppers in the South, documenting their marginal existence through pictures of their farms, their schools, and their homes (Fig. 40). Arthur Rothstein (b. 1915) captured on film the misery of the great drought, as in his photo of an abandoned farm (Fig. 41). Russell Lee (b. 1903) depicted the essence of rural home-town American life (Fig. 42). The seven-year project yielded thousands of negatives, most of them strong and straightforward, many of them shocking.

41. Arthur Rothstein. *Abandoned Farm, Cimarron County, Okla.* April 1936. Photographed for the Farm Security Administration. Library of Congress, Washington, D.C.

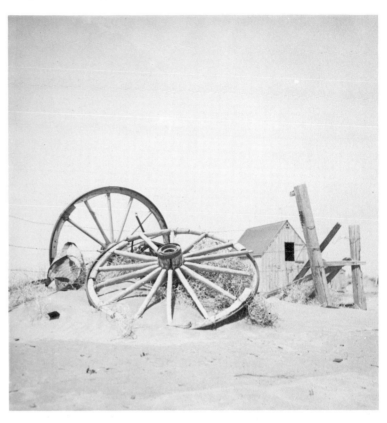

below: 40. Walker Evans. *The Bud Fields Family at Home, Alabama.* 1935. Sharecroppers photographed for the Farm Security Administration. Library of Congress, Washington, D.C.

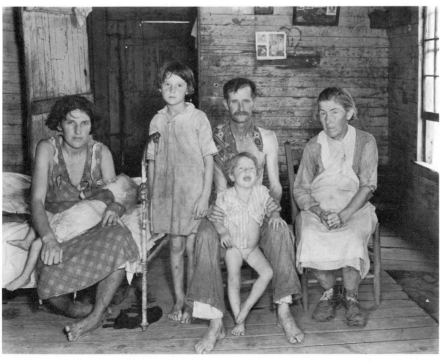

42. **Russell Lee.** *E. Gorder Family Eating Dinner, Williams County, N.D.* September 1937. Photographed for the Farm Security Administration. Library of Congress, Washington, D.C.

When the FSA project was disbanded, several of the photographers applied the experience they had gained to the new field of photojournalism. They found a ready market for their craft in pictorially oriented magazines such as *Life* and *Look*.

Photojournalism

From the earliest days of photography, its practitioners had dreamed of using the camera to record news events. In fact, such pictures *had* been taken as early as the mid-19th century, but there was then no means of making mass reproduction of them. Although photographs often served as models for newspaper and magazine wood engravings, these interpretations lacked the spontaneity of a photographic image. The same problem still plagued Jacob Riis in 1888, when he tried to call attention to slum conditions (Fig. 37). In 1897, however, a method was developed for printing halftones on high-speed presses, and by the turn of the century people had become accustomed to seeing photographs in their daily newspapers. This innovation

opened up a whole new field and made it possible for the public to witness, by proxy, all sorts of national and world events that previously they had only read about.

Erich Salomon (1886–1944), who worked for various German newspapers and magazines during the twenties and thirties, used a small camera and great initiative to obtain pictures in places normally forbidden to photographers. By proving that neither he nor his camera would disturb the proceedings, Salomon managed to gain admittance to courtroom trials, a Hague conference, the United States Supreme Court, the British Foreign Office, and meetings of the German Reichstag (Fig. 43). All of his photographs were made with available light and shot as unobtrusively as possible. In some instances he concealed the camera in a briefcase or a hat and once operated it by remote control. Rarely posing his subjects, Salomon was the first to have his work described as "candid photography."

The Hungarian André Kertész (b. 1893) worked in Paris and gained an international reputation for photographs that captured from the immediate circumstances of light

43. Erich Salomon. *Two Female Politicians of 1930: Katharina von Kardoroff-Oheimb, Wife of a Reichstag Deputy, and Ada Schmidt-Beil.* 1930. Courtesy Magnum, New York.

and environment a tender view of a fleeting, natural moment in the anonymous lives of ordinary people (Fig. 44).

A masterful photographer, Henri Cartier-Bresson (b. 1908) has a particular genius for capturing what he calls the "decisive moment." In 1945 he recorded the dramatic scene that unfolded in a camp for displaced persons when a refugee exposed a Gestapo informer (Fig. 45). By remaining inconspicuous and at the same time knowing instinctively just when to open his shutter,

44. André Kertész. *Couple in the Park.* 1915. Courtesy the photographer.

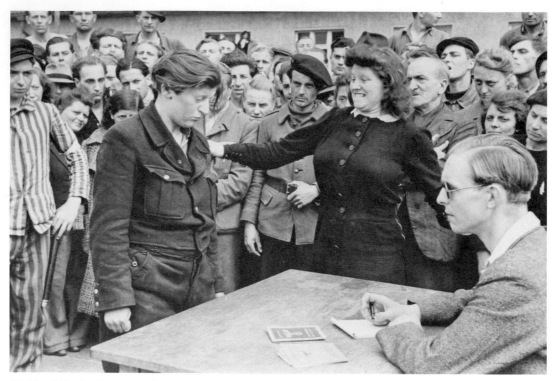

45. **Henri Cartier-Bresson.** *Gestapo Informer Accused, Dessau.* 1945. Courtesy Magnum, New York.
46. **Robert Capa.** *Death of a Loyalist Soldier.* 1936. Courtesy Magnum, New York.

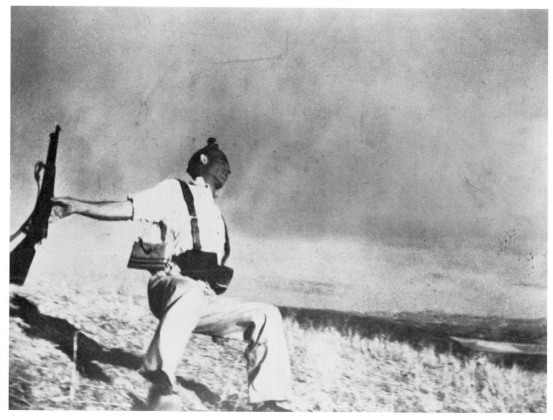

Cartier-Bresson—who had himself spent three years in a German prison camp—caught the precise instant when the refugee's rage burst forth. The angry yet controlled faces of the watching crowd, the clenched fists of the accused, and the ready pen and pencil of the recorder all heighten the photograph's impact.

A special breed of photographers are those who earn their livelihoods by covering war. From Roger Fenton and Mathew Brady (Figs. 18, 19) on down, intrepid men and women have risked—and sometimes sacrificed—their lives to report firsthand from the center of the action. And, such is the nature of international relations that war photographers are seldom idle. Robert Capa (André Friedman, 1913–54) began his career with the Spanish Civil War (Fig. 46), continued throughout World War II, covered the Arab-Israeli war in the late forties, and followed the French into Indo-China. After eighteen years as a war cor-

respondent, Capa was killed in Vietnam when he stepped on an antipersonnel mine.

The politics that lie behind wars have often been the concern of Alfred Eisenstaedt (b. 1898), one of the founding members of *Life*. Over the past forty years Eisenstaedt has traveled extensively, and his pictures alone would almost suffice to present a chronicle of the period. He photographed the activities in the United States during the thirties, the rise and fall of the Nazi and Fascist governments in Europe, the defeat of Japan, and the postwar years in Africa. In addition, Eisenstaedt was among the first to develop the concept of the picture story. Through all his concern with national and global events, there is a warmth and compassion that never loses sight of basic human values or preoccupations (Fig. 47).

W. Eugene Smith (b. 1918) produced an enormous number of picture stories for *Life*. On one assignment he lived for a year

47. Alfred Eisenstaedt. *Drum Major and Children.* 1950. *Life* Magazine © 1972 Time, Inc.

in a poor Spanish village, becoming almost a member of the community in order to photograph its essence (Fig. 48). Smith has a profound sense of mission. His pictures, while focusing on the particular, display a universal quality that helps to further his aim of increasing man's sympathy toward his fellowman.

Specialized Photography

Photojournalism is a rather broad field, dealing as it does with all kinds of events and topics that are considered newsworthy. However, many photographers have chosen to narrow their focus and treat one particular area in greater depth. For example,

Ansel Adams has concentrated on nature photography (Fig. 49) because of his special interest in the environment. Others have addressed themselves to social phenomena.

A history as brief as this cannot deal properly with the many specialized branches of the craft, such as food, fashion, and advertising photography. There have been a few photographers, most notably Richard Avedon and Irving Penn, who brought such sensitivity and technical mastery to the realm of fashion photography as to virtually create a new art form (Fig. 50). Even

48. W. Eugene Smith. *The Breadmaker,* from the *Spanish Village.* 1951. Courtesy the photographer.

above: 49. Ansel Adams. *Pasture, Sonoma County, Calif.* 1957. From *This Is the American Earth* © 1960 the Sierra Club, San Francisco.

right: 50. Irving Penn. *Dior Hat and Dry Martini. Vogue* photograph © 1952 Condé Nast Publications, Inc.

more demanding are certain types of industrial and scientific photography, which require a sophisticated knowledge of the subject matter and, often, modified photographic equipment.

Technological Developments

Despite many improvements in the speed, quality, and dependability of cameras, there have been only two really basic changes in photographic technology over the last few decades. These were the development of color films and the advent of instantaneous processes such as Polaroid.

The desirability of color photographs was apparent from the beginning, and many techniques were introduced. Daguerreotypes were carefully hand-colored with powders, usually to good effect, since the subtle shading of faces, for example, helped to dispel the harsh, metallic quality associated with the process. The delicate nature of the daguerreotype surface prevented any drastic manipulations. On the other hand, the attempt to color ambrotypes and tintypes was less successful (Fig. 577). Gold paint might be applied to the surface to indicate jewelry or military medals, and other equally crude touches were added in a haphazard manner. The fact that tintypes and later paper negatives would accept paint led to even greater abuses. Often, whole scenes were painted over photographs, with the two layers having little resemblance to one another.

In the late 19th century several color processes—usually requiring a series of negatives for a single shot—were developed, but all proved too complicated for general use. The first practical color film was Kodachrome, introduced in 1935 and followed shortly by Anscochrome, Ektachrome, and Kodacolor. These films enabled even the amateur to make successful color photographs. Both Kodacolor and the more recent Ektacolor yield color negatives, from which any number of positives can be obtained. However, the end product of Kodachrome, Anscochrome, and Ektachrome is a positive color transparency that must be projected on a screen. Each transparency is unique and cannot be duplicated without loss of quality. So vast and important is the subject of color that the whole of Chapter 10 has been devoted to it.

A problem that has always plagued photographers—the delay in time between exposure and examination of the finished photograph—was eliminated in 1947, when Edwin H. Land introduced Polaroid film materials. Polaroid film contains developing chemicals in pods. As the film is drawn between rollers in the camera, the chemicals are released and spread to both develop and fix the image in from 10 to 60 seconds. At first only black-and-white Polaroid photographs could be made, but later a color film was perfected (Figs. 696–698). The major drawback of this instantaneous process is that—except with special 4 × 5 inch professional films—there is no usable negative. In order to have duplicates, one must take a picture of the picture, with the inevitable diminution of quality.

The materials that photographers use have changed drastically since Daguerre first sold his invention. Nevertheless, all photographic processes are based on the same principle: that certain silver salt compounds are light-sensitive. The consumption of silver for photographic purposes is enormous. Because the price is very high, scientists have begun to explore other techniques that require less silver or none at all. One of these is Xerox, which works on the principle of static electricity (see p. xvi). While Xerox and similar processes are at present suitable only for reproducing high-contrast copy, rather than halftones, they promise eventually to challenge the existing methods of photography.

Design in Photography

DESIGN: THE PHOTOGRAPHER AND HIS TOOLS

There are certain qualities that distinguish photography from any other medium, and, very often, the finest photographs result when these qualities have been exploited. Any photograph represents a series of choices from among thousands—perhaps millions—of variables: camera, film, filters, subject, time, lighting, viewpoint, exposure, processing. The list would appear to be endless. Yet all these variables fall into two basic categories that the photographer must learn to understand and control: his tools and his subject matter.

The use of photographic paper to make "cameraless" images, pioneered by Schad, Man Ray, and Moholy-Nagy (Figs. 34, 35), frequently serves as a general introduction to the photographic process. Besides illustrating the tonal range of the material, the photogram has possibilities for image making. The image reproduced in Figure 51 was created by having a girl touch her face to a large sheet of photographic paper. Above her head a flash bulb was directed down-

ward. As the flash was fired, its light reflected off the paper to the girl's skin and back again, producing various tones of gray. By experimenting with the photogram, one can gain a basic understanding of photographic materials without the complications presented by elaborate equipment. The following discussion illustrates a few of the ways in which sensitive craftsmen have manipulated various aspects of the photographic process in order to produce exciting and imaginative visual images.

The Lens

Some photographers have experimented with replacing the normal camera lens with a pinhole—almost a reversion to the camera obscura (Fig. 2). Figure 52 reproduces a photograph that was made by substituting a piece of aluminum foil, pierced in several places, for the lens. Because each pinhole in the foil acted as a crude lens, the result was a multiple image, which could not have been produced otherwise without employing a series of lenses. The photographer thus had the advantage of great flexibility in the arrangement of forms. Of course, none of the images is as sharp as those photographed through a lens, but this very softening proved an asset, for it caused the various sections of the print to blend and fuse.

Of his photograph in Figure 52, Frank Salmoiraghi has written:

> The film (4 × 5) is placed in the camera in a semicircular position for exposure, hence the curvature of the lines when the camera used had three pin holes. The images overlapped producing conditions which I refer to as distortion, superimposition, and simultaneity as an inherent characteristic of the design of the particular camera. A very small variation in film or "lens" placement gives a slightly different set of relationships which will produce a different image. I've tried making other cameras in exactly the same dimensions, and each time the result is slightly different, so each piece is unique. The exposure for the photograph was about 30 seconds.

The visual quality produced by inexpensive "box" type cameras fitted with a

51. Photogram of a model's face.

right: 52. Frank Salmoiraghi. *Self-portrait.* 1969. Photographed with a camera built to admit light through three pinholes pierced in aluminum foil. Courtesy the photographer.

below right: 53. Bill Brandt. *Nude on a Pebbled Beach.* 1953. Photographic distortion accomplished with a wide-angle lens. Rapho Guillumette Pictures, New York.

plastic lens often appears in the work of student photographers. While cost, as well as the need to standardize equipment, typically explains the use of such an instrument, the unique character of the photography that results can be desired as an end unto itself. Generally, pictures obtained with a cheap plastic lens have a sharp focus at the center that gradually decreases to fuzziness at the edges.

The lens-fitted camera makes possible pictures characterized not only by sharp focus but also by naturalness in their rendition of perspective and proportion.

Throughout the history of photography, the great majority of its practitioners have been interested primarily in capturing the "real" appearance of things—true perspective and proportion, accurate color or tonal range, and the like. This was certainly the goal of "straight" photographers like Stieglitz (Figs. 26, 28, 29), and it also applies to later craftsmen such as Weston (Figs. 79, 80, 84) and Adams (Figs. 49, 81), who work in an essentially straight mode. But other photographers have become intrigued by the distortions made possible by employing various focal-length lenses. The English photographer Bill Brandt (b. 1906) studied in Paris with Man Ray (Fig. 34), and his work still contains elements of a moody, surrealistic style. Brandt has used

an extreme wide-angle lens to photograph a series of nudes, both indoors and, as in Figure 53, on a pebbled beach. The resulting distortion of form lends a monumental character to the figure and creates a strange, unearthly landscape.

Quite a different quality was sought by Peter B. Kaplan (b. 1939) when he chose a

very long lens to photograph a pride of lionesses in Nairobi National Park (Fig. 54). Instead of expanding and rounding out the scene as a wide-angle lens would do, Kaplan's long lens compresses the forms to make it seem as though the animals were even closer together than they·actually are. This "bunching" effect heightens the sense of physical contact inherent in nature.

Tonal Value

A characteristic of photography is its ability to reproduce a wide range of tones between white and black. Two major variables affect the rendition of tonal values—the film chosen and the manner of processing. By experimenting with either or both of these, one can achieve an "accurate" range of

tones that are faithful to nature or a distorted tone to enhance certain qualities of a particular photograph. The most exciting image will lack impact if its tonal quality is inappropriate. Three photographs of an old farmhouse reproduced as Figures 502 to 504 demonstrate how a mood can be changed by the way a negative is printed. The lighter prints make the farmhouse seem pleasant and inviting, while in the dark one it is a bit foreboding—almost a haunted house. Depending upon which impression the photographer wishes to stress, either version could be effective.

A factual rendition of tones does not always yield the most desirable effect. Aaron Siskind (b. 1903) often makes his photographs somewhat darker than they might normally be in order to emphasize a certain shape or texture (Fig. 55). Siskind is less interested in documentation than in evoking the viewer's response to his organization of forms, textures, and tones. Another photographer may decide for specific reasons to alter even more drastically the tonal range of a photograph. For example, in some situations only pure black and white are desired, with no intermediate tones of gray. Such was the case when Harry Callahan (b. 1918) made his 1951 photograph of a single weed (Fig. 56). Callahan's technique was a combination of *under*exposure and *over*development, with the negative printed on high-contrast paper. The result-

ing image has a delicate, linear quality that is full of fine and subtle mystery.

Pure blacks and whites can also be obtained by employing a very high-contrast film, such as Kodalith (an Eastman Kodak product). Kodalith is made primarily for photoengravers and for commercial applications. When used to make a high-contrast photograph, as Tom Porett (b. 1942) did for Figure 57, the film will record only elements that are black and white, thus

above: 56. Harry Callahan. *A Weed.* 1951. High but delicate contrast achieved with an underexposed and overdeveloped negative printed on high-contrast paper. Courtesy the photographer.

left: 57. Tom Porett. *Untitled.* High-contrast photograph made with Kodalith. Courtesy the photographer.

producing a graphic quality. Porett further eliminated extraneous details by painting on the negative with an opaque medium.

Still another alternative is explored by photographers who retain the normal tonal range in a photograph but *reverse* all the tones to produce a negative image. An interesting characteristic of such prints is that while shapes can be read in the usual manner, the shadows, which are white, have an unexpected quality. In 1955 Clarence John

Laughlin (b. 1905) photographed a clump of dead flowers hanging on the wall of an old cemetery in New Orleans (Fig. 58). By printing the image in negative tonal values, Laughlin managed to convey, as he has written, "something of the feeling of the enormous and endless black plain of the night land—the land of the nocturnal mind. Only a sparse leafless tree thrusts upwards; while below, are tight secretive flowers—as tight and secretive as repressed thoughts."

A similar quality can be found in the work of Paul Caponigro (b. 1932), whose black-and-white prints of natural forms evidence a strong sense of composition. In making his *Negative Print, Brewster, New York* (Fig. 59), Caponigro used a Polaroid negative-positive film and processed the negative through several stages to create the final image. Caponigro points out that his negative was not burned or otherwise tampered with; the visual effect was achieved entirely through conventional processing methods. By contrast, the photograph in Figure 60 resulted from a rather vigorous handling of the negative. Michael J. Teres (b. 1940) actually burned, scratched, and partially dissolved the emulsion to produce a biomorphic image in which only a hand and an arm are identifiable.

Clarity of Focus

Many controversies have raged over the optimum sharpness or softness of focus that a photograph should display. In the beginning, only the elements actually focused on could be in clear focus, because the daguerreotype process was so insensitive that it precluded any consideration for depth of field. Later, as techniques improved to the extent that the photographer could control the degree of clarity in a pic-

above left: 58. Clarence John Laughlin. *Flowers of the Night Land (Magic of the Object Group).* 1955. Print made in negative tonal values. Courtesy the photographer.

left: 59. Paul Caponigro. *Negative Print, Brewster, New York.* 1963. Processed through several stages from Polaroid negative-positive film. Courtesy the photographer.

ture, arguments were presented in favor of various systems. Emerson (Fig. 25) insisted that only the principal elements in a photograph should be in sharp focus, with background areas somewhat softened. The straight photographer, on the other hand, tries to maintain a uniform clarity of focus throughout. Among contemporary practitioners, the tendency is to adjust the focus to serve the needs of a particular photograph.

Fred Sommer (b. 1905) often makes "straight" photographs in which everything is sharply defined, but occasionally he will create an image that is deliberately out of focus (Fig. 61). Sommer prefers to soften the outlines by means of an enlarger, rather than in the camera itself, because this method gives him a better measure of control over the final result. Thus, the negative is in sharp focus, but the print is blurred. By working with the enlarger, Sommer can also enhance the subtle gray tones that appear along the edges of objects when they are thrown out of focus.

For many years photographers have employed screens and other devices to diffuse, in whole or in part, the image produced by the camera lens. As a rule, such contriv-

ances were used for portraits, to help conceal facial blemishes and similar imperfections. However, more sensitive photographers, such as John Brook (b. 1924), have applied this type of equipment to the creation of gentle, flowing images that suggest the warmth and intimacy of human relationships (Fig. 62).

62. John Brook. *Untitled.* 1960. Soft focus created with a special lens designed by the photographer. Courtesy the photographer.

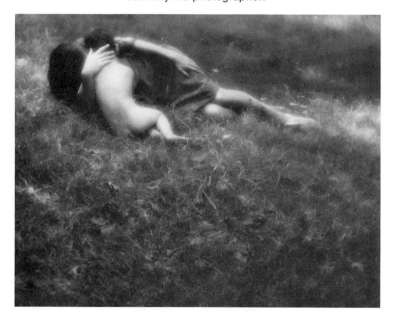

Motion and the Still Camera

A photograph of a moving object produced with a fast shutter speed often enables one to see things that are not normally visible to the human eye. In a very real sense, the camera can extend our vision. This phenomenon was first demonstrated in 1878 by Eadweard Muybridge (Edward James Muggeridge, 1830–1904) with a series of photographs depicting a galloping horse (Fig. 63). Muybridge's photographs proved that a running horse never assumes the pose commonly associated with rocking horses—two legs forward and two stretched back—which had previously been the convention for painted representations of a horse in motion. As a consequence of these experiments, painters were forced to re-evaluate their concepts of locomotion.

The ability to stop action with a very fast shutter speed can often produce quite comic results. Jacques Henri Lartigue (b. 1896), a French photographer, combined a sure technical skill and, unquestionably, a well-developed sense of humor in record-

below: **63. Eadweard Muybridge.** *Galloping Horse.* 1878. Fast motion stopped by the camera. George Eastman House, Rochester, N.Y.

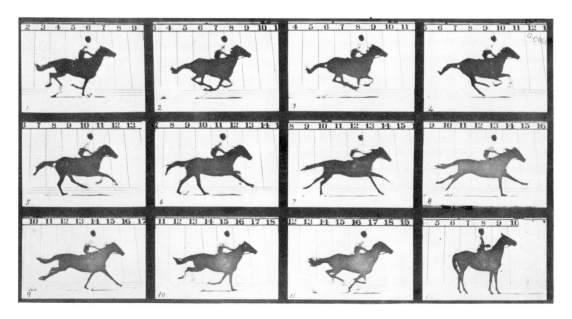

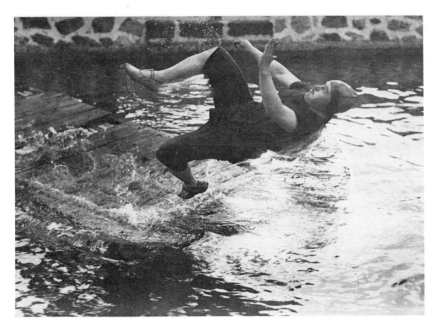

left: 64. Jacques Henri Lartigue. *Jean Haguet, Château de Rouzat.* 1910. Comic statement made by action stopped with a very fast shutter speed. Rapho Guillumette Pictures, New York.

below: 65. Harold E. Edgerton. *Splash of a Milk Drop.* c. 1936. Photograph taken with the aid of electronic flash at 1/100,000 of a second. Courtesy the photographer.

ing the antics of his family and friends. Lartigue's subjects have included his brother's attempts at flying, a girl trying to climb on a donkey, a man falling off a cart, and various people jumping into the water (Fig. 64). To a large degree, one's amusement depends upon projection backward and forward in time. The photograph in Figure 64 inevitably makes one imagine the subject being pushed, off a dock perhaps, and then his ignominious arrival at the water.

In similar fashion, the photographer's skill at capturing a precise moment in time can also lend itself to great drama. Robert Capa's photograph from the Spanish Civil War (Fig. 46) is powerful because it was taken just at the instant when the soldier received the fatal shot. Had Capa made the exposure a moment earlier, he would merely have photographed a running soldier; a moment later his subject would have been a corpse. Moreover, the graceful arc made by the soldier's falling body heightens the impact of the photo.

The ultimate in stopping action is possible with the use of strobe equipment (see p. 327). An electronic flash can produce exposures of one-millionth—or less—of a second. As a result, one can make photographs showing birds in flight that record the position of every feather; one can even stop a bullet in its trajectory or at the point of impact. Such photographs are very useful to engineers and scientists. However, photographs made for experimental purposes often yield dividends in the exciting and unexpected forms thus captured, as in the famous series made by Harold E. Edgerton (b. 1903) of a metal ball rebounding from a shallow dish of milk (Fig. 65). A re-

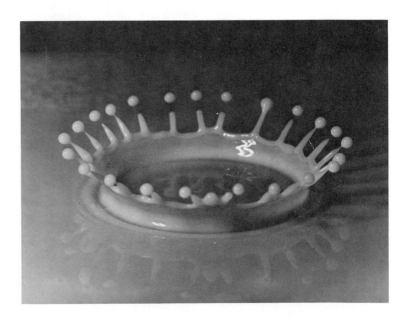

66. Gjon Mili. *Nora Kaye (Pas de Bourrée)*. 1947. Stroboscopic photograph. Courtesy the photographer.

a ballet dancer can record the dancer's physiognamy and the grace of a single pose; but Mili's stroboscopic photo (Fig. 66), with its sinuous pattern of overlapping forms, seems to capture the very essence of the dance.

At the opposite end of the spectrum is the very long exposure created with a slow shutter speed—an effect that exasperated photographers in the past but often fascinates the contemporary craftsman. Early portraits frequently contain ghostlike images that were caused by the subject moving during the exposure period. Much time and effort were expended in the technology necessary to eliminate this problem. Consequently, it seems almost perverse that some modern photographers have deliberately employed the slow shutter speed for action photos. A long exposure accentuates the sense of motion and imparts a fluid visual quality to the image of a moving object (Fig. 67).

Relationships of time and space are the concern of Wynn Bullock (b. 1902), whose rather eerie seascape is reproduced as Figure 68. Bullock used an 8 × 10 view camera firmly attached to a tripod and multiple long exposures to photograph water splashing against rocks and pilings. This technique produced an ethereal, mistlike quality in the waves, but rendered fixed elements of the scene in the normal manner.

The Multiple Image

The image formed on a negative is transparent, which permits light to pass through and produce a print. If the film were to be exposed twice, the negative would contain two superimposed images, and the resulting print would be a composite. The accidental double exposure formerly was a common and disastrous occurrence. But controlled by modern equipment, the combining of two separate realities to make a third that has never before existed offers

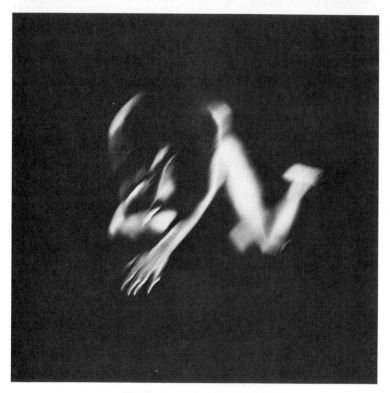

67. Photograph taken with a long exposure.

peating electronic flash enables the photographer to record a series of images in very rapid sequence. This technique has been exploited by Gjon Mili (b. 1904) to produce a number of imaginative, highly patterned impressions. The individual photograph of

photographers an unlimited expressive potential.

Photographers employ various techniques to combine two or more images in a single print. Oscar Bailey (b. 1925) made the cyclopean self-portrait reproduced in Figure 69 from two identical negatives that had been exposed with strong side lighting to record only half of his face (Fig. 70). He

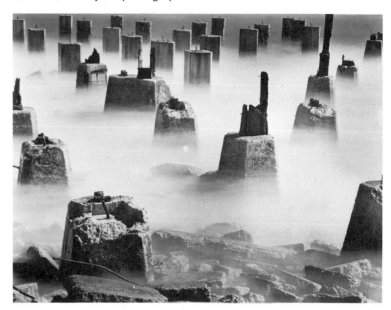

68. **Wynn Bullock.** *The Pilings.* 1958. Photograph made in multiple exposures with an 8 × 10 view camera. Courtesy the photographer.

then "flopped" or reversed one of the negatives and positioned it above the other. Figure 71 illustrates the still striking but less dramatic image that would have resulted if Bailey had arranged the negatives to allow for a normal configuration.

above left: 69. Oscar Bailey. *Self-portrait.* 1968. Image formed by the superimposition of two identical negatives, one of them reversed, with the eyes of the subject coinciding. Courtesy the photographer. See Figure 70.

far left: 70. Oscar Bailey. *Self-portrait.* 1968. Print made from a single negative. Courtesy the photographer. See Figures 69 and 71.

left: 71. Oscar Bailey. *Self-portrait.* 1968. Image formed by the superimposition of two identical negatives, one of them reversed, with the eyes positioned normally. Courtesy the photographer. See Figure 70.

72. Composite photograph.

73. Jerry Uelsmann. *Small Woods Where I Met Myself.* 1967. Composite print made from negatives in different enlargers. Courtesy the photographer.

There is virtually no limit to the number of images that can be combined in a single print. The composite photograph in Figure 72 was produced by making numerous exposures with a Minox subminiature camera and then cutting the negatives into individual pieces. A glass negative carrier holds the fragments for printing. Still another method utilizes the enlarger. Jerry Uelsmann (b. 1934) made the composite print called *Small Woods Where I Met Myself* (Fig. 73) from a series of enlargers each containing a negative.

Harry Callahan prefers to blend images in the camera itself. For example, *Eleanor* (Fig. 74) was made by exposing the figure in a room setting and then superimposing a weedy outdoor environment. Callahan has explored in great depth the possibilities of multiple imagery to create a new reality from two or more familiar situations. A somewhat different approach was employed by Ray Metzker (b. 1931) to build the multiple image reproduced in Figure 75. Two subsequent exposures were made in a 35mm half-frame camera, with a black area first on one side and then on the other. The black area from the first exposure blends with the space separating the two expo-

sures. The finished photograph, therefore, contains two images but works as one. Metzker also works with large mural-size prints, combining several small images in the manner of a mosaic (Fig. 76).

Clearly, there are endless manipulations the photographer can perform with his equipment and materials. Yet no matter how controlled, each photograph must have a subject, and often it is the photographer's treatment of subject matter that determines the effectiveness of the picture.

74. Harry Callahan. *Eleanor.* 1951. Images blended by double exposure. Courtesy the photographer.

left: 75. Ray Metzker. *Untitled.* 1965. Two images composed to function as a single, monumental image. Courtesy the photographer.

above: 76. Ray Metzker. *Untitled.* 1965–66. Composite photograph arranged like a mosaic. Museum of Modern Art, New York.

Design in Photography **47**

DESIGN: THE PHOTOGRAPHER AND HIS SUBJECT

The photographer must bring to his work an attitude different from that of the painter or the sculptor. An artist can modify or alter part of his vision during the course of his work, but a photographer cannot. He must accept or reject what he sees before the photograph is made. For example, if there is a rock in the middle of a scene he wishes to photograph, he must accept it as a rock. It cannot become a tree in order to improve the composition. The photographer's visual process is based upon *selection,* not construction. Because the photograph is generally accepted as a truthful record, any manipulation of the image will be apparent.

The Visual Symbol

Many early photographers thought the photograph could serve as a substitute for the written word. Men like Rejlander and Robinson (Figs. 15, 17) attempted to tell whole stories through their pictures. How-ever, their efforts were largely unsuccessful, because a photograph is not a narrative. The Civil War photos taken by Mathew Brady (Fig. 19) and Alexander Gardner (1821–82) do not tell the story of the war. Rather, they illuminate certain aspects of a particular situation. To be sure, Gardner's image in Figure 77 does illustrate the sniper's equipment, his attire, and his appearance in death. But it does not inform us of his origin, of where he died, in which army he fought, under whose command he was listed, and so forth. Seen in this light, the photograph becomes a different type of statement—symbolic rather than literal. Its value lies in the fact that often such a symbol can convey a more powerful and direct meaning than a lengthy dissertation on the same subject.

The French photographer Jean Eugène Auguste Atget (1856–1927) made a life-work out of photographing everything in Paris that he considered to be "picturesque and artistic." Among his subjects were buildings, ornamental details, pedestrians, peddlers, fountains, and parks. One whole series was devoted to shop windows, usu-

77. Alexander Gardner. *Home of the Rebel Sharpshooter, Gettysburg.* 1863. George Eastman House, Rochester, N.Y.

ally with mannequins and often with figures outside the windows reflected in the glass (Fig. 78). Atget's mannequins act as symbols, for one gets a strong feeling about the nature of humankind even though no people are visible.

Edward Weston (1886–1958) referred to his concern for symbols when he complained that people often feel they have to climb to a high spot and then look down in order to describe a situation. The resulting photographs are no more exciting than commercial postcards. Weston felt that a closeup, a detail, could represent a situation much more strikingly than a vague overall view. His closeups of fruit and vegetables are powerful studies of form (Fig. 79). Weston's attitude toward photographic materials, plus a personal concern for subject matter, crystallized in his idea that a scene should be "previsualized"— that all decisions should be made before the shutter was opened. His photograph of Point Lobos in California (Fig. 80) illustrates both a mastery of composition and a symbolic description of its rugged terrain characteristic of the area.

above: 78. Jean Eugène Auguste Atget. *A Vision in Paris.* Museum of Modern Art, New York.

left: 79. Edward Weston. *Peppers.* 1929. Collection the author.

In a sense, *all* of Ansel Adams' photographs are symbolic, because they represent his concern for the environment. Adams (b. 1902) was committed to ecology long before most people had even encountered the word. The majority of his photographs are taken in the national parks (Fig. 81), and they demonstrate the beauty of unspoiled nature and his hope for its preservation. Adams' work is a classic example of the photographer as visual communicator.

For many people, Dorothea Lange's photographs of migrant workers epitomize the mood of the Great Depression, even though Lange chose to focus on individuals, often in extreme closeup. The callused hands and the utter despair on the face of Lange's *Migrant Mother* (Fig. 39) represent the hardship of a whole decade better than any large overview could.

Point of View

Another aspect of the photographer's selection is his choice of viewpoint. Although he must usually accept or reject the elements before him, he can exercise his control in the angle from which he will shoot.

The advent of the hand camera created a vogue for unusual photographic angles. Such pictures are lighthearted and fun for both the photographer and his audience. However, more serious artists like Coburn utilized the unexpected camera angle to create a whole new vision (Fig. 82). William A. Garnett (b. 1916) became intrigued with the vistas he saw from an airplane, so he learned to fly in order to photograph the earth more perceptively. His aerial photo of sand dunes in Death Valley (Fig. 83)

opposite: 80. Edward Weston. *Point Lobos, Calif.* 1946. Collection Cole Weston.

above left: 81. Ansel Adams. *Moon and Half-Dome, Yosemite National Park.* 1960. Courtesy the photographer.

above right: 82. Alvin Langdon Coburn. *The Octopus, New York.* 1913. George Eastman House, Rochester, N.Y.

right: 83. William A. Garnett. *Nude Dune, Death Valley.* 1954. Courtesy the photographer.

84. Edward Weston. *Excusado.* 1925. Collection Cole Weston.

creates a fascinating abstraction. Quite the opposite point of view is taken by Weston in *Excusado* (Fig. 84), which was photographed looking up from floor level toward the monumental abstraction and gleaming presence of a well-known lavatory fixture. The powerful form, viewed as it is out of context, becomes divorced from our usual associations and assumes an independent identity altogether.

Design in photography evolves from a series of intelligent choices made by the photographer—choice of equipment, of processing methods, of elements to be included in a given image. The selection of these elements requires thorough consid-

eration before the exposure is made, for while some detrimental features can be removed during the enlarging process, the exploration for images takes place essentially in the camera, not in the darkroom. It often happens that after a negative has been printed, the photographer discovers some element so distracting that it actually detracts from the overall effect of the photograph. At this point, of course, it is too late to do anything about it. Therefore, the initial choice of what is and what is not to be included in a given image constitutes a major factor in the photograph's success. Such decisions require sensitivity, skill, experience, and often a measure of luck.

The Camera

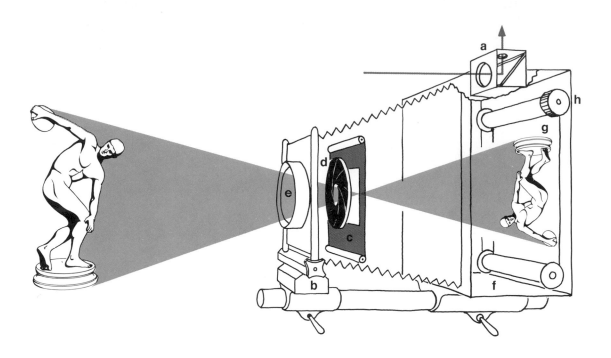

BASIC PARTS
OF THE CAMERA

Despite striking differences in physical appearance, all cameras are fundamentally the same. In essence, the camera consists of a light-tight box with a hole at one end and a light-sensitive material at the other. The hole or *aperture* admits light into the box; the light-sensitive *film* receives light and records an image in response to it. The camera functions to control light in such a way that once it has struck the chemically sensitized surface of the film, exposed negatives or positives can be obtained. In order for this to be accomplished in the most efficient way, several devices have been incorporated into the camera's mechanism.

Every camera, however inexpensive or costly, is equipped with five basic features that enable the instrument to perform properly: the *viewing system,* the *focusing system,* the *shutter,* the *aperture,* and the *lens.* Differences in price between one model and another depend upon the relative simplicity or sophistication of these elements. Figure 85 illustrates the five basic parts as they serve in a classic view camera; their location and arrangement may vary in other types of equipment.

The Viewing System

The photographer's first concern should be the means by which the camera permits him to view the scene it will record. This is of paramount importance, for while the viewing system of a camera resembles that of the human eye, there are significant differences (Figs. 87, 88). As the eye looks at a subject, it is moving constantly from one point to another. The image it conveys is, therefore, a composite of many individual views integrated into a single visual experience. In contrast, the still camera—as distinguished from a movie camera—records all that it views of a given subject in one image. Consequently, the photographer who attempts to record a whole scene in a single photograph must use his camera with greater selection and accuracy than he would require of his eye.

The camera's sighting mechanism enables the photographer to frame the area his camera can record when pointed in a certain direction. Early box cameras did not have a special sighting system; instead, the photographer merely held the instrument at his waist and pointed. This method, obviously, was quite inaccurate, and sub-

opposite: 85. The camera is a light-tight box with a hole at one end and a light-sensitive material at the other. It functions to control light so that once light has struck the chemically sensitized surface of the film, exposed negatives or positives can be obtained. To accomplish this, the modern camera is equipped with 5 basic parts:

a. The viewing system, normally consisting of a lens or set of lenses, permits the photographer to see that part of a scene the camera can record on film.

b. The focusing system works mechanically to move the lens closer to or farther away from the film, thus to make the image sharp or blurred as it strikes the film surface.

c. The shutter, a kind of shield or curtain, opens and closes at various speeds to control exposure; that is, it measures the length of time during which light enters the camera and strikes the film surface.

d. The aperture, like the shutter, is a device for controlling light. It works, not in measured units of time, but by the measured size of the opening through which light enters the camera via the lens. The aperture usually has the form of overlapping thin metal leaves, arranged in a circle, that are called the *diaphragm*. A mechanical device, it can be made to expand or contract and thus to admit into the camera greater and smaller amounts of light.

e. The lens gathers light rays reflected from the scene or subject being photographed and projects them onto the film surface as a completely reversed image.

Other elements shown in the diagram:

f. The box, body, or container enables the camera to seal off all light except that admitted through the lens.

g. The film offers a light-sensitive surface on which can be recorded the image projected by the lens.

h. The film advance moves roll film into position for successive exposures. It achieves this by winding film from one spool and rethreading it onto a second spool. Some cameras receive film in a slot, inserted one sheet at a time.

sequent cameras were fitted with a device called a *viewfinder*. A viewfinder permits one to look through the camera and see the approximate area it will record when the shutter is clicked. This arrangement is perfectly adequate for the ordinary snapshot, and the viewfinder continues to serve in inexpensive cameras.

The term *parallax* identifies a defect inherent in the viewfinder that prevents it from revealing with accuracy the area actually seen by the camera lens (Fig. 86). This discrepancy occurs because the viewfinder and the lens do not sight from the same position. Usually, the viewfinder is located slightly higher than the lens and off

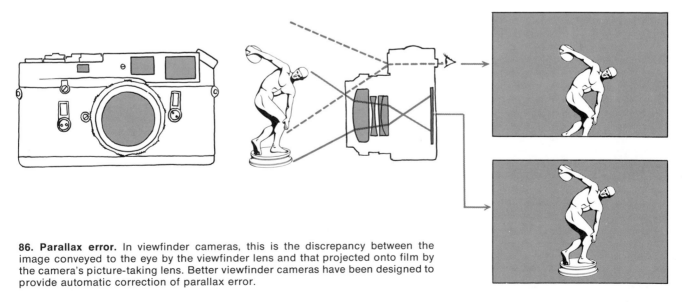

86. Parallax error. In viewfinder cameras, this is the discrepancy between the image conveyed to the eye by the viewfinder lens and that projected onto film by the camera's picture-taking lens. Better viewfinder cameras have been designed to provide automatic correction of parallax error.

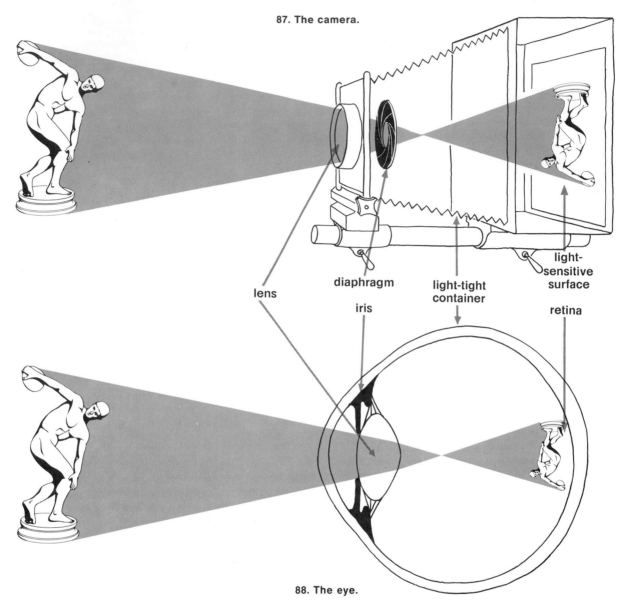

87. The camera.

lens

diaphragm

iris

light-tight container

light-sensitive surface

retina

88. The eye.

87, 88. The eye and the camera. In many ways the eye and the camera are alike. Both have a rigid outer covering, are light-tight, and provide a sensitive surface capable of registering an image projected by light. There is a lens system in each, as well as a diaphragm for regulating the aperture and thus the amount of light that enters. Muscles surrounding the lens of the eye change the curvature of the lens to make it focus on objects at various distances. The photographer focuses the camera by moving its lens to and fro. A bellows makes this possible in some cameras; in others, the position, and therefore focus, is adjusted by rotating the lens.

to one side, so that light is reflected from the subject into the viewfinder at a different angle from that entering the lens. Moreover, the closer the camera is to the subject, the greater the incidence of parallax error. In more costly instruments, such as the Leica, parallax error has been cor-

rected to permit accurate sighting provided the camera is at least 3½ feet from the subject. The degree of refinement depends upon the sophistication of the mechanism.

Of the four basic types of camera, the *view camera* (Fig. 91) and the *single-lens reflex camera* (Figs. 92, 93) permit viewing

directly through the picture-taking lens and thus preclude parallax error. Sighting through the lens is the most reliable viewing system, but this advantage must be considered relative to other characteristics of these cameras, such as higher cost, the care in operation and maintenance required by more sophisticated mechanisms, and, in the instance of the view camera, cumbersomeness in addition to an image on the viewing screen that is reversed and upside down. Unless specifically corrected, the *viewfinder* (Fig. 86) and *twin-lens reflex cameras* (Figs. 94, 95) present the problem of parallax error, but the first is both inexpensive and quick and easy to handle for snapshot purposes, and the second, while compact enough, allows careful composition on its viewing screen as well as convenient sighting, through its look-down viewing system, from ground-level positions.

The Focusing System

The feature of a camera identified by the term *focusing* can be demonstrated by the following experiment. Hold one thumb about 5 inches in front of your eyes. Concentrate on the thumb and observe intently its wrinkles and surface textures. Once visually they have become clearly defined for you, these characteristics can be described as being *in focus*. At the same time, while still concentrating on the thumb, observe the objects in the background, in the area beyond the thumb. If your vision is normal, you will not see these in clear definition; they can be said to be *out of focus*. Next, transfer your attention from the thumb to the background. This change in concentration should bring the background into focus and throw the thumb out of focus. Focusing in this way is a function that normally the human eye performs many times each second, without one's being especially conscious of it.

Figures 87 and 88 illustrate several characteristics shared by the camera and the human eye. The two are alike in that each is light-tight and has a lens at one end. Furthermore, the lenses of both the camera and

the eye are equipped with mechanisms for regulating the amount of light admitted. In the eye this is called the *iris,* in a camera, the *diaphragm.* Directly behind the lens, in each case, is a light-sensitive surface. A set of nerves (rods and cones) in the eye transmit light stimuli by means of the optic nerve to the brain, producing vision. The light-sensitive surface in the camera is the film. Focusing in the human eye is accomplished automatically, because muscles attached to the lens can literally stretch it and change its shape, thus bringing objects at various distances into clear definition. However, since the camera lens is made of glass, it cannot be stretched, and focus must be achieved by other means. The solution to the problem of focusing is to alter the distance between lens and film.

Not all cameras have a built-in mechanism for making this adjustment. Early box cameras and some contemporary models of the Instamatic are designed to produce a relatively sharp image as long as the subject is at least 6 feet from the camera. Other cameras have manually controlled focusing mechanisms (Fig. 85), but these require that the distance between camera and subject be estimated or actually measured, and then the camera set accordingly. Some inexpensive 35mm cameras provide a visual scale to indicate appropriate settings, using symbols such as a mountain for a distant scene and a portrait for closeups. In all such cameras, unfortunately, the focusing tends to be both cumbersome and unreliable.

In order to achieve really sharp pictures, it is essential that one have some dependable means for relating the distance between camera and subject to the distance between lens and film. Two principal devices have been developed for accomplishing this end: the *rangefinder* and the *ground-glass viewing screen.*

The Rangefinder The rangefinder is an optical-mechanical device that produces in the viewfinder a double image of the subject to be photographed (Fig. 89) *except* when that subject is precisely in focus. In other words, when the two images coincide

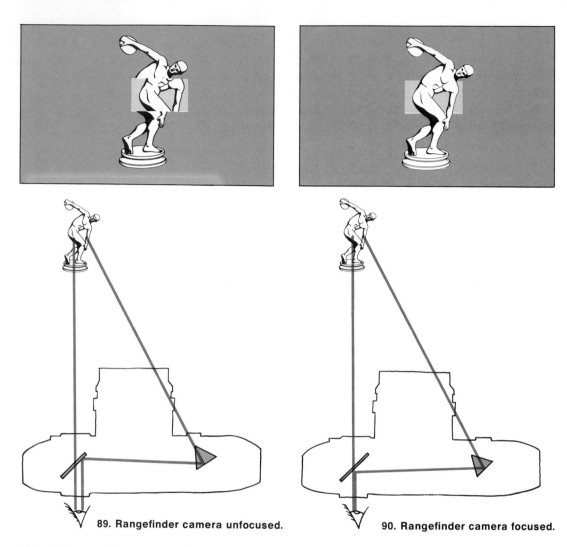

89. Rangefinder camera unfocused.

90. Rangefinder camera focused.

89, 90. The rangefinder camera has the capability to present to the eye, sighting through the viewfinder, two images of the same subject as seen from different angles. When the photographer distinguishes two images, his camera has not been made to focus sharply on the subject. By rotating the prism, or mirror, located at the right of the viewfinder, he can set the prism at an angle correct for making the two images align as one. In doing so he automatically focuses the camera, since the angle of the prism depends, like focus, upon camera-subject distance and thus is mechanically linked or coupled to the lens.

exactly, the camera is in focus (Fig. 90). As illustrated in Figures 89 and 90, the rangefinder consists of a prism, glass block, or mirror plus a semitransparent mirror. Light reflected from distant objects strikes the prism and the semitransparent mirror in a parallel configuration, so the two images in the viewfinder correspond. However, light reflected from nearer objects creates an angle in its path to the prism and the semitransparent mirror (Fig. 89). To correct

for this, the prism is rotated, an adjustment linked to the focusing of the lens. When the prism has been turned to just the proper angle, the two images in the rangefinder coincide, and the camera is in focus (Fig. 90).

The rangefinder coupled to the picture-taking lens tremendously improves the performance capability of the simple viewfinder camera (Figs. 89, 90). Because it is not a focusing lens (that is, does not "see" as the picture-taking lens does), the range-

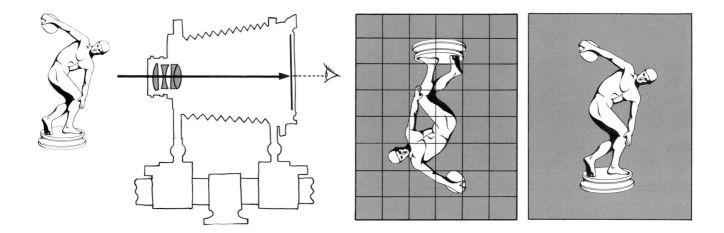

finder presents a bright image that is uniformly sharp throughout the picture. This makes focusing in dim light more feasible than with other systems. However, in some cameras the rangefinder's small peephole window is cramped enough to pose problems in both sighting and focusing.

The Ground-Glass Viewing System An older device for focusing the camera is the ground-glass viewing screen. In this system, light reflected from the subject passes through the camera lens and is projected onto a piece of ground glass to produce an image that can be viewed by the photographer from the reverse side. Thus, he sees what the lens "sees" and can bring the image into focus by watching it on the etched glass screen as he manipulates the lens' focusing mechanism.

When using a view camera, the photographer sights the image from the rear of the ground-glass pane upon which it has been directly projected by the picture-taking lens (Fig. 91). Because the glass screen occupies the same plane as the film, the image it reflects is exactly what will be recorded on the film. Thus, the image the photographer sees is reversed and upside down, but its large size and accurate reflection of what the lens sees provides an opportunity for close inspection of focus throughout the picture, even with a magnifying glass. The bellows in the view camera permits the

91. The ground-glass viewing screen of a view camera occupies the same plane as the film and therefore receives light directly from the picture-taking lens. Thus, the image on the translucent screen reveals exactly what the film will record, including an image whose orientation is reversed and upside down.

91–95. The ground-glass viewing system serves in view cameras and in both single-lens and twin- or double-lens reflex cameras. Upon a sheet of glass etched to a translucent, milky state is projected the image seen by the camera's picture-taking lens or, in the instance of the twin-lens reflex camera, a viewing lens designed to focus as does the picture-taking lens. The photographer focuses the camera by examining the image reflected on the screen as it responds to his manipulation of the focusing mechanism. Except in twin-lens reflex cameras that have not been corrected for parallax, what the photographer sees on the ground-glass screen is what the lens sees, in composition as well as in focus.

photographer to move the lens to and fro and up and down, generally to tilt and twist, until maximum focus has been achieved and distortion eliminated. The weight and bulk of the camera require that it be supported and stabilized on a tripod, and to see clearly the image caught on the milky, translucent glass, the photographer usually views from beneath a black cloth draped over the back of the camera.

The ground-glass system is also used in both the single-lens and twin-lens reflex cameras. As adapted to the single-lens reflex, it requires a rather more complex

92, 93. The ground-glass viewing system in the single-lens reflex camera. Light passing through the camera from the picture lens is reflected from a mirror set in front of the film and projected up through a viewing screen into a five-sided prism that orients the image vertically and horizontally, to reveal it as it would be seen in nature, and then conveys the image to the eye. Thus, both composing and focusing can be accomplished through the camera lens, which eliminates parallax and creates conditions conducive to accurate judgment of picture-making possibilities. When activated, the shutter release causes the mirror to snap up momentarily so that light can expose the film.

92. Single-lens reflex camera.

construction (Figs. 92, 93). Light gathered by the camera lens is reflected upward by a mirror to the ground glass (Fig. 93). The image formed on the ground glass is viewed through a five-sided prism, which rights the image both from top to bottom and from side to side. The image can then be focused by rotating the lens. When the shutter release is pressed, the mirror swings up (Fig. 93) and the shutter opens to permit light to pass through and expose the film. In this position, the mirror prevents light from filtering down through the pentaprism to fog the film. After exposure, the mirror returns to its original position. Thus, viewing through the camera lens is blacked out only briefly.

Although only slightly heavier and more bulky than the rangefinder camera, the single-lens reflex instrument enables the photographer to both compose and focus through the picture lens, and do it with ease and convenience. Because it functions entirely through the picture-taking lens, the single-lens reflex camera can accept any lens capable of fitting the lens mount. It is, however, subject to the care and maintenance liabilities of complicated mechanisms, and the moving mirror makes the shutter action too noisy for working with easily alarmed subjects. The light projecting the image upon the little viewing screen travels by a most indirect route, which makes the image so faint as to be difficult to focus under poor lighting conditions.

As the name implies, the twin-lens reflex camera has two lenses, which are situated one above the other (Figs. 94, 95). The lower lens exposes the film, the upper one serves for viewing. Twin-lens reflex cameras also employ the ground-glass viewing system. As illustrated in Figure 95, the light gathered by the top lens is reflected by a mirror to a piece of ground glass in much the same way as in the single-lens reflex. Like the view camera system, the image appears on the reverse side of the glass, but on the top of the camera. The image is thus projected on a horizontal rather than a vertical plane. A magnifier in the viewing hood helps to exclude unnecessary light, so the ground-glass image can be examined carefully. The upper viewing lens and the lower exposing lens are mounted in such a way that they move back and forth in tandem. Therefore, as the image on the ground glass is brought into focus, the exposure lens is also focused. In general, it is a simple, trouble-free method, but there is one difficulty. Like all mirror images, the reflection on the ground glass is reversed, so if one is attempting an action shot, the camera must be moved in a direction opposite to that of the subject. To overcome this problem, most twin-lens reflex cameras are equipped with a sports viewfinder—a small opening in the back of the magnifying hood leading to a larger one at the front. By peering through this opening, the photographer can see roughly the area that will be photographed. While this supplementary system is not as accurate as the ground-glass method, it succeeds in eliminating the reversal of the image.

**93. Section view
of a single-lens reflex camera.**

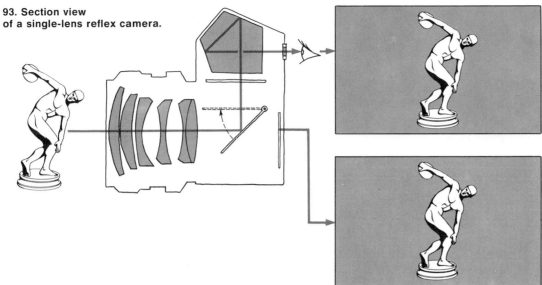

94, 95. The ground-glass viewing system in the twin-lens reflex camera. As the name indicates, this camera has two lenses, one mounted above for viewing and a lower one for picture-taking. Light traveling from the viewing lens is reflected upward by a mirror and projected onto the bottom of a ground-glass plate set into the top of the camera. By looking down onto the other side of the plate, the photographer can view the image in a reverse, or mirror, orientation. In cameras with mechanically coupled lenses, the photographer can focus by manipulating the image seen on the ground glass. Because the mirror is fixed, the twin-lens reflex camera is sturdy and quiet to operate. Unless the mirror is correlated, the separate viewing lens could create parallax error.

**95. Section view
of a twin-lens reflex camera.**

94. Twin- or double-lens reflex camera.

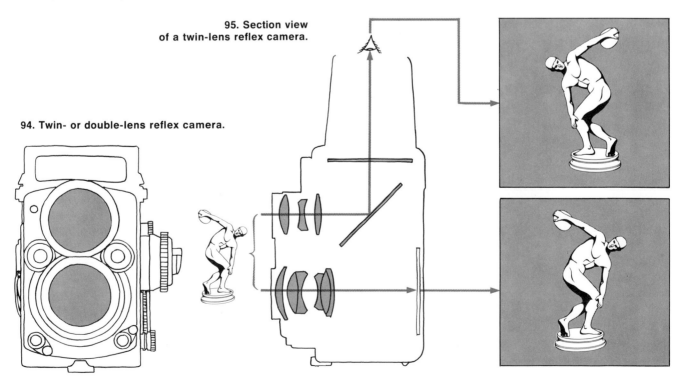

Like that in the view camera, the ground-glass screen of the twin-lens reflex camera reflects the image as a two-dimensional picture, a condition superb for compositional purposes. Because the mirror is fixed, rather than mechanical, the twin-lens reflex camera is both sturdier and quieter than the single-lens reflex. Viewing by means of a flat screen in the top of the camera, instead of at eye level, the photographer can lower the camera to waist level and all the way down to the ground. Slightly larger than the rangefinder and single-lens cameras, but nonetheless a hand-held instrument, the twin-lens reflex also provides a larger film whose potential for fine detail in enlargements is greater. Parallax must be corrected, and this has been accomplished in the better models. Lenses are not changeable on twin-lens reflex cameras, except in the instance of one particular brand of camera.

above: 96. The analogy of the water faucet and the camera shutter. The quantity of water released by a faucet doubles when the time the faucet is held open doubles. Similarly, holding a shutter open for 10 seconds admits twice as much light into the camera, providing twice as much exposure of the film, as would a shutter opening of 5 seconds.

right: 97. The leaf shutter (a), in all cameras, is located in the lens itself.

The Shutter

The shutter and the aperture of a camera control the amount of light that reaches the film. By adjusting these mechanisms, the photographer can vary the exposure of the film according to the requirements of his subject — a dense forest or a sunlit beach.

A popular way to explain the functions of the shutter and aperture is to compare them to the controls of a faucet through which water flows into a container. In this analogy, the water represents light; the valve on the faucet, which determines the amount of water permitted to flow, stands for the aperture; and the length of time the valve is held open to permit a flow of water signifies the shutter. As illustrated in Figure 96, a given amount of water flows into the container when the valve is held open for 5 seconds, and twice as much flows in when the valve is held open for 10 seconds. Similarly, the shutter of the camera controls the length of time during which light is permitted to enter the camera. *If the timing of the shutter opening is doubled, the amount of light will also be doubled.*

Early cameras did not have shutters. Since the photographic materials then available were relatively slow in reacting to exposure, a careful regulation of timing would have been superfluous. One simply fitted a removable opaque cover over the front of the camera to protect the lens when not in use. In preparation for photographing, the operator removed the cap in order to sight and focus upon his subject, then replaced it while the film was inserted. Next, he removed the cap and timed the exposure by the second hand of his watch. This system was fairly crude but perfectly satisfactory as long as an exposure of several seconds was required. It became inadequate only when new materials permitted a split-second exposure time. Many kinds of shutters have been developed, but today all cameras employ either the *leaf shutter* or the *focal-plane shutter*.

The Leaf Shutter The leaf shutter is also called a *between-the-lens shutter,* because

it is always located in the lens itself (Fig. 97). This device consists of a series of tiny metal leaves or blades which, in a closed position, overlap to prevent light from entering the camera. The leaves are controlled by a gear and a taut-spring mechanism. For the shutter to open, the spring must be *cocked*—that is, be in a taut position. Some cameras cock the spring automatically; others require that it be done manually.

When the spring is released, the leaves move away from the center of the lens (Fig. 98), permitting a tiny amount of light to enter the camera. This movement continues (Fig. 99) until the leaves have opened to their fullest extent and the maximum amount of available light pours in (Fig. 100). They remain in this position according to the timing of the exposure and then begin to close (Figs. 101, 102). After the leaves have closed completely, the exposure is finished (Fig. 103).

98–103. The operation of the leaf shutter. Made of a series of small leaves or blades arranged to overlap in concentric order and controlled by a gear and taut-spring mechanism, the leaf shutter opens for preset durations and then closes again. The illustrations demonstrate the positions taken sequentially by the leaves in a shutter as it opens and closes and the relative dimness or brilliance of the illumination each would permit inside the camera. The leaf shutter allows light to spread evenly over the whole negative, building up to peak intensity and then diminishing.

103. Exposure completed.

98. Shutter leaves begin to open, admitting very little light.

99. Shutter leaves half-open.

100. Shutter wide open to admit a flood of light for good exposure.

101. Shutter closing.

102. Shutter nearly closed and excluding most light.

above left: **104. Location of the focal-plane shutter** (a), as the name indicates, is directly in front of the film (b).

above right: **105. An early focal-plane shutter** combined a series of slits in different sizes, cut in an opaque curtain, with varying tensions in the spring mechanism to achieve a range of shutter speeds.

106. Fast focal-plane shutter speed derives from a narrow slit.

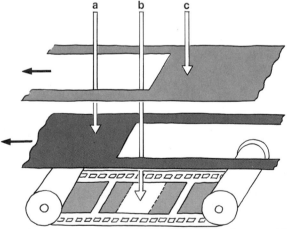

107. Slow focal-plane shutter speed derives from a wide slit.

106, 107. The modern focal-plane shutter. In these diagrams the camera is assumed to be pointing straight up. Ray of light *a* passes through an open section of the top curtain but is stopped by an opaque section of the bottom curtain. Ray *c* is stopped by an opaque section of the top curtain. Only ray *b* reaches the film by passing through open sections that overlap in both curtains. The speed of exposure derives from the width of the opening made by the coincidence of the two curtains and can be controlled by adjusting the curtains in relation to each other.

The Focal-Plane Shutter The focal-plane shutter operates, obviously, near the focal plane of the camera—that is, directly in front of the film (Fig. 104). When this type of shutter was first introduced, it consisted of an opaque curtain interrupted by a slit (Fig. 105). A spring mechanism pulled the slit past the film, in its transit exposing the film to light. By combining a wide slit with a very low spring tension, one produced long exposures (for example, 1/10 of a second), while a narrow slit operated with a high spring tension yielded a fast exposure (such as 1/1000 of a second). A wide range of shutter speeds were therefore available.

The modern focal-plane shutter consists of two curtains, each with a cut-out section, which move in the same track in front of the film. Where the cut-out sections coincide, a slit is formed that can be adjusted by altering the positions of the two curtains in relation to one another. Thus, a full range of shutter speeds can be obtained without changing the spring tension.

Figures 106 and 107 render in simplified fashion a section of the focal-plane shutter. The film is shown to be on a horizontal rather than a vertical plane, which presumes that the camera is pointed straight up. At each side are rollers that accommodate the curtains as they move from side to side. A ray of light (a) entering the lens passes through a cut-out section of the top curtain but strikes an opaque area of the bottom curtain. A second ray of light (c) is stopped when it strikes an opaque section of the top curtain. Only the light at *b* passes through the slit produced by overlapping cut-out sections of the two curtains and exposes the film. In the diagrams, the dotted lines on the lower curtain and on the film indicate the size of the slit. The narrow slit

in Figure 106 indicates a fast shutter speed, the wide one in Figure 107 a slow speed.

The shutter is operated by a spring-and-gear mechanism, which is most often cocked automatically as the film is advanced. When the shutter-release button is pressed, the lower curtain begins to move, followed shortly after by the upper curtain. The length of time that elapses before the upper curtain starts to travel determines the size of the slit, which in turn controls the shutter speed.

With a focal-plane shutter, the negative is not exposed all at once but in sections, as the slit in the shutter curtains passes across it (Fig. 108). The amount of light striking each section at the instant the slit passes must be adequate for exposure. A basic difference, then, between the leaf shutter and the focal-plane shutter is the manner in which light is permitted to strike the film. When a leaf shutter is used, the exposure light is spread over the whole negative, but it builds up in intensity to a peak and then diminishes. The focal-plane shutter maintains constant light, while allowing the negative to be exposed sequentially in segments.

Located at the focal plane, instead of in the lens, this type of shutter can function with whatever lens may be put into the camera. Its location also permits viewing through the lens. A simple mechanism moving in a single direction—as opposed to the leaf shutter, which must both open and close—the focal plane shutter permits speeds as great as 1/2000 of a second. It is, however, relatively noisy and can cause minor distortion in the images of rapidly moving subjects.

It should be clear that the focal-plane shutter creates a time lapse between the exposure of the first section of the negative and of the last—the time required for the slit to travel across the negative. This is no problem when one is photographing a fixed object. However, if the subject is in rapid motion, the action recorded on the first section of the negative will differ slightly from that recorded on the last section, because the subject will have moved during

108. Sequential exposure system of the focal-plane shutter. The illustrations reveal the segments exposed by light traveling through the slit in the focal-plane shutter as it moves across the film. Since each segment receives the same amount of light, the film obtains uniform exposure throughout, as seen in the final print. In contrast to the leaf-shutter system (Figs. 98–103), the focal-plane shutter provides a consistent level of light intensity for each segment, with exposure occurring sequentially from one end of the film to the other.

The Camera 65

right: 109. Jacques Henri Lartigue. *Grand Prix of the Automobile Club of France.* 1912. Depending on the direction the subject is traveling in relation to the direction taken by the light-passing slit, the focal-plane shutter can produce various degrees and types of distortion and yield effects that often are visually fascinating.

110, 111. Shutter speed and its effect on motion. In the photographic record it makes, shutter speed can cause movement to seem stilled or an onward, rushing force.

below: 110. Oscar Bailey. *Waterfall I.* A shutter speed of 1/1000 has stopped the downward movement of rushing water.

bottom: 111. Oscar Bailey. *Waterfall II.* A shutter speed of 1/2 of a second has intensified the rushing movement of falling water.

the interval. This can produce a slight elongation of the subject in the final print, and the degree of distortion depends upon the direction of travel by the subject in relation to that of the slit. With older cameras one could exploit this factor to produce interesting action photographs, such as that made in 1912 by Jacques Henri Lartigue (Fig. 109). However, the focal-plane shutters on modern 35mm cameras do not permit such exaggerated effects, for the size of the slit has been so reduced as to make the distortion too slight to be noticed.

Shutter Speeds Shutters are geared to remain open for various set periods of time, so that the duration of the exposure can be controlled. Most shutters have speed settings that range from 1 second to 1/500 of a second or 1/1000 of a second. The Leica-flex can be set for 1/2000. Common shutter speeds are: 1, 1/2, 1/4, 1/8, 1/15, 1/30, 1/60, 1/125, 1/250, 1/500, and 1/1000 of a second.

Shutter speeds are scaled in relation to one another. For example, a 1/30 permits twice as much light to enter as would a 1/60, and a 1/125 allows only half the exposure of a 1/60. Shutter-speed scales are indicated on the camera, and the settings must be precise—exactly opposite the reference point, not in between. Inaccurate settings produce unpredictable results and can damage the shutter mechanism.

In addition to a full range of shutter speeds, a shutter usually allows for either a B (bulb) setting or a T (time) setting. Some shutters are equipped to offer both. The B setting holds the shutter open for as long as the shutter release is pressed, then closes it when pressure is removed. It is therefore suited to short time exposures of less than 30 seconds. The T setting is more efficient for long time exposures of more than 30 seconds, because the shutter remains open for an indefinite period of time, until the shutter release is pressed again or the shutter-speed knob rotated.

The shutter speed can affect the way in which action or motion is recorded in the final photograph. Figures 110 and 111 both depict waterfalls, but the effect of flowing water in one is quite different from the other. The negative for Figure 110 was exposed at 1/1000 of a second, thus apparently stopping the flow of water. By contrast, the longer exposure—1/2 of a second—used for Figure 111 exaggerates the mo-

tion of the water. In this way, shutter speeds can be used creatively to achieve a particular effect (Figs. 63–67). The imaginative application of the fast shutter speed is demonstrated splendidly by Aaron Siskind's photographic series, *The Pleasures and Terrors of Levitation* (Fig. 112).

In dealing with a moving subject, the photographer must consider several variables if he wishes to prevent blurring and achieve a frozen effect in his picture. First, there is the speed at which the subject is moving; second, the angle of the moving subject in relation to the camera; third, the size of the subject in relation to the size of the proposed image.

A rapidly moving body must be photographed at a faster shutter speed than a stationary subject. For a stop-motion effect a moving vehicle might require a shutter speed of about 1/1000. On the other hand, a rock in a meadow can be photographed at a much slower speed, perhaps 1/30 of a second.

112. Aaron Siskind. *Terrors and Pleasures of Levitation.* 1954. Fast shutter speed has here produced the dramatic effect of stopped or frozen action.

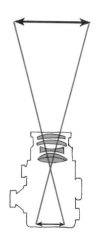

113–119. Shutter speed sufficient to stop action depends upon the speed at which the subject is traveling, the angle of the moving subject's direction in relation to the camera, and its distance from the camera.

right: 113. A subject traveling at a right angle to the camera requires the fastest shutter speed to stop action.

above: 114. A moving subject photographed from a right angle at 1/500 (left) and at 1/30 (right).

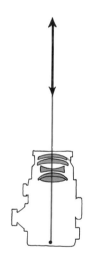

right: 115. A head-on relationship of the camera to a moving subject eliminates movement across the picture plane and reduces the potential for blurring.

above right: 116. A moving subject photographed head-on at 1/500 (left) and 1/30 (right).

Figures 113 to 119 illustrate the relationship between shutter speed and the angle of a moving subject. In Figure 113 the subject is traveling at a right angle to the direction in which the camera has been pointed, so the fastest shutter speed (1/500 or 1/1000 of a second) would be required to stop the action. If the subject is in very rapid motion, even this speed would not be fast enough. The composite photograph reproduced as Figure 114 was made with two different shutter settings. Its subject is an automobile traveling at 15 miles per hour in a path directly across the photographer's

field of vision. The left side was exposed at 1/500 of a second and the right side at 1/30. Differences in sharpness of detail and the effect of stopped action can be readily perceived. And, had the car been traveling at a faster rate of speed, the blurring effect would be still more marked.

If the angle between the camera's orientation and the path of the moving object is changed—for example, if the subject is moving directly toward the camera (Fig. 115)—the degree of potential blurring at any given shutter speed setting is reduced. For the composite photograph in Figure

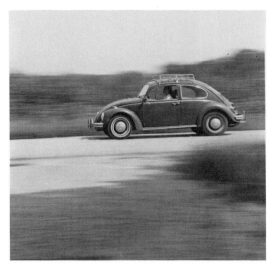

117–119. **Panning a subject in motion** means moving the camera along an arc in the same direction taken by the subject. The effect of the subject's speed (blurring) is thereby reduced.

right: 117. Camera-subject orientation for panning.

above left: 118. Fast shutter speed and panning. A moving subject photographed at 1/500 by a panning camera.

above right: 119. Slow shutter speed and panning. A moving subject photographed at 1/30 while panning.

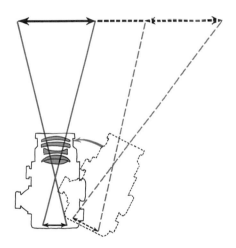

116, one exposure was made at 1/500 (left) and another at 1/30 (right). While there is still a visible difference between the two halves, especially in legibility of the license plate, the discrepancy is not so great as in Figure 114.

Figure 117 illustrates a technique called *panning* that is frequently used to photograph moving objects. The camera is moved in an arc to follow the subject, thus reducing the relative rate of speed at which the subject passes before the camera. Figures 118 and 119 were both made by panning on a car traveling at 30 miles per hour—twice the speed employed for the previous illustrations. Figure 118 was exposed at 1/500 and Figure 119 at 1/30, but the outlines of the car are sharp even at the slower shutter speed. There is, however, a striking difference between the two photos in the appearance of background and foreground areas. The 1/500 exposure (Fig. 118) makes the car appear to be standing still on the road, but with the slower speed the blurring of weeds and trees enhances the effect of motion (Fig. 119). Oscar Bailey combined the panning technique with a slow exposure to make the photograph reproduced in Fig-

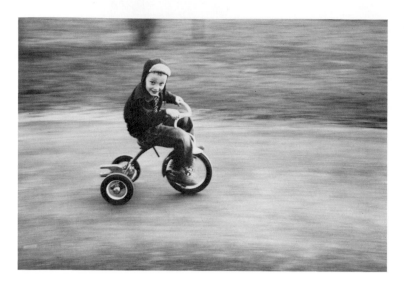

above: 120. Oscar Bailey. *Child on a Tricycle.* The panning technique has made the subject seem to speed forward at a breakneck rate.

121–123. Varying in relation to shutter speed the three factors of the speed of a moving object, its angle of direction, and its distance from the camera can result in special and interesting effects. A spinning wire sculpture varies the relationship among the three factors.

above right: 121. A fast shutter speed arrests the spinning sculpture sufficiently to record its form.

right: 122. A medium shutter speed blurs motion in the spinning mobile sculpture.

below right: 123. A slow shutter speed creates a soft, fluid image from the action of the spinning sculpture.

ure 120, in which the child appears to be operating his tricycle at breakneck speed.

The distance between the camera and a moving subject can also have a profound effect upon the desirable shutter speed, because the farther away a subject is, the less pronounced its speed will seem. One might, for example, photograph a distant, fast-moving vehicle with an exposure of 1/60, whereas the same vehicle, traveling at the same speed, might require a shutter speed of 1/250 or 1/500 to produce the same effect if it were closer to the camera.

In summary, three factors—the speed of a moving subject, its angle of direction, and its distance from the photographer—in-

fluence the choice of a shutter speed. By varying these elements in relation to one another, the photographer can achieve special effects, often quite interesting ones. Figures 121 to 123 all depict the same wire sculpture, but the three photos were made with different shutter speeds. The fastest exposure (Fig. 121) reports faithfully the outlines and contours of the sculpture; a medium exposure (Fig. 122) blurs the form to some degree; and an unusually slow shutter speed (Fig. 123) produces a soft, fluid image that is perhaps more truly representative of the sculpture's essence than an accurate description of its components.

Unfortunately, there can be no set formula to guide the photographer in choosing the shutter speed that will best enable him to achieve the desired effect. One can only experiment by varying the shutter speed for several exposures. In many cases, accidents turn out to be happy ones.

The Aperture

Like the shutter, the aperture of a camera provides a means for controlling the amount of light that will be admitted to expose the film. The two mechanisms function together. As with the shutter (Fig. 96), the analogy of the faucet valve is useful in understanding how the aperture works (Fig. 124). If the length of time during which the faucet valve is held open can be compared to the shutter speed, the degree to which the faucet is opened can signify the aperture size. A faucet valve that is wide open will permit twice as much water to flow into the container in 5 seconds as one that is only half open. Similarly, *the larger the opening in the aperture, the greater the amount of light that will reach the film.*

In the human eye, too, the amount of light flowing through the lens must be regulated. In absolute darkness there can be no vision, but too much light is dazzling and can harm the eye. The pupil functions to soften these two extremes, opening and closing as required by varying light conditions. This action is performed automatically.

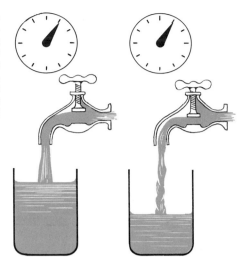

124. The analogy of the water faucet and the camera aperture. A wide-open faucet releases twice as much water in 5 seconds as one that is only half open. Similarly, the larger the aperture, the greater the amount of light admitted into the camera.

The camera requires the same regulation of light intensity. If too much light enters the lens, the negative will be *overexposed,* or lacking in detail; too little light will give inadequate exposure, or *underexposure,* and the negative may even be blank. In early photography, light entering the camera was controlled by interchangeable devices called *waterhouse stops*—sheets of metal with apertures in different sizes (Fig. 125). On a dark day, when maximum avail-

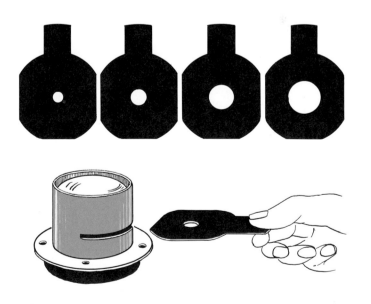

125. Waterhouse stops, pieces of metal in different sizes, could be inserted into the lens of early cameras to control the admission of light.

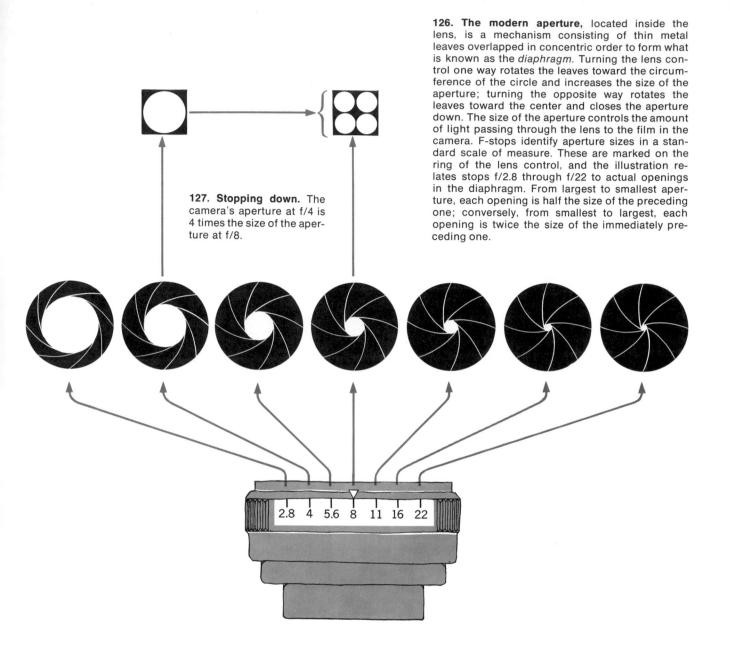

126. The modern aperture, located inside the lens, is a mechanism consisting of thin metal leaves overlapped in concentric order to form what is known as the *diaphragm.* Turning the lens control one way rotates the leaves toward the circumference of the circle and increases the size of the aperture; turning the opposite way rotates the leaves toward the center and closes the aperture down. The size of the aperture controls the amount of light passing through the lens to the film in the camera. F-stops identify aperture sizes in a standard scale of measure. These are marked on the ring of the lens control, and the illustration relates stops f/2.8 through f/22 to actual openings in the diaphragm. From largest to smallest aperture, each opening is half the size of the preceding one; conversely, from smallest to largest, each opening is twice the size of the immediately preceding one.

127. Stopping down. The camera's aperture at f/4 is 4 times the size of the aperture at f/8.

able light was needed to create an adequate exposure, the photographer would select a waterhouse stop with a large aperture; a smaller aperture, perhaps the equivalent of f/16, would be more appropriate for a bright sunny day. This system was really quite efficient, but camera design has since become considerably more sophisticated.

In the modern camera, the aperture is located inside the lens. It consists of over-lapping thin metal leaves that form a circle called the *diaphragm* (Fig. 126). By turning an adjustment on the lens, the photographer can move the leaves outward toward the circumference of the circle, thus widening the size of the aperture and permitting all of the available light to pass through; alternatively, one can contract the diaphragm to allow only a minute opening. Consequently, a continuous range of aperture sizes is

Table 3.1 Aperture and shutter-speed combinations yielding the same exposure

Exposure	1	2	3	4	5	6	7
F-stop number	f/2.8	f/4	f/5.6	f/8	f/11	f/16	f/22
Shutter speed	1/125	1/60	1/30	1/15	1/8	1/4	1/2

provided, each controlling the effective diameter of the lens and the amount of light that can pass through it.

A standard scale of numbers, called *f-stops*, is used to measure aperture sizes. The same numbers are presented on virtually all lenses: f/1.0, f/1.4, f/2, f/2.8, f/4, f/5.6, f/8, f/11, f/16, f/22, f/32, f/45, f/64. Figure 126 demonstrates the relative aperture sizes for a selected number of f-stops. As illustrated, f/2.8 represents the maximum opening, and the measurements are so scaled that each succeeding f-stop is one-half the size of the next larger one and decreases the amount of exposure by half. Thus, an f/4 aperture will admit half as much light as an f/2.8. One must be careful not to confuse the numerical value of the f-stop numbers with the size of the aperture. A common mistake, for example, is to suppose that because f/8 is numerically twice f/4, the amount of exposure for f/8 will be half that of f/4. This is in fact not so. Rather, the aperture set at f/5.6 is half as large as that at f/4, and f/8 is only one-fourth as large. As the diagram in Figure 127 shows, it takes four circles of f/8 size to equal one of the f/4 size.

The f-stop scale is indicated on the camera lens. Unlike the shutter settings, the aperture scale is continuous, and settings need not be precisely *on* the f-stop mark. The photographer can, if he desires, set the aperture anywhere between the reference points. Interim settings are commonly used with color film, but they are seldom necessary for black-and-white photography.

No lens has a full range of possible f-stops from f/1.0 to f/64. The lens on a 35mm camera generally has a maximum aperture of f/1.4 and a minimum of f/16. The range on twin-lens reflex cameras is f/3.5 to f/22; on view cameras it may be f/5.6 to f/45.

Aperture Setting and Shutter Speed In order to achieve the best possible exposure, the photographer must reconcile the relationship between shutter speed and aperture size, since both control the amount of light entering the camera. If a given amount of light is required to expose the film properly, an *increase* in the shutter speed (which reduces the amount of time during which light is permitted to enter) must be matched by an *increase* in the aperture size (which permits more light to enter during that period of time). In other words, one adjustment compensates for the other. Since consecutive shutter speeds are related to one another in the same way that f-stop numbers are—each being twice the amount of the preceding number—the exposure can remain consistent as long as the two factors are correlated properly. Table 3.1 lists seven different sets of f-stop and shutter-speed combinations, all of which are capable of yielding the same exposure. Each change in one series of numbers has been compensated for by a corresponding change in the other. Failure to establish the appropriate relationship between the f-stop number and the shutter speed can result in a negative that is either overexposed or underexposed.

The Lens

A camera lens produces the image that becomes the photograph, and the quality of this image depends upon many variables. In fact, the lens is such a complicated subject that an entire chapter has been devoted to it. In Chapter 6 are explained the principle of a lens, its various characteristics and the way these function, as well as certain factors that govern the selection and purchase of a lens.

CHOOSING A CAMERA

There are so many different cameras available today that selecting the right one is not easy. A camera represents a considerable investment; thus, the choice should be made carefully, with a clear understanding of one's own requirements and a minimum degree of influence from advertising or sales pressure. The following survey outlines briefly the types of cameras now in popular use, noting what each can and cannot do and their relative advantages and disadvantages. Like any tool, no one camera is suitable for every photographic situation. Some cameras are quite versatile, while others have been designed to perform in rather specific ways. As a result, cameras exist in many different designs, sizes, and shapes. Furthermore, modifications are constantly being made in current models and new models introduced. Any discussion of camera types must therefore be broad and general. The major categories of equipment are:

Nonadjustable cameras (box and less expensive Instamatic cameras)
Subminiature cameras (Minox)
Miniature cameras (35mm)
 Rangefinder (Leica)
 Single-lens reflex (Pentax)
Cameras using 120 film
 Twin-lens reflex (Rolleiflex)
 Single-lens reflex (Hasselblad)
View cameras
Press cameras
Polaroid cameras
Special purpose cameras
 Stereo (Stereo Realist)
Panoramic (Widelux, Horizont)
Underwater (Nikonos)

Nonadjustable Cameras

Box cameras and inexpensive Instamatics are representative of the type of camera that cannot be adjusted (Fig. 128). After George Eastman introduced the first of these in 1888 (Fig. 21), the box camera quickly became a household item. Econ-

128. The Instamatic,
a modern nonadjustable camera.

omy rather than versatility was its principal virtue; the box camera could produce good pictures only on bright, sunny days, while on dull days the negatives were underexposed. However, when the weather was right, the Kodak box served successfully as a Sunday afternoon camera.

The focus, aperture size, and shutter speed of such cameras are set during manufacture. In order to obtain relatively sharp pictures, one must hold the camera at least 6 feet from the subject. The early box cameras presented a more formidable problem, in that the shutter speed was set at 1/30 of a second. It is difficult to hold a camera still for that length of time or to realize any degree of clarity in an action photograph. Present-day nonadjustable cameras like the Kodak Instamatic have partially eliminated this drawback with a faster shutter speed of 1/45 or 1/60 of a second.

The other limitation of the nonadjustable camera—the requirement that the subject be at least 6 feet away—can to some extent be overcome through the use of supplementary lenses, which permit photographing at a distance of less than 3 feet. These are portrait lenses and are relatively inexpensive. However, when the viewfinder is used on close subjects, parallax error (Fig. 86) is pronounced, and allowance must be made for it. Of course, the portrait lens must be removed to photograph distant objects and produce pictures that are in proper focus.

The Instamatic camera, in addition to its faster shutter speed and supplementary

lenses, has several other advantages over the old box camera. Film is contained in a plastic cartridge that has only to be dropped into the camera, thus eliminating the need to thread the film on a leader. Also, the exposure count is automatic, which makes it unnecessary to keep track of the number of exposures by watching through a tiny red window as the film advances. All this means that the film can be loaded, advanced, and removed much more rapidly. At the outset, only a limited selection of film was available for such cameras, but this situation is improving. The early Instamatic was designed for the amateur market and was not at all costly — from $15 to $25. However, newer models with added refinements are beginning to compete in price with the 35mm camera.

Subminiature Cameras

Many small subminiature cameras — often more like toys or novelties than serious instruments — have been produced over the years. The first well-designed subminiature was the Minox (Fig. 129), which appeared after World War II. Competitors were soon developed, and today there are many subminiature cameras from which to choose. Most of them use 16mm motion-picture film or, like the Minox, have special film cartridges. With such small film, the photographer must exercise unusual care in exposing, developing, and printing the negative. Some professional laboratories have special equipment and employ different techniques to obtain maximum quality from the small negatives, but the quality of the image is still not as high as that produced by larger film. Because of the degree of technical skill required to obtain successful prints, subminiature cameras are not recommended for beginners. The cameras, which range in price from about $50 to $300, are practical when small prints are acceptable or when bulkier equipment cannot be used.

Recently, Eastman Kodak introduced the Pocket Instamatic, a camera so small it fits easily into a shirt or suit pocket. The

129. The Minox,
a subminiature camera.

Kodak Pocket Instamatic yields a 13 × 17mm negative, which is larger than the subminiature size (a Minox negative is 9 × 11mm). Hence, it is not a true subminiature, but it remains smaller than a 35mm camera. Kodak designed the Pocket Instamatic specifically for making color slides or color prints. A specially constructed carousel projector, optically excellent, produces an acceptable image on a screen, and with a newly developed type of color film, Kodacolor II, snapshot-size prints of good quality can be obtained. More recently, a black-and-white film, Verichrome Pan VP 110-12, has been offered for the Pocket Instamatic. The latter is a medium-speed film, since the camera is not adjustable for the variety of speeds found in existing black-and-white film.

Miniature Cameras

The 35mm camera — including the rangefinder, such as the Leica (Fig. 130), and the single-lens reflex, such as the Pentax (Fig. 131) — is so called because it uses 35mm motion-picture film. The small film permits

130. The Leica rangefinder,
a 35mm camera.

131. The Pentax single-lens reflex,
a 35mm camera.

rangefinder method (Figs. 89, 90) or the single-lens reflex adaptation of the ground-glass method (Figs. 92, 93). The first 35mm cameras used the rangefinder, and this is still considered by some to be a faster means of focusing, but much depends upon personal preference. Because this system requires less light to focus, it has an advantage in relatively dark situations, but at the same time, the viewfinder on some inexpensive rangefinder cameras is likely to be small, dark, and difficult to see through. It may also be inaccurate, with a high degree of parallax error. More costly rangefinders, such as the Leica, have a large, bright viewfinder that has been fully corrected for parallax.

The lenses on many 35mm rangefinder cameras are interchangeable, so one can substitute a wide-angle or telephoto lens. The rangefinder is also quieter in operation than the single-lens reflex, because it has fewer moving parts. Moreover, it is cheaper to build and thus lower in cost. Typical prices for the 35mm rangefinder camera vary from about $50 to $500.

The subject is viewed directly through the lens of a single-lens reflex camera. This enables the photographer to bring the composition into focus visually and naturally. One can also determine the visual effect that out-of-focus images or any out-of-focus areas will have. This is important, and it is not possible with rangefinder cameras. On the rangefinder, correct focus must be sought through the use of charts and scales, and out-of-focus effects cannot be predetermined.

Direct viewing through the camera lens makes the single-lens reflex camera ideal for closeup photography — that is, for recording subjects not more than 3 feet away. The rangefinder cannot focus at less than about 3 feet, and the viewfinder is subject to parallax error. Even parallax-corrected viewfinders require special attachments if they are to be accurate at distances smaller than 3 feet. There are certain methods for adapting rangefinder cameras to closeup photography (see pp. 328–330), but they are cumbersome and not very satisfactory.

the camera to be smaller and lighter than others that were in general use at the time it was developed, and also makes financially practical the manufacture of a wide-aperture lens. Thus, one can photograph successfully even in rather dark places. The film is relatively inexpensive and allows 36 exposures per roll. The shutter is cocked automatically as the film is advanced, permitting a rapid succession of exposures. At the same time, vast improvements have been made in the design of enlarging equipment; thus, high-quality print enlargements, which had been unobtainable with earlier equipment, are now possible. All these factors contribute to the popularity of the 35mm camera, and it is perhaps the most widely used instrument today.

There are many 35mm cameras to choose from, at a variety of prices. All employ one of the two focusing systems: either the

The single-lens reflex camera tends to be noisier in operation than the rangefinder, because the mirror changes position prior to each exposure (Fig. 93). This can be a problem whenever the photographer may wish to remain unperceived. In such situations, the quieter rangefinder offers a definite advantage.

Most, but not all, single-lens reflex cameras are equipped to accept interchangeable lenses. However, some models have only two accessory lenses that can be attached to the normal lens for moderate wide-angle and telephoto results. Putting one lens in front of the other is a compromise between quality and economy, and quality often suffers.

Early versions of the single-lens reflex camera tended to be slow in operation and awkward to handle, since they demanded more manual adjustments than rangefinder equipment. Improvements in design have now eliminated this problem. The lowest price for a 35mm single-lens reflex is about $50, the highest approximately $1,000.

Mention should be made also of the *half-frame* 35mm camera, which accepts regular 35mm film but produces twice as many exposures per roll. Each negative is thus half the size of a normal 35mm negative. These cameras are generally quite inexpensive, but the small negative cannot yield very high-quality enlargements.

Many types of film are available for the 35mm camera: a full range of black-and-white, several kinds of color film, and even special film like infrared. Because the film is obtainable on a worldwide basis, the camera is a good choice for travelers. It is also excellent for anyone who wants color slides as the end result of his photographic efforts. The success of color slides—the cheapest and easiest way to enjoy color photography—has popularized the 35mm camera among hobby photographers, although photojournalists and other serious craftsmen have used it extensively.

When high-quality enlargements are desired, the compact 35mm camera presents a problem, for it determines that the negative must be small, and in general the

132. The Rolleiflex,
a twin- or double-lens
reflex camera for 120 film.

sharpness and quality of an enlargement are products of the negative. Therefore, the 35mm negative must be exposed and processed with care. Any technical error will be magnified and readily visible in the enlargement, which could effectively destroy the quality of the finished work.

Cameras Using 120 Film

Certain models of both the twin-lens reflex and the single-lens reflex cameras are designed to accept 120 film. In both, the negative produced is $2\frac{1}{4}$ inches square, a size that yields quality enlargements. A full range of black-and-white and color films are available, but the color film intended for making slides is considerably more expensive than that for the 35mm camera. The projector suitable for $2\frac{1}{4}$ slides is also costly.

The twin-lens reflex is a very dependable camera (Fig. 132). Its mechanism is sim-

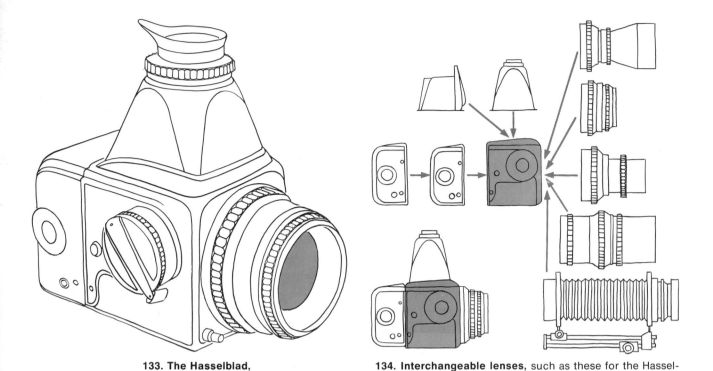

133. The Hasselblad,
a single-lens reflex camera for 120 film.

134. Interchangeable lenses, such as these for the Hasselblad, increase the versatility of a camera.

ple to understand and convenient to operate. The camera is versatile but not overly expensive, which makes it a good choice for beginners. One disadvantage is the reversed image that appears on the ground-glass viewing screen (Fig. 95). Also, since the camera has two lenses, a human subject often looks into the focusing lens, rather than the exposing lens, which gives the portrait image a curious, faraway expression.

Twin-lens reflex cameras were originally designed in Germany, but many are now made in Japan. The Japanese models—Yashica and Minolta—are much cheaper than the German ones, their prices ranging from $60 to $150. German Rolleicord and Rolleiflex models are priced from $180 to $580. Despite this difference, many Japanese products are of excellent quality.

A major drawback in most types of twin-lens reflex cameras is that the lens cannot be removed; the photographer is limited to working with a standard lens. Two exceptions are specific models of the Rolleiflex and the Mamiyaflex. The Tele-Rolleiflex,

costing approximately $650, has a fixed telephoto lens, which means, of course, that the photographer would need a second camera—and both would be expensive. The Mamiyaflex is equipped with seven interchangeable lenses, ranging in type from wide-angle to telephoto. With a normal focal-length lens, it costs about $400.

The most versatile of all roll-film cameras is the single-lens reflex (Fig. 133), of which there are many types. Some are inexpensive but rather poorly designed and mechanically troublesome. The Japanese Bronica, the Swedish Hasselblad, and the German Rolleiflex SL66 are expensive—from $375 to $995—but they are instruments of superior quality. These are similar to the 35mm single-lens camera, with one important exception: they are equipped with a special film magazine that can generally be removed from the camera when the film is only partly exposed, without damaging the film. Later, the magazine can be reinserted and the rest of the film exposed. This feature proves particularly use-

ful when the photographer is using black-and-white and color films alternately in the same camera. Single-lens reflex cameras also have interchangeable lenses. Figure 134 suggests the versatility of a Hasselblad, but the Bronica and Rollei are equally flexible.

With a single-lens reflex camera it is possible to identify on the viewing screen the *depth of field*—that is, the area of a scene, from foreground to background, that will be sharp in the final photograph (see Chap. 7). This is another advantage over the twin-lens reflex, in which depth of field must be determined by reference to a depth-of-field scale, since it is impossible to actually see what in-focus and out-of-focus sections will look like.

View Cameras

The view camera was the earliest type of camera made. Even today, it differs very little from the camera obscura (Fig. 2). This large, heavy camera (Fig. 135) requires a tripod. Its lens is removable, so one can substitute various special-effect lenses. The film is loaded into holders, each accommodating two sheets of film, and common film sizes are 4 × 5, 5 × 7, and 8 × 10 inches. An 8 × 10 print, contact-printed from an 8 × 10 negative, represents the ultimate in quality, since nothing is lost in enlargement. Adjustments on the view camera (see pp. 334–336) permit the photographer to control perspective and depth of field, an advantage one does not have in miniature cameras. The view camera is therefore adaptable to many commercial uses. View cameras are priced from about $125 for a 4 × 5 Calumet to more than $1000 for an 8 × 10 Sinar.

Press Cameras

The press camera (Fig. 136) is a 4 × 5 semi-portable view camera once much used by newspaper photographers. It often has a flash gun or electronic strobe unit for indoor shots. This camera is rapidly being replaced by the 35mm and the twin-lens reflex.

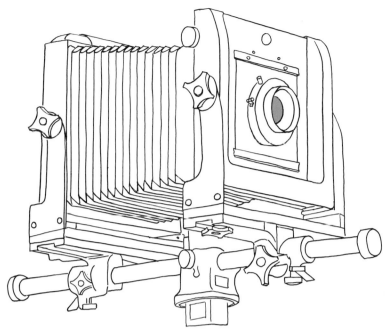

135. A view camera.

136. A press camera.

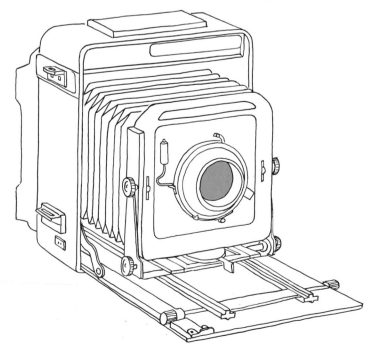

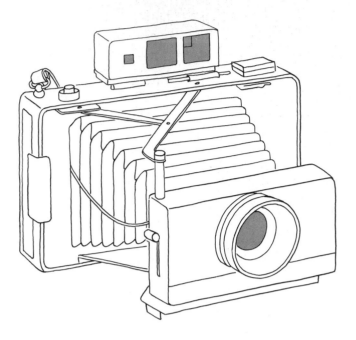

that both develops and fixes the image in a single operation—is squeezed out by the rollers and spread evenly between film and paper. The whole process requires only a few seconds. Finally, the print is stripped from the negative and coated with a special applicator that helps to make the image permanent.

The most recent innovation from Polaroid is the SX-70, which actually develops the print *outside* the camera. Immediately after exposure, the camera automatically ejects a 17-layer self-developing print, on which the image gradually emerges over a period of about 10 minutes. A special protective coating prevents light from damaging the print during the developing process. There is no negative, and the photographer need not wait between exposures for the image to be developed.

Polaroid cameras are priced from about $15 to almost $300, depending on the sophistication of a particular model. Both black-and-white and color film are available, although some models use only color film. Polaroid has also introduced an improved film holder, called the Polaroid 545 Land Film Holder. It costs about $60 and can be used in the 4 × 5 sheet-film camera. Many types of film are available for this holder, including fine-grain film, high-contrast film, and extra-fast film. The possibilities offered by such variety appeal to both the amateur and the professional, especially to those involved in scientific documentation.

The major drawback to the Polaroid process is that duplicates or additional prints of a given exposure cannot be made easily. The original must be rephotographed, which is both costly and detrimental to quality. However, a printable negative can be obtained by using a Polaroid 545 Land Film Holder with a specific type of film, 55 P/N.

The instantaneous nature of the Polaroid process does not mean that it produces second-rate photographs. On the contrary, the black-and-white prints are rich in value and have a full range of tones, while the color is pleasant, soft, and subtle (Fig. 698).

Polaroid Cameras

The Polaroid process, introduced in 1947, initiated a new concept in photography. Because the negative is developed right in the camera, the photographer can see the results of his efforts almost immediately, without having to wait for darkroom processing.

Polaroid cameras (Fig. 137) are in a category by themselves, and they require special types of film. The earliest models employed roll film, but this proved awkward in loading. More recently, a film pack containing sheets of film has been adopted. Each sheet has a protruding tab which, when pulled, initiates development of the exposed film and moves the next sheet of unexposed film into position. Something of the sophisticated complexity supporting the convenience of the Polaroid system can be seen in Figures 696 and 697.

Polaroid film is in two parts: the film proper and a sheet of specially prepared paper. As the tab is pulled, the film is brought into contact with the paper and is passed with it between two rollers. A monobath-type developing agent—that is, one

Special Purpose Cameras

A *stereo camera* produces an illusion of the third dimension. It is really two cameras in one, for two lenses, mounted side by side much like a pair of human eyes, are linked to operate in unison. The resultant double image is blended into one by a special viewer, and the effect is strikingly three-dimensional. Stereo photography was much in vogue many years ago, but since special viewers were required, the process did not continue to develop. Today, stereo cameras are available for either 35mm or 120 roll film. The Stereo Realist (Fig. 138), which yields 28 stereo pairs for each loading of 35mm film, is priced at about $300.

The *panoramic camera* was introduced as a special device to photograph broad views or large groups of people. The lens was mounted to swing from side to side during exposure, and focal distortion was compensated for by setting the film against a curved surface. Modern versions of the panoramic camera are the Japanese Wide-lux (Fig. 139) and the Russian Horizont, both of which employ wide-angle lenses.

Underwater cameras must, clearly, have moisture-tight containers. Some models are bulky, expensive, and susceptible to leakage. The modern Nikor Nikonos II (Fig. 140) is a small, easily held 35mm camera that can be used under water to a depth of 150 feet. It is moderately priced between $200 and $275. Because visibility under water is generally poor, a 28mm wide-angle lens can be substituted for the normal 35mm lens. In addition to underwater photography, such a camera is practical in any situation when accidental wetting is possible — such as on a canoe trip or in the rain.

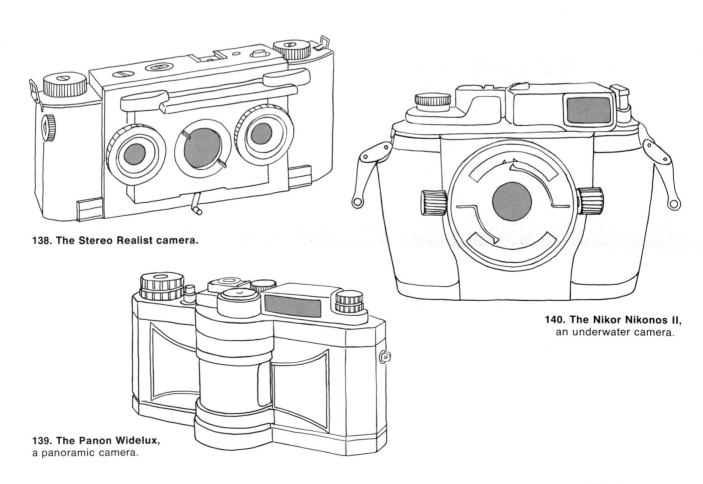

138. The Stereo Realist camera.

139. The Panon Widelux,
a panoramic camera.

140. The Nikor Nikonos II,
an underwater camera.

Camera Accessories

The photographer usually requires four basic accessories: an *exposure meter,* a *lens hood,* a *cable release,* and a *tripod.* The exposure meter (Fig. 141) helps to determine the correct exposure setting by providing a measure of the surrounding brightness. A lens hood prevents extraneous light from striking the lens. A cable release is a flexible shaft for tripping the shutter without touching and possibly jarring the camera. The tripod is a three-legged support that holds the camera still at a fixed position. The latter two devices are essential for long exposures.

In summary, no one camera can fulfill all requirements; each has certain assets and liabilities. Choosing the right camera depends to a large extent on what the camera will have to do. This decision should be governed by consideration of the photographer's abilities and needs, of the end product desired, and, to be sure, of the potential owner's budget. How many wealthy tourists have been observed, pathetically overladen with expensive equipment, going about taking pictures that an Instamatic would produce equally well!

The Instamatic is wholly adequate for black-and-white souvenir snapshots of travels or of people.

For better-quality results, a 35mm camera should be considered. It is lightweight, economical to operate, and quite versatile—ideal for color transparencies or slides. Quality enlargements can be obtained from its negatives if exposure and processing techniques are carefully performed.

When even higher quality is desired, a camera that produces negatives larger than 35mm is indicated. One might choose a camera that uses 120 film, either a twin-lens or a single-lens reflex. However, if the end-product is to be color transparencies, a 35mm camera is probably the better choice, since the projector for $2\frac{1}{4}$ slides is quite expensive.

Following the principle that the larger the negative, the higher the quality of the final print, a view camera gives the best results. But other features of the camera tend to inhibit spontaneity.

A serious photographer may require several cameras, because his needs are so varied. The ultimate in versatility is the possession of a camera that is particularly suited to each situation the photographer is likely to encounter.

Exposure

THE PROPERLY EXPOSED NEGATIVE

Accurate exposure is essential if negatives are to record faithfully the wide range of tones in a scene. About fifty basic and distinct tones of gray can be rendered in a photograph, but the range of tones in nature far exceeds this. For every photograph, then, a choice must be made between tones to be neglected and tones to be emphasized. How well the choice is reflected in the final print depends largely upon how the negative has been exposed.

In a properly exposed negative considerable detail will be recorded in the light (shadow) areas as well as in the dark (highlight) areas. This means that the shadow areas must be adequately exposed, for if they are not, they will show up in the negative as thin in texture and lacking in detail. The finished print will seem dark and featureless. Although a degree of correction for underexposure is possible in printing the negative—by a technique called *dodging* (see pp. 264–266)—no developing tricks can supply details that do not exist in the negative. It is easier to correct for overexposure in the dark, or highlight, areas; rarely is a negative so dark that detail cannot be brought out with such printing techniques as *burning-in* (see pp. 267–272). For maximum detail, therefore, it is better to overexpose—with the shadow areas in mind—than to underexpose, especially since most film in use today has a higher tolerance for overexposure than for underexposure. The old maxim, *Expose for the shadows and develop for the highlights,* remains sound advice. The modern exposure meter helps the photographer to gauge the type of exposure required in a given situation and has become a basic part of his equipment.

EXPOSURE METERS

In the early days of photography there were no exposure meters. Instead, the photographer set up a darkroom close to where he was photographing and developed his negative immediately after each exposure. If it was unsatisfactory, he tried again. He recorded his results and, as the quality of dry plates became more reliable, compiled charts to guide him in new situations. Numerous devices were introduced through the years in an effort to provide a more accurate and consistent method of controlling exposures, but the results were usually disappointing. The present-day exposure meter has largely resolved this problem with great efficiency.

All modern exposure meters function on either a *selenium cell* or a *cadmium sulphide cell* system. When exposed to light, a selenium cell produces an electrical current that is registered by a needle moving across a gauge. The more light there is available, the greater the amount of current, and hence the higher the needle reading. This system is accurate and reliable for most daylight situations.

The cadmium sulfide system (cds) meter is generally more expensive. Based on a more recently developed semiconductor principle, it consists of a small battery that is in a series circuit with a gauge and the cadmium sulfide cell. When light strikes the cadmium sulfide cell, the resistance in the circuit changes and affects the gauge. This type of meter requires a battery, which can wear out, but it is considerably more sensitive to low light than the selenium cell meter.

Among the various types of hand-held exposure meters are *reflected-light meters,* which measure light reflected by the subject; *incident-light meters,* which measure light falling on the subject; and *spot meters,* which measure reflected light from only a small portion of the subject to be photographed. In addition, some cameras contain *built-in meters* capable of automatically adjusting for proper exposure. Meters of all types and qualities are available in many different brands, their prices generally dependent upon relative sensitivity and versatility. Generally speaking, inexpensive meters are adequate for daylight photography but are not sufficiently sensitive for the lower light levels encountered at night or in dark interiors.

141. The exposure meter admits light into a sensitive cell that registers with a needle on a gauge the brightness of a subject or the illumination of its environment and permits the gauge reading to be converted into the shutter speeds required at various f-numbers for the film being used.

a. Reflected light. An opening in the top admits for measurement light reflected in a limited arc from the subject or a small area of the subject.
b. Incident light. Once the spherical "mushroom cap" light diffuser has been slipped to the left so as to cover the light-admission opening, the meter receives and measures light coming toward the subject within a broad 180° arc, which is virtually all the light falling on the subject from the direction of the photographer's position.
c. The ASA speed indicator must be set for the ASA rating of the film that light is being measured for.
d. Light switches, one for a high level of light and one for low light, permit, when pressed, light to enter the meter lens and strike the sensing cell that activates the needle on the measuring gauge.
e. The light scale must be set, by turning the large outer dial, so that the arrow points to the number indicated by the needle on the gauge.
f. Time and f/, or speed and aperture, align on two circular scales at the outer rim of the dial and pair to indicate appropriate combinations of f-stops and shutter speeds capable of producing correct exposure for the light intensity measured. Here the range that can be used, depending upon capability of the individual camera, is from f/32 at 1/2 of a second to f/1.4 at 1/1000 of a second.
g. EV numbers are a system, seldom employed, for rating aperture speed combinations on a scale from 1 through 12.

Elements of Exposure Meters

An instruction manual is issued with most meters and should be read carefully, for although meters are basically similar, the method of operation varies from one type and brand to another. Complete familiarity with a particular meter is essential.

Figure 141 is a diagram of the Gossen Lunasix exposure meter, an instrument suitable for illustration purposes since the procedures for operating it are applicable to other meters. One must first set the *ASA film-speed indicator*. This shows the speed, or sensitivity to light, of the film being used in the camera, according to a uniform rating scale established by the American Standards Association (see p. 162). In order for the reading to be correct, the meter must be set for the appropriate ASA speed of a given film.

The meter illustrated in Figure 141 is adjustable for both reflected-light and incident-light measurement, but it must be set accordingly. An accurate reflected-light reading cannot be made with the meter set for an incident-light reading, nor the other way around.

Assuming the meter has been set to measure reflected light, the photographer would next press one of the two levers on the side of the meter—the high-level switch if conditions are fairly bright, the low-level switch if they are dark. This sets the needle in motion, and it comes to rest at some point along the gauge. In the diagram it has stopped between 15 and 16. The photographer next rotates a dial to set this number in the window marked "scale" at the bottom of the meter. The latter setting causes two scales juxtaposed around the circumference of the meter dial—one marked "time" for shutter speed and the other marked "f/" for aperture—to adjust in relation to one another. The paired numbers of the two scales now align to indicate the various combinations of shutter speed and f-stop numbers that will yield the proper exposure. In the diagram the range is from f/32 at 1/2 of a second to f/1.4 at 1/1000 of a second. Any of the paired combinations will produce the same exposure, the choice

left: 142. Reflected-light measurement is taken from light reflecting off the subject at an angle. It can be measured by a meter pointed toward the subject.

right: 143. Incident-light measurement is taken by pointing the meter away from the subject toward the light source falling from the direction of the camera.

limited by the capability of the particular lens, since none has a full range of f-stop numbers from f/1 to f/90.

The photographer's decision to use a certain combination of shutter speed and f-stop number will depend upon his subject and on the effect he hopes to obtain. For a stopped-action effect on a fast-moving object, he would choose a fast shutter speed — perhaps 1/1000 of a second combined with an f/1.4 setting. A stationary subject could be shot with a slower shutter speed, such as 1/30 of a second with an f/8 setting. The latter combination would also provide greater depth of field — that is, a larger area of the scene in sharp focus (see Chap. 7).

Instead of individual settings for aperture and shutter speed, some cameras employ what is known as the *Exposure Value System,* or *EV*. This method is explained fully on page 98, but it should be pointed out that, for such cameras, a reading is taken from the small window in the exposure meter that is marked "EV Exposure Scale," rather than from the combined time and f-stop scales.

As indicated, some exposure meters are designed to measure light reflected from the subject (Fig. 142), while others are calibrated to measure incident light, or light falling on the subject (Fig. 143). With the addition of certain accessories, some meters can be made to do both, but they are awkward to handle. The meter illustrated in Figure 144 is quite easily converted. One merely slips either the opening for reflected-light readings or the light-diffuser for incident readings over the meter's light-admission opening. Both types of measurement are necessary, for each has advantages in particular situations.

Reflected-Light Meters

Light radiating from the sun or from some artificial source falls on objects that have various degrees of reflectance. A white object will reflect a large percentage of the light, whereas a black object absorbs most of it. These various degrees of reflectance establish the range of tonal values in a scene and are translated in photographic

144. Adjustable meters, like that in Figure 141, permit both reflected light and incident light to be measured. Slipped over the light-admission opening, the reflected-light opening makes possible this type of measurement. The reflected light admitted is from a relatively limited arc; thus, read at close range, the light is from a small area of the subject. The "mushroom cap" of the light diffuser, once slipped over the light-admission opening, allows virtually all the light striking the subject from the camera's direction (incident light) to be measured.

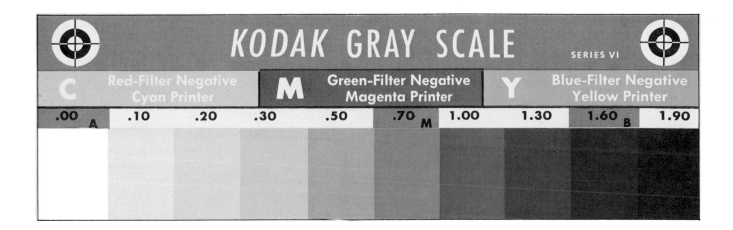

KODAK GRAY SCALE SERIES VI

C	Red-Filter Negative Cyan Printer			M	Green-Filter Negative Magenta Printer		Y	Blue-Filter Negative Yellow Printer		

.00 A	.10	.20	.30	.50	.70 M	1.00	1.30	1.60 B	1.90

terms into various shades of gray, from light to dark. A photographer must relate the tonal values of a scene to this gray scale in order to determine how the scene should be photographed.

For purposes of simplification, the total range of possible shades of gray has been divided into ten standard zones, moving from lighter to darker around a median or average shade (Fig. 145). This median shade has been established as the equivalent in tonal value to an 18 percent degree of reflectance in nature, considered a standard average. An *18 percent gray card* (Fig. 146), reproducing the *average* shade of gray, is available from Eastman Kodak.

A reflected-light meter is designed to measure reflected light in terms of various shades of gray and to determine an exposure that will reproduce these shades of gray in the final print. The accuracy of the meter can be tested, for example, by taking a reading from the 18 percent gray card and then photographing the card according to the exposure data given (Figs. 646, 647). If all variables—such as camera type and the procedures for film development and printing—are fixed, the resultant print should faithfully reproduce the tonal value of the gray card.

In using a reflected-light meter, the photographer must first determine which area, or tonal value, of the scene he wishes to reproduce as an average gray, and then point the meter at this area or at several surrounding points to obtain an average reading. The tonal range of the photograph

above: 145. The Kodak Gray Scale divides the total range of light intensity possible in nature into a value scale of ten zones, moving from lighter to darker around a median or average gray.

below: 146. The Kodak Neutral Test Card, or "18 percent gray card," provides the average shade (18 percent degree of reflectance in nature) on which the gray scale (Fig. 145) has been based. By measuring light reflected from the gray card placed within 6 inches of a subject, the photographer can determine the aperture-speed combinations likely to yield a photograph with good, averaged tonal quality. (See Figs. 646, 647).

will vary from light to dark according to whether it is the dark or the light areas in the scene that the photographer has selected for measurement. Most reflected-light meters read the same area as would a normal lens in the camera, so the photographer can stand near the camera and obtain readings of various values in the scene.

For reflected-light measurements, the meter is pointed carefully at the subject (Fig. 142). In photographing a landscape, for example, one would not direct the meter toward the sky or at an area of maximum reflected light, for this could distort the relationship of tonal values in the rest of the scene. Frequently, a number of readings are taken of various parts of the subject, both brightly illuminated and shaded. The readings thus obtained can be averaged to determine the correct exposure.

Several readings were taken in preparation for making the photograph reproduced in Figure 147. The side of the barn in direct sunlight produced the highest reading (19 on the Lunasix scale), while the grass in the shade gave the lowest (15 on the Lunasix scale). The average was used for exposure, with emphasis on "exposing for the shadows." Of course, the photographer had to verify that the film in his camera was capable of accommodating the range of tones his meter recorded. Modern black-and-white films have an exposure latitude of four f-stop numbers. As long as the meter reading falls within this range, satisfactory exposure is possible. Some meters indicate the range on the scale by a

147. Reflected light measured in a landscape. The numbers superimposed on the image represent reflected-light readings taken on the Lunasix scale from various areas of the scene. An average of the extreme readings was used to make the photograph.

letter U for the underexposure limit and the letter O for the overexposure limit.

Why should it be necessary to take an averaged reading when one can be had merely by referring to a gray card? The reason is that averaged tonality cannot really be standardized. Different factors in different situations affect it, and the averaged reading from a scene could be higher or lower than the average indicated by the gray card.

The errors most commonly made in using a reflected-light meter occur when pointing the meter, for it can read only what it is pointed at. Often, the inexperienced photographer aims the meter too high, at the sky in a landscape, for instance, rather than at the ground. As a result, the ground area appears underexposed and lacking in detail. This point can be demonstrated in the photographs reproduced as Figures 148 and 149. The negative for Figure 148 was exposed according to a reading obtained by pointing the exposure meter at the sky. It reveals little more than a silhouette; all detail in the ground area is lost, except for the strong highlights on the cow's back. By contrast, the negative for Figure 149 was exposed according to a reading obtained by aiming the meter at the ground. There is a full range of tones, and the cow in the field is sharply rendered.

Because the meter reading for exposure was taken from a very bright tonal value—the sky—the negative for Figure 148 was underexposed. But meters are designed to read gray. A reading from a source brighter than an average gray will produce an underexposed film, and one from a source darker than an average gray the reverse. In this case, the exposure meter, when pointed at the sky, indicated an exposure of f/22 at 1/500 of a second; when pointed at the ground, the reading was f/11 at 1/125 of a second. The difference between the two is four f-stop numbers, and this is also the difference between the gray of the standard gray card and a clear sky. In Figure 149 the tonal value of the grass and the cow is approximately that of a gray card, showing that the negative used to produce that print was properly exposed.

top: 148. A reflected-light meter pointed at the sky resulted in this seriously underexposed photograph.

above: 149. A reflected-light meter aimed at the ground made possible the good tonal range of this photograph.

The photographer must exercise special care when taking a reading from a subject that is small in size and surrounded by a large area of a contrasting tonal value. The photographs reproduced as Figures 150 to 152 provide an example. The subject is a man dressed in black standing against a white wall. For Figure 150 the meter was pointed at the subject from the position of the camera. Light reflected off the wall influenced the reading and caused the negative to be underexposed, so the print is dark and lacks detail in the shadow areas. The reading for Figure 151 was made from the black figure. This print is considerably lighter—in fact, too light, for it seems washed out. A compromise made the negative for Figure 152, which was exposed on the basis of averaged readings taken from a point near the white wall and another near the black figure. The resultant print shows detail in both light and dark areas.

All three negatives were printed on the same brand of paper of the same contrast grade, and each was exposed and developed for a standard length of time. Such consistency is necessary in order to demonstrate the effects produced by different meter readings. Obviously, the most satisfactory print is that of Figure 152, where the meter's diagnosis for exposure was based on correct information—an averaged reading. For Figure 150 the meter was made to interpret the white wall, which is consid-

153–155. A brilliant subject in a dark environment must be photographed from an average of reflected-light readings.

right: 153. A reflected-light meter aimed at the brilliant subject caused loss of detail and general light grayness characteristic of prints made from overexposed negatives.

right center: 154. Longer exposure for a print made from the overexposed negative in Figure 153 resulted in an acceptable photograph. An overexposed negative is more correctable in the printing process than an underexposed negative.

bottom: 155. Averaged readings of light reflected from both black and white areas produced a photograph scarcely distinguishable from that in Figure 154 except for slightly more detail in the white dress and somewhat less grain overall.

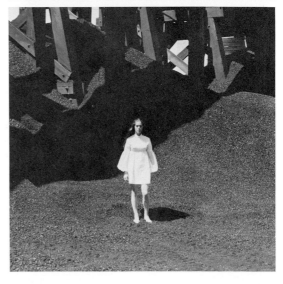

erably brighter than a gray card and therefore has a tonality higher than average. But the meter saw the wall as gray and indicated an exposure accordingly. Similarly, for Figure 151 the black figure is rendered as an average gray. Theoretically, in the photographs of the cow (Figs. 148, 149), the sky in the first print (Fig. 148) should have been recorded as gray, but the effect would have been odd, and a correction was made in printing the negative.

As these illustrations demonstrate, an exposure meter must have the benefit of proper information if it is to provide correct exposure data. The prints reproduced in Figures 150 and 151 are unsatisfactory not because a white wall dominated the scene but because the person using the meter failed to understand fully its requirements and to feed it the information it needed.

In the photographs reproduced as Figures 153 to 155, the variables have been changed. The subject here is a woman dressed in white standing against a dark background. Pointing the meter at the white subject produced an overexposed negative (Fig. 153), with no detail in the white areas. The coal on the ground appears too light, and the print has an overall light gray quality. Figure 154 was made from the same negative, but it was given a considerably longer exposure time in the printing process. The negative for Figure 155 was exposed on the basis of averaged readings

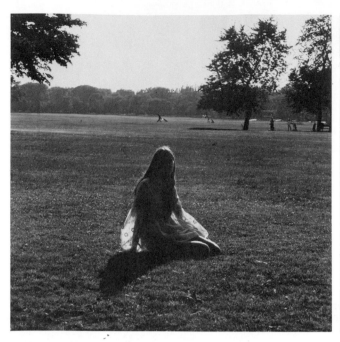
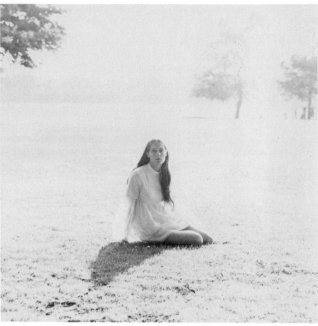

156–159. Knowledgeable use of the reflected-light meter can yield effective pictures photographed under conditions of extreme contrast in light. Back lighting in portraiture offers such an opportunity.

left: 156. Measuring light reflected from the background reproduced the figure as a mere silhouette.

right: 157. Measuring light reflected from the subject's face set the well-defined figure off against a featureless background.

taken from both black and white areas in this scene of extreme contrasts.

The differences among these prints are not really distinguishable in reproduction, but in fact the white areas of the print in Figure 154 show somewhat less detail, the overexposure of the negative having obscured much of it. Upon close examination this print also has slightly more grain than the print of Figure 155. Increasing the exposure time in printing the negative required some additional time, effort, and care, as well as a glass negative-carrier to keep the negative from buckling during the exposure. But this inconvenience, along with a slight loss of detail and an increased graininess, is relatively minor compared to the total failure of turning out a worthless photograph, which was the case in Figure 153. Thus, we can conclude that overexposure is generally a less serious error than underexposure, and that the exposure meter

must be used at all times in a knowledgeable manner.

Other situations require as careful a meter reading as the extremes of contrast just described. An example is portrait photography. The technique of lighting a subject from behind can be very effective, for the soft-light quality of a face in shadow is attractive, and furthermore the sitter has no need to squint. But in order to obtain the desired effect, one must plan the exposure with care. This principle is illustrated by the series of photographs in Figures 156 to 159. In making the first picture (Fig. 156), the exposure meter was pointed at the background, with the result that the figure is recorded as a mere silhouette. Details of the face are lost, because the whole face area is underexposed. Next, the photographer took a reading from the face, to produce the image in Figure 157. Here, the face and figure are clearly defined and

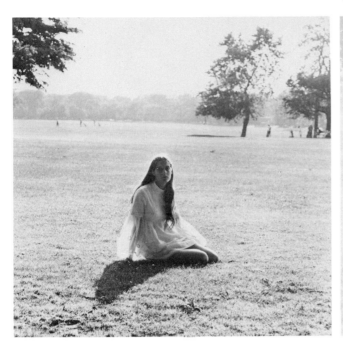

left: 158. Averaging reflected-light readings taken from the face and the background produced the most successful print in this series.

right: 159. A lighter print made from the underexposed negative used for Figure 156 reduced tonal contrast between figure and background but provided an unacceptably light print. Thus, as a comparison of Figures 154 and 159 reveals, an underexposed negative is less correctable in the printing process than an overexposed negative.

have a pleasing tonal quality, but they are set off in sharp contrast against a rather featureless background. As a compromise between the two extremes, the readings from face and background were then averaged, and these data were used in making the exposure for Figure 158. Clearly, this is the most successful print of the series. The difference in value between the flesh tones and an 18 percent gray was slight, so the exposure meter could be used to take direct readings from the face.

One further attempt was made to reconcile the difference in tonal value between the figure and the background in this particular image. From the underexposed negative used to print the image in Figure 156 the photographer made a much lighter print, and the results are reproduced in Figure 159. This technique obviously failed; the print lacks both a proper range of tones and the soft quality demonstrated by Figure

158. One can readily see from this series of illustrations that the tonal quality of a print depends primarily upon the exposure and not upon darkroom procedures.

Incident-Light Meters

The incident-light meter measures the intensity of light falling on a subject. Unlike the reflected-light meter, it is pointed *away* from the subject (Fig. 143) and toward the camera. This means that light striking the exposure meter is the same as that striking the subject.

With a reflected-light meter, direct light enters the light-admission opening to strike the light-sensing cell in much the same way as light enters a normal camera lens. However, the incident-light meter is equipped with a shell-like diffuser over the meter opening (Fig. 144, right), which diffuses light as it passes to the sensing cell, just as

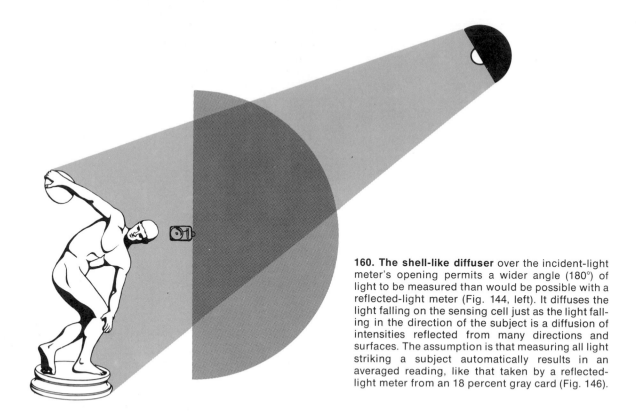

160. The shell-like diffuser over the incident-light meter's opening permits a wider angle (180°) of light to be measured than would be possible with a reflected-light meter (Fig. 144, left). It diffuses the light falling on the sensing cell just as the light falling in the direction of the subject is a diffusion of intensities reflected from many directions and surfaces. The assumption is that measuring all light striking a subject automatically results in an averaged reading, like that taken by a reflected-light meter from an 18 percent gray card (Fig. 146).

light falling on the subject is diffused. This device enables the photographer to measure a wider angle of light than he could with a reflected-light meter. With the incident-light meter, all the light falling on a subject from the direction of the camera is measured (Fig. 160). The assumption is that the varying degrees of light reflected from different areas and objects in the scene will average out, and the reading obtained will be equivalent to that taken by a reflected-light meter from an 18 percent gray card. Thus, incident-light readings always represent an average.

The incident method of measuring light originated in color motion-picture work, where an average exposure generally is required. It can also be employed for commercial black-and-white photography, general color photography, or product photography, and is especially useful for copying. The procedure for obtaining an incident-light reading differs considerably from the measurement of reflected light, because the light-receiving element in the meter—the

light-diffuser—must receive the same quality of light as the subject. The following principles govern the use of an incident-light meter:

1. The meter should be held close to the subject and directed toward the camera (Fig. 143), so that light strikes the diffuser in the same way that it strikes the subject. A light-diffuser directed toward the subject would clearly report inaccurate data.
2. Light striking the diffuser must be of the same intensity as that falling on the subject. A reading taken from a subject to be photographed in sunlight, for example, must be obtained in sunlight.
3. A partially shaded subject requires that the light-diffuser be held half in shade and half in light in order for the meter to yield an average reading.
4. If the subject is lighted from the back, the light-diffuser must be held in the shadow of the subject and pointed toward the camera.

The incident-light method permits a photographer to take an average reading from subjects that are often difficult to read by the reflected-light system. For instance, beaches and snow scenes are bright in value, with light tones predominating. They nearly always include portions of average or darker-than-average tonality as well, but because the light tones overwhelm, the reflected-light meter cannot easily take an average reading. In this case, the incident-light meter would be more efficient.

On the other hand, the average reading from an incident-light meter is of little value in determining exposure for extremes on the tonal scale—that is, for objects that reflect a great deal of light (very bright) or objects that absorb most of it (very dark). In such cases, one can often compensate for the meter's limitations by arbitrarily adjusting the aperture. For extremely bright subjects it is usually enough to decrease the exposure by half an f-stop or a full f-stop. Dark subjects, such as dark bronze sculpture, are even more of a problem, because it is difficult to estimate the number of f-stops by which the exposure should be increased. Thus, dark subjects are more easily read with a reflected-light meter.

Built-in Meters

Many cameras have built-in metering systems that enable the photographer to determine proper exposure in a way that is accurate, fast, and more convenient than using a hand-held meter. Such cameras are very popular and are available in a fairly wide price range. Some built-in meters are fully automatic in determining exposure data; others are only partially so.

Automatic Meters A built-in exposure meter reads reflected light from the same area of a scene that affects the camera lens. As the camera is pointed at objects or areas that reflect varying degrees of light, the meter measures the light, and a small motor attached to it automatically adjusts the aperture size and the shutter speed. For anyone confused by, or unable to co-

ordinate, the functions of aperture and shutter, this is indeed a blessing.

The automatic meter is quite adequate for ordinary situations, but it does not always guarantee an accurate exposure. For example, if the subject is a person dressed in black standing in front of a large white area, the white will be overexposed in the negative. The opposite will obtain if the situation is reversed—a subject dressed in white placed against a dark background. Similarly, in photographing a landscape, the photographer may wish to point the camera at the sky, but the meter should be directed downward in order to obtain adequate exposure of the ground areas. Such divergent conditions are impossible to reconcile unless the automatic exposure settings can be corrected manually.

There are many ways of compensating for the deficiencies of an automatic exposure meter, the methods depending upon the make of camera and the particular controls with which it is equipped. Some cameras have a "hold" button, which, when pressed, will maintain an exposure reading even though the photographer changes his position. Other models can be switched from automatic to manual control. One can also modify the exposure by setting the meter for a different ASA rating than that of the film actually in use. If more exposure is required, the meter is set for a lower ASA rating; if less, a higher rating. Sometimes the exposure can be adjusted by setting the camera for flash bulbs. In certain models of the Instamatic, a flash-bulb setting changes the shutter speed from 1/90 to 1/45 of a second. The picture is taken by simply inserting a burned-out bulb in the flash reflector.

Semiautomatic Meters Many 35mm single-lens reflex cameras have built-in metering systems that are partially automatic. With this type of equipment, an exposure-indicator needle and a reference point—possibly another needle—are visible through the viewfinder. Depending on the camera, they may be located either at the top or at the side of the picture area. To control the

161–167. Exposure meters built into cameras permit accurate, fast, and convenient measurement of light intensity. Such metering systems can be either automatic (in which a small motor adjusts the aperture and shutter speed) or semiautomatic, like the averaging, center-weighted, and spot meters illustrated in this series.

left: 161. A landscape subject suitable to be photographed by using the built-in metering systems illustrated in Figures 162–167.

exposure, the photographer manually adjusts the aperture size or the shutter speed until the exposure-indicator needle is lined up with the reference point. The design of semiautomatic metering systems varies from manufacturer to manufacturer, but there are three basic types: the *averaging meter,* the *center-weighted meter,* and the *spot meter.*

An averaging meter has two cds cells located one on either side of the eyepiece. Both are focused on light entering the camera through the lens, and each cell measures light reflected from one-half the picture area. A linkage between the cells automatically averages the two readings.

A center-weighted meter also employs two cds cells, but in this case they are focused in such a way that the areas read by each overlap. This design was developed on the assumption that most photographers tend to place their principal subject matter near the center of the composition, and that this region should therefore be given priority in determining proper exposure.

The spot meter has only one cds cell, which measures light reflected from a limited area of a scene.

Any of these semiautomatic meters can produce a satisfactory exposure reading under conditions of normal light contrast. However, when the subject to be photographed presents a marked contrast between light and dark areas, special care must be exercised. Figures 162 to 167 illustrate how the various meters could be used to make the photograph in Figure 161.

Figure 162 shows the portion of the scene hypothetically read by the twin cds cells of an averaging meter. The resultant negative would be underexposed, because the cells are reading more sky than ground. To correct for this, the photographer has only to point the meter lower (Fig. 163).

A center-weighted meter pointed at the same scene (Fig. 164) would compound the trouble, because the area of concentration is doubly sensitive. Therefore, the negative would exhibit a greater degree of underexposure. Again, a more accurate exposure reading would be obtained by aiming the meter at a lower point to include more of the ground (Fig. 165).

The least accurate reading would be obtained by directing a spot meter at the sky (Fig. 166), because this type of instrument records only a small portion of the scene. Since the meter reads a portion of the composition consisting almost entirely of sky, the print would be badly underexposed. As in the previous two cases, the problem is corrected by aiming the meter somewhat lower (Fig. 167).

The various situations just described are simplified because the barn featured in the photograph is precisely in the center of the composition. However, if the photographer had intended that the barn be off to one side of the composition, he would have had to direct the meter either to the left or to the right, as well as down. It is most impor-

below: 162. The twin cells of an averaging meter would, because aimed at the sky, result in an underexposed negative.

center: 163. Pointing the twin-cell averaging meter lower corrects Figure 162.

bottom: 164. The center-weighted meter has twin cells that overlap in focus. Aimed at the sky, this double sensitivity would produce still more extreme underexposure.

top: 165. Aiming the center-weighted meter lower could solve the problem in Figure 164.

center: 166. The spot meter reads only a small portion of a scene; measuring here solely the light intensity of the sky, it would produce a badly overexposed negative.

above: 167. Pointing the spot meter lower could yield a more representative reading of the tonal range in a scene.

tant to keep in mind the special characteristics of one's equipment in taking any light-meter reading.

Spot Meters

In addition to the semiautomatic spot meters that are built into a 35mm camera, there are hand-held varieties similar to the reflected-light and incident-light meters. This type of spot meter, too, reads light reflected from a subject or scene, but only from a small portion thereof. Most reflected-light meters can read over an angle of about 40 degrees; by contrast, the spot meter angle may be 10 degrees, 3 degrees, or even 1 degree. The advantage of this extremely narrow angle is that small, key areas of a scene—a patch of snow, shadow areas of rocks, rocks in sunlight—can be singled out for special measurement so that the exposure will give these elements the desired emphasis. Moreover, the spot meter is well adapted to reading distant objects that cannot be physically approached for closeup measurement. In order to determine the best exposure, the photographer would average readings obtained from several objects. A spot meter is a specialized piece of equipment and is rather expensive.

Because the spot meter focuses on such a small area, the photographer's aim is critical. Some meters are equipped with an eyepiece to encourage precision. As the photographer looks through it, he sees a magnified image of the field read by the meter, with a circle inscribed in the center. He then redirects the meter until the particular area to be measured falls within the circle. After setting the meter for the ASA rating of his film, he opens the meter, and the various possible aperture and shutter-speed combinations are automatically aligned along the meter's outer dials.

Extinction Exposure Meters

The extinction meter is less sophisticated than the types previously described, because its method of reading is visual. To operate such a meter, the photographer points it toward his subject and looks through the meter, whereupon he sees a series of letters on a scale of different values from light to dark. The letter in the darkest value that is still readable is matched to the ASA rating of the film, and a scale provides a selection of aperture and shutter-speed combinations. Extinction meters are relatively cheap, but since they do not take into consideration the subjective difference in individual eyes, they are not very accurate. Two different people can obtain quite dissimilar readings under the same circumstances. The extinction meter has generally been replaced by the more reliable photoelectric exposure meter.

EXPOSURE VALUE SYSTEM

The Exposure Value System simplifies the determination of aperture size and shutter-speed combination, because it combines the f-stop number and the shutter speed into a single unit, ranging from 2 to 18. Under this system, 2 is a low reading, and each successive number provides half the exposure of the previous one. For example, EV 9 (Exposure Value 9) provides twice the exposure of EV 10. Most exposure meters have an EV scale in addition to the dual f-number and shutter-speed scales. After an exposure reading is taken, the camera can be set accordingly. The subject must be analyzed to determine whether a fast shutter speed or great depth of field is required. Because the shutter speed and the f-stop are cross-coupled, any change in one automatically changes the other.

EXPOSURE CHARTS

Charts cannot substitute for the exposure meter, and the photographer should not rely on them exclusively. However, in the absence of a meter, such charts can serve as guides to reasonably accurate exposure.

Outdoor Exposures

Table 4.1 provides a list of suggestions for estimating outdoor exposures. It recom-

Table 4.1 Suggested aperture and shutter-speed settings for outdoor exposures

Film	Bright sun, beach, snow	Bright sun, strong shadows	Light overcast, no shadows	Heavy overcast, open shade	Deep shade
Eastman Kodak film					
Pan.-X (32 ASA)	f/16 1/60	f/11 1/60	f/8 1/30	f/5.6 1/30	f/4 1/30
Ver.Pan (125 ASA)	f/16 1/250	f/11 1/250	f/8 1/125	f/8 1/60	f/5.6 1/60
Plus-X Pan (125 ASA)	f/16 1/250	f/11 1/250	f/8 1/125	f/8 1/60	f/5.6 1/60
Tri-X Pan (400 ASA)	f/22 1/500	f/22 1/250	f/8-11 1/250	f/8 1/125	f/5.6 1/125
GAF (Ansco) film					
Versapan (125 ASA)	f/16 1/250	f/11 1/250	f/8 1/125	f/8 1/160	f/5.6 1/30
125 B&W (125 ASA)	f/16 1/250	f/11 1/250	f/8 1/125	f/8 1/60	f/5.6 1/30
Super Hypan (500 ASA)	f/22 1/500	f/16 1/500	f/11 1/250	f/11 1/125	f/8 1/125

mends settings for an adjustable camera using different film speeds and under varying conditions. The lighting situations indicated refer to the brightness of illumination from the sun. However, one is nearly always confronted with a mixture of lighting conditions, since bright, average, and dark areas reflect light in varying degrees. In most cases, the light reflections can be thought of as an average. Notable exceptions would be very dark subjects, which require maximum exposure, or very light ones in light surroundings, which call for minimum exposure. The accuracy of the chart depends upon the degree to which existing conditions correspond to the examples. Fortunately, the exposure latitude of modern black-and-white film helps to reduce the margin of possible error.

Indoor and Nighttime Exposures

Table 4.2 suggests a number of exposure settings for certain indoor and nighttime situations. It should be noted that these suggestions are intended only as points of departure, for lighting and other factors vary so much under these conditions that it is impossible to estimate exposure settings with any precision. The use of Tri-X or GAF (Ansco) Super Hypan film is recommended.

When the accuracy of a suggested exposure setting is in doubt, the photographer can increase his chances of achieving a

Table 4.2 Exposure settings for dark scenes

Subject matter	F-stop	Shutter speed
Boxing, wrestling ringside	f/5.6	1/125
Movie marquees, neon signs	f/8	1/30
Campfires	f/5.6	1/60
Television, bright picture	f/5.6	1/30
Store windows	f/5.6	1/30
Brightly lighted interiors, offices, restaurants, etc.	f/5.6	1/30
Main Street, very bright	f/4	1/30
Wet streets	f/4	1/30
Flood-lighted buildings	f/16	1 sec.
Fireworks	f/16	1 sec.
Rainy night	f/11	4 sec.
Snowy night	f/11	15 sec.
Skylines	f/8	10 sec.
Landscape, full moon	f/8	1 min.
Landscape, snow	f/11	1 min.

good exposure by a method known as *bracketing*. After one negative has been exposed at the recommended setting, a second is made at twice the exposure and a third at half. The results will indicate whether more or less exposure than the suggested setting may be required. Sometimes an even more drastic bracketing range is necessary. The cost of the extra film is really secondary to the goal of obtaining a properly exposed negative.

TIME EXPOSURES

For time exposures the camera must be held absolutely still. It is usually mounted on a tripod for any exposure longer than 1/30 of a second, but if a tripod is not available, an improvised support—such as a fence, a tree, or a chair—can be used.

A cable release is another requirement for time exposures. If the shutter-release control is operated manually, any slight movement of the hand can jar the camera. A flexible cable release, extending between hand and camera, eliminates this hazard. Cable releases are inexpensive and easily adapted to most cameras.

Because few cameras permit a T (time) setting, pressure on the shutter release control must be both exerted and released by hand. If the time exposure is prolonged, there is a tendency to relax or change the position of the fingers, causing the shutter to close prematurely. To avoid this, many cable releases are equipped with locking devices.

RECIPROCITY FAILURE

The sensitivity of film to exposure, and therefore its ability to record differences in exposure, diminishes after a certain period of time, generally in low-light situations that call for long exposures. This phenomenon is called *reciprocity failure*. Under normal circumstances, an increase in exposure will produce a proportionately darker value in the negative. After a certain period of time, however—generally about one second—the degree to which the negative values darken diminishes slightly.

Exposure-meter scales do not take this factor into account. Consequently, *reciprocity failure factors* (or *RF factors*) have been worked out for each type of film, indicating the amount by which shutter speeds, as determined by the meter, must be multiplied to obtain proper exposure. For example, if the RF factor of a certain type of film is 4 at an indicated shutter speed of 30 seconds, the shutter speed must be set for 4 times 30 seconds, or 120 seconds, in order to produce a satisfactory negative. Information on the RF factor of all types of film is available from the manufacturer. However, for most black-and-white film, RF factors can be used as follows: shutter speed 1 to 2 seconds, RF factor 1.4; shutter speed from 2 to 6 seconds, RF factor 2.0; shutter speed from 6 to 16 seconds, RF factor 2.8; shutter speed from 16 to 35 seconds, RF factor 4. Failure to take reciprocity failure into account results in an underexposed negative.

Light

CHARACTERISTICS OF LIGHT

The very term *photography* derives from two Greek words that together mean "to draw by light." Not only does all photography depend upon light, photography is, in addition, an excellent medium for demonstrating that light can be described as both a form of energy and a form of matter.

Energy and Matter

Light has been defined as energy making visible those bodies that produce it (Fig. 168). As energy, light is the visible part of the electromagnetic spectrum whose wavelike pulsations, emitted by the sun, are received at one polar extreme as X rays and gamma rays and at the other as radio waves. What distinguishes each type of energy is its wavelength. Generally halfway between the X rays and gamma rays, which at .00000000004 inch are the shortest, and the radio waves, measuring as much as 6 miles in length, can be found those energy wavelengths that are visible to the human eye and have been termed *light* (Fig. 579). These range from .000016 inch for blue-violet to .000028 inch for red. Shorter waves immediately adjacent to those in the visible spectrum are *ultraviolet;* the longer

above: 168. Light is energy making visible the bodies that produce it. IRVIN L. OAKES. *Sunset Time in Ohio.* Photo Researchers, New York.

ones on the other side of the visible spectrum are *infrared.*

As matter, light consists of particles called *photons.* The differences between light and matter can be seen as one of the dominance of either wave characteristics or particle characteristics (Fig. 169). It is thought that while particles characterize matter, its wave characteristics can be discerned under certain special conditions. Because in light the dominance is reversed, light traditionally has been defined as energy. In photography, we are mostly concerned with the wave, or energy, aspect of light (Fig. 170), but there are instances in which light does in fact behave more like a particle. For example, in reacting with photographic film, light as a photon strikes a molecule of silver bromide or silver iodide and, disrupting it, causes the exposure to be made (Figs. 288, 289).

Principles of Light

Light enables us to see; it is by the same light that film is exposed. However, the record provided on film is not always what the photographer has perceived through the camera. This is because film has neither the same light sensitivity as the human retina nor the interpretive power of the human brain to develop optical signals into a complete experience of seeing. An example familiar to almost any photographer is a color transparency that has been made indoors, under conditions of artificial light from a tungsten source, with outdoor type film, whose emulsion assumed the conditions of natural light. Such a transparency almost inevitably appears too "hot," tinged all over with red (Fig. 609). The explanation is that the color film recorded what was actually there, an environment affected by a light source with a higher proportion of red in it than could be found in natural daylight. We would not have perceived the red in the scene, for the brain automatically interprets physical evidence to make it understandable according to our conception of what an environment illuminated by white light should look like.

What the photographer needs is a working knowledge of a few basic principles of light and the way it functions in relation to material substances. He must be concerned about the intensity or brightness of the light he is working by (which is a product of the height of the wave crests), its color (created by the length of the waves or the distances between their crests), and the angle at which the light is cast (Figs. 581–583, 613). All these factors are involved when light waves interact with the substance of surfaces, atmosphere, and filters. It is the interaction of light with matter that produces the effects we see in the world and those, frequently different, that the camera records in a photograph.

Light is energy that makes visible those bodies which produce it, and such luminous bodies are the sun, an electric-light filament, and the wick of a lighted lamp (Fig. 168). Light radiates in all directions from

169. The dualistic nature of light. In one respect, light has the nature of waves, like those made by a rope when vibrated (a). In another, light has the nature of particles, like the discrete parcels of energy in bullets emitted by a machine gun (b).

170. Light waves are electromagnetic in that they consist of an electric field and a magnetic field, the direction of whose energy is, in both instances, perpendicular to the direction of the light wave's advance.

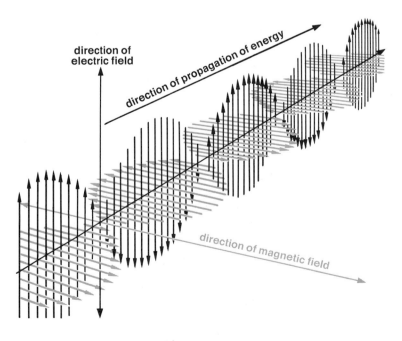

its point of origin. The radiation travels in a straight line from the source, the direction of which can be observed in shadows cast. It is possible also to think of light as the energy that makes visible those bodies which receive and affect light. Illuminated bodies are the moon and virtually any object present in the visible world. These condition light in many ways, according to their different reflectances (white, gray, black), surface characteristics (shiny, smooth, rough), degree of transparency (transparent, translucent, opaque), and color (blue, green, red). Thus, as it strikes matter, light can be reflected, refracted, transmitted, or absorbed.

Light travels in straight lines through a transparent medium. The velocity of light varies according to the density of the medium it passes through. Its velocity is greater in empty space than in air, and greater in air than in water, glass, and other substances more dense than air. As we saw in the chapter on light meters (Chap. 4), the term *incident light* describes light before it reaches an object. Emanating directly from the source, it should be considered white in color; that is, the mix of wavelengths in the visible spectrum that the human eye perceives independently as violet, blue, green, yellow, orange, and red or all together as white. Upon striking matter, this light is inevitably affected by it, in ways that can be described by the illustrations in Figures 171 to 180.

Air in the atmosphere and window glass are considered to be transparent because they *transmit* light by permitting it to pass through them (Fig. 171). Ground or opal glass and tissue paper are translucent because, while allowing light to pass through, they cause it to be scattered or diffused in the process, which is *refraction* (Fig. 172).

Opaque substances do not permit the passage of light and can *reflect* or *absorb* it only. Because white contains the potential for all light and all color, a white surface can reflect approximately 95 percent of the light radiating toward it. If the surface is smooth or highly polished, the angle of incidence and the angle of reflection are equal (Fig. 173). The reflected light is therefore *directional;* that is, it maintains in direct order, but in the opposite direction, the path taken by the incident light to the point of deflection and pursues in reflection the character of the striking light. Light that is reflected "regularly," as from mirrors or highly polished surfaces, is also called *specular reflection*.

A smooth gray surface, such as the Kodak Neutral Gray Card often used with a reflected-light meter to obtain average readings (Fig. 146), reflects approximately 18 percent of the light striking it (Fig. 174). The light reflected has been reduced in proportion to the amount of black added to white to make gray. Black does not have the property to reflect light; therefore, it absorbs both light and color. Because the surface is relatively shiny, like that in Figure 173, the angle of incidence and the angle of reflection are the same.

Black does not have the property to reflect light and color, and a black surface absorbs almost all of any light that may fall upon it. However, it reflects enough light to permit the texture of the surface to be revealed, which in Figure 175 is smooth like that in Figures 173 and 174. Absorbed light tends to produce heat, which is why on a bright, sunny day, a black surface is warmer to the touch than a white one. Rough or heavily textured surfaces reflect light rays irregularly—that is, in a scattered or diffused manner (Fig. 176).

The effect of different media upon light's velocity accounts for the bending or refraction of light rays as they pass at an oblique angle from one medium into another. In photography it is by refracting the light passing through it that a camera's lens causes an image to be formed on film (Figs. 196, 197). An object has color by virtue of the color of the light that it refracts, reflects, and absorbs. An opaque object appears red when it reflects or transmits red light rays only and absorbs the light rays of all other colors (Figs. 177, 580).

Transparent substances, such as glass and crystal, do not refract uniformly the light of the various wavelengths. This makes it possible to break up white light

171. Air and window glass transmit light and are therefore considered to be *transparent*.

172. Ground glass and tissue paper scatter light rays—that is, diffuse or refract them—and are therefore termed *translucent*.

173. Opaque substances prohibit the passage of light; if shiny they can reflect it only.

174. A smooth gray surface reflects approximately 18 percent of the light striking it and absorbs the rest.

175. A black surface absorbs almost all light striking it and reflects only enough to reveal the surface's texture.

176. Rough surfaces reflect light rays irregularly.

blue paint

177. An opaque object has a color when it reflects the light rays of that color and absorbs the others.

178. Red glass absorbs blue and green light rays and transmits red only.

179. Blue glass transmits only blue light rays and absorbs all others.

into a rainbow-colored array of bands each of whose colors—violet, blue, green, yellow, orange, and red—corresponds to a component of the total visible spectrum that is white light (Figs. 225, 578).

A colored piece of glass, like the colored surface that reflects only selected parts of the light, absorbs some colors from the white light striking it and transmits others. Red glass absorbs the blues and greens and transmits only the red light (Fig. 178). Similarly, blue glass allows only blue, and green glass only the color green, to pass through (Figs. 179, 180).

180. Green glass permits green light rays to pass while absorbing all others.

171–180. The behavior of light varies according to the nature of the matter it strikes.

LIGHT IN PHOTOGRAPHY

It is the light reflected from an object that enables the eye to see and the camera to photograph. Holding a piece of film near an object and exposing it to a lighted subject will simply cause the film to turn black; the exposed film will not have recorded an image. For an image to be recorded, film must be exposed only to a *selected* number of rays reflected from the subject. Such selection can be made by directing light to the film through a tiny pinhole. This was the method devised in the earliest camera obscura (Fig. 2), and it would function today to make photographs.

The picture in Figure 181 was produced by removing the lens from a camera and replacing it with a piece of aluminum foil perforated by a pin prick. Polaroid film was used and the exposure determined by trial and error. An exposure of 8 seconds yielded this moderately sharp image. The small pinhole permitted the film to be struck by a selection of the total number of light rays reflected from each point on the subject. Such rays strike film in clusters, forming on the film small circles known as *circles of confusion* (Fig. 182). Owing to the small size of the pinhole, the circles of confusion in our illustration were small, tightly bunched, and therefore reasonably sharp.

For Figure 183 the pinhole was enlarged and the exposure reduced from 8 seconds to 1. The image this produced is less sharp. Here, the larger hole permitted less selection; that is, an increased number of light rays entered through the aperture, to make larger circles of confusion (Fig. 184). These were also grouped into larger clusters, with some overlapping. It was the overlapping of the clusters that in the end caused the image to blur. (Circles of confusion are also illustrated in Figures 205, 206, 259, 260, and 272–275.)

To obtain the picture reproduced in Figure 185, an inexpensive convex lens (a magnifying glass purchased in a dime store

right: 183. Photograph made by enlarging the pinhole used for Figure 181.

right center: 184. Large circles of confusion. The larger the light-admission opening, the less selective it is of light rays, the larger the circles of confusion, and the greater the blur caused by their overlap.

bottom right: 185. A 98-cent magnifying glass bent light rays to bring them to focus at one point as a sharper image, made from a 1/400 second exposure, than the pinhole could permit (Figs. 181, 183).

for 98 cents) replaced the aluminum-foil pinhole for an exposure reduced from 8 seconds to 1/400 of a second. The lens functioned to bend the light rays issuing from each point on the object and bring them together at one point on the film. This resulted in a brighter and sharper image than would have been possible with the pinhole method.

Chapter 6 provides a full discussion of the properties and propensities of lenses. Relevant to our purposes here, however, is some consideration of how the lens is able to produce the image that the camera records—of what happens to light as it passes through a piece of shaped glass, the lens. Figures 171, 172, and 178 to 180 demonstrated what occurs when light passes through a flat piece of glass.

Light passing through the void of outer space travels at a speed of 186,000 miles per second. Slowed down somewhat as it enters the earth's atmosphere, light travels at a still more reduced speed as it passes through materials of various densities. Striking transparent glass at a right angle, light passes straight through without its velocity being modified to any significant degree (Fig. 186). This occurs because all wavelengths within the white light strike the glass simultaneously. But light that strikes glass at an *oblique* angle has its

186. Light striking transparent glass at a right angle is little affected in velocity and not at all in direction.

187. Refraction. Light striking glass at an oblique angle must alter its course, a change caused by rays striking the glass sequentially rather than simultaneously.

188. Prism refraction makes the reorientation of light more evident.

course altered by virtue of the fact that the various wavelengths within the white light do *not* strike the glass simultaneously. This change in direction of light's path is the phenomenon called *refraction*.

The principle of refraction is illustrated in Figure 187. There, light in the lower part of the ray is shown to enter the glass slightly ahead of light in the top portion. Glass reduces the velocity of light as it receives light from its passage through air. Thus, that part of the light ray entering the glass first is slowed before the part that enters later. The result is the change in direction taken by the light ray. As the light issues into the air again on the other side of the glass, the process is reversed, with the light that was first slowed down being the first to resume the velocity permitted by air. The direction of the light's course remains the same, but displaced by a fraction of a degree. (As revealed by Figures 188 and 578, the change of direction, or refraction, is more evident when light passes through a prism.) By refracting light uniformly around the 360° of its curvature, the angle of the lens' convexity selected, bent, and brought to focus the rays that made possible the reproduction of the image seen in Figure 185.

THE PICTORIAL QUALITIES OF LIGHT

The appearance of a subject is directly influenced by the quality of light illuminating it. Because of light conditions that suddenly prevail, photographers often become aware of new possibilities in scenes they already know well from past associations. Light is never stable and never the same a second time. Its fluidity is absolute. Light makes each succeeding minute of every environment a new experience, and gives each situation the potential for aesthetic discovery. The photographer sensitive to and knowing about the qualities of light will produce superior photographs.

When Harry Callahan made the photograph reproduced in Figure 189, he had the late afternoon sun at his back and over to one side. It was a situation to recall the

classical lighting scheme urged by the instructional manuals published to accompany the first box cameras—the photographer positioned to have the rays of the sun coming over his shoulder and the subject positioned to face the light. However unpleasant for the subject, the relationships permitted slow films to receive adequate exposure. In Callahan's picture, the dark value and long cast of the shadows are products of the sun's low angle. This type of light generated radiation that brought emphasis to texture in the tree trunks and ground foliage. Created by the light, such effects, along with that in the relationship between the trees and their shadows, give the photograph its special quality.

In the next illustration, a photograph of rocks and surf made by Minor White (Fig. 190), the direction of the lighting is the

right: **191. Dorothea Lange.** *Andrew.* 1959. Oakland Museum, Calif. Side lighting and indirect illumination of the face.

below: **192. Imogen Cunningham.** *John Winkler, Etcher.* 1958. Courtesy the photographer. Shadows cast to create pattern and to yield form definition.

reverse of that in Harry Callahan's composition. Called *back lighting,* it illuminates the subject from behind rather than head on. Here, the sunlight passing through and reflecting off the surf gives the water a sparkling effect. Typical of back-lit scenes is the strong contrast between the areas in direct sunlight and those in the shade. This serves to dramatize the shape of the great rock and its shadow, reduce the tonal separation between them, and thus combine the two to produce one massive dark form. It also reinforces the brilliant detail in the sun-struck pool of water on the rock. A setting sun would not permit such a reflection to remain long, and to record the effect White had to act rapidly in setting up his camera, determining exposure, and then exposing the film.

To photograph the boy in Figure 191, Dorothea Lange employed harsh side lighting. This caused light to reflect from the subject's hand back into his face and bring to this area enough indirect illumination to keep it from becoming excessively dark. In this instance, the intermediate tonal quality of the reflected light was necessary, whereas in Minor White's photograph (Fig.

190), its very absence contributes to the work's striking quality. Illuminated by the intensity of side lighting, the boy's light-colored hair appears to be glowing.

Harry Callahan photographed the scene in Figure 189 to reveal light radiating through shadows to emphasize textures. In Figure 192 Imogen Cunningham utilized shadows to create a complicated shape that is fascinating in its own right and by this shape to draw out the forms of the objects at the subject's back. Because the light areas are dominant, in a scene that is mostly in the shade, the shadows appear to be an overlay placed upon the scene. Generally, in situations of this character, the light is so intense relative to shadow that the resulting prints lack detail in the lighted passages. Almost solid white, the lighted areas invest a photograph with a radiance of strange and mysterious quality.

Although striking the subjects from different angles, the light in all the examples just discussed (Figs. 189–192) traveled in a straight line and must therefore be considered directional. In the following illustrations, the situation is more complex.

Filtered through rain and fog, the light in Figure 193 became scattered and diffused. Because it does not have direction, the light neither reveals its source nor casts shadows. Although both of Minor White's pictures, that in Figure 190 and the other in Figure 193, have rocks and water as their subject, each evokes quite a different sense of pictorial reality. The first is bold and forceful and has definite tonal separation

193. Minor White. *Ocean, Schoodic Point, Maine.* 1968. Courtesy the photographer. Light diffused by atmosphere does not cast shadows.

between the various objects in the scene. Softness, quietude, and the blending of forms, induced by their closeness in tonality, characterize the second. Differences of this sort do not make one photograph superior to the other; rather, they represent distinctions in such qualities as mood and feeling that can be obtained from lighting and its organization within a photograph.

Lighting can also be exploited to produce a *silhouette*. After the sun has set, the sky can remain very bright from reflected light, but without direct light, objects visible in the scene appear as silhouettes. A tall form can stand out as a black shape against the bright sky (Fig. 194). In Figure 195 Harry Callahan created a silhouette by beaming intense light upon a white mass and photographing a nude figure against it. Determining the exposure for the white mass, he did not allow the figure to receive sufficient exposure to betray its detail. The result has the immaculate quality unique to a form expressed as a silhouette, which, in photography, is a product of careful design based upon a sophisticated exploitation of the properties and potential of light.

Artificial light and its relationship to photography are the subject of Appendix A, located on pages 322–327.

left: 194. Norman Myers. c. 1970. Courtesy Sapra Studio Photographers, Nairobi. Without direct light, objects stand out as silhouettes.

below: 195. Harry Callahan. *Eleanor.* 1958. Courtesy the photographer. Nude photographed against an illuminated white mass.

The Lens

DESCRIPTION OF A LENS

A camera, whatever the quality of its other features, is only as good as its picture-taking lens. No other aspect of the camera can be considered so important as the lens. A good lens is one capable of producing sharpness and accuracy in the image it projects upon the film. This capability results from an ingenious bit of machinery composed of several layers of different kinds of optical glass, each ground to an extremely fine tolerance and all combined to adjust mechanically and smoothly for exact focusing. Such is the sophistication of modern optics that lenses can be had in normal, long, and short types, as well as in models permitting "slow" or "fast" photography, but the right lens is the one that yields the picture the photographer wants to make and achieves a photograph of a quality he can respect.

A problem fundamental to photography is that which the eye solves by controlling the basic nature of light in a way to make vision possible. As light strikes an object, its rays bounce off from all points and scatter in all directions (Fig. 196). This

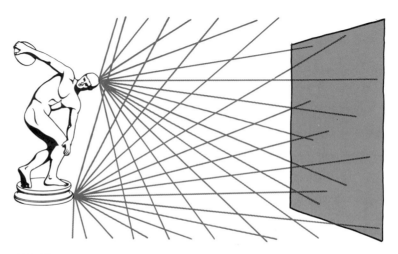

196. The problem in the basic nature of light. As light strikes an object, its rays reflect from all points and scatter in all directions. Light rays striking sensitized film at random expose the film generally without recording an image.

197. The solution provided by the lens. The camera's lens selects and sorts out light rays and directs them, ray by ray, to render, point by point, the subject that first bounced them into the general environment.

is why a piece of sensitized film placed in front of a subject cannot record an image of a subject. Light rays coming at the film in a chaotic confusion would strike everywhere and at random, exposing the film generally rather than in the ordered fashion that could render an image. For an image to be formed, light rays emanating from a subject must be selected and controlled to fall upon the film's "surface" in an order sufficiently coherent to recapitulate the form from which they derived. It is the camera's lens, introduced into the space between the subject and the film, that selects and sorts out light rays and directs them, ray by ray, to reproduce, point by point, the subject that first bounced them into the general environment (Fig. 197).

In order to understand the design and function of the *lens*, one must first consider the *prism*, a crystal form with three or more faces whose intersection edges are all parallel. A prism has the ability to bend (*refract*) light rays. Figures 198 through 200 assume that light rays are coming from a great distance (*infinity*) and can be considered parallel before they enter the prisms and lenses. If the prisms are arranged in the manner shown in the upper part of Figure 198, the light rays passing through the prisms will *converge* at one point on the other side. Conversely, when the prisms are arranged in an opposite manner, as they are in the lower half of Figure 198, the light will *diverge*.

A lens is a solid piece of glass (or other transparent material) that is a refinement of two prisms. There are two basic types of lenses: *positive* and *negative*. A lens that causes light rays to converge (Fig. 199) is called *positive;* one that causes light rays to diverge (Fig. 200) is referred to as *negative*. The determining factor is the thickness of the lens in the center as related to the thickness at its edges. A positive (*convex*) lens is thicker in the center and thinner at the edges, while a negative (*concave*) lens is thinner in the center and thicker at the edges. Lens shapes are not limited to the two basic forms in Figures 199 and 200. There are in fact many possible shapes, the

198–200. The lens, as a refinement of two crystal prisms, bends (refracts) light rays so that they either converge or diverge. The examples in this series assume light rays traveling parallel to each other as they enter the transparent, light-transmitting material of prisms and lenses.

above: 198. Prisms with a "positive" orientation refract light rays so that they converge; prisms with a "negative" orientation refract light rays so that they diverge.

above: 199. A positive lens has a convex form—is thicker in the center and thinner at the edges. It transmits light rays and refracts them to converge on the far side of the lens.

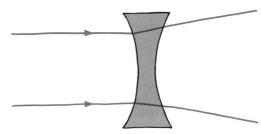

200. A negative lens has a concave form—is thinner at the center and thicker at the edges. It transmits light rays and refracts them to diverge on the far side of the lens.

201. Lenses have various shapes, some positive (left) and some negative (right).

202. Modern lenses consist of several elements assembled into a compound whose purpose is to provide more accurate focusing under a much wider range of light conditions than could ever a simple lump of convex glass. All together the elements correct blurrings and distortions that result from the aberrant way light behaves once its rays have been affected by a lens. The several elements, by opposing one another optically, correct or balance the aberrations caused by each. The diagram above illustrates in section a three-element lens composed of a single convex lens sliced in half with a color correction element inserted between the two halves. Below is a seven-element lens.

most common of which are illustrated in Figure 201.

Although a lens in its essential state is a solid piece of glass, variously shaped pieces, or *elements*, can be incorporated into the design of a lens so as to make the lens project a sharp, undistorted image under a wide range of light conditions. All the while they control light and thus make photography possible, lenses cause aberrations in the behavior of light that result in blurred and distorted images. For instance, the light rays of various colors originating at the same point and traveling parallel to one another refract at different angles once they enter a lens. This makes, for example, red rays and blue rays from the same beam strike film at different points, resulting in an unfocused image. Such a defect in

the function of a lens is known as *chromatic aberration* (Figs. 225, 226).

Both the curvature of the lens and the glass it is made of determine the way a lens is able to bend light. Knowing this, the lensmaker can counterbalance, in a series, lenses of opposing properties and characteristics until he has designed a compound that one by one cancels optical errors and possesses the capability of projecting upon film a true and sharply focused image. Such a complex lens may have as many as eight elements; a zoom lens could include up to twenty. Simple lenses, of course, have fewer. Figure 202 shows both a three-element lens and a seven-element lens.

The Positive Lens

A positive lens bends light rays in an inward (*convergent*) direction, so that eventually the rays meet. In Figure 203 the light rays reflecting off one point of the subject travel in a straight line, whatever their direction. If one ray hits the top part (a) of the positive lens, it is bent by the lens in a downward direction. Another ray hitting the lens near the bottom (c) will be bent upward. When still another ray hits the center (b) of the lens, it continues in a straight direction. The point at which the three rays meet is the point at which the image is formed. This image is a *real* image —one that can be seen on a sheet of ground glass in the view camera (although the image will be upside down and reversed from left to right, as in Figure 91).

The Negative Lens

As Figure 200 shows, a negative lens also bends light rays, but in an outward (*divergent*) direction. In Figure 204 a light ray that hits the surface at *a* is refracted by the first surface of the lens and again by the second surface (b), and it travels outward. A light ray that hits the lens at *c* is refracted by the first surface and again by the second (d), so it also travels outward. Because the rays do not converge, no image can be formed on a flat surface; therefore a negative

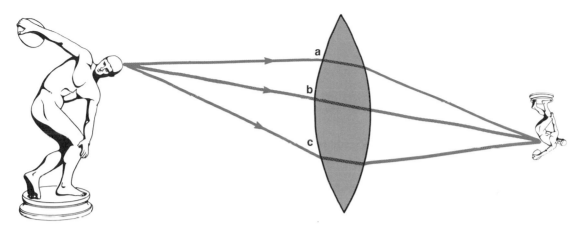

203, 204. Light rays reflecting off one point travel in a straight line, whatever their direction.

above: 203. Convergence of light rays occurs when one ray strikes the top part of a positive lens (a) and is bent downward, another ray reflected from the same point strikes the bottom of the positive lens (c) and is bent upward, and a third ray hits the center of the lens (b) and continues in a straight direction.

204. Divergence of light rays occurs when a ray reflects from one point on a subject and strikes the outer surface on the upper portion of a negative lens (a), there to be refracted by both the first surface and then the second surface (b) until it travels outward. A second ray reflected from the same point would strike both surfaces on the lower portion of the negative lens (c, d) and be refracted outward. Diverging light rays cannot form images on the flat surface of film, but because they project a virtual image (right side up and not backwards, as at e), the peculiar properties of a concave lens make it suitable for use in a viewfinder. It can also help correct aberrations caused by other lenses.

lens cannot be used to take pictures. However, such a lens has properties that are requisite for an ideal viewfinder. When looking through a negative (concave) lens, the eye imagines the light to be coming in a straight line from the other side of the lens. One will see a *virtual* image—right side up, not backwards, smaller than the subject, and always in focus.

Although a negative lens is never used as the principal lens in a camera, it often serves as one element in a lens to help correct image defects. It may comprise one element in a telephoto lens.

FOCUSING

The distance between the lens and the focal plane is critical, for if the focal plane is too near the lens or too far from it, the resultant image will be out of focus. A simple experiment illustrates this point. By

205, 206. Circles of confusion. Light rays converge in clusters, called *circles of confusion.* At the plane of absolute convergence, the cluster concentrates into a tight, sharply focused point. At planes forward of or beyond the focus point, the clusters gather in large, loosely formed circles that reproduce on film as fuzzy, unfocused images.

left: 205. A magnifying glass held over a sheet of paper on a sunny day directs rays of sunlight to converge in a large circle when the paper is at distance *a* and *c* and to focus at distance *b*. At *a, b,* and *c* light rays strike the paper in circles of confusion. Those at *a* and *c* are fuzzy as a result of their large size, the product of their distance from *b;* that at *b* is a tight cluster, therefore constitutes sharp focus.

right: 206. Highlights demonstrate circles of confusion. A highlight on the wet rock is in focus because formed on film by a tightly clustered circle of confusion. The greater their distance on either side of the plane of focus, the larger the circles of confusion and the more blurred the rendering of the highlights.

holding a magnifying glass over a sheet of paper on a sunny day, one can project a circle of light onto the paper, and the appearance of the circle will vary depending upon how far the glass is held from the paper. At point *b* in Figure 205, the circle would become very small, and the paper

might begin to smoke or even burst into flames. In other words, the sun is *in focus* only at *b.* The light rays are parallel before entering the glass because they come from a great distance—the sun. At points *a* and *c,* however, the circles of light are large. Such circles of light are called *circles of confusion.* An image produced from large, overlapping circles of light will be fuzzy or blurry—that is, *out of focus.* Figure 206 illustrates the concept of circles of confusion (as do Figures 182, 184, 259, 260, and 272–275). The photographer focused on a reflected dot of light (a *highlight*) on the edge of a wet rock. As other highlights progress backward or forward from the rock, the degree to which they are out of focus (the circles of confusion) becomes greater.

Properties like the thickness and amount of curvature of a positive lens determine the focal point of the light rays. A thick lens causes the light rays to converge closer to the lens than does a thin lens (Fig. 207). The type of glass used for the lens is also a factor—some glass has a high degree of refraction, some a low degree. A thick lens made of low-refractive glass could have the

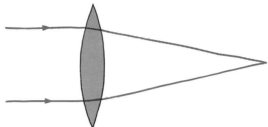

same properties as a thin lens made of high-refractive glass. However, Figure 207 is a simplification of lens characteristics, for the refractive indexes of different types of glass have not been considered.

Resolving Power

Another characteristic of a lens related to focusing is its ability to produce fine detail. This ability is called *resolving power* and is determined by measuring a lens' ability to distinguish between closely spaced lines. The more lines it distinguishes, the higher is its resolving power.

FOCAL LENGTH OF THE LENS

The distance between the lens and the *focal point*—where the light rays converge when the lens is focused at infinity—is the *focal length* of the lens (Fig. 208). For example, if light rays that originate from an object at infinity are first gathered and then bent by the lens and converge at a point 12 inches from the lens, the lens has a 12-inch (300-mm) focal length. The focal length is measured in millimeters for short lenses and in both inches and millimeters for long lenses.

SIZE OF IMAGE

The photographer can control the size of an image in two ways. First, he can consider the focal length of his lens. If it is short, the image will be small (Fig. 209); if long, the image will be large (Fig. 210).

The second—and probably more common—way to change the size of an image is to vary the distance between the subject and the lens. A subject that is far from the lens will produce a small image, while a

207. A thick lens causes light rays to converge closer to the lens than does a thin lens. Thickness and curvature, as well as the type of glass used, affect the way lenses refract light and bring its rays to focus.

208. Focal length is the distance between a lens focused at infinity and the point at which light rays converge inside the camera.

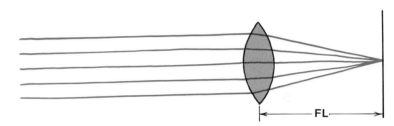

209–211. The size of an image can be controlled by either focal length or the distance from the camera to the subject.

above: 209. Short focal length produces a small image.

210. Long focal length yields a large image.

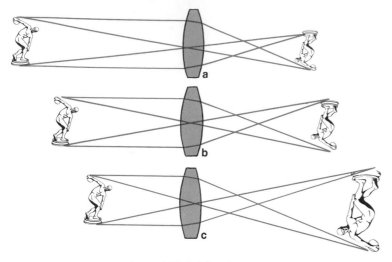

near subject yields a larger image. In Figure 211 the image changes as the distance between the subject and the lens varies: the greater the distance, the smaller the image; the closer the subject is to the lens, the larger the image. The size of the image in the center diagram (b) is intermediate relative to the other two images.

Depending on the distance of the subject from the lens, the distance from the lens to the point at which an image is in focus can vary. In *a* of Figure 211 the distance between lens and image is shorter than in *b* or *c*. The distance between lens and image is greatest in *c*, where the lens is focused on a nearby object.

above: 211. Subject-lens distance affects the size of the image projected onto film. The image also projects upside down and reversed from left to right. Also dependent upon subject-lens distance is the distance from the lens to the point of focus.

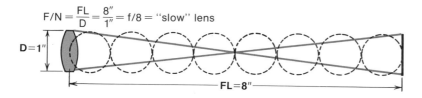

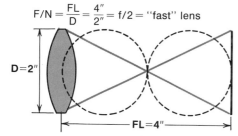

212. F-number, or light-gathering capability of a lens, derives from the lens diameter divided into its focal length. The larger the diameter, the greater the amount of light it can gather; the shorter the focal length, the smaller the amount of light lost in traveling to the focal plane. Therefore, the larger the lens diameter and the shorter the focal length, the greater the power of the lens to project light upon film—and the smaller the f-number. The smaller the f-number, the "faster" the lens.

213. F-number is a fraction. Thus, f/2 represents a larger size than f/8, just as one-half of a pie (a) is greater than one-eighth of a pie (b).

THE F-NUMBER

F-Number Formula

The availability of many lens sizes makes essential an accurate, standard method for identifying the light-gathering capability of a lens. The standard procedure is to state this power numerically, in terms of the following formula:

$$F/N = \frac{FL}{D}$$

In this formula, F/N stands for the f-number and represents the light-gathering capacity of a lens; FL represents the focal length of the lens (the shorter the focal length, the smaller the quantity of light lost traveling to the ground glass or film); and D indicates the effective diameter of the lens (the larger the lens, the more light it is capable of gathering). The diagrams in Figure 212 have been designed to illustrate relative diameter and focal length of a lens.

It is easiest to think of the f-number as a fraction. A simple analogy may help: 1/2 of a pie (also a round object) is larger than 1/8 of a pie. Similarly, an f/2 lens is larger than an f/8 lens and therefore has the ability to gather more light. Student photographers often make the error of thinking that an f/8 lens or aperture is larger, when clearly it is not (Fig. 213).

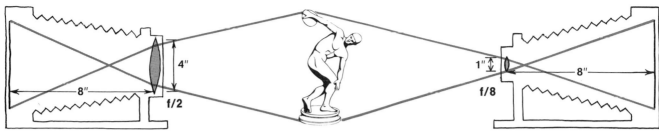

214, 215. The diameter and the focal length of a lens determine the intensity of the light the lens can project upon film. The f-number derived from this combination applies to all lenses, regardless of size.

above: 214 Lens diameter is one of the two variables in the f-number formula. The larger the lens, the brighter the image it can project upon film. Thus, of two cameras each equipped with a lens whose focal length is 8 inches, that with a lens 4 inches in diameter (left) has an f/2 lens capable of casting upon film four times as much light as could a camera whose lens has a diameter of 1 inch (right), making an f/8 lens. The larger the lens, the wider the range of light conditions in which the camera can function.

215. Focal length is the other of the two variables making the f-number formula. The shorter the focal length, the smaller the amount of light lost traveling to the focal plane, and the brighter the image projected upon the film. Thus, of two cameras each fitted with a lens 2 inches in diameter, the one whose lens offers a focal length of 4 inches (right) has an f/2 lens capable of delivering twice as much light to the focal plane as the camera whose lens extends its focal length to 8 inches (left) making a lens size of f/4. Thus, the shorter the focal length of its lens, the wider the range of light conditions in which the camera can function.

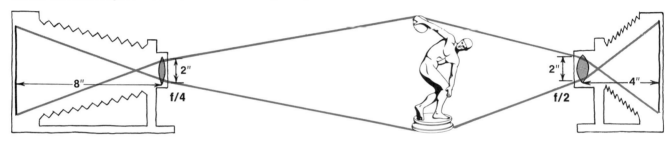

Diameter of Lens

Any f-number has two variables: the diameter of the lens and the focal length (which is related to the distance light must travel from the lens to the film). Therefore, the f-number formula is based on both factors. Figure 214 involves only the diameter of the lens; the focal length of both lenses is 8 inches. Two view cameras are focused on the same subject. One camera has a much larger lens than the other, 4 inches compared to 1 inch. How would the ground glass images differ in the two cameras?

Lens with 4-inch diameter:
$$F/N = \frac{FL}{D} = \frac{8''}{4''} = f/2$$

Lens with 1-inch diameter:
$$F/N = \frac{FL}{D} = \frac{8''}{1''} = f/8$$

The camera with the larger lens, the f/2 lens, would have a brighter image because the lens can gather more light. A nonadjustable camera, such as the Kodak Instamatic, has an f/11 or f/16 lens suitable for making photographs only on bright days. In photographic parlance, a "large" lens is synonymous with a "fast" or "high-speed" lens. Because lenses of this type enable the photographer to take advantage of available, even dim light, he can photograph in a wide variety of situations.

Focal Length of Lens

The foregoing examples of the f-number formula consider only the diameter of the lens. Focal length, the second variable, is illustrated in Figure 215. Two view cameras are here focused on the same subject but their lenses have different focal lengths,

216–219. The simple lens is an improvement over the pinhole, but it has characteristics that distort the rendition of the subject.

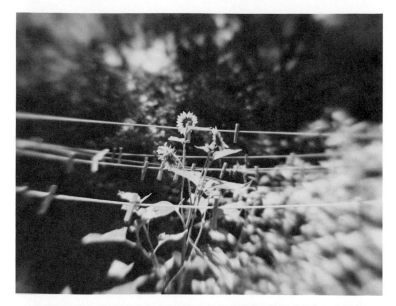

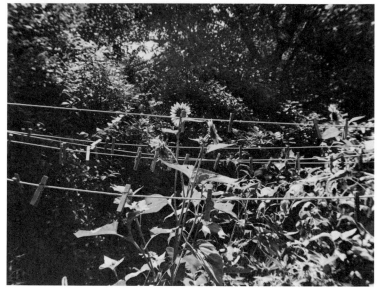

above: 216. A sharp center portion of the image resulted from exposure through a simple lens with aperture set at f/5.6 and speed at 1/400.

right: 217. Overall sharpness of image derived from exposure through a simple lens with aperture set at f/32 and speed at 1/10.

8 inches in one instance as compared to 4 inches in the other. Formulas suitable for deriving the f-numbers are:

Lens with 8-inch focal length:

$$F/N = \frac{FL}{D} = \frac{8''}{2''} = f/4$$

Lens with 4-inch focal length:

$$F/N = \frac{FL}{D} = \frac{4''}{2''} = f/2$$

The camera with the 4-inch focal length lens would produce the brighter image. The diameter of both lenses is the same (2 inches), but one camera has a shorter focal length, which accounts for its smaller number and the consequence of its greater light-gathering ability.

In summary, we can say that the intensity of the light reaching the film is dependent upon two factors, and these are the diameter of the lens and the focal length of the lens. The f-number derived from this combination is applicable to all lenses, regardless of the actual size of the individual lens.

left: 218. A complex lens replaced the simple lens, and the same exposure as that in Figure 216 (f/5.6 at 1/400) made possible a much-improved image.

below: 219. An image superior to that reproduced in Figure 217 resulted from the same exposure (f/32 at 1/10) made with a complex lens.

LENS ABERRATIONS

The simple lens is a great improvement over the pinhole (Fig. 181), but it has certain characteristics that distort the rendition of the subject. A subject photographed at f/5.6 with the simple lens (Fig. 216) is repeated in Figures 217 through 219. In Figure 216 the center portion is sharper than the edges. The small pinhole example as shown in Figure 181 is not so sharp generally, but at least the sharpness is consistent. The photograph for Figure 217 was made with a restricted amount of light entering the simple lens. The aperture was stopped down from f/5.6 to f/32, and the exposure was increased from 1/400 to 1/10 of a second, but the sharpness was greatly improved. Figure 218 was made with a quality lens—that is, a complex lens—and a wide-open aperture, f/5.6. Figure 219 was made with this same lens, but the aperture was stopped down to f/32. The difference in sharpness between the photograph made

with the simple lens at f/32 (Fig. 217) and that made with the complex lens at f/32 (Fig. 219) is not altogether easy to see in the reproductions. The photographs reproduced in Figures 220 to 224 clearly reveal the difference in sharpness. These photographs are magnified sections of the left side of the subject in Figures 216 to 219. Figure 220 was made with the medium-size pinhole; the weed in the lower left corner is visible but not very sharp, and it lacks contrast. In Figure 221, made with the simple lens and a wide-open aperture (f/5.6), the weed is so fuzzy and distorted that it cannot

even be identified. Stopping down the aperture to f/32 (Fig. 222) sharpened the clothesline and pins, but the weed is still not clearly defined. Figure 223 was made with the complex lens and the aperture wide open (f/5.6), and the weed is sharply defined. The last photograph (Fig. 224) was also made with the complex lens, but with the aperture stopped down (f/32), so the weed is slightly sharper.

220–224. **Lens aberrations** can be seen in a series of magnifications made of a detail in the photographs reproduced in Figures 181 and 216–219.

far left: 220. The medium-size pinhole (Fig. 181) made the weed visible but not sharply rendered, and the image lacks contrast.

left: 221. The simple lens and a wide-open aperture (Fig. 216) so distorted the weed it cannot be identified.

below left: 222. A smaller aperture with the simple lens (Fig. 217) sharpened the clothesline and pins while leaving the weed's form unresolved.

below center: 223. The complex lens used with a wide aperture (Fig. 218) gave definition to the image of the weed.

below: 224. The complex lens used with a stopped-down aperture (Fig. 219) rendered the weed still more sharply than in Figure 223.

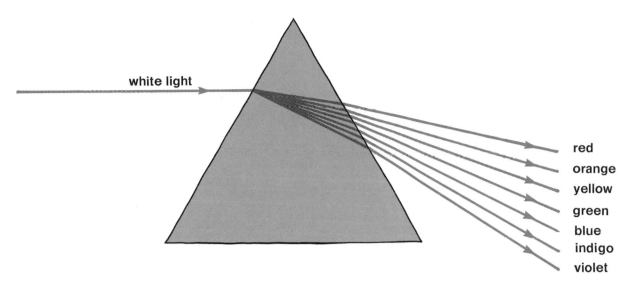

white light

red
orange
yellow
green
blue
indigo
violet

Decreasing the size of the aperture is not a total solution to the problem of distorted images. There are other defects that can be produced by a lens. For example, tiny dots may be rendered as tear-shaped, or some colors may be in focus while others are not. The center of the image may be in focus while the edges are out of focus, or vice versa. The perspective of a straight line, such as the edge of a building, may be rendered as if it were bent. These short-comings of a lens are called *aberrations*. They are minimized in the design of a lens by the inclusion of variously shaped elements, the relationship in placement of elements to each other, and the type of glass from which the element is made. The common aberrations are *chromatic aberration, spherical aberration, coma, astigmatism,* and *curvature of field.*

Chromatic Aberration

White light is composed of the various colors of the spectrum, and each color has its own group of wavelengths. This can be demonstrated by passing white light through a prism (Fig. 578). Each color, because of its respective wavelength, will be bent differently, and all the colors together produce a spectrum (Fig. 225). For example, red has a longer wavelength than blue, and its angle leaving the prism is less acute than that of blue (Fig. 226). One might think of

225, 226. Chromatic aberration. White light contains all the colors in the visible spectrum, even though it is variation in wavelength that distinguishes the color of light. As white light passes through a prism, each of the wavelengths refracts differently, which causes the light rays to separate according to wavelength and form a spectrum.

above: 225. White light passing through a prism refracts according to the various wavelengths contained in white light and thus forms a spectrum (Fig. 578).

226. The angle of refraction is different for each wavelength; that for red is, for example, less acute than the angle for blue.

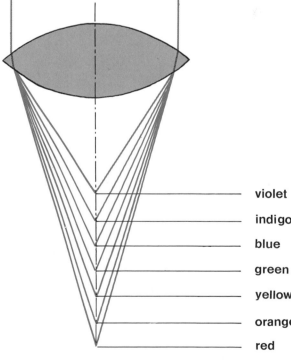

violet
indigo
blue
green
yellow
orange
red

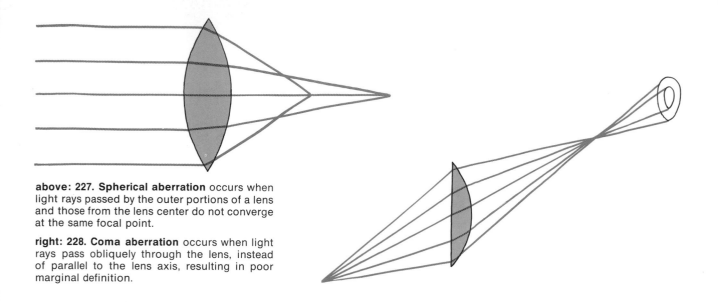

the lens as a continuous prism that has the ability, depending on adjustable variables, to control the point at which a color comes into focus. Years ago, when only black-and-white film materials were available, chromatic aberration was not quite such a problem. However, the advent of color film materials made it a critical factor. Fortunately, the difficulty has been solved by the inclusion of various types of glass—that is, various elements—in the lens (Fig. 202).

Spherical Aberration

Spherical aberration occurs when light rays that enter the outer portions of a lens fail to reach the same focal point as those entering the center of the lens (Fig. 227). This problem can be partially overcome by stopping down the aperture, but ideally the lens should be constructed to contain the elements necessary to prevent its occurring.

Coma

Coma is quite similar to spherical aberration. It is the inability of a lens to produce equal magnification in all areas of the lens (Fig. 228). Light rays pass obliquely through the lens instead of parallel to the axis of the lens, resulting in poor marginal definition.

Light emanating from a dot would create a tear-shaped photographic image.

Astigmatism

In the discussion concerning chromatic and spherical aberrations, the subject was presumed to be on the lens axis. If it is not on the axis, astigmatism may occur. A lens with severe astigmatism could not produce a plus sign (+) in perfect focus, for when the horizontal line was brought into focus, the vertical line would be out of focus, and vice versa (Fig. 229). In the diagram, the horizontal light rays come from source a and are represented by lines b and d, which come into focus at a different distance (f) from the lens than do the vertical light rays c and e, which meet at h. The image at g would not be a sharp point of light but a rather generalized circle of confusion. In the construction of a lens, the use of special glass (rare earth) and the spacing of elements (slightly apart) tend to eliminate this problem.

Curvature of Field

A simple lens has to a certain degree a curvature of field; it cannot form an image of a wheel, for example, in sharp focus on one

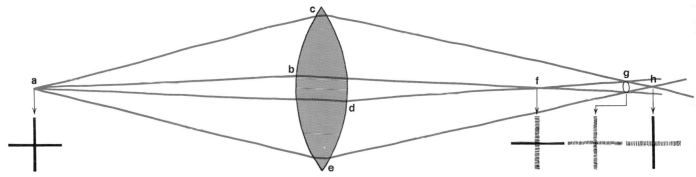

229. Astigmatism is an aberration that occurs when the lens cannot bring into common focus lines on the same plane that are horizontal and those that are vertical. The subject (a) reflects light rays (b, d) from its horizontal element that focus at a point (f) different from that (h) where rays (c, e) from the vertical element focus. In between would occur not a sharp point of light but a rather generalized circle of confusion (g).

below: 230. Curvature of field. Because a simple lens is curved it cannot form on the single, flat plane of film a sharply focused image of both radial and tangential lines. At *a* the circular outer edge of a wheel is in focus, but the spokes are out of focus. The opposite is true at *c*. At *b* a compromise permits both edge and spokes to appear in moderate focus.

plane (a flat piece of film) because the lens is curved. If one point is clearly defined in the image, the other is not (Fig. 230). At *a* the outer edge of the wheel is in focus but the spokes are out of focus; the opposite occurs at *c*. Point *b* is a compromise, and both the edge and the spokes are moderately sharp. Most complex lenses are designed and constructed to avoid this problem.

Other Problems of the Lens

Flare Light, as it passes through the numerous elements in a modern lens, reflects off the various surfaces inside the lens. This internal reflection causes ghost images, or light areas, to appear in the resulting photograph. A technique known as *coating* minimizes this problem. The various elements are coated with a material that helps to reduce internal reflection. Because the front surface of the lens is also coated, one must be very careful in cleaning the lens, because a too-vigorous rubbing can remove the coating.

Curvilinear Distortion A diaphragm in the lens can produce either a barrel-type or a pincushion-type distortion (Fig. 231). Placing the diaphragm between the elements helps to reduce this problem.

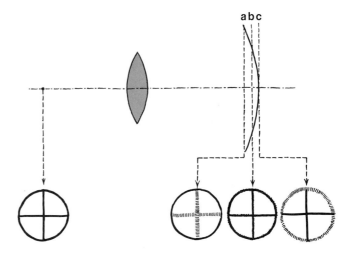

below: 231. Curvilinear distortion. A subject (a) photographed through an aperture diaphragm placed in back of a lens (b) can produce a pincushion-type distortion (c); placed in front of the lens (d), the diaphragm causes a barrel-type distortion (e) to occur in photographs.

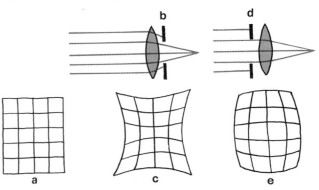

THE USE OF VARIOUS FOCAL-LENGTH LENSES

The lens on a camera is usually designed to photograph the same area that the photographer is able to see. For example, if he must stand 10 feet from a subject in order to see it in its entirety, the camera must also be 10 feet from the subject. The lens used in this example would be considered a "normal" lens for that particular camera. A lens with a 50mm focal length is normal for a 35mm camera, while a 4 × 5 inch camera requires a 6-inch lens, because the respective film sizes are different. The larger the film size, the longer the lens must be to cover it adequately. The normal focal length for a given lens is usually equal to

Table 6.1 Focal length and film size

Focal length	Film size	Figure
50mm lens	35mm roll film	232
75mm lens	120 roll film	233
5- to 6-inch lens	4 × 5 sheet film	234
12- to 14-inch lens	8 × 10 sheet film	

232–236. Normal focal length for a lens usually equals the diagonal measure of the camera's film size. The larger the film size, the longer the lens must be to cover the film adequately.

232. 50mm lens and 35mm roll film.

233. 75mm lens and 120 roll film.

234. A 5- to 6-inch lens used with 4 × 5 sheet film.

the diagonal measurement of its film size. Table 6.1 lists the appropriate film sizes for a selected range of focal lengths (Figs. 232–234).

A normal lens for one camera is not always normal for another. In fact, the opposite is often true; a 6-inch (150mm) lens is normal for a 4 × 5 camera, but it is an extremely long lens for a 35mm camera. The effect of using a 6-inch (150mm) lens on a 35mm camera is an extreme magnification (Fig. 235). If the opposite combination—a short lens on a large-format camera—is employed, the photographer would have difficulty focusing the camera. Even if this problem were overcome, the coverage of the short focal-length lens would exceed its respective normal negative area on the large piece of film. For example, a 50mm lens used on a 4 × 5 inch camera would cover an area about 2 inches square (Fig. 236). The lens produces a circular image, and the size of the film (which is rectangular or square) must fit inside this circle with some room to spare. In the example reproduced here, the

amount of coverage is considerable, because the lens was focused on a nearby object (10 feet). If it were focused at infinity, the coverage would be slightly less.

In addition to lenses that magnify the image of a subject or scene, there are lenses capable of including more of it than would a normal lens. These are called *wide-angle* lenses. The photographer, while standing at one spot, can effectively change the rendition of a subject by using various focal-length lenses.

below: 235. A long lens (6 inches) used in a 35mm camera produced extreme magnification.

bottom: 236. A short lens (50mm) used in a 4 × 5 camera projects onto the large film a circular image far in excess of the picture frame that normally would fit inside the circle of light.

Table 6.2 and Figure 237 indicate the angle of coverage for various focal-length lenses; the diagram shows what portion of the scene would be photographed.

Figures 238 through 244 demonstrate how different focal-length lenses, because of their respective angles of coverage, enable the photographer to change his rendition without altering his position. The image of the woman varies greatly in size as she is photographed with lenses ranging from wide-angle to telephoto.

In addition to changing the size of the image, various focal-length lenses may render a subject in rather unusual ways. The rendition may seem distorted, yet it is odd only because it is contrary to the way we normally see things. In the animal world many of these so-called distortions are normal. For example, the hawk and the eagle, floating high in the sky on updrafts, have eyes that enable them to see small animals on the ground; their eyes are similar to a long-focal-length or telephoto lens. By contrast, the visual range of a fish under water seldom exceeds 200 feet. (This distance is quite short compared to our ability to see for miles on a clear day over land or water.) As a result, the fish can see more area at a given distance; its eyes are similar to wide-angle lenses.

Table 6.2 Focal length and angle of coverage

Focal length in millimeters	Type of lens
8–18	Fisheye
21, 28, or 35	Wide angle
50–55	Normal
85–135	Medium long
200–1000	Long (telephoto)

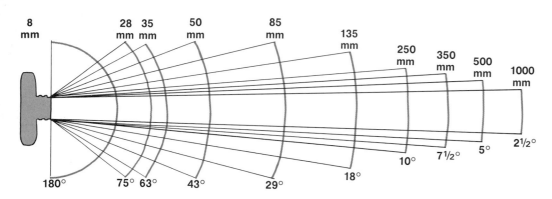

237–244. The angle of coverage. The portion of a scene that a photographic image can reproduce is determined by the focal length of the lens used to make the photograph. The camera-subject distance remained the same for the photographs reproduced in Figures 238–244.

above: 237. Lenses of various focal lengths permit quite different angles of coverage.

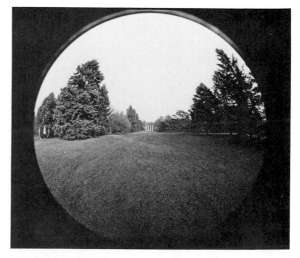

238. 8mm (fisheye) lens.

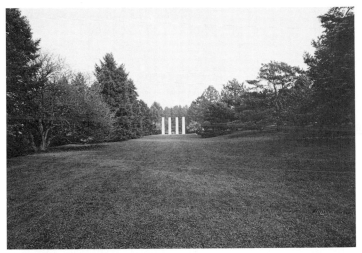

239. 28mm (wide-angle) lens.

240. 50mm (normal) lens.

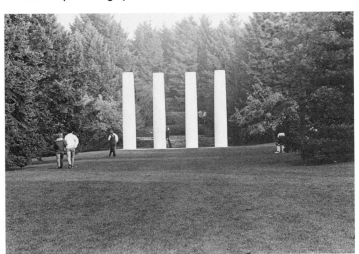

241. 135mm (medium-long) lens.

242. 350mm (long) lens.

243. 500mm (telephoto) lens.

244. 1000mm (telephoto) lens.

Long-Focal-Length and Telephoto Lenses

Often an obstacle or situation makes it impossible for the photographer to manipulate his distance from the subject, with the result that a normal lens cannot present the desired image in the camera's viewfinder. For example, approaching a wild animal is not only dangerous but awkward, because the animal may sense an intrusion and flee. But photographing with a normal lens from a great distance produces in the total scene a very small image of the subject, and it is usually not practical or satisfactory to enlarge a tiny section of the negative.

Most medium- and high-priced cameras provide for interchangeable lenses. The normal lens can be removed to insert one allowing greater magnification. However, the photographer should seriously consider the degree of magnification he really needs. Too often an inexperienced person will purchase a lens much longer than neces-

sary. A lens twice the normal focal length of the camera can be useful, for it will increase the image size while the camera itself remains conveniently small. Many photographers prefer lenses in the range between normal and double. Such lenses enable them to photograph a subject from a slightly greater distance and are ideal for portraits, because a normal lens used at close range produces a slightly distorted image. Figures 245 through 247 show how various focal-length lenses result in different renditions of a subject when used to photograph near objects. The shortest lens produces a rather odd rendition (Fig. 245), the normal lens a slightly distorted one (Fig. 246). The medium-long lens is the most satisfactory (Fig. 247). Lenses in the last category are common in commercial portraiture.

A long-focal-length (telephoto) lens renders perspective in a different manner from the way the human eye works. The longer the telephoto lens in relation to normal focal length, the more pronounced is the impres-

245–247. Long focal length permits the lens to produce a close-view image when camera-subject distance is relatively great. It also prevents the distortion often present in close-view images made by normal lenses.

245. A short lens yielded an odd rendition of the subject.

246. The normal lens produced a somewhat distorted rendition of the subject.

247. A medium-long lens gave the most satisfactory rendition.

248–252. The longer the telephoto lens, the more compressed the rendition of space between objects in a scene. To illustrate the principle, the photographer, in this series, held the sign on the fence at normal size, by substituting lenses of various focal lengths and by varying the distance between camera and sign.

248. 35mm lens.

249. 55mm lens.

sion of diminished space between various objects in the scene. Everything is compressed: the scene has the quality of a mosaic or a paste-up—a feeling of visual flatness. Figures 248 through 252 demonstrate how various focal-length lenses render the size of a distant basketball backboard in relation to the backboard in the foreground. The photographer held the sign on the fence at uniform size, while he substituted various focal-length lenses and varied the distance from the camera to the sign. With the wide-angle lens (Fig. 249), the camera was near the sign; with the telephoto lens (Fig. 252), it was many yards

away. The distant backboard seems to advance, because there is little sense of space between it and the closer one.

Lenses that exceed 200 millimeters are generally considered telephoto lenses. The overall length of a telephoto lens is less than the actual focal length of the lens, yet the lens produces the same magnification. This is because the shapes of the various elements in the lens are designed to make long lenses slightly lighter and less cumbersome than they would otherwise be.

A long lens, because of its focal length, produces very little depth of field, even at small aperture settings. It permits one to

250. 105mm lens.

251. 200mm lens.

252. 300mm lens.

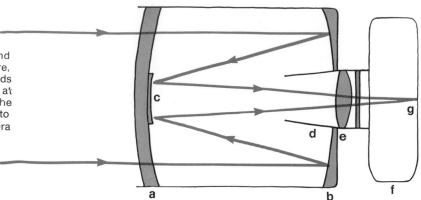

253. Mirror optics can help accomplish the kind of focusing provided by a telephoto lens. Here, light passes through the glass at *a*, which holds the mirror at *c*, and refracts off the mirror at *b* onto the mirror at *c*, which again refracts the light to make it pass through a tube (d) and into the camera lens (e), there to enter the camera (f) and focus at the plane of the film (g).

photograph with the background entirely out of focus, and thus offers a means of separating objects optically instead of by differences in tonal value (see pp. 328–332 in the Appendices).

Long-focal-length lenses are quite susceptible to movement of both camera and subject. A telephoto lens is generally rather slow; few are faster than f/4. (The increase in actual lens area necessary to make the telephoto lens faster would, in addition, make the lens heavier and bulkier.) As a result, the long telephoto lens requires either a fast shutter speed or a tripod, or, better still, a combination of the two.

Rangefinder cameras are not well suited for extremely long telephoto lenses, and in fact may not accommodate such lenses. At the risk of making them rather bulky, one can convert some 35mm rangefinder cameras to single-lens reflexes with expensive accessories that will accommodate long lenses. However, single-lens reflex cameras accomplish the same task without expensive and bulky accessories.

Atmospheric haze, often a problem when a telephoto lens is used, requires the addition of suitable filters (see pp. 337–343 in the Appendices). Yellow, orange, and red filters offer increasing degrees of penetration of atmospheric haze, but the resultant negatives often lack contrast. In this case, a slower film can be used, because it has more contrast than a faster film. Another solution is based on the underexposure-overdevelopment technique (Figs. 534, 535).

A supplementary lens system equipped with a *teleconverter* has recently been introduced. This accessory is attached to the camera, and the telephoto lens is fastened to it. The use of a teleconverter can double the relative focal length of the lens; for example, a 200mm lens effectively becomes a 400mm with the addition of a 2× teleconverter. However, the teleconverter generally cuts down the relative sharpness of an image, so its use involves a compromise between maximum quality of rendition and cost of equipment.

Mirror Optics The principle of including mirrors in a lens is not new. It has been utilized for many years in the construction of astronomical telescopes. In the past few years, mirror lenses have been used in cameras to serve the same purpose as long lenses. Figure 253 illustrates how such lenses work. Element *a* would look strange from the front because the middle is opaque. This piece of glass protects the inner mirror *b* and holds mirror *c*. As light enters the lens, it passes through the glass at *a*, refracts off mirror *b* to mirror *c*, and then passes through a tube to the camera. Some lenses have additional elements in the tube, as well as provisions for accepting neutral-density filters.

A mirror-optic lens is thicker but shorter, and lighter in weight, than a telephoto or long-focal-length lens, and it causes fewer problems with color aberration. Mirror-optic lenses do not permit the use of a

diaphragm; they must rely upon neutral-density filters and the shutter in the camera to regulate exposure. As a result, they create very little depth of field. Tiny dots of light that are out of focus (circles of confusion), such as reflections off water, appear in the resulting photographs as dots with black centers (like doughnuts).

Wide-Angle Lenses

A wide-angle lens is the opposite of the telephoto lens. A normal lens that is the same distance from the subject as the photographer covers the same area seen by him. By contrast, the wide-angle lens covers that same area from a position much closer to the subject. If, for example, a camera with a normal lens must be 10 feet from the subject in order to photograph it in its entirety, a camera with a typical wide-angle lens need be only 7 feet away to accomplish the same thing. This factor is especially important if the photographer, because of an obstruction, cannot stand far enough away from the subject to photograph it with a normal lens. In other words, the wide-angle lens offers a means of changing the photographer's effective distance from the subject without his actually moving. The wide-angle lens, which has a short focal length, produces great depth of field. It would not be suitable for portraiture or other situations in which the photographer wishes to have the background extremely out of focus. When photographing very fast activity that occurs close to the camera, the wide-angle lens proves useful because the focusing is not nearly so critical as it is with a normal lens.

The amateur photographer must be aware that a wide-angle lens produces a special quality of imagery (Fig. 53). Perspective and proportion are different from those seen by the eye, and the imagery has a round, fluid quality. Moreover, the shorter the lens, the more pronounced this rendition is. This effect, when handled carefully, can yield exciting results, but in other cases the distortion may be disturbing. Using a wide-angle lens to photograph architectural

subjects is sometimes desirable, for the perspective can be quite dramatic. On the other hand, a portrait produced with a wide-angle lens seldom flatters and in fact often seems grotesque—the subject's head rendered very round and abnormally large. In the instance of other subjects with fewer emotional connotations than portraiture has, this same type of distortion may be desirable. In Figure 254 the parts of the model's body near the lens are rendered abnormally large and the distant ones very small. The photographer sought this exaggerated perspective in order to change the shape of the body into a new form—one that has a thin, drawn-out quality.

The ultimate in extreme wide-angle lenses is the *fisheye*. Lenses of this type

254, 255. A wide-angle lens is the opposite of a telephoto lens: it optically extends the real space separating the camera from its subject. The lens renders space and perspective in a special way and makes forms seem round and fluid.

254. A thin, drawn-out form resulted from the use of a wide-angle lens.

cover such a wide area that everything is rendered in a circular fashion; there is even a round image on the negative (Fig. 255). The depth of field is also great. In many instances the rendition produced by a fisheye lens is so exaggerated that the viewer can scarcely recognize the subject. It may even seem to have a strong element of fantasy.

In summary, the basic purpose of a wide-angle lens is to enable the photographer to record a large subject or scene from a relatively short distance. But he can also use a wide-angle lens to produce a deliberate visual exaggeration that is interesting and exciting. In fact, the popularity of this technique has reached the point where the identity of the original scene or subject is sometimes lost or forgotten.

Because a wide-angle lens represents a considerable investment, the buyer should base his choice upon his needs and experience. The photographer is often presented with a dilemma because he must consider several aspects: the distance from the subject to the camera, the kind or quality of rendition he desires, and so on. An inexperienced amateur may purchase the widest of wide-angle lenses even though its degree of coverage far exceeds his requirements. Not only are such lenses extremely expensive, but they also produce a rendition that may be too exaggerated to be desirable under ordinary circumstances.

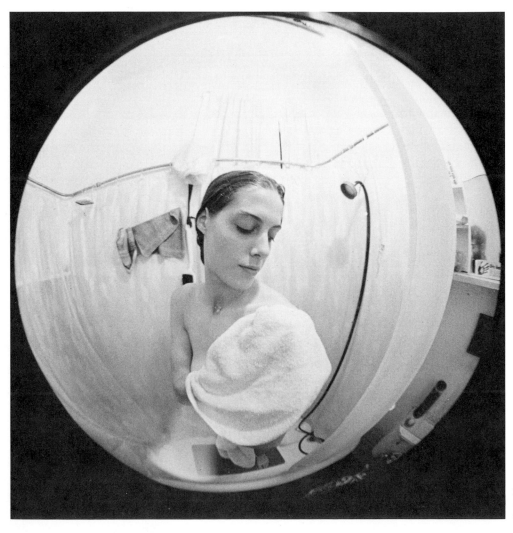

255. **The fisheye** is the ultimate in extreme wide-angle lenses.

above: 256. A short-focal-length lens that swings from one side to the other provides coverage as great as 140 degrees. This image was made with a Widelux camera.

If distance from camera to subject is the main consideration for purchasing a wide-angle lens, a lens with a 35mm focal length would be best on a 35mm camera. This lens produces a noticeable increase in coverage when compared with a 50mm (normal) lens, yet the rendition is not overly exaggerated. The 35mm wide-angle, the 50mm normal, and the 100mm medium-long lenses are an ideal combination for a 35mm camera. They provide versatility, are not prohibitively expensive, and keep the degree of distortion to a minimum. If, through experience, the user finds the 35mm wide-angle lens to be too long, he might consider another length, such as a 28mm lens. The photographer should acquire lenses gradually, so as to relate them to actual needs.

The photographer who wishes to produce distortion with an extreme wide-angle lens should consider a lens with a focal length shorter than the suggested 35mm. A lens with a 20mm to 30mm focal length will increase the roundness of a subject, and a 17mm, 18mm, or 19mm lens will produce an even more drastic rendition. The most radical rendition would be created by a fish-eye lens, with typical focal lengths as short as 9.8mm, 7.5mm, and 6.2mm. There is even a 1.9mm fisheye. These lenses are extremely expensive and produce such exaggerated distortion they are suitable only for limited situations.

Another way to include a large portion of a scene is to use a camera whose lens is mounted in such a way that it literally swings from one side to the other while making the exposure. The film is on a curved plane in the camera, which eliminates problems of focus. The resulting negative is considerably longer than it is wide. This principle is not new; there was a daguerreotype camera that produced a panoramic photograph. In recent years the Japanese Widelux (140 degrees) and the Russian Horizont (120 degrees) have become available (Fig. 139). These cameras accept 35mm film and have a 26mm or 28mm focal-length lens (instead of the normal 50mm lens on a 35mm camera), which is a wide-angle lens. The lens swings during the exposure, producing a negative that is $\frac{15}{16} \times 2\frac{1}{4}$ inches (24mm \times 59mm). A normal 35mm negative is $\frac{15}{16} \times 1\frac{7}{16}$ inches (24mm \times 36mm). The combination of a short-focal-length lens and the swinging property gives the camera a coverage of 140 or 120 degrees. Figure 256 was made with a Widelux camera.

CARE OF LENSES

Because the lens is made of glass, it must be protected from scratches that could reduce its effective sharpness. A lens cap should be attached when the camera is being carried or stored. When the camera is in use, a sunshade not only helps ward off stray light, but also offers protection. The lens must be kept clean, for any dust, dirt, lint, or fingerprints reduce its sharpness. However, the lens must be cleaned carefully, because its surface is easily scratched. The following items are needed for cleaning lenses: a camel- or sable-hair brush, or an infant's rectal or ear syringe; lens tissue; lens cleaner (Kodak).

The camel-hair brush is used for gently whisking away any dust, dirt, or other foreign matter that may be on the lens. An infant's rectal or ear syringe can also be employed to blow dust or dirt from the lens. The lens tissue is used to carefully and lightly wipe the lens in a circular motion—never in a scrubbing motion.

Any lens tissue other than that specified for photographic lenses should be avoided. Lens tissue sold for eyeglasses often contains a cleaner that is extremely harmful to the coating on a lens.

The Kodak lens cleaner is especially good for removing fingerprints from the lens. Because the cleaner is a detergent, it helps remove the oil from a fingerprint, which makes wiping less necessary.

Accessory lenses should have their own protective cases. Cases sometimes come with the lens; often they must be acquired.

Depth of Field

The Relation of Aperture
to Depth of Field

In addition to the effect it has on the amount of light entering the camera, the size of the aperture (the opening that admits light) also helps to determine how much of a scene can be photographed in sharp focus. Measured from near to far between foreground and background, the area or zone in which it is possible to photograph images in sharp focus is termed *depth of field*. The larger the aperture, the more shallow the depth of field the opening permits; the smaller the aperture, the greater the amount of foreground and background it will bring into sharp focus. Phrasing it another way, we could say that a large aperture produces very little depth of field, while a small aperture produces a large amount of depth

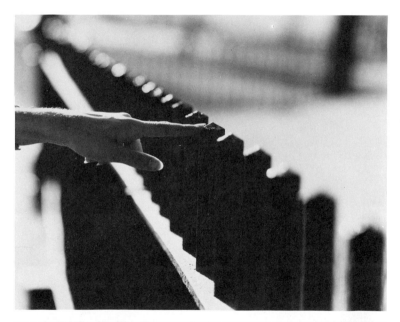

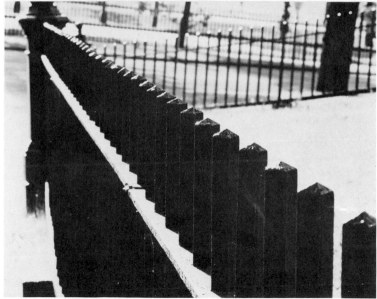

257, 258. Depth of field is the zone of sharp focus in a photograph. Its extent, from near to far, is determined by aperture, the focal length of the lens used, and camera-subject distance.

above: 257. Larger aperture (f/2.8) permitted only slight depth of field—barely the breadth of the subject's index finger.

left: 258. Small aperture (f/22) yielded a much greater depth of field than in Figure 257, bringing many of the fence pickets into sharp focus.

259, 260. The smaller the aperture, the greater the depth of field. In these illustrations, the broken lines represent light rays from objects located beyond the point of sharpest focus; the solid lines trace light rays from objects at the point of sharpest focus.

right: 259. A large amount of light admitted by a wide aperture permits the great number of spread and overlapped circles of confusion typical of out-of-focus imagery in shallow depth of field.

below: 260. A reduced amount of light admitted by a narrow aperture results in smaller, tighter circles of confusion that permit the sharp imagery representative of great depth of field.

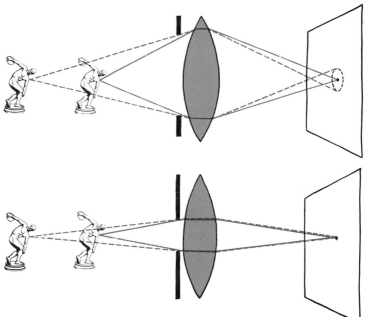

of field. By understanding the principle of depth of field and the effect that several factors have upon it—particularly aperture, the focal length of the lens being used, and the distance between the camera and its subject—the photographer possesses another means to control his work and achieve whatever his purposes may be, whether accurate and literal photographic documentation or expressive interpretations of visual experience.

To obtain the picture in Figure 257 the photographer selected a large aperture (f/2.8) and thereby realized only slight depth of field—hardly more than the measure of the subject's index finger on which the lens was made to focus. The picket the finger touches is sharply defined, but all the other pickets in the fence have dissolved out of focus. In Figure 258 the scene was photographed with a small aperture (f/22), and this yielded an image with a good many more of the fence pickets recorded in sharp focus. Here, the depth of field is greater than that in Figure 257.

The differences in depth of field seen in Figures 257 and 258 derive from the physical character of the circles of confusion made by the two apertures used. A large aperture permits a relatively large number of light rays to enter the camera from each point on the subject. Released into the camera by the lens, they converge toward

the focal plane to form a cluster that, on striking the film, covers a small circular area called a *circle of confusion* (Figs. 182, 184, 205, 206). Because of their greater size, the circles of confusion formed by a large aperture overlap and impinge upon one another, and it is the overlapping that produces the blurriness of an out-of-focus photographic image. A small aperture admits fewer light rays from each point on the subject, and by striking the film in tighter clusters, these create circles of confusion that remain discrete (not overlapped), thus making possible a more precisely defined photographic image.

The solid lines in the illustration reproduced as Figure 259 represent the path of light rays from a point on a near subject that is in focus; the broken lines represent the path of light rays from a point on a more distant subject, beyond the depth of field. As the rays from the two images in the scene are gathered by the lens and made to converge toward the focal plane, those from the image in focus form a concentrated cluster on the film, while those from the distant image converge and then spread into a larger, more generalized circle of confusion. The circle of confusion is large when the diaphragm opening is wide, smaller when the diaphragm opening is small. Thus, as represented by the dotted lines in Figure 260, the distant figure has

been brought into focus—made to fall within the depth of field—by the smaller size of the aperture. *The smaller the aperture, the greater the depth of field.*

THE CONTROL AND MANIPULATION OF DEPTH OF FIELD

A fundamental objective in photography is to obtain pictures in which all images are clearly and cleanly visible and readily identifiable for what they are in one's visual experience of physical reality. Depth of field can be manipulated to produce such a result, but it also lends itself to exploitation for effects that depart from perfect, brilliant clarity and do it for the purpose of satisfying specific representational or expressive intentions. Soft focus can be appropriately mood-evoking, and a detail picked up in sharp focus from a fuzzy environment has the potential for dramatic emphasis. Action can be suggested either by photographing a moving object to appear blurred against a clear, stable background or by freezing the form in motion against a background that is blurred. When the photographer controls and manipulates his means and materials so as to create effects that not only record a scene or event but also convey its meaning and significance, he bases his work on fundamentals transcending those of the technology that make possible photographs of such clarity all objects in them can be identified with absolute certainty.

Depth of field is an optical phenomenon inherent in photography, and the manipulation of it has important consequences for the kinds of pictures the photographer can produce. Determining how much depth of field may be necessary—limited or extensive—is subject to both technical and aesthetic considerations.

Figures 261 through 264 illustrate four different approaches to the phenomenon of depth of field. In Figure 261 the photographer focused on the background and limited the depth of field to keep all but the background out of focus. To make the photograph in Figure 262 he focused on the middle ground while continuing to limit the depth of field. This made both foreground and background out of focus. For the picture in Figure 263 he brought the foreground into focus and placed middle ground and background beyond a shallow depth of field. This particular use of depth of field often has served effectively whenever, as in commercial and portrait photography, it seemed important to have the essentials of the background suggested behind an object optically separated from it. For his fourth experiment (Fig. 264) the photographer somewhat reversed his procedures by directing only one-third of the focus to the middle ground and by expanding depth of field to its maximum range. This brought into reasonably sharp focus images present in all three planes—foreground, middle ground, and background.

Several elements are involved in the manipulation of focus and depth of field. For instance, the flag as photographed in Figures 261 through 263 has been frozen in mid-flutter, but its movement is blurred in Figure 264. To maintain the same exposure for all four pictures, the photographer in each instance set the shutter speed in relation to the f-number. For Figures 261–263, only a wide aperture could yield the desired limitation in depth of field, and to control the amount of light entering the camera he had to compensate by selecting a fast shutter speed, one quick enough to stop the flag's movement. To increase the depth of field for the picture in Figure 264, the photographer closed down the aperture; to admit sufficient light into the camera he had to adopt a compensating shutter speed, one too slow to freeze the action of the flag. It is difficult to realize in a single photograph both great depth of field and the arrest of action. The two objectives are attainable with very fast film, but this could diminish the quality of the prints.

To obtain enough exposure to enable him to make the picture in Figure 265, the photographer had to sacrifice all concern for depth of field. The longer exposure needed for greater depth of field would have

261–264. **Controlling and manipulating depth of field** permits the knowing photographer to select from a wide range of possibilities for interpreting subject matter.

above left: 261. Focus on the background and limited depth of field kept all but the background out of focus.

above right: 262. Focus on the middle ground and limited depth of field.

below left: 263. Focus on the foreground and limited depth of field.

below right: 264. Expanded depth of field and one-third focus on the middle ground brought into focus images present in all three planes—foreground, middle ground, and background.

required, given the conditions of minimal light, the use of a tripod and a subject that could remain absolutely still. Here, neither of these was possible.

Often, however, the photographer has the possibility of choosing to utilize a great depth of field or none whatever. For Figure 266 the photographer thought it appropriate to separate the tombstone from its background. However low the light, he had a still subject to work from, and the combination of wide aperture and a very close subject permitted him to focus the tombstone within a limited depth of field and use the sharp focus to make the subject stand forward in isolation from the much-dissolved background. For the picture in Figure 267 the photographer gained maximum depth of field by adopting a very small aperture.

For the series based on the picket fence (Figs. 257, 258) and for that taken in the cemetery (Figs. 261–264) the focal length of the lens and the distance from the camera to the subject remained the same. Had the photographer changed either the focal length or the distance between camera and subject, he would also have brought about a corresponding change in depth of field. Thus, there are, in all, three factors that function to determine depth of field:

1. Aperture
2. Focal length of the lens
3. Distance from camera to subject

To test or demonstrate the principle of these factors, it is essential to hold two of them constant while making the third a variable. For example, throughout the discussion of the relation of aperture to depth of field, focal length and camera-subject distance remained the same (Figs. 257–260). To evaluate the effect of focal length, it is aperture and camera-subject distance that must be held consistent. To test the effect of camera-subject distance, the photographer must not change aperture or focal length.

opposite: 265. No depth of field was possible in this photograph, owing to the low illumination of the scene and the rapid movement of the subject.

right: 266. Shallow depth of field was explicitly selected here, for the still subject would have permitted the long exposure necessary to realize great depth of field under conditions of low light.

267. A small aperture produced maximum depth of field in this photograph.

268–271. The shorter the focal length of a lens, the greater the depth of field. To demonstrate this principle, aperture and camera-subject distance must remain constant. In the series reproduced here, aperture was fixed at f/5.6 and the camera set at 10 feet from its subject.

left: 268. A 50mm lens of short focal length.

below: 269. An 80mm lens of normal focal length.

The Relation of Focal Length to Depth of Field

The shorter the focal length of a lens, the greater the depth of field. A wide-angle lens has a short focal length and can provide great depth of field at any f-number. Possessing a longer focal length, the nor-mal lens offers less depth of field relative to that possible from a wide-angle lens. Equipped with a very long focal length, the telephoto lens is capable of no more than a limited depth of field.

To demonstrate the principle in the relation of focal length to depth of field, a bridge railing was photographed with a

above: 270. A 150mm lens of longer than normal focal length.

right: 271. A long lens of 250mm.

short-focal-length lens of 50mm (Fig. 268), a normal-focal-length lens of 80mm (Fig. 269), a 150mm lens of a longer than normal focal length (Fig. 270), and, finally, a long lens of 250mm (Fig. 271). Held constant throughout this series, the distance of the camera from its subject was fixed at 10 feet and the aperture set at f/5.6.

A comparison of these several pictures reveals quite readily that the wide-angle lens, with its short focal length, produced the most extensive depth of field (Fig. 268). This can be explained by reference to the circles of confusion made from points at the extreme limits of the depth of field and those made from its center. The diagram

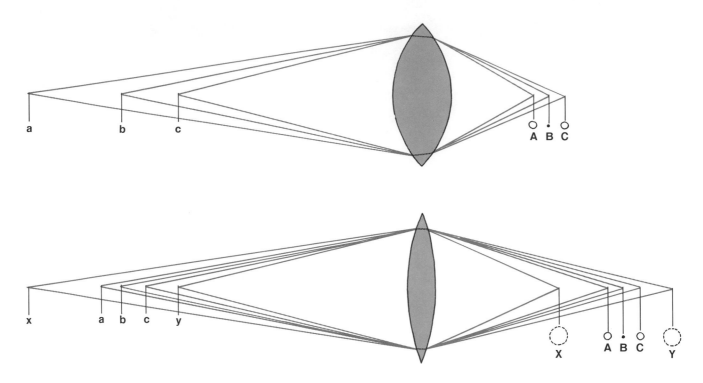

272, 273. Circles of confusion explain differences in depth of field produced by a lens of short focal length and by one of long focal length.

top: 272. A lens of short focal length projects reasonably small circles of confusion from A to C for all subjects present in real space from *a* to *c*. At B is the point of focus.

above: 273. A lens of long focal length projects large circles of confusion at X and Y for subjects present in real space at *x* and *y*, which therefore would be rendered on film as out of focus. From A to C the circles of confusion are small enough to permit sharp focus for objects found at *a* and *c*.

in Figure 272 has been devised to show rays of light being drawn into the camera from points *a, b,* and *c* and the size of the circles of confusion that these create once they have converged inside the camera and then struck the focal plane (A, B, and C). The circle of confusion formed by rays derived from point *b*, at the center of the focus within the depth of field, is such a tight cluster it appears as a black dot (B). The circles of confusion (A and C) released by rays from points *a* and *c* are large enough to have the character of actual circles. The closer the point of convergence (of light rays that have entered the camera) to the focal plane (where light rays become circles of confusion), the smaller and tighter the circles of confusion, and, concomitantly, the clearer the photographic image.

Conversely, the circles of confusion are larger and create fuzzier images the farther from the focal plane has been the convergence of their light rays. Thus, at *a* and *c* are the limits of this lens' tolerance for depth of field. At *b* therefore is the point of primary focus, but all images within the tolerance ranging from *a* to *c* should be recorded in reasonably sharp focus.

The depth of field provided by the short-focal-length lens in Figure 272 seems quite generous compared with that to be had from a lens with long focal length. In Figure 273 this is again measured by means of circle-of-confusion tolerance. Here, the area from *a* to *c* that has sharp focus at A and C is much briefer. In this diagram X and Y represent the size of the circles of confusion derived from points *x* and *y*,

274–277. The closer the lens to the subject, the more shallow the depth of field. In this series aperture and lens focal length remained constant.

above: 274. Focusing on a near subject diminishes depth of field.

275. Focusing on a far subject increases depth of field.

which have the same location as *a* and *c* in the diagram illustrating the short-focal-length lens (Fig. 272).The circles of confusion at X and Y are too large for tolerance and would be seen as out of focus.

The Relation of Camera-Subject Distance to Depth of Field

The closer the lens is to the subject, the less the depth of field. Figure 274 illustrates what happens to depth of field when the focus is upon subjects photographed at close range. Registered on the focal plane, light rays from an in-focus subject arrive in a circle of confusion with the concentrated character of a dot. Rays from a subject at a point only slightly more distant than the in-focus subject converge too far

from the focal plane and therefore fan out to make a large and unfocused circle of confusion. The closer the in-focus subject to the lens, the larger the circles of confusion made by light rays from points in the scene that are out of focus. The tendency toward larger circles of confusion, which inheres in focusing fixed at close range, results in shallow depth of field.

The principle of optics just defined functions in such a way that the farther the lens is from the subject, the greater the depth of field. This can be seen in a comparison of Figure 274 with Figure 275, both of which have the same f-number. The greater depth of field in Figure 275 reduces the difference in definition between the in-focus image and the out-of-focus image. This has been illustrated photographically

in Figures 276 and 277. Both made at the same f-number, the former picture was shot with a camera set a mere 3 feet from the subject and the latter from a distance of 10 feet. It is quite apparent that the greater distance between camera and subject has yielded a more extensive and therefore more inclusive depth of field.

DEPTH-OF-FIELD SCALES

Each type of camera is different, and the way each has been designed to indicate depth of field is dependent upon the camera's focusing system. Such simple instruments as the box camera or the Instamatic are not adjustable for focus and therefore have a fixed depth of field. Providing the subject is at least 5 feet in front of a non-adjustable camera, sharpness of focus can be assured all the way to infinity. Other types of cameras are equipped with depth-of-field scales, usually in two parts: one for f-numbers and the other for camera-to-subject distance (Figs. 278–280). Located at the center of the depth-of-field scale is the maximum f-number, or the widest aperture for that particular lens, which in the example here is f/3.5. Arranged, virtually as brackets, on either side of this central point are succeeding f-numbers.

As it moves along the f-number scale, the distance scale indicates the depth of field. Figures 278 through 286 have been designed to illustrate the effect that the relation of distance to f-number has upon depth of field, but since depth of field is a product of not only f-number and distance but also the focal length of the lens, the same lens (f/3.5) has been used for the following examples.

In Figure 278 the diagram shows that the position for number 10 has been set opposite f/3.5 on the f-number scale. This means that the camera is focused on an object 10 feet away. Then, should the photographer, using this lens and this distance, choose f/3.5 as his aperture, the depth of field would be the 2 feet marked off by the brackets enclosing the f/3.5 position. But depth of field varies according

top: 276. Camera-subject distance of 3 feet produced a shallow depth of field.

above: 277. Camera-subject distance of 10 feet yielded considerable depth of field.

278–286. Depth-of-field scales on cameras usually are in two parts: one for f-numbers and the other for camera-subject distance. Bracketed around the maximum f-number possible for the lens are succeeding f-numbers. As it moves along the f-number scale, the distance scale indicates depth of field.

above left: 278. With focus at 10 feet from the camera and an aperture of f/3.5, the scales indicate a depth of field of 2 feet, marked off by the brackets enclosing the f/3.5 position.

above right: 279. Set at f/8 for a focus 10 feet from the camera, the scales indicate a 5-foot depth of field, the extent from slightly more than 9 feet to slightly less than 15 feet bracketed by f/8 on either side of the central f/3.5.

left: 280. Aperture closed down to f/22 for a camera-subject distance of 10 feet makes the scales indicate a depth of field extending from 7 feet to 23 feet in front of the camera.

to f-number or aperture chosen, and its exact measure can be identified on the scales. Set at f/8, this lens at 10 feet from the subject provides depth of field equaling 5 feet, the extent indicated, from just over 9 to slightly less than 15 feet, by f/8 in brackets on either side of the central f/3.5 (Fig. 279). With the aperture closed down to the f/22 stop, the depth of field, counting from f/22 to f/22 on the bracketed scale, would provide sharp focus for all images located no closer than 7 feet and no farther away than about 23 feet (Fig. 280).

Depth-of-field scales are indispensable aids for the photographer whose camera cannot reveal depth of field visually. Because lenses are cylindrical, the scales usually appear on a curved plane. In older cameras and press cameras the depth-of-field scales are flat and located on the lens

bed. But scales are not visual indications and cannot reveal what the rendering may be of subjects partially or completely out of focus. Although experience makes prediction possible, the most satisfactory of all methods is that based on ground-glass focusing. In a view camera, all parts of a scene appear on the ground glass as in or out of focus as a final photograph would render them.

The typical situation, however, is a camera fitted with scales. The frequency of their use depends upon how the camera is focused. Scales must be used for all cameras requiring manual adjustment for distance, and this includes rangefinder cameras. Despite its ground-glass focusing system, the twin-lens reflex camera offers a scale for measuring depth of field. The depth-of-field scale functions for the single-

lens reflex as well, even though it is less essential to this type of camera, since viewing depth of field is actually visible through the camera's lens.

Zone Focusing

Zone focusing is a technique that works to good advantage with cameras marked for depth-of-field scales. For instance, to catch a subject whose high speed can be anticipated (as in sports), the photographer has only to set up his camera for distance and arrange depth of field so that when the subject enters it the picture can be snapped.

Hyperfocal Focusing

Hyperfocal distance is that measured from the lens to the nearest plane of the depth of field when the focus has been placed at infinity. The technique of *hyperfocal focusing* makes possible the maximum depth of field for a given f-number. Normally, it can be applied out of doors on occasions permitting the aperture to be closed down. In Figure 281 aperture has been selected at f/16; the lens focused at infinity places the hyperfocal distance at 25 feet, or the point at which would appear the in-focus object closest to the camera. If the focusing scale is changed to position the hyperfocal distance of 25 feet at f/3.5 (where the "critical focus" arrow appears on an f/3.5 lens in infinity focusing), the depth of field increases by one-half the hyperfocal distance

281–286. Hyperfocal focusing is a technique for increasing depth of field when focus has been set at infinity.

left: 281. Hyperfocal distance is the plane of focus nearest to the camera when focus has been set at infinity. For an aperture of f/16 on an f/3.5 lens, this can be found at a distance of 25 feet from the camera.

right: 282. Placing the 25-foot mark on the scale at f/3.5, where the "critical focus" arrow appears, increases the depth of field by one-half the hyperfocal distance; that is, it makes depth of field commence at a distance of 12½ feet from the camera and continue into infinity.

(Fig. 282). In this instance, hyperfocal focusing has increased depth of field by one-half of 25 feet to commence at 12½ feet from the lens and continue into infinity.

How this principle works can be seen visually in Figures 283 through 286. In this series the photographer wanted the figure to appear in its entirety close to the camera and, at the same time, to have the whole background in sharp focus. For Figure 283 he set the focus at infinity and hoped that a small aperture would achieve sufficient depth of field to include even the front plane of the figure. This almost succeeded, but close scrutiny reveals the face to be slightly out of focus. An enlargement makes the lack of crisp focus seem still more marked (Fig. 284). For the photograph in Figure 285 he used the hyperfocal technique of

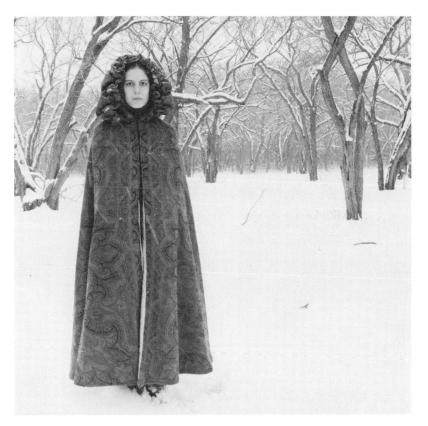

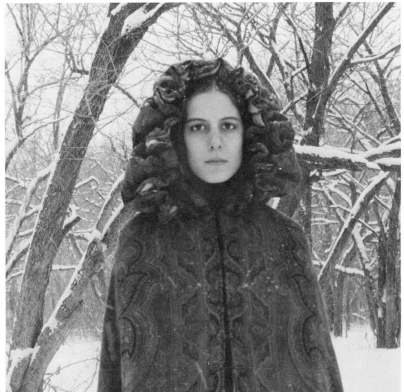

above: 283. Bright light, small aperture, and distance set at infinity failed to include a near subject within depth of field.

right: 284. Imprecise focus is marked in this enlargement taken from Figure 283.

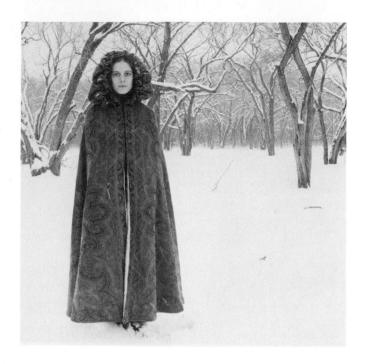

focusing, and this brought all elements of the subject into clear definition. An enlargement shows the degree to which snow crystals on the hair and the paisley pattern on the fabric have now been rendered in precise detail (Fig. 286).

285. Hyperfocal technique rendered the subject in sharp focus.

286. Crisp focus is apparent in an enlargement taken from Figure 285.

Film

THE CHARACTERISTICS OF FILM

The image recorded on film after it has been exposed in the camera has two salient properties: it is *latent*, that is, not visible until it has been subjected to developing procedures; and—except for slides or transparencies—it is in *negative* form, capable of being printed into any number of positives. The first of these principles was introduced by Daguerre (see pp. 4–6), who thus overcame the problem faced by earlier experimenters of being unable to halt the exposure of their images. The second was conceived by Talbot (see pp. 7–8) as an improvement over the one-of-a-kind daguerreotype.

The light-sensitive materials available today are much more complex than Daguerre's and Talbot's coated plates. Most modern black-and-white roll and sheet films consist of six layers (Fig. 287): the *top coat*, a protective layer of hard gelatin that helps to prevent scratches on the emulsion; the *emulsion*, a layer of gelatin containing light-sensitive crystals of silver *halides* or compounds, which, during development, turn black in proportion to the amount of exposure they have received; the *subbing*, a special gluelike gelatin that adheres the emulsion to the support; the *support*, a strong but flexible transparent plastic; a *second adhesive* layer; and, finally, the *antihalation backing*, a coating (absent from some special-purpose films) that contains dye which is dissolved by fixer during the developing process. While the film is being exposed, the antihalation backing prevents light from reflecting off the support or the camera itself and back through the film. Such reflections would create halos around bright areas of the photograph and reduce the sharpness of

287. Modern black-and-white film consists of six layers, which all together measure about .005 inch in thickness.

a. The top coat is a layer of hard gelatin that insulates the emulsion against scratches.
b. The emulsion layer, where the image forms, consists of gelatin containing light-sensitive crystals of silver halides.
c. The subbing layer, a special gluelike gelatin, adheres the emulsion to its support below.
d. The support provides a strong but flexible plastic (cellulose-acetate) base for all the other component layers of film.
e. A second adhesive layer bonds the support to the antihalation backing below.
f. The antihalation backing contains dye that prevents light from reflecting off the support or off the camera itself and back onto the emulsion, which reflections could create halos around bright areas of the images.

left: 288. A silver bromide crystal consists of silver and bromide ions (electrically charged atoms) that are held by electrical attraction in the "perfect" abstract form of a cube. The extra electron present in each bromide ion is what distinguishes the ion from an uncharged bromine atom. Because the electron is extra, the charge of the bromide ion is negative. Each silver ion, by having one electron less, can be distinguished from an uncharged silver atom. Because it lacks an electron, the silver ion is positively charged. In the symmetry of the arrangement of ions in a crystal, it is the irregularities that have the freedom to react in a way to make the crystal light-sensitive for purposes of forming an image on film. Such deviations are elements whose shape or location is irregular relative to the abstract perfection of the crystal's form. Inside a silver bromide crystal, impure elements can function as "sensitivity specks" to attract the unaligned, therefore "free," silver ions.

right: 289. Photons striking a silver bromide crystal elevate to a higher orbit of energy the extra electrons of the aligned bromide ions, which releases the electrons to travel freely until they have attained a sensitivity speck. The electrical attraction of their negative charges draws the positively charged "free" silver ions, and together these electrical charges balance to make atoms of silver metal. The modest chemical change that such a cluster represents helps to form the latent image in film, which becomes the visible photographic image of the negative, once the silver atoms have had a much more radical change worked upon them by the development process—a change that converts the entire crystal into silver.

electron bromide ion

sensitivity speck

free silver ion

the image. The top emulsion and the antihalation backing are purposely made the same thickness in order to minimize possible curling of the film when it is dried after processing.

Photography is the product of a reaction that occurs between light and the crystals present in general distribution throughout the emulsion layer of film (Figs. 287, 288). The reaction takes place when no more than a single submicroscopic crystal is struck by as few as two of the many billions of photons with which objects in

natural light are bombarded during each passing second (Fig. 289). Each light-sensitive crystal consists of electrically charged atoms of silver and bromine—ions sustained in a cubical arrangement by their electrical attraction. Within the "perfect" abstraction of the cubical form, it is the irregular and impure elements that permit the photographic process to occur. Certain silver ions have an irregular location in the cube, which gives them the freedom to move about. Molecules of "impurities" constitute "sensitivity" spots capable of re-

acting with the vagrant silver ions to form, once the crystal has been struck by light, a collection of uncharged atoms of silver metal. Thus collected, this bit of metallic silver is what, along with countless other such clusters, make the latent (that is, invisible) image present in exposed film. In the development process, chemicals work upon the emulsion in such a way that the metallic silver specks of the latent image function as hooks to which the remainder of the silver becomes attached. By this process is formed the image that appears in developed film — transparent and negative.

Where the negative is dark, exposure and development have converted millions of light-sensitive crystals into metallic silver. These areas of the film have become dense with blackened silver, their density proportionate to the amount of light that struck them. Because of their density, they block, to greater or lesser degree, the passage of light. Where the negative passes more light or passes it freely, little or no silver is present. These areas of the negative do not have density and are considered to be "thin."

Black-and-white film exists in many different types, each of which can be distinguished according to six basic characteristics: *color sensitivity, contrast, light sensitivity, grain, resolving power,* and *acutance.*

Color Sensitivity

Years ago, film had little color sensitivity — that is, ability to respond to certain wavelengths of light in the visible portion of the electromagnetic spectrum — and was therefore unable to represent these tones effectively in black and white. Three photographs of a rural scene (Figs. 290, 292, 294) made with three different films illustrate a gradual improvement in sensitivity to the various colors present (Fig. 588): white clouds against a blue sky; a brilliant red barn and hay wagon; a green band across the center of the photograph representing one crop in the field; and a second crop in the

foreground, which is a tannish and yellowish green. The gray barn roof is held as a constant tone in all three illustrations to demonstrate more clearly the particular color capability of each type of film. The diagrams in Figures 291, 293, and 295 are wedge *spectrograms,* which in this case show the relative color sensitivity of each film to daylight. (There is also a set of spectrograms for tungsten illumination.)

The photo in Figure 290 was made with a film that is oversensitive to blue (Fig. 291) and re-creates the color sensitivity of early photographic materials (Fig. 18). The sky is totally white and lacks any suggestion of clouds. Because the negative was overexposed in order to record elements that are not blue, it was totally opaque in the sky area. Conversely, the reds and greens, which showed little density in the negative, are rendered very dark.

Orthochromatic films represented an improvement over the earliest photographic materials. A dye added to the emulsion made it sensitive to green as well as to blue (Fig. 293), but it was still insensitive to red. Thus, in the photograph reproduced as Figure 292, the green grass and trees appear more natural, but the barn and the wagon remain abnormally dark.

The photograph in Figure 294 was made with *panchromatic* film, which is sensitive to all colors (Fig. 295). Consequently, the barn and the wagon have tone, and the clouds are visible. This is by far the most naturalistic and satisfying rendition.

Contrast

The term *contrast* describes a film's ability to record values of gray — that is, white through gray to black. Films that record only a limited number of values are referred to as *contrasty,* while those that record a greater number of values are considered to be not so contrasty.

A photograph made with a very high-contrast film such as Kodalith (an Eastman Kodak product) records only elements that are either black or white (Fig. 296). This film is normally used in graphic art studios

290–295. Color sensitivity in three different films can be demonstrated in a series of photographs made of a scene composed of white clouds in a vivid blue sky, a bright red barn and hay wagon, a crop of green banded across the center, and a foreground crop in yellowish green (Fig. 588). To illustrate the color capability of each film the gray barn roof was held constant for all three photographs. The wedge spectrograms (Figs. 291, 293, 295) reveal the relative color sensitivity that each film has to the various wavelengths in the visible, or daylight, portion of the electromagnetic spectrum.

far right: 290. Film oversensitive to blue left the sky blank and caused the reds and greens to be rendered dense and dark.

right: 291. Blue wavelengths had a relatively strong effect on the film used for Figure 290.

far right: 292. Orthochromatic film, sensitive to green as well as to blue, also left the sky blank but gave the fields and trees a more plausible appearance.

right: 293. Blue and green wavelengths affected the film used for Figure 292.

far right: 294. Panchromatic film, sensitive to all colors, discriminated tonal differences throughout the picture, even in the sky and clouds.

right: 295. Light waves of all lengths within the visible portion of the electromagnetic spectrum were recorded by the film used for Figure 294.

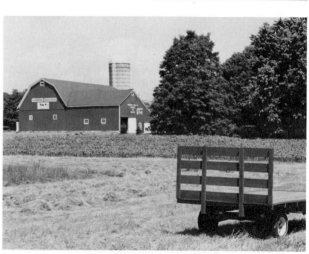

296, 297. Contrast describes the capability of film to record values—white through gray to black.

left: 296. High-contrast film records few values, mostly the elements that are either black or white.

right: 297. Normal-contrast film records a full range of values.

to copy type and to make halftone negatives for photomechanical reproduction. It yields very sharply delineated images—a quality desired by many photographers (Fig. 57). When the same scene is photographed with ordinary film, it reveals a full range of tones from white through gray to black (Fig. 297). The ability of photography to produce this kind of image is basic to the medium and therefore is generally preferred.

Light Sensitivity

The size of the silver halide crystals in a film's emulsion determines other major characteristics of that particular film, among them its light sensitivity or *speed*. The larger the crystals are, the greater the sensitivity, and the other way around. This means that a film with high sensitivity (a *fast film*) requires less light to produce an image than one with low sensitivity (a *slow film*). The various speeds available to the photographer are indicated by *ASA numbers* established by the American Standards Association, which tests films. (The European counterpart is the *DIN number,* for Deutsche Industrie Norm.) The major classifications of film speed, by average ASA (and DIN) ratings, are:

Slow films, about 32 ASA (16/10 DIN), which require a high light level;

Medium films, about 125 ASA (22/10 DIN), which are used in average or normal light situations, such as outdoors on a sunny day, and therefore the most common;

Fast films, about 400 ASA (27/10 DIN), which are needed when the light level is low—for example, on a very cloudy, rainy day or indoors under available light—or when a fast shutter speed is required to stop action;

Extra fast films, about 800 ASA (30/10 DIN), which are used only when the other types of film are too slow—under the dimmest light conditions or when the fastest possible shutter speeds are necessary.

The ASA number of a film is not an absolute. To begin with, manufacturers are usually conservative when assigning any number to a film, because they feel that slight overexposure is less of an evil than underexposure. Moreover, photographers themselves can alter the ASA while processing the film by manipulating variables such as temperature of solutions, developing time, type of developer, and method of agitation (see pp. 209–210).

Grain

In addition to speed, the size of the light-sensitive crystals in a film's emulsion determines the nature of its grain, the textural

298–301. Speed and grain relate to the size of the light-sensitive crystals in a film's emulsion. The larger the crystals, the faster the film; also, the larger the crystals, the more granular the texture of the print yielded by the fast film. A gain in speed means a loss in detail and fine texture, and vice versa.

right: 298. A scene of wide tonal range from which a section was enlarged for Figures 299–301.

far right: 299. Fast film (ASA 400) reveals in enlargement so much grain that the image looks mottled and rough, and fine detail has been lost.

right: 300. Slow film (ASA 32) made possible smoothness and clarity.

far right: 301. Medium-speed film (ASA 125) reproduced some graininess and forfeited some detail.

quality of tones in a print that are produced when microscopic particles of silver clump together during development. A fast film, though highly sensitive to light, is considerably grainier and, hence, less sharp than a slow, fine-grain film. When choosing the best film for a particular situation, then, the photographer must consider not only whether it will give satisfactory exposure under the conditions of available light but also the kind of image it will create. Since it is impossible to attain both maximum speed and the finest visual quality simultaneously, photographers often compromise by using a medium-speed film.

Figures 299 to 301 show a portion of the scene reproduced in Figure 298 as photo-graphed with three different kinds of film —a fast, grainy film; a medium-speed, moderately fine-grain film; and a slow, fine-grain film. Sections of each negative have been enlarged to show the variations in texture more clearly, and a comparison of the enlargements reveals obvious differences in the renditions of the scene. The fast film (Fig. 299) gives the lettering on the sign a mottled, indistinct appearance and makes the smooth, painted wood seem rough. The image lacks sharpness because the grain obscures fine detail. The slow film (Fig. 300) produces a very clear image, whereas the visual quality created by the medium-speed film (Fig. 301) falls midway between the two extremes.

302–305. Graininess relates to the degree of enlargement made from the original size of the negative.

above left: 302. Grain is unobtrusive in a total print.

above right: 303. Grain obtrudes in an enlargement taken from a small section of the negative used for the print in Figure 302.

right: 304. Reduced camera-subject distance, rather than enlarged detail, is the best way to obtain a bust portrait without sacrificing quality.

When enlargement is held to a minimum — that is, when the prints made from a film are much the same size as the negatives — the grain will generally not be noticeable or obtrusive. However, with small film sizes like 35mm, the negatives require such extreme enlargement that grain may inter-fere with the clarity of the image. Three photographs of a young woman leaning against a tree (Figs. 302–304) illustrate this point. Having seen the overall print (Fig. 302), the photographer decided to enlarge a small portion of the negative to obtain a portrait (Fig. 303). This degree of

305. Granular texture can serve aesthetic purposes. This print is an enlargement taken from a small section of a negative made with fast film loaded in a subminiature camera. See also Figure 314.

magnification resulted in such a coarse grain that the woman's face has the consistency of gravel rather than flesh, and her features are indistinct — seldom a desirable quality.

Too often, the novice photographer will attempt to find images by means of the enlarger, rather than the camera. He will put a negative in the enlarger and raise it as high as possible, then hunt about for a portion of the negative that appeals to him. This practice is unfortunate for aesthetic reasons, but it will also have a deleterious effect on the quality of the print. In this case, if the photographer wants a portrait,

he should move his camera closer to the subject and obtain the picture without sacrificing quality (Fig. 304).

Of course, extreme graininess is often employed to create special visual effects. The photograph reproduced as Figure 305 was made with a subminiature camera loaded with fast film, and the camera was deliberately set up in such a way that the figure occupied only a small portion of the tiny Minox negative. Thus, the combination of grainy film plus the drastic enlargement necessary to obtain a picture yielded an altogether exciting, albeit heavily textured, image.

Table 8.1 Common varieties of black-and-white roll film

Speed	ASA	Sizes
Slow		
Adox KB-14	20	35mm
Adox R-14	20	120
Adox KB-17	40	35mm
Adox R-17	40	120
Agfa Isopan IFF	25	120, 35mm
Agfa Isopan IF	40	120, 35mm
Ilford Pan F	50	35mm
Kodak Panatomic-X	32	120, 35mm
Medium		
Adox KB-21	100	35mm
Adox R-21	100	120
Agfa Isopan ISS	100	120, 35mm
GAF (Ansco) 125 Black & White	125	120, 35mm, 126 Cartridges
GAF (Ansco) Versapan Gafstar	125	120
Ilford FP4	125	120, 35mm
Kodak Plus-X Pan	125	120, 35mm
Kodak Verichrome Pan	125	120, 35mm, 110 Cartridges
Fast		
Agfa Isopan Ultra	200	120, 35mm
GAF (Ansco) Super Hypan	500	120, 35mm
Ilford HP4	400	120, 35mm
Kodak Tri-X Pan	400	120, 35mm
Extra fast		
Agfa Isopan Record	400–2,000+	120, 35mm
Kodak Royal-X Pan	1,250	120
Kodak 2475 Recording	1,000–3,200+	35mm

Table 8.2 Common varieties of black-and-white sheet film

	ASA
GAF (Ansco)	
Versapan Gafstar	125
Super Hypan 4 × 5	500
Kodak	
Panatomic-X 6140	64
Plus-X Pan Professional 4147	125
Tri-X Pan Professional 4141	320
Royal Pan 4141	400
Royal-X Pan 4166	1,250

Resolving Power

The resolving power of a film is its ability to distinguish between closely spaced lines. A technique for determining the extent of this ability is to photograph a chart that consists of areas of parallel lines. The distance between the lines ranges by degrees from rather far apart in some areas to very close in others. At some point on the negative the lines can no longer be distinguished as lines, but are seen as a tone of gray. This indicates the limit of resolving power for a particular film. In general, the slower films have the highest resolving power.

Acutance

Acutance is a term that describes a film's sharpness. It is accurately gauged by placing a knife edge on film, then exposing and developing it. The silhouette of the knife edge on the negative is examined with a microscope. Because light scatters when it strikes the silver halides in the emulsion, there is always some gradation of white to black at the boundary between bright and dark areas. The narrower this gradation is, the higher the acutance of the film.

FILM TYPES AND FILM CARE

Tables 8.1 and 8.2 list the more common varieties of roll and sheet films that are presently available. There are many highly specialized sheet films intended for specific commercial needs, but these have not been included in Table 8.2 because they are outside the requirements of most photographers.

Novice photographers too often make a practice of experimenting with several types of film instead of developing a thorough understanding of any single one. Only through a consistent use of a film from one manufacturer can the beginner really perceive any undesirable characteristics it may have and thereby acquire a sound basis for trying another.

The photographer should also bear in mind that film is perishable; after a certain period of time, various components begin to break down, with a resultant loss of both quality and speed. It is therefore advisable to avoid "surplus bargains," since the film is often out of date. Excessive heat and moisture are detrimental to any film. By keeping film in a freezer, one can ensure preservation for a maximum length of time, but, of course, it is not ready for use until it has been thawed completely over a period of several hours. The original wrapping must be left intact to prevent moisture from condensing on the film and ruining it. An alternative is to store film in the refrigerator, where the temperature is low enough to aid in preservation but high enough to permit a warm-up period of only half an hour to an hour.

THE EXPOSURE OF FILM

The amount of black silver that is formed in various areas of a negative, or what is termed the *density* of a negative, is basically proportional to the intensity of the light that struck the film during exposure. A properly exposed negative has an ample deposit of black silver particles in its emulsion and therefore has good density. An overexposed negative has excess density and is frequently called *thick;* conversely, an underexposed negative, which lacks a sufficient deposit of black silver particles and thus has too little density, is referred to as *thin.*

The relationship between exposure and density can be shown diagrammatically by means of the *H & D curve* (Fig. 306), a tool for the study of how light affects light-sensitive materials (*sensitometry*). Named for F. Hurter and V. C. Driffield, who did the initial research in this field, the curve is also used to explain contrast variations in a particular film as a result of changes in exposure and development, as well as differences in contrast and sensitivity among films generally.

In Figure 306 the vertical scale represents the deposit of silver, or the density, and the horizontal scale indicates the degree of exposure. Each number from 1 through

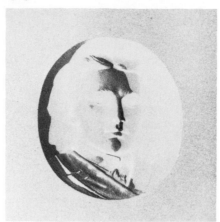
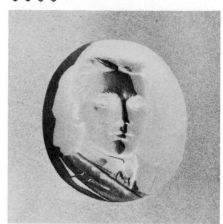

306–311. The density of a negative, or the amount of silver formed in various areas of the negative, is basically proportional to the amount of light that struck the film during exposure.

306. The H & D curve reveals diagrammatically the relationship between exposure and density. For a given film, it is called the *characteristic curve.* The relatively flat *toe* (0–2) and *shoulder* (32–64) indicate that the density of the negative does not invariably increase proportionally with the amount of exposure given to the film. At each point on the exposure scale the amount of light beamed onto the subject was doubled. The varying densities of the resulting negatives can be seen in Figures 307–311, all made with ASA 32 film and the same aperture and shutter speed. (See also Figs. 633, 634.)

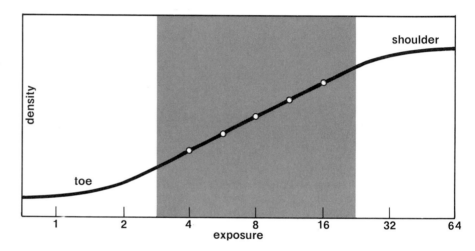

64 represents twice the exposure of the previous number. Between points 1 and 2 on the curve it is evident that an increase in exposure produces very little change in density. This portion of the curve, called the *toe,* would suggest a negative with density in the shadow areas only. Between points 2 and 4 on the curve there is a slight change, and from 4 through 16 the curve rises in direct proportion to the increase in exposure. In other words, any increase in exposure yields a directly proportional increase in density. The negative prints reproduced in Figures 307 through 311, showing a man's face on a tombstone, demonstrate the degree of density one could expect at each point from 4 to 16 on the scale—a steady progression from a pale, faint image to a rather dark one. After point 16, an increase in exposure fails to increase the density, so the curve levels off to form the *shoulder.*

The inability, after a point, to produce a darker tone in proportion to the exposure received is characteristic of all light-sensitive materials and is called *reciprocity failure* (see also pp. 100, 298, 299). It is a special problem when photographing at night, and the photographer may need to increase his exposure by three, four, five, or more times in order to avoid underexposing the negative. The general guidelines cited on page 100 can be used to estimate reciprocity failure for extended exposures. The information is not completely accurate, since the reciprocity factor varies with different types of film, but it provides a helpful guide for situations in which the illumination is low. Light meters do not take reciprocity failure into consideration.

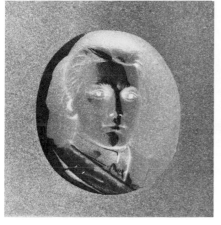

opposite above left: **307. Light equal to 2 bulbs** thickened this negative only slightly.

opposite above right: **308. Light as powerful as 4 bulbs** yielded a negative of this density.

above left: **309. Light power corresponding to 8 bulbs** provided a moderately dense negative.

above center: **310. Light comparable to 16 bulbs** produced a negative of marked density.

above right: **311. Light measurable as 32 bulbs** made a richly dense negative.

below: **312. Extreme overexposure** resulted in a negative so dense that in the print the subject appears as a stark-white silhouette, owing to the utter opaqueness of this area in the negative.

It is evident from the H & D curve (Fig. 306) that a shorter-than-normal exposure, which would fall in the toe portion of the curve, also presents a problem in the relative density of a negative. When using an electronic (strobe) flash, with an exposure of less than 1/1000 of a second, it is generally recommended that black-and-white film be overdeveloped by about 20 percent to compensate for this factor.

The correctly exposed negative demonstrates a full range of tones and yields a natural rendition of the subject. By contrast, an overexposed negative contains areas that may be so dense that light cannot penetrate them; consequently, they appear stark white and devoid of detail on a print. The rather eerie photograph in Figure 312 was produced by posing the subject in the direct path of sunshine so that he received

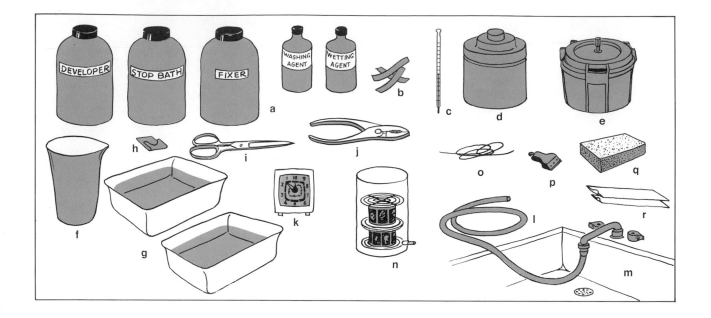

an enormous amount of light. In printing the negative, an attempt was made to compensate for this effect by burning-in (see pp. 267–272) the figure area, but to no avail, since that portion of the negative was so far overexposed as to be totally opaque. In this particular case, the results are rather interesting, for the figure seems to be glowing mysteriously. However, for most situations of this kind—if one were photographing a bride in a white dress, for example—the stark-white effect would not be welcome. Of course, a very small bright area—a highlight—is often desirable, because it lends a sparkling quality to the print within its tonal range.

A thin, or underexposed, negative presents just the opposite appearance. It, too, lacks a full tonal range, but in this case it has a pale, transparent quality. Only whites and light grays are visible, with no dark tones or blacks. A technically poor negative almost invariably yields a print that is unsatisfactory.

FILM PROCESSING

The techniques outlined in this chapter stress the best methods of processing film to achieve consistent and permanent results. The meaning of the word "permanent," however, is a subject of much debate among serious photographers and museum curators. In some commercial situations, a negative and a resulting print that last until they have been reproduced by photomechanical means are considered to have adequate permanence, but other types of photographs might not be regarded as permanent unless they can endure, with no loss of quality, for at least fifty years. Some negatives and prints fade after a few years, while others that were made more than a hundred years ago show no hint of changing. A photographer's lack of foresight during processing can truly be unfortunate, for in later years a seemingly unimportant picture may have historical or aesthetic significance. On a more personal level, ensuring the permanence of a negative or print should be an integral part of the photographer's general concern for excellence in his work.

The ultimate in permanence is achieved by *archival processing*, which can preserve a negative or print for hundreds and perhaps thousands of years. To attain this degree of perfection requires procedures

opposite: 313. Materials and equipment needed to develop roll film:

a. **Chemicals:** developer, stop bath, fixer, washing agent, and wetting agent.
b. **Litmus paper.**
c. **Thermometer.**
d. **Stainless-steel developing tank** and/or
e. **GAF plastic developing tank.**
f. **32 oz. graduate.**
g. **Temperature-control pans** (2).
h. **Film cassette opener.**
i. **Scissors.**
j. **Pliers.**
k. **Interval timer.**
l. **Hose.**
m. **Sink** fitted with faucets mixing hot and cold water.
n. **Film washer.**
o. **Strong twine** or wire.
p. **Film clips** or clothespins.
q. **Viscose sponge.**
r. **Film storage envelopes** made of polyethylene or low-sulfur paper.

and chemicals that are generally beyond the facilities available in most college or other community darkrooms. Of course, the first prints made by a student photographer seldom warrant this degree of preservation, and if at a later time it should become evident that certain pictures do require archival permanence, their life can be prolonged by applying some of the necessary procedures at that point. In general, archival processing is beyond the scope of this book, but some aspects of it are covered under specific topics. (See the Bibliography for sources of a thorough discussion of processing for permanence.)

PROCESSING ROLL FILM

Equipment

The materials and equipment identified in Figure 313 are representative of what is required for developing roll film. We will consider each in the following discussion:

Chemicals The silver halides in a film's emulsion form a latent image when exposed to light. *Developer* is a chemical solution that makes this image visible by breaking

down the exposed crystals and allowing their black particles of silver to clump together. There are so many different film developers on the market that the student photographer is often confused about which to select. In fact, the choice of one over another is generally based more on personal preference than on the inherent advantages of a particular brand. Previously, developers could be divided easily into three categories: fine-grain, all-purpose, and high-energy. However, improvements in both film and developers have made it difficult to distinguish the results produced by all-purpose and high-energy developers. The following brands will yield the finest grain with such films as Kodak Panatomic-X or Adox KB-14:

Rodinal
Edwal Minicol 2
Ethol TEC
FR X-22
Kodak Microdol-X
Edwal Super 20

In order to ensure consistent quality, developers can be used according to either the replenishing system or the one-shot system. The *replenishing system,* applicable to Microdol-X and Edwal Super 20, relies upon a solution that is added to the developer to increase its capacity in proportion to the number of rolls developed. For example, a quart of developer may be able to accommodate six or eight rolls of film before it is weakened to the extent that developing time must be increased. However, a quart of developer plus a quart of replenisher can develop ten to thirty rolls.

The other four developers listed employ the *one-shot system,* in which a rather concentrated stock solution is mixed with water, used once, and then discarded. The solution is always fresh and need not be replenished. Either system is viable, with choice dependent upon preference.

A second group of developers produce medium to fine grain and usually increase the film speed. Most are based on the replenishing system, but a few can be treated as one-shot developers. These include:

Acufine
Rodinal
Clayton P-60
Kodak HC-110
Ethol UFG
FR X-100
Diafine
Edwal FG 7, A & B
Kodak D-76
Ilford Microphen
Promicrol

Some of these, Acufine for one, enable films to be exposed at various ASA film speeds. In a dark situation with Tri-X film, an ASA film speed of 600 to 800 would be sufficient. In very dark situations where maximum film speeds such as 1600 to 2000 ASA are needed, extended development will produce the desired increase.

Diafine is a *two-bath developer* and is unique in that it specifies the same developing time for all films, regardless of speed. It can be used within a temperature range of 70° to 85°F., with a minimum developing time of 2 minutes and a maximum of 8 minutes. Furthermore, there is no prescribed time for any temperature, and the solution never needs replenishing. The film is immersed in the first solution (A) for at least 2 and not more than 5 minutes, then agitated vigorously. Then the film is drained but not rinsed, immersed in the second solution (B) for from 2 to 5 minutes, and agitated gently. One must be careful not to allow any B solution to contaminate the A solution. Finally, the film is drained and placed immediately in fixer, without the usual 15-second stop bath, after which it is washed and dried in the normal manner. The combination of this developer and fast film results in a high ASA film speed without excessive contrast or grain.

Another type of solution is the *monobath developer,* which both develops and fixes the film in one operation. It is manufactured in liquid form and employs the one-shot system. A monobath developer reduces the film speed somewhat and provides lower quality than do conventional devel-

opers, but it is useful when extremely rapid processing is desired. For a variety of reasons, monobath processing chemicals are not readily available for purchase.

Specific information concerning optimum times and temperatures for all the developers listed would not be practical because of rapid changes in technology. The time-temperature chart on page 351 in the Appendices is deliberately left open so the reader can fill in the most current information about the developer he has found suitable for his purposes.

The developers that have been mentioned by name are by no means the only ones available. Many developers and other chemicals appear on the market, enjoy a brief vogue, and then disappear; however, those listed have been popular with photographers for some time and can be expected to endure. As with film and other materials, the beginning photographer should experiment thoroughly with one at a time, rather than jumping from one to another.

In many college or other communal darkrooms where chemicals are furnished, a more economical developer such as Kodak's D-76 is necessary. This will not produce the finest grain with slow films, but it is a good general-purpose developer for average photographic conditions. Its availability in bulk quantities is also a consideration when a large volume of work is produced. Depending on the type of film involved, D-76 is often diluted for use and then discarded. Another versatile developer is Kodak HC-110, which can serve as a one-shot developer—a useful feature when the possibility of contamination exists.

When both roll and sheet films are to be developed, a good choice is D-76 or UFG, both of which are interchangeable. The time required for these solutions to work is ample for the tray method of developing sheet film (see pp. 200–204). Other developers are not so flexible and function best with a single type of film.

Extremely fast films, including Royal-X Pan (120) and 2475 Recording film (35mm),

314. David Vine. *Pears.* 1973. Fast film and high-energy developer produce a granular effect in the printed image, a quality sometimes sought but often considered to be undesirable.

require a very high-energy developer—Kodak's DK-50 or Acufine. DK-50 heightens grain and contrast (Fig. 314), so it is not recommended for normal roll film. Instead, it is typically used to develop sheet film in commercial situations, since enlargements of the already large negative would not in most instances be of a scale to make the grain noticeable. Acufine produces adequate development and yet keeps the grain to a tolerable size.

The *water rinse* merely helps to dilute the developer and physically wash it away. However, the *stop bath* neutralizes it chemically. The stop bath is a dilute solution of acetic acid and can be used for several rolls of film.

The *fixer* stops all development and removes the unexposed silver deposits, thus ensuring the permanence of the image. It contains a hardening agent, which makes the emulsion less susceptible to scratches, and is usually twice the strength of the fixer used for developing prints. Concentrated liquid fixer can be mixed in different ratios to accommodate both film and paper. The fixer, too, can be used for several rolls of film.

A *washing aid* is a chemical that accomplishes two purposes. First, and most important, a washing aid helps to increase the permanence of the image by breaking down some compounds into others that are less detrimental and more readily washed out. Second, when negatives that have been washed for a few minutes are transferred to a washing aid and then washed for a further specified period, the total washing time can be shortened. This is a serious consideration when warm water is limited. Two popular washing aids are Hypo Neutralizer and Permawash.

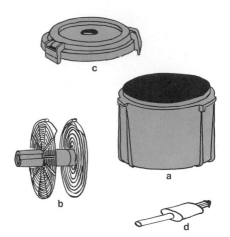

all the air. Each bottle should be clearly labeled and used for one solution only. A single bottle should not be used to hold developer, then fixer, then again developer, for a very small quantity of fixer will contaminate the developer.

Roll Film Developing Tanks　A developing tank is constructed in such a way that liquids can be poured in or drained without removing the lid, thus enabling the photographer to develop roll film with the lights on. *Only the loading of the tank requires total darkness.* Many types and brands are available, but some of the older or the less expensive plastic tanks do not properly accommodate present-day thin films, so the film will not load properly and may wrinkle. There are three basic types of developing tanks suitable for roll film, some made of plastic, others of stainless steel.

The GAF model is a plastic developing tank consisting of four parts: the tank, the reel, the lid, and the agitator (Fig. 315). The reel is adjustable to accept different film sizes. When the two sections of the reel are spread as far as possible, film size 120, the widest of the roll films, can be loaded; when they are pushed close together, the reel can be made to accommodate 35mm film.

Stainless-steel developing tanks include the Nikor and the Kindermann, which consist of a tank, a reel, a lid, a cap, and a lifting rod (Fig. 316). The reels for this type of tank are not adjustable, so a different one must be used for each film size. Stainless-steel reels do not break if they are dropped, and they can be reused immediately. They do not present a problem with dampness, as the GAF film reels do. However, the main advantage of the stainless-steel tank is that it provides for better agitation of the film. Because the lid and cap are essentially watertight, one can invert the tank completely to allow for even development. Also, the tanks are available in different sizes, so more than one roll of film can be processed at a time. An investment in a stainless-steel developing tank and reels is a wise one.

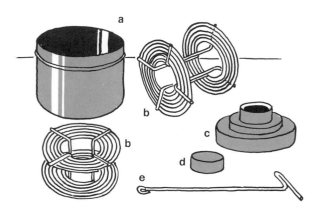

A *wetting agent,* such as Kodak's Photo-Flo, is important in helping the film to dry without water marks, which often produce blemishes on the print. Wetting agents are highly concentrated and must be diluted for use. A prepared solution accommodates many rolls of film.

Containers　Clean polyethylene bottles are available at photographic supply outlets for the storage of chemicals. Discarded bleach bottles made of the same material are not recommended, since plastic is more porous than glass, and any residue of bleach could contaminate the solutions, especially developer. Because oxygen weakens developer, a flexible polyethylene container is particularly useful; before being capped, it can be squeezed until the level of the developer rises to the top and forces out

The Paterson developing tank is similar to the Nikor, but it is made of plastic and is therefore less expensive. It, too, comes in various sizes to permit processing of several rolls of film. The reels are non-adjustable.

Film Cassette Opener The 35mm film cassette opener is a device, marketed by Eastman Kodak, that does exactly what its name implies. A bottle opener or pliers works equally well for this purpose.

Scissors An ordinary pair of scissors about 4 inches long is adequate for most darkroom needs.

Thermometer Since the developing of film is a chemical process, precise reading of the solution temperatures is important, and most cheap thermometers are not sufficiently reliable. The darkroom thermometer should be accurate and easy to read, and it must register quickly. Eastman Kodak offers one model for less than $3.

Graduate (32 oz.) The choice of a graduate depends upon the financial resources of the user. Inexpensive plastic ones can be obtained easily, as can the more expensive stainless-steel type.

Funnel The funnel should be large enough to allow the contents of the developing tank to be emptied rapidly.

Timer The timing of film in the developer is critical, for a variance of half a minute can produce noticeable differences. A wristwatch or clock is accurate but not very convenient, since the photographer must remember when he started and when he should stop. An interval timer with an audible reminder is more effective, and there are two basic types. The least expensive is a windup timer (Fig. 317) that can be set for a predetermined period. By pulling down a lever the photographer activates the timer, and it rings when the time has elapsed. The electric GraLab Timer (Fig. 318) is more accurate and easier to

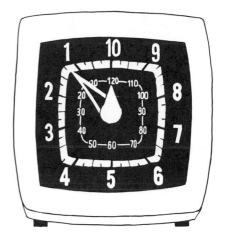

317, 318. An interval timer with an audible reminder is more effective than a wrist-watch or ordinary clock for accurate processing of film and prints.

right: 317. A windup timer is the less expensive of the two types of interval timer.

below: 318. The electric GraLab Timer is accurate, fast, and easy to reset.

reset. This last feature is particularly valuable when the developing process includes a series of steps that must be performed in total darkness.

Film Washer The device for washing film can be chosen according to one's budget. The plastic film washer is most convenient, because it does not require the constant supervision that is necessary if the developing tank is used to wash the film. Even an ordinary plastic juice container (Fig. 363) can be modified to serve as a film washer, but this arrangement demands intermittent attention.

Viscose Sponge A photographic viscose sponge is essential darkroom equipment; the type of sponge used for household cleaning is not suitable.

situation under typical darkroom conditions. It can be altered according to the particular facilities available. Before actually starting, the photographer should organize everything that he is likely to need, in order to avoid confusion and even possible destruction of the film.

1. Assemble the chemicals.
2. Check the developer for contamination (optional).
3. Check the temperature of the solutions.
4. Pour developer into the tank.
5. Set the interval timer.
6. Remove the film from its carrier.
7. Load the film on a reel.
8. Place the loaded reel in the tank.
9. Agitate the film.
10. Drain the developer.
11. Pour in the water rinse or stop bath.
12. Drain the water rinse or stop bath.
13. Pour in the fixer.
14. Drain the fixer.
15. Make the first rinse.
16. Pour in the washing agent.
17. Make the final rinse.
18. Soak in the wetting agent.
19. Remove the film from the reel, hang and wipe it.
20. Dry the film.
21. Rinse the reel and tank.
22. Provide for storage of the negatives.

Film Clips One can purchase stainless-steel clips to hang and weight film while it is drying, but pinch-type clothespins will suffice.

Film Envelopes The use of certain materials for negative envelopes is now seriously questioned. It has been found that brown craft-type paper envelopes and the glue that holds them together have a damaging effect on negatives stored in them for any length of time. The paper has a high sulfur content, which attacks the negative, and the glue can leave marks. Even glassine envelopes can cause trouble. Either a rag paper with low sulfur content or a certain type of plastic envelope produced by the Print File Company is recommended by those seriously concerned with archival permanence of the photographic image.

Procedure for Developing Roll Film on Reels

The following step-by-step procedure for developing roll film assumes an ordinary

Assembling the Chemicals One must be certain that there is enough developer on hand to fill the developing tank, for otherwise only the portions of the film covered with solution will be processed. The photograph reproduced in Figure 319 was taken from a roll of film developed in a three-quarters-full tank.

Containers filled with all necessary chemicals should be assembled before processing is begun (Fig. 320). This preparation is especially important for darkrooms in which chemicals are used by a community.

If the photographer begins to process his film without having the fixer in his possession, he may find that someone else is using it when he needs it. While he is waiting, the film may dry in the tank and become permanently marked. (To prevent such marking the photographer could fill the tank with water, but it is a far better practice to have everything at hand before starting.)

Checking the Developer for Contamination
Chemicals for developing film must be used in the proper order and kept free of contamination. The possibility of such contamination arises most frequently in communal darkrooms, where chemicals are routinely returned to a central container. If someone should accidentally pour fixer into the supply of developer, the developer is ruined, and, unfortunately, this often does not become evident until someone else attempts to process his film. Film that is

processed in contaminated developer is perfectly blank—a total loss.

To prevent such an occurrence, one can check the developer by inserting a piece of litmus paper (Fig. 320). If the paper turns bright green, the solution is free of contamination; if it turns orange, the developer is spoiled. The litmus paper has a pH range of 2 to 10 and is available commercially from supply houses. Such a test is well worth the few seconds it requires.

Checking the Temperature of the Solutions
All chemical solutions used for processing film, as well as the rinse and wash water, should be within the temperature range of 68° to 75°F. Those that are not must be warmed or cooled as necessary (Fig. 321). Subjection of film to drastic temperature changes causes excess grain and, in extreme cases, *reticulation*—the physical cracking or wrinkling of the emulsion. As the photograph in Figures 322 and 323

320, 321. All chemicals necessary to the processing of exposed film should be assembled and checked before development is commenced.

left: 320. Check the developer for contamination by inserting a bit of litmus paper to see whether it turns bright green (indicating a pure solution) or orange (proving contamination).

right: 321. Check and assure a temperature of 68° to 75°F. for all chemical solutions, including rinse and wash, used in processing film. The correct temperature can be obtained by holding the solution-filled bottle under a tap and running hot or cold water over it (Fig. 437). A technique for maintaining temperature is to set the bottles of solution in a temperature-control tray and fill it with water of the needed temperature. Care must be taken not to splash water into the solutions. An important precaution against contamination is to rinse the thermometer just before introducing it into a solution.

322, 323. Reticulation, a cracking of the emulsion, results from the effect upon film of drastic temperature changes that occur during the development process.

left: 322. Fatal effect of reticulation on a negative.

below: 323. Enlargement of reticulation on the negative printed in Figure 322.

tures for whatever brand of developer he may be using. It is important not to attempt to develop film at a temperature outside the range specified; therefore, it may be necessary to warm or cool the developer to some degree. However, provided the temperature falls within the given range, it is easier to vary developing time than temperature.

The chart on page 351 makes a distinction between roll film and 35mm, even though 35mm is, of course, a roll film. This is because 35mm Panatomic-X and Plus-X are most often processed with certain developers, used on a one-shot basis.

Pouring Developer into the Tank　While the lights are still on it is good procedure to prepare the developer tank and fill it with solution so that when the film has been threaded onto the tank's reel it can be immediately and totally immersed in developer. Pouring solution into the tank while the lights remain on eliminates the possibility of the volume of solution being insufficient to cover the film from bottom to top. Also, immersing film into a filled tank permits solution to reach all parts of the film simultaneously, whereas filling the tank after the film has been loaded into it can be slow enough to cause the film to develop unevenly, the unevenness resulting from the solution's having reached some parts of the film before others. Not only should the solution be of the correct temperature when it is poured into the tank, but once poured, it should be stabilized at that temperature. This can be done by standing the tank in a temperature-control pan, pouring into the pan enough water of the correct temperature for the water's level to rise within a half-inch of the top of the developer tank, and then filling the

demonstrates, reticulation is fatal to the image on the negative.

The proper developing time for a given set of negatives depends not only upon the type of film and brand of developer, but on the temperature of the solution as well. A specific amount of time is required for each gradation of temperature between 68° and 75° at which the developer may be used. A sample time-temperature chart is provided on page 351, where the reader can fill in the correct times and tempera-

tank with the developer solution (Fig. 324). After pouring in the developer, the photographer should recap the solution bottle and return it to the temperature-control bath arranged for the chemicals.

Because he will need them in the dark, the photographer should make sure he has all the components of the developing tank at hand (Fig. 325). It is not uncommon for the inexperienced photographer to make all the preparations for developing—turn out the lights, remove the film from its roll or cartridge, load it onto the developing reel, and place the reel in the tank—only to discover that the lid for the tank is missing. This situation can seldom be rectified,

and the film is ruined. Another common problem occurs when the novice photographer has difficulty loading his film onto the reel, gives up, puts the curled film into the tank without the reel, and seeks help. If the tank is a GAF model, which is light-tight only with the reel in place, the film is ruined. However, stainless-steel tanks are light-tight with or without the reels.

Setting the Interval Timer Another practical preparation that can be made prior to extinguishing the lights is to set the interval timer so that it will be ready to function the instant the film has been immersed in developer solution (Fig. 326).

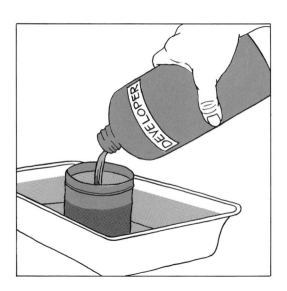

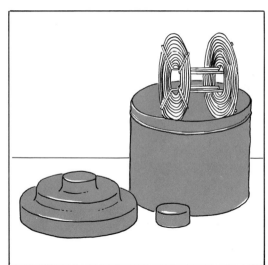

above: 324. Pour developer into the tank. Fill the tank with developer of the right temperature. The temperature can be stabilized by maintaining the filled tank in a temperature-control pan, in which the water level should not rise so high as to overflow into the tank. Recap the solution bottle and return it to the temperature-control bath prepared for the chemicals.

above right: 325. Arrange and account for all component parts of the developer tank—container, reel, lid, and cap—before extinguishing the lights.

right: 326. Set the interval timer so that it will be ready to function the instant the film has been immersed in developer solution.

far left: 327. To unroll the film, pull the short extension of paper backing, which will bring forward the film and cause it to unwind from the spool.

left: 328. Handle the film only by the edges as it curls away from the backing.

below left: 329. Remove the tape that attaches the film to the paper backing at the end of the roll.

327–329. Roll film consists of the spool, the film itself, and the opaque paper backing that prevents exposure while the camera is being loaded and unloaded. In the camera the film winds from one spool onto another. *The transfer of the film from its spool to the developing tank must take place in total darkness.*

Removing Film from Its Carrier Since film is sensitive to all colors of light, it must be unwrapped or removed from its cartridge and loaded onto the developer reel in total darkness. Continuous roll film— as opposed to individual sheet film—comes packaged in three different ways: on a spool, in a cassette or cartridge, or in a drop-in, instant-loading cartridge. The first of these, ordinary *roll film,* is available in many sizes —120, 620, 127, and so on. Each roll consists of the spool, the film itself, and the

opaque paper backing, which prevents exposure while the camera is being loaded or unloaded. The paper also acts as a leader to guide the film through the camera. Numbers on the backing help to prevent an overlapping of exposures when the film is advanced. In an inexpensive camera, these numbers are viewed through a red opening at the back. More expensive equipment does not employ this visual cue, since the film advance is generally automatic.

As the exposed film is unrolled in total darkness, the beginning of the film emerges after a short length of paper backing has been pulled out (Fig. 327). The film curls when it is separated from the backing and should be handled only by the edges in order to prevent fingerprinting (Fig. 328). The tape that attaches the film to the backing must be removed next (Fig. 329). Sometimes there is a spark caused by static electricity, but while this is a bit startling, it causes no harm to the film.

Recently, a new film size called 220 has been introduced. It is the same width as 120 film but twice as long and has a paper leader only at the beginning and end of the film, with no backing between these points. The film is unraveled from the spool and, after the paper leaders have been cut off, loaded in the same manner as regular 120 film. GAF developing tanks will accom-

right: 330. Open the cartridge with lever action from a bottle opener (or special cassette opener) while holding the can by the end from which the spool protrudes.

far right: 331. Cut off the tongue, on the protruding end of the film, at a right angle to the film.

below right: 332. Cut off the opposite end of the film to prevent the tape adhering the film to the cartridge from sticking to any other portion of the film.

330–332. A cartridge or cassette packages 35mm film, which is perforated along the edges with sprocket holes designed to engage with the camera's film advance and exposure-counter mechanism. The container eliminates the need for a paper leader. After exposure, the film is wound back into the cartridge prior to removal from the camera. *Film must be removed from the cartridge and placed in the tank in total darkness.*

modate these long rolls, but 120 Nikor reels generally will not, so special reels must be obtained.

Because it is used for motion pictures, *35mm film* has sprocket holes along the edges. In the camera, these sprocket holes intermesh in a gear mechanism that operates the exposure counter and film advance. Since 35mm film comes in a cartridge, it does not require a paper leader. The actual film is trimmed for a short length so that it can be attached to the camera's take-up spool. After exposure, it is rewound into the film cartridge prior to removal from the camera.

To process 35mm film one must take it out of the cartridge in total darkness. Years ago, Kodak cartridges were made in such a way that merely pounding the protruding end of the plastic spool on a table would remove the opposite flange. Such cartridges were reusable, and similar ones are still available for those who prefer to load their own with bulk film. GAF cartridges, for example, are still reusable and can be opened easily by the pounding method. However, Kodak's present cartridges are used only once and require a tool to open them. An ordinary bottle opener will remove the flange from the end of the cartridge in which the spool is less protruding. A simple lever action is usually sufficient to accomplish this (Fig. 330).

Eastman Kodak also markets a special cassette opener that can be attached to the wall. One slides the cartridge into place and pulls down in the same manner as one would use a wall-mounted bottle opener. The flange comes off to permit removal of the film. Some European films are packaged in screw-off containers.

After removing the film, the photographer carefully cuts off the "tongue" section at a right angle to the film (Fig. 331). The far end should also be cut (Fig. 332)

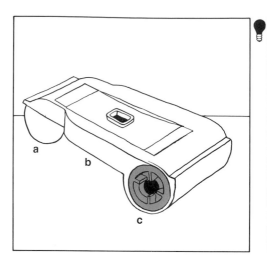

far left: 333. The smooth end of the Instamatic cartridge (a) contains the film, which during exposure passes through a flat section in the center (b) as the gear mechanism on the right (c) causes the film to be wound into that end of the cartridge.

left: 334. Remove the film by holding the flat center portion of the cartridge in the left hand and grasping the right side with pliers. Then separate the film from its paper backing as in Figures 327–329.

333, 334. The 126 Instamatic drop-in cartridge permits instant loading of film into the camera.

to prevent the tape, which attaches the film to the spool, from sticking to any other portion of the film.

The *126 Instamatic cartridge* is a new film system that has been introduced by Eastman Kodak (Fig. 333). As purchased, the film is contained in the left side of the plastic cartridge. During exposure it passes through the central flat section, then moves into the right-hand portion of the cartridge. To begin processing the film, one need open only the right side of the cartridge, an operation that is performed in total darkness. Since in the dark it is difficult to be certain about which part of the cartridge contains the exposed film, one should feel for the gear mechanism (visible in Figure 333), which engaged with the camera to advance the film. The empty side is smooth, which eliminates the possibility of confusion.

The photographer removes his film from the cartridge by holding the flat center part in the left hand and grasping the right side with pliers, then lifting and twisting it (Fig. 334) until it pops open. (A device specially designed to open cartridges is available from Eastman Kodak, but it is intended primarily for photofinishers who handle a large volume of work.) The film is then separated from the paper backing. It is the same width as 35mm and can be loaded onto the developing reel in the same manner.

Loading the Film on a Reel　The plastic GAF developing tank has an adjustable reel, so each size of film is loaded in essentially the same way. It is advisable to set the reel for the proper film size and to be doubly sure that everything is prepared before the lights are turned out.

While grasping the reel, the photographer feels the inside surfaces for the two small bumps that indicate the entrance (Fig. 335). The left hand holds the reel, while the right hand picks up the film and carefully inserts it into the entrance (Fig. 336). The beginning portion of the film can be touched, because there are no images there. However, one must be careful not to crease or wrinkle the film, since this causes marks that will show in the resulting photographs. After the film has been pushed in a short distance, it will stop. The photographer now holds the reel in his right hand, reaches with the left into the space between the two sections of the reel, and pulls the film slightly to move it past the ratchet mechanism (Fig. 337). He then grasps half the reel in each hand and slowly twists the two sides in opposite directions with a back-and-forth motion (Fig. 338). This will operate the ratchet mechanism, which should gradually advance the film onto the reel. During the whole procedure, the film must be kept curled so that it will not be

right: 335. Locate the entrance to the GAF reel by feeling the two small identifying bumps.

far right: 336. Insert the film into the reel entrance, using the right hand while the left hand holds the reel. Push the film in a short distance until it stops.

335–338. Load the film onto the reel of the developing tank. The GAF tank has an adjustable reel that should be set before the lights have been extinguished.

right: 337. Move the film past the ratchet mechanism. To do this, hold the reel in the right hand and with the left hand reach into the space between the two sections of the reel and there grasp the film to pull it forward.

far right: 338. Advance the film onto the reel by grasping the two halves of the reel and twisting them back and forth in opposite directions so as to operate the ratchet mechanism. The reel will feel loose when it has been completely loaded with film.

scratched. After the reel has been twisted for a while, it will feel loose, a signal that the film is completely loaded. The length of the film determines how many twists will be necessary; a 36-exposure roll of 35mm film is 5 feet long, whereas 120 film is only 2 feet long. Even if the reels are perfectly dry, as they should be before loading commences, the long 36-exposure roll can present problems, since friction builds up between the film and the reel, making it difficult to move the roll through the channels. The presence of any moisture

at all will cause the film to stick, whatever its length may be.

The procedure for loading a stainless-steel tank differs in that the reel has a clip on the inside by which to attach the film. Again, before turning out the lights, the photographer should make sure everything is prepared. He picks up the reel in his left hand and, with the right, feels the direction of the metal spiral. His finger should move with the spiral, not against it. Grasping the center of the reel in his left hand, the photographer uses his thumb to push the spring

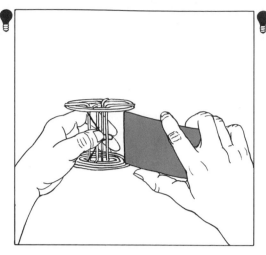

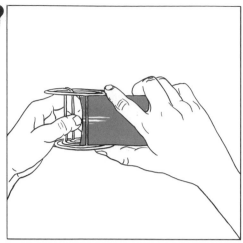

far left: 339. **Press the spring clip down** with the thumb of the left hand that holds the center of the reel.

left: 340. **Insert the film into the clip** with the right hand, making certain the film is centered between the two halves of the reel. The film should be made to buckle slightly, but not wrinkle or crease, as it enters the reel.

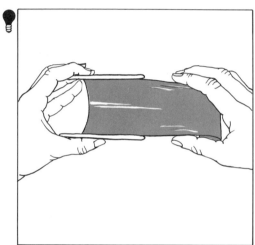

339–342. **The reel of a stainless-steel tank** has a clip on the inside by which to attach the film. While the lights remain on, the photographer should determine the direction of the spiral, by running his fingers along its wires, and make certain the reel is properly oriented to guide the film toward the core of its spiral.

above: 341. **Rotate the reel to wind the film** into the groovelike space between the wires of the spiral. The left hand does this while the right holds the rolled film and slightly buckles the portion moving into the reel.

right: 342. **Creased or wrinkled film** results in a print spoiled by crescent shapes.

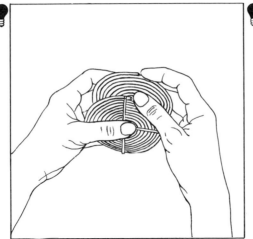
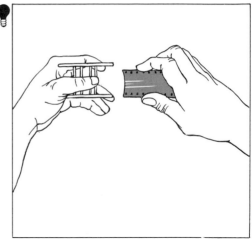

343–345. Load 35mm film onto a stainless-steel reel that has either a spring clip, a hook arrangement, or a slot.

above: 343. The spiral must run clockwise once the reel has been properly oriented. Check this by holding the reel in the left hand with the right feeling the wire end of the reel.

above right: 344. Square-cut film makes the film load straight and prevents jamming in the reel.

right: 345. Insert the film into the core of the reel and rotate it into the innermost spiral, holding the film slightly buckled with the right hand while working the reel with the left hand. Continue until the film has been completely threaded into the grooves of the reel, with the edges of each loop of film fitted into their own spaces between the spiraling wires.

clip down (Fig. 339), while with the other hand buckling the film slightly and gently inserting it under the clip (Fig. 340). He should feel carefully to make certain that the film is evenly spaced in the middle of the reel. Next, while holding the slightly buckled film in his right hand, the photographer uses his left to slowly rotate the reel so as to wind the film into the space between the wires of the spiral (Fig. 341). The buckling should not be so pronounced that it creases or wrinkles the film, since this will create small crescent shapes on the resulting photographs (Fig. 342).

The method employed to load 35mm film onto a stainless-steel reel depends on whether the reel has a spring clip, a hook arrangement, or a slot, as the Nikor has. One should study the instructions accompanying the reel to find out how to use it properly. The photographer holds the reel in his left hand and, with his right, checks to make sure the spiral is turning clockwise (Fig. 343). If it is not, the end of the reel, which is wire, may hook into a sprocket hole, wrinkle the film, and prevent it from loading properly. The end of the film must be cut off at a right angle (Fig. 344), for if it is cut diagonally, the film will not load straight and will eventually jam. Next, the film is gently buckled and inserted into the slot (Fig. 345), and the reel is rotated, slowly and carefully at first, then faster until the roll is loaded. Sometimes the film

ger of scratching the film. An alternative is to reverse the film and load from the other end, so that the wrinkle may work itself out.

The improper loading of film on a reel may cause certain areas of the film to touch and therefore remain undeveloped (Fig. 346). It is a good idea to practice on old film, rather than attempting, in total darkness, to follow unfamiliar procedures with good film.

Placing the Loaded Reel into the Tank
The reel loaded with film should be lowered into the tank filled with developer (Fig. 347). This must be done smoothly, to avoid generating bubbles, but also rapidly so that the part of the film that enters the solution first will not develop significantly longer than the portion entering last. The instant the reel strikes the bottom of the tank, the photographer should start timing the development. Briefly agitating the reel up and down, using the index finger, helps to dissipate whatever air bubbles may have clung to the film. The photographer can then secure the tank with a light-tight cap (Fig. 348) and turn on the lights.

tends to balk. If this occurs, it should be unwound for a few rotations and started over again. Difficulty in loading can also be caused by wrinkles in the film, which sometimes develop when the camera is not handled properly. If the photographer should attempt to advance the film after the entire roll has been exposed, or to rewind film onto the cassette without releasing the rewind control, the film may wrinkle. Then, when he begins to load the film onto a reel for developing, it may jam. In some cases one can merely smooth out the wrinkle with a finger, but this also creates the dan-

far left: **347. Lower the loaded reel into the tank,** smoothly but rapidly, and start the timer. With the index finger, briefly agitate the reel up and down to disperse clinging air bubbles.

left: **348. Cover the tank and turn on the lights.**

349. Air bubbles clinging to film in the developer cause clear spots on the negative that print as dark spots.

Agitating the Film It is important for the film to receive proper agitation, or continuous motion, when it is immersed in any of the solutions, but this is especially critical with the developer. The film should be agitated vigorously at first to dislodge any air bubbles that may occur on the emulsion. Portions of the film covered by air bubbles will not develop; they will appear as clear spots on the negative and as black marks on the resulting print (Fig. 349).

Agitation also ensures that fresh developer is constantly brought into contact with the film. Developer has a tendency to slow down after reacting with the silver halides in the emulsion, thus producing a barrier between the film and fresh developer. All areas of the film should be agitated equally. If, for example, the edges receive more agitation than the center, these portions will be darker in the negative and lighter in the print. In some pictures this effect is not noticeable, but with light-gray tones — in a sky, perhaps — the unevenness is readily apparent. The photograph reproduced in Figure 350 demonstrates the results of improper agitation with the tank method of development. The same scene, made from a negative developed evenly by the tray method (see pp. 194–196), shows the correct rendition (Fig. 351). Often, one can

top: 350. Uneven agitation of film during tank development can produce unevenness in the density of negatives and the prints made from them.

above: 351. Adequate agitation by means of the tray method of development ensures a negative of even density and correct rendition of the image's tones.

compensate for the excessive development by burning-in (see pp. 267–272) during the printing process, but proper development is far preferable.

The construction of the reels and tanks can affect one's method of agitation. For instance, a plastic developing tank like the GAF model cannot be inverted, because its top is not leakproof (Fig. 352). Therefore, the only means of agitation is to turn the agitator knob, which rotates the reel. This tank does not provide the best method of ensuring even agitation, so the film is susceptible to air bubbles. A good way to compensate for this problem is to load the film into a tank full of developer, then lift the reel up and down two or three times to dislodge the air bubbles. Then, the lid can be put on and the remaining steps carried out with the lights on. Many beginners spin the agitator knob constantly, so the negatives are both excessively and unevenly developed. With practice, one learns to agitate the tank consistently at the best speed.

Stainless-steel tanks, such as the Nikor and Kindermann, have watertight lids that permit inversion. Photographers disagree about the most efficient manner of agitation, but literature provided by the manufacturers is very helpful. As a rule, the agitation begins with inverting the tank and tapping it down hard (Fig. 353). There-after, the kind of repetitive motion employed depends on the type of film and brand of developer. Most often, the tank is turned over rapidly for the first ten seconds and then once every minute (Acufine) or twice every minute (Microdol) for the rest of the developing period. If the agitation is insufficient, air bubbles may occur; if too rapid, the edges of the film may become excessively developed. Between agitations the photographer should, of course, return the tank to the temperature-control tray.

Stainless-steel tanks that accommodate more than two rolls of 120 film are not recommended, for they make it difficult to develop the film evenly. Relatively small quantities of film, in which the ultimate in quality is desired, mandate the *tray method* of developing, but when the volume of film is great, the photographer should employ the *tank method*.

Draining the Developer Just before the timer sounds, the photographer should remove the cap from the developer storage bottle set in its temperature-control pan. The instant the signal comes, he uncovers the tank's pouring hole and rapidly drains all solution into the developer bottle (Fig. 354). If using a developer-replenisher, he should pour this into the developer storage bottle before draining the tank. Thus, in

right: 354. Drain the developer tank the instant the timer sounds by removing the cap from the pouring hole and rapidly emptying the solution content into the developer storage bottle. Then return the tank to its temperature-control tray.

far right: 355. Fill the tank with running water controlled at 68°–75°F. Do this through the tank's pouring hole without removing the tank cover. Instead of a water rinse, stop bath can be used.

the event the bottle overflows, it is used developer, rather than replenisher, that will spill. Once emptied of developer, the tank should be returned to its temperature-control tray.

Pouring and Draining the Water Rinse or Stop Bath Through its pouring hole the developing tank is filled with running water, again at a temperature between 68° and 75°F. (Fig. 355). It is then agitated for about 10 seconds and emptied (Figs. 356, 357). This procedure is repeated twice. In between and following these operations, the

tank should be returned to its temperature-control tray. If a stop bath is used, the photographer fills the tank, agitates it for 10 seconds, and then pours the solution back into its container.

Pouring and Draining the Fixer The length of time film should remain in the fixer (at 68° to 75°F.) depends upon the type of film and the brand of fixer involved (Figs. 358, 359). It should never be left in the solution for longer than the specified period, since this will bleach out the image on the negative. Furthermore, the film will be so

right: 356. Agitate the water rinse for about 10 seconds.

far right: 357. Drain the water rinse, and repeat the rinsing, agitating, and draining. Return the tank to its temperature-control tray.

far left: 358. Pour fixer into the tank to overflowing. The solution should have been maintained in the temperature-control bath at 68°–75°F. Time the fixing duration according to instructions provided by the solution's manufacturer for the film used.

left: 359. Agitate the fixer periodically for about 3 minutes.

360. Drain the fixer into the solution storage bottle. Now the tank cover can be removed.

Making the First Rinse A brief water rinse prior to immersion in the washing agent helps to remove excess fixer. When the washing agent normally is used for many batches of film to the point of exhaustion, the rinse will prolong its life. On the other hand, if the washing agent is used only once and then discarded, the rinse will act to remove more of the fixer and increase the permanence of the image. A brief rinse (about 2 minutes) in running water controlled at 65°–75°F. is adequate (Fig. 361). Once the film has been rinsed, the tank and the sink should be drained.

Pouring In the Washing Agent The washing agent increases the permanence of negatives and reduces the time required for the final wash. The exact time will depend upon the brand used. The tank should be filled to overflowing (Fig. 362) and gently agitated from time to time with a back-and-forth movement. The solution can be drained into its storage bottle.

Making the Final Rinse The final rinse, which should be of a generous volume, removes the fixer and washing agent. Too often, inexperienced processors use just a trickle, which is not very effective. The temperature of the water is also important. Cold water, besides presenting the possibility of reticulation, is not sufficiently

saturated with fixer that the final wash will not remove all of it, thus jeopardizing the permanence of the image.

The film should be agitated periodically. After three minutes, the lid can be removed. If the film has been loaded on stainless-steel reels, the photographer can remove it to check the results. Stainless steel permits the reloading of wet film, but the plastic reels do not. Fixer is reusable and should be poured back into its container (Fig. 360). Now the tank cover can be removed, for the film has been fixed against reaction to light, and the tank placed in a sink fitted with faucets for mixing hot and cold water and plumbed to drain.

right: 361. **Rinse the film with water** for about 2 minutes. This should occur in a sink fitted with the faucets adjusted to provide water at 68°–75°F. and plumbed for drainage.

far right: 362. **Fill the tank with washing agent** and let it overflow. Move the tank so as to agitate from time to time for the duration recommended by the solution's manufacturer. Pour the solution into its storage bottle.

active to dissolve all the chemicals that must be removed from the film. In fact, it is better to rinse film for 20 minutes in water of the proper temperature (68° to 75°F.) than to rinse it for hours in extremely cold water. The developing tank is not the ideal container in which to rinse film. Fixer-laden water is heavier than fresh water, so it must be drained from the bottom. An ordinary polyethylene juice container (Fig. 363) with a few holes punched in the bottom serves very well. The amount of drainage should be regulated to allow some water always to flow over the top of the film, so that it is covered at all times. If the developing tank must be used, one should continuously fill, agitate, and drain the tank. In the winter, especially, air bubbles are likely to form when hot water is added to cold, but a periodic raising and lowering of the reel will dislodge them. If they are not removed, the areas of the film that they cover will not be sufficiently washed.

There are also a number of plastic film washers on the market. These are available in different sizes, and the size suitable for two 120 reels or four 35mm reels is recommended. One such washer distributes water at an angle through holes in the bottom of the tank to produce a turbulent type of agitation. Another brand (Fig. 364) has a plastic tube attached to the side of

363. **The final rinse** assures the negative's durability. Transfer the loaded reel from the developer tank to a container perforated at the bottom to drain the heavy, fixer-laden water. Running water controlled at 68°–75°F. must course through the container and over the film for about 20 minutes, flowing over the top and out the bottom. Make sure the film is covered and agitated by the moving water for the whole of the washing period.

364. **Film washer** with a tube to fill the tank with water from the bottom and another to produce bubbles by drawing down air from above the height of the overflow. This prevents air bubbles from adhering to the film's surface.

far left: 365. Soak the film in a wetting agent. To do this, return the film to its tank, pour in solution, and then after 60 seconds drain the wetting agent back into its storage bottle.

left: 366. Dry the film, after removal from the reel, by attaching it to a line and weighting it with clothespins or a clip. Pull the film taut and gently wipe it down with a single stroke on each side, using a sponge squeezed out in a wetting agent. After wiping the film free of wetting agent, let the weighted film dry in a dust-free area.

the washer, the end of which is above the height of the overflow. As water enters the cylinder from the bottom, it draws air down through the tube and produces a bubbling action that eliminates the possibility of air adhering to the surface of the film. Adequate washing is very important for the durability of the image and is one of the major steps leading to archival permanence.

Soaking in the Wetting Agent The film is soaked in wetting agents—for example, Eastman Kodak Photo-Flo—for no longer than 60 seconds, again at the usual temperature. A prepared solution can be used for many rolls of film. For this purpose, the film can be returned to its tank and the tank filled with, then drained of the wetting agent (Fig. 365).

Removing the Film from the Reel The film is removed from the reel and hung up and weighted at the bottom with film clips or clothespins. This must be done gently, because the emulsion will have been softened by the liquid baths. With a sponge moistened in wetting agent, the photographer wipes down the length of the film on both sides (Fig. 366). The sponge should be well squeezed, not dripping. Next, the excess wetting agent is wiped off so that the film will dry evenly and free of water marks. It is dangerous to use a community-owned

sponge, for if it is accidentally dropped on the floor, it may pick up dirt that will scratch the film. When many people use the same darkroom, each one should have his own sponge, which must be squeezed dry after use, wrapped in plastic wrap, and stored in a dust-free area.

Drying the Film When it is hung up to dry, the film should have a clothespin or film clip attached to the bottom in order to prevent it from curling excessively (Fig. 366). The film will curl a bit in the early stages of drying, but it will straighten out when it is fully dry. If the film were not weighted in this way, two areas of the emulsion might contact one another and form a perfect bond. The attempt to separate them after drying would rip the film or remove parts of the emulsion, thus destroying the images.

Film should be dried in a room or cabinet that is dust-free and not subject to extremes of temperature, preferably away from heavily traveled areas. Otherwise, people walking past will create air currents that may deposit dust, dirt, and miscellaneous impurities on the film while it is still wet. If such particles remain on the negative when it dries, they become imbedded in the emulsion and print as white spots. It is almost impossible to remove dust and dirt once the film has dried, even

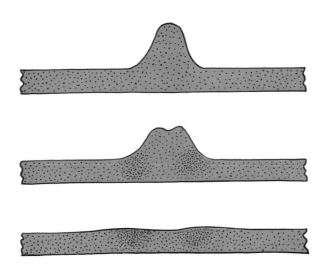

right: 367. **Raised surface of film** caused by water-spotting a dry negative.

center right: 368. **Altered silver halides** resulting from a dried water spot.

below right: 369. **Relocated silver halides,** the consequence of a dried water spot, affect the way the film passes light.

by resoaking in wetting agent. The center area of a room, away from windows, usually is more free of dust and temperature changes.

As soon as the film has dried thoroughly, it should be removed from the drying area or cabinet. This is not so important in the privacy of one's personal darkroom, but it is vital in community situations, because other people are not always careful in placing and removing their film. All too often, while someone is hanging his wet negatives in the drying area, he will splash water on dry negatives nearby and cause the surface to rise (Fig. 367). When this portion dries, it shrinks back to near normal size, but the arrangement of silver particles has been altered (Fig. 368). This new grouping will in turn affect the way in which light passes through the negative in printing (Fig. 369), and the resultant photograph will have light areas that are difficult to correct by spotting. The best procedure is to wet the entire negative immediately in wetting agent, wipe off the excess, and hang it again to dry. There is also the danger of film accidentally being knocked to the floor. If this happens, the damp negatives will become filthy, possibly beyond repair.

Rinsing the Developing Tank and Reel Both the reel and the tank must be rinsed in running water, so that no wetting agent will carry over into future batches of developer and contaminate them.

Caring For the Negatives Each negative should be respected as a crucial part of the aesthetic experience the finished photograph offers the observer. If it is of poor quality, whatever potential interest the image might have held will be destroyed. It is important, therefore, to care for the negative properly. Negatives are extremely delicate—easily wrinkled and highly susceptible to scratches. A scratch appears as a black mark on the photograph and is permanent. It is usually too difficult to retouch the small negatives from roll film cameras. Dirt or lint can be brushed or blown off a negative before it is printed, but fingerprints are hard to remove without damaging the film. A wad of cotton moistened with carbon tetrachloride or pure alcohol will help to remove prints and smudges, but prevention is easier than cure. Film should be handled only by its edges at all times.

After drying, the film should be cut into strips about 6 inches long. One should not cut each negative individually, because the tiny segments would be difficult to handle. As mentioned previously, the negatives should be stored in polyethylene or low-sulfur rag envelopes. Above all, they must be kept in a clean, dry place.

Alternate Methods for Developing Roll Film

The Deep Tank Method The deep tank method for developing roll film is used primarily by small-volume photofinishers. It enables one to process a large quantity

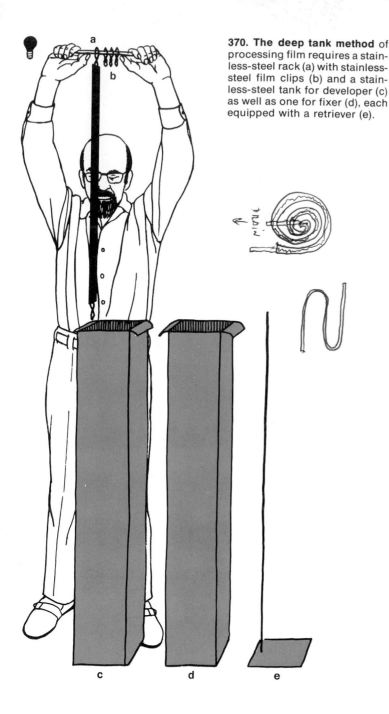

370. The deep tank method of processing film requires a stainless-steel rack (a) with stainless-steel film clips (b) and a stainless-steel tank for developer (c) as well as one for fixer (d), each equipped with a retriever (e).

of solution. With some brands of developer, the cost for such an amount is rather high, but with care—that is, with an airtight floating lid—the solution can be used for many months. New tanks are quite expensive, but they can often be found secondhand or even fabricated of Plexiglas. One tank is used for developer, a second for fixer. The retriever is necessary to recover film when it rips off the top clip and falls to the bottom of the container.

The size of the tanks determines how many rolls of film can be developed at once. For example, average-size tanks might accommodate six rolls of 120 film. Tanks of this sort will also accept rolls of 620, 127, and 126 (Instamatic) film, as well as 20-exposure rolls of 35mm. However, a 36-exposure roll is rather long and must be looped—attached with a clip at either end and weighted in the center—to fit the tank. Looping reduces the number of rolls that can be developed at once.

The film must be separated from the paper leader in total darkness and attached to one of the stainless-steel clips. Another clip is affixed to the opposite end of the film so that it will hang straight. The loaded rack is then inserted into the developer and slowly lifted up and down to the extent of 1 to $1\frac{1}{2}$ inches to dislodge the air bubbles. After development has been completed, the rack is lifted out, drained momentarily, and inserted into the stop bath. All of these processing steps require total darkness, so practice is essential to avoid dipping the film in the wrong tank or scratching it as it is removed. It is helpful to mark the tanks with luminescent tape. After the film has remained in fixer for a few minutes, the room lights can be turned on. The film is then transferred to stainless-steel reels (Nikor or Kindermann) for the first rinse, neutralizer, and final rinse.

The Tray Method The tray method is suitable for developing 120, 620, 127, 126, and 20-exposure rolls of 35mm film, but 36-exposure rolls are too long to handle. This method was used extensively years ago, when film was not yet sensitive to red,

of film at once with uniform agitation. The necessary equipment (Fig. 370) includes a stainless-steel rack with stainless-steel film clips, additional clips for the bottom of the film, and several stainless-steel tanks, each of which has a retriever.

The tanks measure about 5 by 7 inches and are 4 feet deep. Each requires 7 gallons

371. The tray method of processing film requires four 8 × 10 trays, similar to those used for processing prints. They hold, respectively, water, developer, stop bath, and fixer.

water developer stop bath fixer

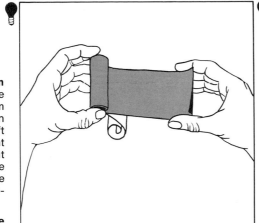

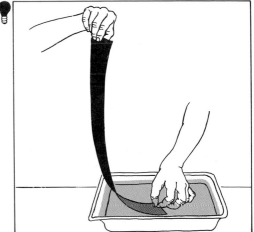

right: 372. Unroll the film by separating it from the paper leader, letting the film roll back on itself, and then grasping the roll in the left hand while with the right hand leading it out for about 6 inches. The direction of the curl should be up so that the emulsion side faces the photographer.

far right: 373. Lower the film into the water bath.

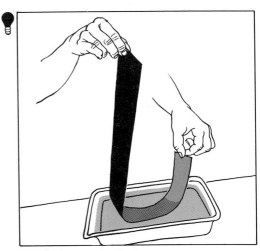

374. Slowly raise the film with the left hand.

and a red safelight could be used to observe the procedures. However, modern films are sensitive to all colors, so they must be processed in total darkness. This makes the tray method rather difficult.

The special advantage of this method is that it permits very uniform agitation. With other developing techniques, there is nearly always a slight overdevelopment at the edges of the film, but this is rarely noticed in the resulting prints. However, in certain types of photographs—such as beach or snow scenes, or landscapes that contain a relatively large area of sky—the lightening at the perimeters would be quite evident. In this case, the tray method is indicated.

The tray method requires four 8 × 10 inch trays, such as those used for sheet film (Fig. 371). The first holds water; the second, developer; the third, stop bath; the fourth, fixer. The film is separated from the paper leader and allowed to roll upon itself. The photographer then grasps it in the left hand and unrolls it with the right for about 6 inches (Fig. 372). The direction

of the curl should be upward, so that the emulsion side is facing the photographer; the film can then be looped more easily. Attempting to unroll the film against its normal curl will cause it to twist and end up in a mess. The film is then placed in a tray of water (Fig. 373) and slowly raised with the left hand (Fig. 374) until one end is out and

left: 375. Raise the film until one end is out while the other remains in the water bath.

right: 376. Reverse the last exercise until the opposite end is out of the water and the other is immersed. Continue for a few minutes to raise and lower the film, in this back-and-forth way, until the film is thoroughly wet and limp and no parts are sticking together. After brief drainage, the same kind of up-and-down agitation should occur first in developer, then for 10 to 15 seconds in the stop bath, and, finally, in the fixer for 1 minute. Thus fixed, the film can be handled in full light and loaded onto a stainless-steel reel for further fixing, the first rinse, the neutralizing washing agent, the final wash, and the wetting agent.

the other is in (Fig. 375). This motion is next repeated in reverse: the left hand is lowered while the right is raised (Fig. 376).

The looped portion of the film must always be covered by solution as it is raised and lowered in a sweeping motion. If the hand raising the film goes too fast, the film will be lifted out of the solution, a situation that is brought to the photographer's attention by the sound of liquid dripping off the film back into the tray. On the other hand, if the lowering is too rapid, the film may overlap and stick together or get scratched. This repeated lowering and raising continues for a few minutes until one is certain that the film is thoroughly wet and limp, and that no parts of it are sticking together. If the film should twist because there is too much slack, it should be pulled taut and subjected to the same procedure all over again. This method of agitation requires coordination, so it is a good idea to practice on old film, with the lights on.

Next, the film is drained momentarily and transferred to the developer, where the same up-and-down method of agitation is employed. Since the motion is constant, the developing time is shorter than that required by the tank method. (Although this is another advantage to consider when trying to determine which method of development is preferable, one should be aware that some developers are not suitable for the tray method, because constant agitation builds up contrast.) Once developed, the film is drained briefly and transferred to the stop bath for 10 to 15 seconds. It is then placed in fixer for 1 minute, after which the room lights can be turned on to view the results. Finally, the film is loaded onto a stainless-steel reel for the remainder of the fixing time, the first rinse, the neutralizer, the final wash, and the wetting agent.

The tray method is rather slow, because only one roll can be developed at a time, but it is often the answer when uniform agitation is necessary. It is also employed by photographers who desire to inspect their film as it is being developed.

377–393. **Sheet film** is stiffer than roll film and must be loaded into a film holder for exposure in a view camera. This can be loaded and unloaded in absolute darkness only.

right: 377. The sheet film holder accepts two sheets (a) on either side of an opaque barrier (b). An opaque slide, black on one side and white on the other (c), fits over each sheet and prevents accidental exposure.

far right: 378. Remove and clean the two slides with a wide, soft, dry paintbrush.

SHEET FILM

Loading the Film Holders

View cameras and press cameras employ sheet film, the common sizes of which are 4×5 inches, 5×7 inches, and 8×10 inches. A few smaller sizes, such as $2\frac{3}{4} \times 2\frac{1}{4}$, $2\frac{1}{4} \times 3\frac{1}{4}$, and $3\frac{1}{4} \times 4\frac{1}{4}$, are also available. Sheet film is stiffer than roll film, so it must be loaded into a *film holder* for exposure. The film holder accepts two sheets, one on each side, separated by an opaque barrier. An opaque slide, black on one side and white on the other, fits over each sheet to prevent accidental exposure (Fig. 377).

Loading a film holder requires absolute darkness; thus, it is wise to organize necessary items while the lights are still on. First, the two slides are removed from the holders and placed on a clean table. The holders should be brushed clear of all dirt, lint, and dust (Fig. 378). A wide, soft paintbrush is helpful for this purpose, and compressed air, if available, is also effective. It is important not to deposit moisture when blowing off the dust orally. Once the holders are clean, the lights must be turned out, so that the box containing film can be opened (Fig. 379). Each piece of film has a notch in the upper right corner, which enables the photographer to identify its type in total darkness (Figs. 380, 381).

379. Extract the film from its box once the lights have been extinguished.

380. Plus-X Pan sheet film, identified by the notching on the upper right edge.

381. Infrared sheet film, identified by its characteristic notching.

In addition to specifying the film size, the notch also helps the photographer to distinguish the emulsion side of the film. Failure to load the film emulsion side up will result in nonexposure. The photographer picks up the film with his right

far left: 382. **Check for emulsion side up** by verifying with the forefinger of the right hand that the identifying notches are in the upper right corner.

left: 383. **Guide the film under both retainers** of the holder, using the left hand.

far left: 384. **Improper loading** occurs when only one side of the film sheet slides under the retainer.

left: 385. **Correctly loaded film** fits under both retainers.

386. **Insert the slides,** white side up, once sheets have been loaded and the hinges folded over (a).

hand—by the edges only—and checks with his forefinger to make sure that the notch is in the upper right corner (Fig. 382). The left hand helps to guide the film under both retainers (Fig. 383). If the sheet can be lifted on one side (Fig. 384), then it is held by one retainer only, and it must be removed and loaded properly (Fig. 385). A piece of film inadequately secured could fall out of the holder into the bellows space of the camera and ruin succeeding shots, unless the photographer looks through the camera between exposures. Once both sheets have been loaded correctly, the hinges are folded over, and the slides are inserted white side up (Fig. 386), to indicate that the film is still unexposed. In the dark, the white side can be identified by a notch or bump on the edge around the tab

right: 387. Place the loaded holder in the back of the camera.

far right: 388. Pull out the slide nearest the lens.

right: 389. Take the picture.

far right: 390. Reinsert the slide, black side up, once the picture has been taken.

391. Remove the holder loaded with exposed film.

of the slide. After both exposures (or if the holder is empty), the black sides should be showing. In this way a holder will indicate whether it is exposed, partially exposed, or empty, thus lessening the possibility of double exposures or of exposing an empty holder. The lights can now be turned on.

The holder is placed in the back of the camera (Fig. 387), and the slide nearest the lens pulled out (Fig. 388). Pulling out the other side would ruin the film by exposing it to light passing through the ground glass. It is important that the shutter of the camera be closed at this time to prevent overexposing and spoiling the shot. Once the picture has been taken (Fig. 389), the slide is reinserted with the black side showing (Fig. 390), after which the holder can be removed from the camera (Fig. 391).

far left: 392. Remove exposed film from the holder in complete darkness.

left: 393. Feel the notch on the under edge of the slide tab to confirm that exposed film is being removed from the holder.

394. Film hangers are used by commercial photofinishers for suspending sheet film in developer.

Developing Sheet Film

Exposed film must be removed from the holder in complete darkness (Fig. 392). If only one sheet has been exposed, the holder should have the black side of the slide facing up before the lights are turned off. By feeling for the edge of the slide tab, one can eliminate possible confusion about which side of the holder contains exposed film (Fig. 393). Many photographers, as a matter of habit, feel the tab before opening a holder, to be sure which side has been exposed.

Several different methods can be used to process sheet film. One consists of loading the film into a plastic developing tank in total darkness, then developing it with the room lights on. However, this procedure is not recommended, since the rather poor agitation results in low-quality development. Commercial photofinishers, to whom volume is a major consideration, employ *film hangers* (Fig. 394) — stainless steel or plastic frames that can hold from one to four sheets of film, depending upon the size of the film and the processing tanks. A number of hangers can be used together, so that ten, twenty, or even thirty sheets can be processed simultaneously. However, volume processing and top quality seldom coexist. Too-vigorous agitation, for example, can produce uneven develop-

ment or mottling along the film edges, because the developer creates turbulence around the hanger's stainless-steel holes.

The most common method calls for each sheet of film to be processed individually, which practice gives the photographer maximum control over quality. For instance, if the tones in a photograph are rather flat, the film processing can be altered to obtain more contrast (see p. 209). Besides permitting flexibility in processing, this method is generally accepted as the best way to obtain evenly developed negatives.

First, the photographer arranges four developing trays in a row (Fig. 395). The first tray at left contains water used to wet the film before development. If one develops only a sheet or two of film, this step may not be necessary, and some photographers question its inclusion altogether. The second tray contains developer. The brand to be used depends upon the kind of film involved, although such developers as D-76, UFG, and Acufine are satisfactory in most cases. The third tray contains a stop bath — water or diluted acid solution. When plain water serves as a stop bath, it should be changed after each batch of film has been processed, since water alone is not particularly forceful in counteracting the effect of the developer. The fourth tray contains the fixer.

water developer stop bath fixer

395. Sheet film development, by the most commonly used technique, requires that four trays of solution be arranged in advance—water, developer, stop bath, and fixer, all stabilized at a temperature of 68°–75°F.

As with roll film, the temperature of all solutions should be held between 68° and 75°F. The developing time depends on the specific film and developer involved, so information packed with the solution should be consulted. One must prepare and organize the chemicals before turning out the room lights.

The exposed film is removed from the holders in absolute darkness and placed in a box, such as an empty film box (Figs. 379, 396). The photographer then picks up the film with his left hand and transfers it to the right (Fig. 397), which inserts it into the water (Fig. 398). This operation is repeated for each sheet of film. By following

396. Place exposed film in an empty film box, once it has been removed from the holder.

below: **397. Lift one sheet of film with the left hand** and transfer it to the right hand suspended over the water tray.

below right: **398. Immerse the film in water,** keeping the left hand dry.

far left: 399. **Arrange sheets into a pile** in the water.

left: 400. **Pull the bottom sheet out.**

far left: 401. **Place it on top.**

left: 402. **Press the entire pile down** into the water. Continue shuffling the sheets until all are wet and none sticking.

such a procedure, the photographer allows his right hand to be wet, while the left always remains dry. A wet hand should never be used to remove film from the box, because it may splash water on other sheets and cause them to stick together, and they can seldom be separated without destroying the image. The number of sheets that can be developed at once depends upon the photographer's level of experience. The beginner should limit himself to two or three, but with practice, six or eight can be handled safely.

After all the film sheets have been placed in the water, both hands are used to arrange them in a pile (Fig. 399). Then, the bottom sheet is pulled out (Fig. 400) and set on the top (Fig. 401), and the entire pile is pushed down (Fig. 402). This operation is repeated until one is certain that all the

sheets are wet and none are sticking. The whole pile of film is then transferred to the developer sheet by sheet (Figs. 403, 404), and the timer, which was preset before the lights were turned off, is started. The same method of agitation is followed during this step, with a continuous and consistent motion.

Once the development has been completed, the photographer, with his left hand, lifts a sheet of film from the tray, holds it momentarily to allow excess solution to drain off, and transfers the sheet to his right hand, which inserts it into the stop bath (Fig. 405). If this procedure is adhered to, the possibility of contaminating the developer is eliminated. When the proper length of time has elapsed, during which the film was agitated by shuffling (Fig. 406), the film is moved sheet by sheet

right: 403. Briefly drain the film sheet by sheet over the water bath and transfer it to the developer.

far right: 404. Immerse the film in the developer, sheet by sheet, start the preset interval timer, and agitate by shuffling with a continuous and consistent movement.

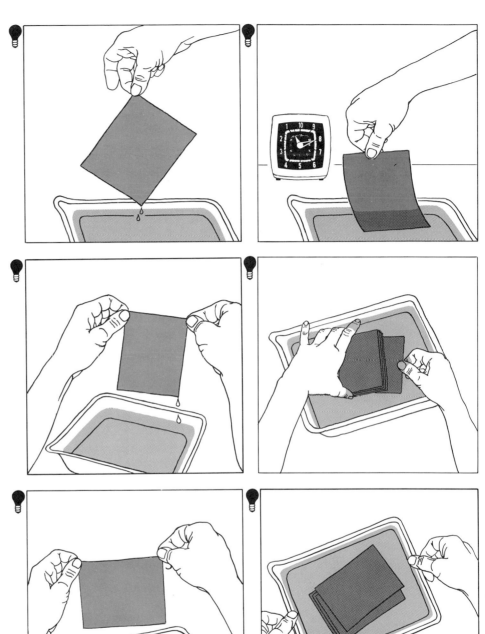

right: 405. Transfer the film to stop bath. To avoid contaminating the developer, proceed by using the left hand to lift one sheet from the developer, letting the film drain briefly over the developer tray, and then shifting the sheet to the right hand for immersion in the stop bath. This must be accomplished gently but at a deliberate speed.

far right: 406. Agitate the film in stop bath by shuffling it for the duration specified for the solution used.

right: 407. Immerse the film in fixer, transferring it there sheet by sheet with the same left-to-right movement employed for the preceding steps.

far right: 408. Agitate the film in fixer for a few minutes; *then turn on the lights and inspect the results.*

to the fixer for a few minutes, after which the room lights can be turned on without risk of reexposing the film (Figs. 407, 408).

One can wash sheet film in several different ways. The simplest method consists of pouring water into a photo tray with a hose and agitating the film in the manner already described (Figs. 409, 410). This method is effective, because it ensures adequate agitation and a sufficient volume of water, but it does require time and attention. Film should never be left unat-

far left: 409. Empty the water tray and begin to fill it with fresh water of the correct temperature (68°–75°F.), using a hose so as to create a swirling movement.

left: 410. Wash the film for 2 or 3 minutes by transferring it sheet by sheet from the fixer into the tray of swirling water. Agitate throughout the washing period.

tended in a tray of swirling water, since it may get scratched by moving about. The corners of sheet film are sharp and can easily damage the soft emulsion.

Film hangers are customarily used in commercial situations, because they allow a greater number of sheets to be accommodated at once. It is all too common, however, for someone merely to place the hangers in a container and let the water flow into it without providing for proper drainage at the bottom. As mentioned previously, fixer-laden water is heavier than fresh water, so it remains at the bottom of the tank and prevents the film from being washed properly. Air bubbles also impede washing when they are allowed to collect on the hangers and film, but they can be dislodged by frequent lifting up and down of the hangers. Some tanks have plastic tubing with very small holes in the bottom, through which a timer periodically sends out a burst of compressed air (Fig. 411). The air rising to the surface carries away any bubbles with it.

After the film has been rinsed for 2 or 3 minutes, the tray containing it should be drained and then refilled for agitation in

411. A film-washing tank fitted at the bottom with small plastic tubes through which timed bursts of compressed air dispel during the washing process whatever bubbles may have collected in the tank.

washing aid (Figs. 412, 413). The length of time it must remain in this solution depends upon the brand, but it is generally about 2 minutes. Next, the film is given a final wash for 15 minutes (Fig. 414) and, finally, immersed in a wetting agent (Fig. 415). Excess solution is wiped off the negatives with a viscose sponge moistened in wetting agent. The negatives are then hung up to dry (Fig. 416) with enough space between them to prevent contact.

The Film Pack

A film pack is a unit that contains sixteen sheets of film. When placed in a *film pack adapter,* it can be inserted into the back of a view or press camera in the same manner as a film holder (Fig. 417). The adapter has paper tabs that are pulled out as each picture is taken to replace exposed film with unexposed. The film pack adapter permits many more shots than a holder, although it is approximately the same width, and it is also less susceptible to tiny light leaks, which sometimes occur in the hinges of a film holder. Also, the problem of maintaining cleanliness, so vital with a holder, is eliminated. Some photographers even prefer the film available in packs to the kind that comes in sheet form, but because it is thinner, it presents greater difficulty in developing. Another problem arises in the

right: 412. Hold the pile of film against the bottom of the tray and drain the tray of water into a sink.

far right: 413. Refill the tray with washing aid and agitate the film for about 2 minutes.

right: 414. The final wash can be accomplished by draining the tray of washing aid, using the technique illustrated in Figure 412, and refilling the tray with water of the correct temperature swirled from the hose. Agitate for 15 minutes; then drain the tray of water.

far right: 415. Wetting agent should then be poured into the tray containing the negatives. After agitating for a few minutes, remove the negatives one by one.

above: 416. Hang the negatives to dry, attaching them to a line, one by one, with clothespins. Wipe the negatives of excess solution by dragging over the surface of each side a viscose sponge squeezed out in wetting agent. Drying should take place in a dust-free area not subject to extremes of temperature.

right: 417. The film pack contains 16 sheets of film that, when placed inside an adapter, can be inserted in the back of a view or press camera. The pack system solves the problem of quantity and cleanliness in photography made with view and press cameras.

far left: 418. Remove exposed film from the pack in total darkness by holding the pack with one hand and pulling the cover in the opposite direction.

left: 419. Lift the pack's top and extract the sheets of film.

far left: 420. Pick up the sheets one by one and buckle them slightly to commence separating each from its paper backing.

left: 421. Separate the film from the paper where the two are taped together.

422. Place the film in an empty film box.

right: 423. The film pack cover (a) has a tab (b) that attaches the cover to the pack (c) by aligning with a notch (d) in the pack itself.

far right: 424. Press the top of the pack down with the left hand to begin closing the pack.

423–427. The film pack can be difficult to close if the mechanism that secures its cover in position is not understood.

printing stage, for the negatives may require trimming to fit the negative carrier or may "pop" during long printing exposures. A glass negative carrier can remedy the situation. A relatively minor problem is the difficulty of selecting specific negatives for development from a group of sixteen. Eastman Kodak has recently introduced a numbering arrangement on the paper tabs, which enables the photographer to make notes sheet by sheet at the time of their exposure.

To remove exposed film from the pack (in total darkness), the photographer holds the pack with one hand and pulls the cover in the opposite direction (Fig. 418). Sometimes a light twisting action helps. Next, the top is lifted, and the sheets are taken out (Fig. 419). They are set in a pile, then picked up one by one and buckled slightly, so that the film begins to separate from the paper backing (Fig. 420). The film is separated from the paper at the point where the two are taped together (Fig. 421), then placed in a box—again, an empty film box —because it is quite flimsy and easily dropped (Fig. 422).

The photographer can remove all sixteen sheets from the pack at once, or he can take out just a few without disturbing the others. For example, if he made only ten exposures and wanted to develop them

immediately, he could open the pack in the normal manner and then feel for the exposed sheets, which would be on top of the pile. Exposed negatives have a ragged edge that is left when the paper tab is pulled off, while unexposed sheets still have their tabs.

Replacing the cover can be a chore if the mechanism is not understood. When the cover is removed, the top of the pack is raised slightly by a spring inside, which maintains pressure on the film during exposure. There is a notch in both portions of the pack, and the cover has a tab, which, when in place, holds the two sections together (Fig. 423). It is not at all difficult to remove the cover, but replacement takes a bit more care, because the notches in top and bottom must be perfectly aligned for the pack to close properly. To close the pack, one holds the top down over the bottom with the left hand (Fig. 424). While the middle finger of the right hand holds down the paper tabs, the thumb and index finger set the cover in position and move it from side to side, so that it straddles the unit. If the corner of the cover enters the space between the two portions of the pack, there will be no movement, and the cover will not fit properly. Two fingers of the left hand are used to hold the cover flat while it is slid into place with a slight twisting action

427. The repositioned and secured cover cannot be lifted from the pack, which makes the pack ready to function for the remaining exposures.

(Figs. 425, 426). When the cover is in its proper position, it cannot be lifted (Fig. 427). The film pack can now be placed back in the holder for the remaining exposures.

The procedures for developing pack film are the same as those described for sheet film. However, in this case a preliminary water bath is even more strongly recommended, because pack film has a greater tendency to stick together. There are special holders for such film, but the tray method is quite satisfactory. The final washing can be accomplished either in holders or in trays; the latter procedure requires constant attention but provides for uniform agitation and eliminates the problem of air bubbles.

DEVELOPING FILM BY INSPECTION

The fact that panchromatic film must be developed in total darkness can prove to be a handicap, for in some cases a negative must be inspected during the processing in order to control the length of the developing time. In fact, some photographers do this as a matter of course. After 50 percent of the normal developing period has elapsed, the negatives can be viewed with a safelight, but reflected light only. One must not hold the film toward the safelight in an attempt to see through it; the film is opaque, and only the surface can be inspected.

This technique works for both roll and sheet film, but sheet film, by nature, is easier to handle. When the photographer tries to cut apart roll film in the dark, he always runs the risk of destroying a negative. Development by inspection is very difficult, requiring both practice and an awareness of how negatives should look when viewed under such conditions. By adding a *desensitizer* to the solution, one can make the process of inspection somewhat easier. A desensitizer renders film partially nonreactive to certain colors of light, and even fairly bright light in one of these colors will not harm the negatives. However, a desensitizer generally requires more initial film exposure, so it is seldom practical. Furthermore, the chemical is not compatible with several of the roll film developers.

THE QUALITY OF THE NEGATIVES

Intensification and Reduction

Nearly every photographer has at one time or another produced negatives that, because of errors in exposure or development, are too poor in quality to yield satisfactory prints. In some cases such negatives can be salvaged through the use of an *intensifier* or a *reducer*. A thin, underdeveloped negative requires intensification, and a thick, opaque one, reduction. However, these procedures should be considered a last resort and introduced only if there is no opportunity to make a new negative. They are difficult to effect and cannot be thought of as a substitute for proper technique.

Intensification increases the opacity of a negative. Basically, it compensates for underdevelopment, with a slight correction for underexposure. The three types of intensifiers are: *subproportional,* which improves opacity in the shadow areas; *proportional,* which helps to correct deficiencies of both exposure and development, and is therefore most commonly used; and *superproportional,* which strengthens opacity in the highlight areas and enhances contrast.

Reduction, conversely, decreases the opacity of a negative. Both GAF and Kodak offer easily mixed preparations, of which there are again three types: *subtractive* or *cutting,* which counteracts overexposure by diminishing silver density equally over the whole negative, so that contrast is not affected; *proportional,* which reduces both contrast and overall density and is used when a negative is too opaque for enlarging; and *superproportional,* which tones down highlights and decreases contrast. The last of these three is rather difficult to control.

Before reduction can be attempted, a negative must be thoroughly fixed and washed. This makes observation difficult, since a wet negative appears somewhat different from a dry one. The photographer should treat one negative at a time, and then wash it immediately afterward. Complete instructions accompany the packaged reducers.

Fast Film

The miniature camera, which has a fast lens and uses fast film, allows a photographer to make pictures without the benefit of supplementary light—that is, flash bulbs or an electronic flash. Photographing by available light yields pictures of realistic quality, since the original situation is more faithfully rendered. Moreover, the subjects are not aware of the camera, so they seem relaxed and unposed. When photographing with available light, the photographer must consider three factors: the *speed of the camera lens,* the *ASA film speed,* and the *film developer* to be used.

This type of photography requires a lens with a maximum f-number of at least f/2 and a fast film, such as Kodak's Tri-X or GAF's Super Hypan. Since film speed is partly dependent on the developer employed, even fast films require a high-energy solution—UFG, Acufine, or Diafine—in order to obtain maximum speed. Some developers can increase the relative film speed by a factor of two and often four times the norm. For example, 35mm Tri-X

film, which has a manufacturer's ASA rating of 400, can be increased to between 800 and 1200 ASA if developed in Acufine, and to between 2000 and 2400 ASA when processed in Diafine.

The ultimate in speed is obtained when Kodak 2475 35mm recording film is developed in Acufine (3200 ASA) or in Kodak's DK-60 (about 4000 ASA). The combination of Acufine with 120 Royal-X film also produces a rating of approximately 4000 ASA. These ratings are necessarily inexact, because they can be affected by the lighting of the subject, the work habits of the photographer, and the photographer's personal taste in negative opacity.

Fast films used in conjunction with high-energy developers often result in rather grainy photographs (Fig. 314). In many instances a slight texture is attractive and desirable, but excessive grain may reduce the sharpness of the image.

In available-light photography the lighting is often very high in contrast and requires a careful meter reading. A hood is necessary to help prevent lens flare. When people are included in a photograph of this kind, the photographer should take a meter reading from a skin tone or, if there is not even enough light for this reading, a white card can be substituted. A correct reading is about two and a half times the exposure indicated by the white card. Above all, one must be careful not to overexpose the negatives. Since available-light photographs use fast film and high-energy developers, they are grainy to begin with, and overexposure tends to increase this effect.

Shutter speeds are generally slow for photographing in available light. Therefore, one must brace the camera during exposure to minimize the possibility of movement. In addition, it is wise to make the exposure at the peak of the action, since motion is least at that point. The combination of camera and subject movement is one of the foremost causes of fuzziness in available-light photographs.

Because maximum f-numbers are used, depth of field is always shallow. Focusing is a special problem; when people are involved, the photographer should focus on their eyes, for if these features are not sharp, the print is generally a failure.

The Print

PHOTOGRAPHIC PRINTS AND PRINTMAKING

Photographic printing is the process that makes possible the conversion of an image developed in negative on transparent film into a positive image with the opaque and permanent substance of paper. Wherever the negative is black the corresponding passage in the print retains the whiteness of paper, since the black will have blocked the passage of light and thus prevented the paper from being exposed. By allowing light to pass, the negative's clear passages cause the corresponding areas in the paper to be exposed and subsequently, once developed, to assume the character of blackness in an infinite range of darker and lighter tonal values (Figs. 428, 429).

Fundamentally, the printing of pictures involves the projection of light through a negative onto paper that has been specially coated with light-sensitive emulsion. After exposure, the procedure for developing photographic prints follows in a general way the methodology described in Chapter 8 for developing film into negatives. First, the paper is placed in a developer, then into a stop bath to arrest the chemical action of the developer, and next in a fixer for the removal of all undeveloped crystals. The final print should be washed and dried. In all, these steps make a fairly complicated sequence that must take place in a darkroom supplied with all necessary materials and equipment.

DARKROOM FACILITIES

The discussion here has been developed around the needs of the individual photographer interested in organizing a workshop for printing pictures at home. For a school or college or for a commercial photographer, the ideal setup would be quite different; in the one instance equipment must be shared and in the other the concern is for great efficiency in the production of fine prints.

The first consideration is space. The most convenient arrangement is not the household bathroom or kitchen but a permanent one in which equipment can be set up and left there for use whenever required (Fig. 430). Any room, such as a guest bedroom, that does not serve daily needs would suffice. For reasons of efficiency, the space should be adequate to contain all equipment, in order and in close proximity. Windows in the room must be made light-tight. This can be done either by cutting mount board to the inner dimensions of the

428. Negative.

429. Positive.

glass and taping it around the perimeter with black plastic electrical tape or by draping over the windows black plastic sheeting like that used for construction equipment. A continuous, unperforated material, plastic sheeting is more light-tight than would be a woven fabric. However, when heated by the sun, it can give off an unpleasant odor, which eventually diminishes. Wherever several people use the darkroom, it may be necessary to arrange access as a light-trap door or a sliding door. The door to a darkroom prepared for use by a single person could be simply weather-stripped or draped to prevent light from entering at the bottom.

430. The darkroom should be a permanent arrangement made ready for use whenever required—a light-tight space adequate to contain all necessary equipment, in order and in close proximity, and furniture with the capacity to provide sufficient working surfaces and storage for materials and tools. The space should be arranged to accommodate both the "wet" processes and the "dry" handling of negatives and prints.

a. **Light-tight entrance.**
b. **Airconditioner.**
c. **Electric outlet.**
d. **Safelights.**
e. **Shelves.**
f. **Drawers and cabinets.**
g. **Sink with drainage.**
h. **Water source.**
i. **Tongs.**
j. **Trays** (5).
k. **Pails** (2).
l. **Timer.**
m. **Sweep-second clock.**
n. **Graduates** (8 oz. and 32 oz.)
o. **Funnel.**
p. **Chemicals for film development.**
q. **Chemicals for print development.**
r. **Table top.**
s. **Enlarger.**
t. **Enlarger easel.**
u. **Enlarger timer.**
v. **Paper cutter.**
w. **Contact printing frame.**
x. **Printing paper.**
y. **Clothesline.**
z. **Clothespins.**

431, 432. Safelights provide enough illumination in the darkroom to permit the photographer to see what he is doing once the bright lights have been extinguished, but they must be appropriate for the particular paper being used.

left: 431. Direct illumination is provided by this type of safelight.

432. Indirect illumination, projected upon the ceiling, is possible from safelights designed like this one.

Despite the implication of the term *darkroom,* the walls and ceiling do not need to be painted black. Even with light-gray or white walls, a room that is light-tight will be dark when the lights have been turned off. Here, film can be handled without fear of exposing (*fogging*) or damaging the print during development. Except when film is being transferred into the developing tank, which must be done in total darkness, a safelight can be used throughout normal darkroom activity.

In addition to space and light-tightness, an important factor of a darkroom is its ventilation. An exhaust fan will do, but an airconditioner can provide ideal conditions.

The darkroom should be divided into a dry area for the handling of negatives and then a wet area for processing (Fig. 430). This precaution can prevent the accidental splashing of chemicals onto negatives. In the dry space it would be well to set aside an area for laying out negatives and printing paper, as well as for a paper cutter and an enlarger. On the wet side should be accommodated an orderly arrangement of five trays: one for the devel-

oper, one for the stop bath, two for the fixer, and a final one for water. Buckets can be used to transport water and chemicals to and from the room. It is also possible to improvise by washing prints in a sink or bathtub.

Several layers of newsprint spread over the work table can absorb liquids splashing from the trays. While pouring chemicals into a sink, the photographer must be sure to open the tap and run water. Otherwise, the chemicals may corrode the plumbing, which could be expensive to repair.

The ideal darkroom provides an abundance of work space, for sorting negatives and reviewing proof sheets, and plenty of shelving, drawers, or cupboards for the clean and safe storage of lenses and condensers. It is especially important to maintain a clean darkroom, for dust and dirt make it difficult to obtain clean prints. Linoleum floor covering, which can be mopped, helps to control the accumulation of dust.

There must be electrical outlets to serve the safelight, the enlarger, and all other electrical equipment. The color and intensity of the safelight should illuminate the darkroom sufficiently to enable the photographer to find what he needs without groping about in a darkness that is too dense and murky (Figs. 431, 432). The light must be safe and appropriate for the type and brand of paper used in the darkroom. This is important, and tests can be conducted to determine whether a light is safe. A simple test is to place a coin on a sheet of photographic paper and expose them to to the safelight for three or four minutes. After development, should the circular area covered by the coin remain white while the surrounding area turns gray, the light is not safe. The problem of too much illumination can usually be solved by moving the safelight farther from the work area, by reducing the voltage of the bulb, or by projecting the light onto the ceiling.

The various pieces of equipment cited and illustrated for Figure 430 are those needed in a fully furnished darkroom. Certain of the items can be dispensed with

wherever economic considerations may seem paramount. A sweep-second clock, for example, could also serve as a timer.

PRINTING PAPER

Printing papers are manufactured in a variety of textures, tones, and surface finishes. By his choice of emulsion the photographer can, for instance, make black-and-white images look golden or silvery, crisp with contrast or softly modulated.

Like film itself, photographic printing paper has been coated with a gelatin or emulsion to make it sensitive to light. Dispersed within the emulsion are the light-sensitive particles, called *silver halides,* that contain chloride, bromide, and iodide. It is these that receive and respond to light transmitted through the clear or gray areas of the image recorded in negative on the film. By turning dark or black, they contrast with the white of the paper and, reversing the negative image, become a positive opaque record of the scene the photographer perceived through the lens of his camera.

Paper emulsions are not as fast as those on film, nor are they *panchromatic;* that is, sensitive to all colors. Because it has been intentionally made *orthochromatic,* or insensitive to red, paper emulsion permits the photographer to work in a darkroom by the minimal illumination of an orange or red safelight.

The immense range of textures, tones, colors, and surface finishes characterizing photographic printing paper poses a temptation to the beginning photographer curious and enthusiastic to experiment with the various brands and types. To avoid the disappointment of waste, confusion, and unpredictable results, it is better, however, to commence with one paper and proceed systematically to another only after the possibilities of the first have been thoroughly investigated and sensitively controlled. Whatever paper the photographer may select, it will be characterized by *image tone, base color, surface lustre, speed, weight,* and *contrast.*

Image Tone

Depending upon the character of the emulsion (the size and form of the silver granules), photographic papers have different tones or tints ranging from reddish brown to black. A paper with a brownish or brown-black tonality is said to be "warm," a quality that results from an emulsion derived from silver bromides. The blue-black tonality possible in paper comes from an emulsion composed almost entirely of silver chloride crystals, and this may produce the coldest effect of all. The immense range in the variety of papers that a photographer can select from and the subtlety of the differences among them are too great to be covered in this book, but the photographer should be prepared to control his work by examining carefully and comparing papers published in the sample books stocked in photographic supply stores. Only after a thoughtful review of the materials and of his own tastes and intentions should he actually place an order for paper.

Base Color

The color of the paper supporting an emulsion varies from off-white through the creams and ivories to pure, gleaming white. The quality that finally affects printed pictures comes from the base color combined with the image tone of the emulsion. An off-white base color, for example, yields a warmer tonality, and to complement this characteristic, such paper usually has a warm emulsion applied to it. Typically, an emulsion of colder tonality coats stock that is stark white.

Surface Lustre

Surface is another aspect of paper that can vary through a wide range of different characteristics. Like color and image tonality, it has a pronounced effect upon the ultimate appearance of the photographic print. *Surface lustre* refers to both texture and finish. Texture can be rough or smooth, resemble burlap, linen, or silk, and have either a

glossy finish or a dull one called *matte*. Many photographers, especially those concerned for portraiture, use paper with a matte finish, for the associations this evokes with the all-rag, handmade papers on which are worked such fine-art products as etchings, engravings, and charcoal sketches. By refracting light, the matte surface dims highlights, suppresses details, and generally reduces the tonal range that emerges with such sparkling clarity when photographs have been printed on paper with a glossy surface. The infinite value variations unique to photography should not be sacrificed for the futile objective of making a photograph look like something it is not.

Speed

The speed of photographic papers varies. Like film, some photographic papers are more sensitive to light than others. Paper suitable for photographic reproduction can be classified into two fundamental categories having to do with the speed of the response the emulsion is capable of making to light. The classifications are:

1. Contact printing paper
2. Projection printing paper (suitable for enlargements)

The first serves for prints in which the size of the image is precisely that found in the negative; the second receives the image only after it has been projected through a lens for purposes of enlargement. Because in contact printing the light source is closer to the paper than would be the case in the enlargement process, contact paper can produce a high-quality, delicate image without the speed necessary for projection paper.

Weight

Photographic papers are available in two thicknesses classified as single and double weight and in a more sheer state called *document weight,* a light paper used only for special purposes. Double-weight paper has, logically, twice the thickness of the single-weight stock that is both more frequently used and less expensive. The heavier paper works better for overscaled enlargements, those measuring 11×14 or 16×20 inches. Being more substantial, it is less likely to suffer the kind of wrinkling that occurs, especially in school laboratories, when a number of prints are washed and dried simultaneously. A wrinkle breaks the emulsion and, since it cannot be repaired, ruins the print. For reasons of economy, however, the beginning photographer should work first with single-weight paper and turn to double weight only after he has gained some experience in printing.

Contrast

The distinctions in value, from deep black through many degrees of gray to white of a high purity, are known as *contrast*. In black-and-white photography, all elements of form, color, light, and texture are registered as variations in value (the element of lightness or darkness, such as shading, that characterizes an image or scene). Such variations, or contrast, are created by the original lighting of a scene or subject, but they can be controlled—suppressed, exploited, or changed entirely—in the process of developing the negative as well as in the choice made for paper and in the technique used to print the negative. A low-contrast paper tends to reduce value variations and to unify all elements of a picture within a limited range of value dynamics (Fig. 433). Its tendency is to smooth and flatten contrast, and the effect can often be seen in portrait photography. High-contrast paper has the capability to dramatize and make more acute the striking blacks and whites of a picture already photographed to be "contrasty" (Fig. 434).

Modern photographic papers can reinforce whatever effect the photographer may wish to create, and most manufacturers make their papers in grades of contrastiness ranging from 0, for softness or low contrast, through 2, considered normal, to 5 or 6, which offers the hardest or most contrasty effect. In addition, such *variable-contrast*

right: **433. Low-contrast paper** tends to yield a limited range of values.

below: **434. High-contrast paper** dramatizes the black-and-white polarities of a photographic print.

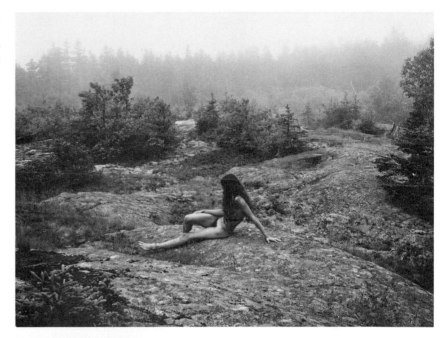

papers as Kodak's Polycontrast and DuPont's Varigam offer the possibility, by means of filtration, of achieving in one paper not only gradations of contrastiness equal to the range of four grades in ordinary paper but also subtle half-step differences, which all together make a potential for some seven distinct degrees of contrastiness. This variety is sufficient to ensure a good-quality print even when made from an under- or over-exposed negative. Because there is no exact correlation between the contrast numbers of different manufacturers, most photographers find it wise to work from one brand.

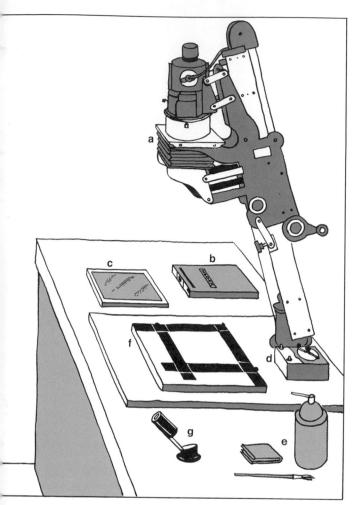

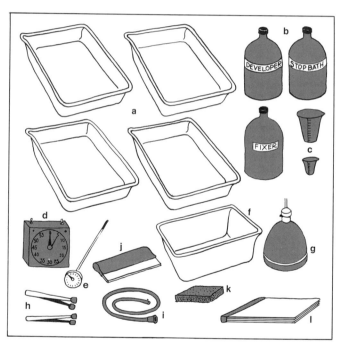

435, 436. Equipment needed for developing prints should be assembled before processing has commenced and while the bright lights remain on:

below: 436. Wet area:
a. Four trays.
b. Chemical solutions.
c. Graduates.
d. Second timer.
e. Thermometer.
f. Temperature-control pan.
g. Safelight.
h. Tongs.
i. Hose.
j. Squeegee.
k. Sponge.
l. Blotters.

above: 435. Dry area:
a. Enlarger.
b. Printing paper.
c. Contact printing frame.
d. Enlarger timer.
e. Cleaning devices.
f. Printing-paper easel.
g. Magnifier for fine focusing.

PRINTMAKING: PREPARATION

The process of developing photographic prints is somewhat similar to that for developing film into negatives. There are, however, differences. Developer suitable for paper is too harsh for film development, and, correspondingly, film developer is too weak for paper. But the stop bath can be the same for both film and paper. So also can the fixer, although usually this solution is less concentrated and contains less of the hardener that helps to strengthen the gelatin component of film.

The chemical solutions necessary for the developing, stopping, fixing, and washing processes in the making of photographic prints are manufactured by many companies, some of which produce developer only, while others offer a complete line of

photographic products. The companies listed below market photographic chemicals:

Acufine Edwal
Agfa-Gevaert Ethol
Clayton FR
DuPont GAF (Ansco)
Eastman Kodak Ilford

Equipment

Because the development process moves along rapidly once the lights have been turned off, it is essential that all equipment and materials be made ready and arranged in orderly fashion while the darkroom remains illuminated. On a work table in the wet area of the darkroom, four trays should be set out and lined up to contain the chemical solutions necessary to process prints through developing, stopping, fixing, and washing (Figs. 435, 436). Also arranged near the trays for immediate use should be a timer, a thermometer, and sets of wood, plastic, or stainless steel tongs needed for agitating the paper prints in their chemical baths and for transferring them from bath to bath. To prevent the contamination of one solution by another, the same tray must always be used for whatever solution has gone into it before. A similar caution should be exercised with tongs. Mistakes can be avoided by labeling the equipment with a felt-tip marker. Owing to deposits of silver particles, the developer tray could turn black. This is not alarming, but periodically the deposits should be removed with Kodak Tray Cleaner.

An important factor is the temperature of the working solutions used for processing photographic prints, with 68–70°F. (room temperature) generally considered to be the most desirable. Water that is too cold cannot sufficiently dissolve the chemical powders, and very hot water darkens the developer, thus reducing the visibility of the emerging image, and changes the competence of the solutions. Through a deliberate modification of the recommended temperature, special effects can be achieved in photographic printing, but this potential

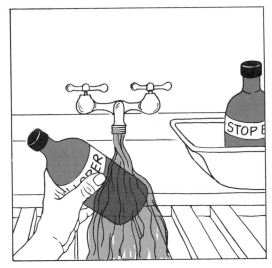

437. Stabilize solutions at 68°–70°F. This can be done by running water of the correct temperature over the storage bottles and then maintaining the bottles in a temperature-control pan filled with water of the correct temperature. Testing should be done with a thermometer.

should be explored only after the photographer has mastered the basic procedures for developing, stopping, fixing, washing, and drying prints. Solutions can be controlled for temperature by placing them, contained in bottles, inside a tray filled with water heated or cooled to bring the solutions to and stabilize them at the temperature needed (Fig. 437). Testing can be done with a thermometer.

"Working" solutions are dilutes derived from chemicals concentrated in dry (powdered) or liquid state. Containers for storing and working with photographic chemicals, whether concentrated or diluted, can be almost any kind of bottle, as long as it is dark in color, can pour easily, and has a cap capable of closing tight against air. All such containers should be labeled for their contents.

Supplies

Developer The most commonly used developers are produced in the form of powder and must be mixed with water to yield a solution. To make the solution, the pho-

tographer should follow the instructions provided by the manufacturer of the powder. Typically, the developer powder is first mixed with enough water to dissolve all dry particles into a liquid concentrate suitable for storage in air-tight containers. Then, at the moment developer is required for actual processing, the liquid concentrate must be diluted into the state of a working solution.

Once in the tray and exposed to air, the developer gradually loses strength, and within a few hours it can turn black with oxidation. This occurs more rapidly as prints are immersed in the solution. Thus, working solutions should be prepared only when the photographer intends to make immediate use of them. Throughout the time the working solution is in the tray and subject to use, it must be checked periodically for temperature and, despite safe-lighting, for color. Prints processed in exhausted developer cannot be of the best quality; usually they lack deep, rich tones and eventually come to appear stained.

The differences among brands of print developer are less marked than among brands of developer suitable for film. Fundamentally, there are but two types of developer made for processing photographic prints on paper: one providing a warm tone, and another capable of giving a cold tone. A warm-toned paper developed in a warm-tone solution results in prints whose tonality is brownish. Cold-toned photographic paper processed in a cold-tone developer yields prints with a blue-black tonality. A standard, commonly used paper developer is Eastman Kodak's Dektol, a product especially well suited to situations requiring large quantities of solution chemicals.

Stop-Bath Solution The purpose of the stop bath is to arrest the action of the developer as soon as it has brought forth the printed image to the photographer's satisfaction. An acetic solution, the stop bath (also called *shortstop bath*) does this by neutralizing the alkaline developer and stabilizing its action. Generally, stop-bath solution derives from glacial acetic acid,

an acid concentrate available in liquid form that can be harmful in the handling and must be diluted to make a less dangerous 28 percent stock solution. To mix stock solution, add 3 parts of glacial acid powder to 8 parts of water, taking the utmost care to prevent the acid from making contact with either skin or eyes. *The acid must be poured slowly into the water, never the water into the acid, for spattering could cause burns wherever it strikes flesh.* This stock solution can be stored in bottles like those used for developer and then prepared as needed for the stop bath. To obtain normal-strength stop bath, dilute the 28 percent stock solution in the proportion of $1\frac{1}{2}$ ounces of liquid concentrate to 32 ounces of water.

Sometimes, in lieu of a chemical stop bath, developer action is arrested simply by flushing the print with water. Stop bath, however, neutralizes the developing agent, instead of merely washing it away, which is enough to make stop bath preferable. Stop-bath solution can be used for many prints. It has become exhausted when the solution fails to remove the slippery coat that developer leaves on the surface of prints. Solution no longer up to full working strength should, of course, be discarded and replaced. Because of the possibility of stains, it is not recommended that an attempt be made to revive exhausted solution by mixing into it an additional quantity of acetic acid.

Fixer The popular but inaccurate designation for fixer is *hypo,* after sodium hyposulfate, the original term used in 1819 for sodium thiosulfate, a chemical compound that acts as a collecting agent for undeveloped silver halide particles. Silver halide particles that have been sensitized by light during exposure are converted by action of the developer into metallic silver. Those not affected by light during exposure and therefore not developed must, because they remain light-sensitive, be removed. Otherwise, they would eventually, once exposed to daylight, begin to change into metallic silver and thus to attack the permanence of

the image. The image becomes fixed when the print has been relieved of all undeveloped silver halide particles.

Available as a liquid or a powder, the fixer offered by most producers now has the form of a liquid concentrate ready for dilution into a "rapid fixer." Often used with fixer is a hardener, especially for the processing of film, this agent serves to fortify the emulsion, which could otherwise soften in high temperatures. The dilution for fixer and hardener should be that specified by the manufacturer.

Wash A final washing of prints further ensures their permanence by removing all fixing solution, which, if left on the prints, could eventually cause them to fade and turn yellow. This can be accomplished with running water whose temperature range does not exceed 65–80°F. A workable arrangement is a tray with a hose attachment, providing water can be supplied in sufficient volume, the temperature range checked and controlled, and the prints hand-rotated throughout the washing period. A way to avoid such a laborious procedure is through investment in a print washer. Machines of this sort range in price from ten to several hundred dollars, and the actual investment should relate to the volume of work required of the equipment. A tray syphon can handle as many as six prints, but a circular stainless-steel washer (the type of equipment often used in schools) has the capacity to accommodate many more prints. A commercial studio might well require a floor-model washer. An archival print washer (Fig. 438), a machine capable of processing prints as large as 16 × 20 and as many as thirty 8 × 10 prints at a time, provides archival permanence.

A print washer keeps prints circulating by power from either water pressure or an electric motor. This constant, gentle movement prevents them from sticking together and allows water to wash over all surfaces. The archival washer solves the problem of prints adhering to one another by containing each print in a separate compartment.

438. An archival print washer can process prints as large as 16 × 20 and as many as thirty 8 × 10 prints at a time.

Because of the heaviness of fixer-laden water, good drainage must be an important aspect of washer design. As water enters the archival washer it mixes with air and generates bubbles whose turbulence causes the fixer-laden water to rise to the top level of the washer, where it can be drained off.

Whenever warm water is scarce, in winter for instance, a washing aid, or "hypo eliminator," can help conserve the supply. This solution permits washing time to be reduced and imparts archival permanence by flushing from the prints all residual chemicals present in paper and emulsion. Washing time can be cut in half by transferring to the washing aid prints that have washed in water for a few minutes.

METHODS OF PRINTING

Contact Printing

Contact printing was the original method of printing negatives, and it remains the process most typically used for negatives of such size (4 × 5 inches or greater) that their images do not require enlargement. This technique consists quite simply of putting photographic paper in contact with a negative and exposing it. For a print to result, the contact must occur between the

439. The emulsion side of film and paper is that toward which both film and paper curl.

440. The simplest method of contact printing utilizes a bare electric bulb and a sheet of thick plate glass, placed on top of the negative(s) arranged emulsion side down, which, in turn, rest(s) upon the emulsion side of the paper. The whole sandwich is pressed against the smooth surface of a table or cabinet top. Above, the light is turned on to make the exposure.

emulsion side of the negative, which is dull, and the emulsion side of the paper, which is shiny (Fig. 439). To repeat:

- Film has an emulsion side that is *dull*.
- Paper has an emulsion side that is *shiny*.

Both film and paper curl toward the emulsion side, which places the emulsion on the inside in the instance of both film and paper and makes it possible to identify the emulsion side for either even in the low illumination of the darkroom.

The ultimate choice of the type of photographic paper used for contact printing depends upon the process to be followed for its exposure, but, as already noted, the speed of contact paper usually is slower than that required for enlargements. The procedures outlined below are recommended because they permit the employment of enlargement paper as well as contact paper, which reduces the variety of equipment needed in a darkroom.

The simplest method of contact printing utilizes a bare electric light bulb and a piece of thick plate glass ($11 \times 14 \times \frac{1}{4}$ inches) that is free of scratches and has had its edges ground smooth. First, the paper is placed on a table emulsion side up; on top of the paper should go the negative with its emulsion side down. Next, the glass presses these in sandwich fashion flat against the table. Finally, the light bulb is turned on to make the exposure (Fig. 440).

A more sophisticated variation of this method can be had by using a *contact printing frame*. Reproduced in Figure 441, this device consists of a wood or metal frame fitted with a spring back that holds negative and paper together under a glass lid. Thus secured in the frame, the paper, whether of the contact or of the enlarging variety, can be exposed either by the light of a bulb suspended from the ceiling or by a beam of light projected from an enlarger.

A contact printing machine equipped with its own light source provides an efficient way to make contact prints (Fig. 442). Here, however, contact printing paper must be used, not enlarging paper, for its

441. **The contact printing frame** is fitted with a spring back designed to hold negative(s) and paper together under a glass lid and secure them for exposure.

slower speed reduces the possibility of an overexposure from the extremely close light source. (In circumstances that make the use of enlarging paper necessary, the photographer can reduce the intensity of the contact printer's normal light by installing bulbs of lower intensity or by placing a sheet of clean white paper on the glass between the light source and the negative.) The negative rests next to the glass, emulsion side up, and on top of it should go the photographic paper, emulsion side down. By the safelight the photographer can see the negative through the paper clearly enough to enable him to center the composition properly. Next, the lid goes down and is locked with a catch, providing such a device accompanies the machine. This holds the negative and paper in firm contact. The contact printer can be activated by a switch designed to regulate the light for exposure.

Many contact printing machines are equipped with more than a single bulb; some offer a whole series of tiny bulbs that can be turned on or off independently to make selected areas lighter or darker (Fig. 443). In this way the contact printing method permits the photographer to accomplish *dodging;* that is, hold back light from certain portions of the negative (see pp. 264–266). It also gives him the possibility of *burning-in,* which allows more exposure in specific areas while protecting the rest of the negative (see pp. 267–272).

A proof sheet is a contact print that reproduces in one assemblage all the nega-

442. **A contact printing machine** is equipped with its own light source. On top of the glass plate go, first, the negative(s), emulsion side up, and, next, the paper, emulsion side down. After clamping down the lid, the photographer effects exposure by activating a switch that controls the light located in the box under the glass plate.

443. **Contact machines equipped with several bulbs** subject to individual control enable the photographer to effect dodging and burning-in.

far left: 444. **Wipe the negatives with a soft cloth** to clean their surfaces of dust particles and fingerprints.

left: 445. Clean the contact frame with a cloth moistened with water or with glass cleaner. Then open the frame all the way so that the glass cover lies back flat on the surface of the worktable.

far left: 446. Insert the negatives, emulsion side up, under the clips along the outer edge of the glass cover. After loading the contact frame with strips of film, *turn off the bright lights and leave on the safelight.*

left: 447. Insert a sheet of printing paper into the slot along the hinged side of the glass cover, making certain to orient the emulsion side of the paper toward the negatives.

far left: 448. Press the paper gently against the negatives and begin to lift the glass cover.

left: 449. Close the frame to secure the negatives and paper in a flat position ready for exposure.

444–452. The proof sheet is a contact print that reproduces in one assemblage all the negatives on a roll of film. It reveals which negatives are worth enlarging into finished prints and prevents excessive handling of negatives by providing a clear, visible record of both negatives and their numbers.

450. Expose the printing paper by the contact methods already discussed (Figs. 440–443) or by means of an enlarger and then develop.

451. Printed contact sheet.

452. Examine the contact print with a magnifying glass and identify, by marking with a grease crayon, the negatives acceptable for enlargement.

tives on a roll of film (Figs. 444–452). Made by any of the methods used to print a single contact print, the proof sheet is an extremely useful intermediate stage in the process leading to final prints. The contact prints on it give much clearer evidence than could a negative, especially in the instance of such small film as 35mm, of which negatives are worth enlarging and making into finished prints. The opportunity to control through selection is particularly worthwhile when the photographer has made many different exposures from the same subject. Since the proof sheet reproduces the whole film, including the frames that bear negative numbers, it provides a good system for organizing negatives. Too, handling proof sheets, rather than searching through film strips, is a safe way to locate a negative by its number while avoiding the risk of damage to a whole collection of developed film.

Enlarging

The process of printing by enlargement, also known as *projection printing,* is a relatively recent development, one that enables the photographer to realize prints scaled larger than the negatives. In contact printing there is a one-to-one relationship

453. The enlarger scales a photographic image to greater size by projecting the image across a space by means of light beamed from a lamp through the negative and a focusing lens and casting it upon light-sensitive paper. The machine consists of a number of parts:

a. The enlarger head houses the light source, the negative holder, and the lenses—all the enlarger's principal working elements.

b. The supporting column connects with the enlarger head in a mechanical way so that the enlarger's main working parts can be adjusted up or down. The distance of the lens from the printing paper determines the scale of the enlargement.

c. The light source can be either an incandescent light bulb or a tubular fluorescent lamp.

d. The condenser system, whether paired convex lenses, or a sheet of diffusing glass, functions to distribute light uniformly over the negative.

e. The negative carrier holds the negative flat and level in a position located between the condenser system and the main, or focusing, lens.

f. The lens bends and controls light rays so as to convey an image to the printing paper placed on the baseboard.

g. The bellows permits the lens to be focused by moving up and down.

h. The diaphragm regulates the amount of light passing through the lens.

i. The baseboard supports both the enlarger's superstructure and the easel designed to hold the printing paper flat, level, and in position to receive the enlarged image beamed through the focusing lens.

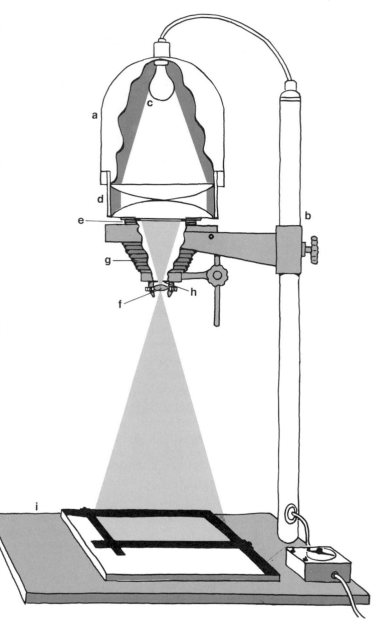

between the size of the print and the size of the negative the print came from, and to have large prints by this method the photographer must first use a large, even cumbersome camera with the capacity for oversize film. Needless to say, contact printing offers a sure way of obtaining the sharpest, clearest image that can be had from film. Nevertheless, today's precision instruments—cameras and enlargers—are capable of transforming small negative images into large prints of good quality. Smaller cameras and film size as well as selection by the intermediary of proof sheets all make possible a remarkable degree of economy in modern photography.

The enlarger is a projector mounted to function vertically from a position adjusted for height and fixed upon an erect column (Fig. 453). The projector sends light through the negative and on into the lens, which optically bends light rays from the

image to fall and focus as an enlargement upon the paper held by the easel at the base of the column sustaining the enlarger. Since it is the distance between the lens and the image it casts upon the printing paper that scales the image and determines the size of its enlargement (Fig. 454), an enlarger must offer to the photographer a mechanical means for controlling this distance. The controls are built into the several elements that together compose an enlarger.

Because it houses the enlarger's principal working parts — its light source, a holder for the negative, and the lenses — the enlarger head connects with its supporting column in such a way that it can be adjusted, by sliding or cranking, up and down the column's vertical length. The light takes its source from either an incandescent bulb or a tubular fluorescent lamp; most often it is the former.

The light from the lamp falls upon a condenser system, arranged as a pair of convex lenses or as a flat piece of frosted (diffusing) glass, which functions to distribute light uniformly over the negative and thus prevent dimness around the edges of the print. A negative carrier, positioned over an opening between the condenser system and the main lens below, holds the negative flat and level. A bellows permits further and more refined adjustment to be made in the distance from the enlarger's main lens to the printing paper. It serves to focus the image clearly upon the printing paper, an operation that occurs by means of a turning knob. Like that in a camera, the enlarger's lens bends light rays to convey an image to the focal plane, which in the instance of enlargement printing is light-sensitive paper. The effect of the lens is subject to control not only by the bellows but also by a diaphragm, which, as in a camera, can be adjusted to regulate the amount of light passing through the lens. The device for adjusting the whole enlarger head higher or lower can take any one of several forms, but typically it works either as a clamp or as a wheel geared to roll in traction and lock into position upon a rail. At the base of the column is a platform that

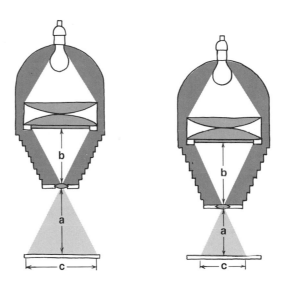

454. The degree of magnification provided by an enlarger depends upon lens-to-paper distance and upon lens-to-negative distance. The longer the distance from lens to paper (a) and the shorter the distance from lens to negative (b), the greater the degree of magnification for the image projected upon the easel (c).

supports both the superstructure of the enlarger and the easel holding the printing paper flat, level, and in proper position to receive the enlarged image beamed by light from the main focusing lens.

Light beamed directly from a lamp to the negative would concentrate in the center of the image and provide less illumination toward its edges. The resulting distortion could be seen as a print either too light at the center or too dark at its perimeter.

Enlargers exist in many different brands and with a variety of control mechanisms, but fundamentally they can be classified according to one of the two basic optical systems developed for distributing light evenly over the entire surface of a negative. Thus grouped, one type of machine is known as the *diffusion enlarger,* the other as the *condenser enlarger.*

The Diffusion Enlarger　In the diffusion system of enlarging images a sheet of frosted or cloudy glass intercepts the light rays beamed from the lamp and by the process of refraction spreads them generally over the entire negative (Fig. 455).

455. The diffusion enlarger spreads light rays more or less evenly over the entire negative and projects them through it by means of a sheet of frosted glass, which refracts light beamed from the lamp.

456. The condenser enlarger gathers rays beamed from the light source and directs them by means of interfaced convex lenses to spread uniformly over the negative and project through it.

Because refraction scatters light rays randomly in many directions, some light rays never reach the negative, while others overlap, and the result is an overall loss of light before it enters the main lens. Therefore, prints made by a diffusion enlarger tend to have softened details and a rather diffused appearance, which effect frequently has been preferred in portraiture. In some enlargers light is diffused from a fluorescent bulb, and in others the diffusion occurs when light is bounced off the inside of a sphere before it passes through the negative. On the grounds that it causes the loss of a certain amount of image quality, a diffusion system is not recommended for the enlarger intended to serve all purposes in the darkroom.

The Condenser Enlarger A superior system for directing light from its source through the negative and into the enlarging lens is one based upon two saucer-shaped lenses, called *condensers,* whose convex sides are interfaced (Fig. 456). This arrangement gathers light and controls it to spread the beams uniformly and project them directly through the negative. The system loses little light and conserves most of it for the printing paper, while the straight line of the projection minimizes the overlapping of light rays. It permits the photographer to realize from small 35mm film printed images that are forcefully true to their negative sources.

Enlarging Lens Because of its importance to the ultimate quality of photographic prints, an enlarger should be purchased only after its capabilities and the individual photographer's purposes have been carefully considered. In general, the quality of the enlarger should match the quality of the camera whose negatives it must enlarge into printed images. The best negatives in the world could not yield fine prints if these are processed by an enlarger equipped with an inferior lens. The enlarger's size should also correspond to that of the film intended to be served by the enlarging equipment. It is the *focal length* of the enlarging lens (the distance over which the lens can project an image and bring it to focus on paper when focus has been set at infinity) that determines the actual degree to which an enlarger can accommodate film of a given size. An enlarger lens designed for a small film size cannot cover the entire area of a larger negative (Fig. 457); con-

Table 9.1 Corresponding film and enlarger lens sizes

Film	Enlarging Lens
35mm, Instamatic	50mm
$2\frac{1}{4} \times 2\frac{1}{4}$	75 or 80mm
$2\frac{1}{4} \times 3\frac{1}{4}$	90–100mm
4×5	135–150mm

versely, a lens intended to work with a larger negative would fail to magnify a small film sufficiently (Fig. 458). Some enlarger lenses have been prepared to function specifically with 35mm film; others are made for 120 film but can also serve for 35mm film. More expensive enlargers can be adapted for use with 4 × 5 film as well as with smaller sizes. Table 9.1 draws a correspondence between film sizes and the focal length of the enlarger lenses needed to cover them adequately.

Enlargers versatile enough to make them suitable for use with a variety of film sizes have interchangeable lenses. When the enlarger is of the condenser type, the condenser lenses must also be modified in some way whenever the enlarging lens is changed. For some adaptable machines a specific set of condensers must be installed to match the focal length of the lens selected; otherwise, light will be distorted to concentrate its greatest brightness at the center of the negative. For others the adaptation can be accomplished by repositioning the condensers or by supplementing them with additional condensers.

above: 457. A too-small enlarging lens cannot cover the entire area of a large negative (left), even when the enlarger head has been lowered to attain the least distance possible between lens and easel (right).

below: 458. An oversize enlarging lens would fail to magnify a small film sufficiently (left), even when the enlarger's head has been raised to realize the maximum distance possible between lens and easel (right).

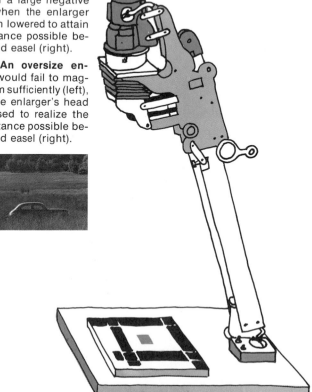

PRINTMAKING PROCESSES

Exposure

After selecting a negative and determining its suitability for printing, the photographer should proceed to prepare it for insertion into the enlarger. First, he must tilt up the enlarger's lamp housing and extract the negative carrier (Fig. 459). This is a frame-like device designed to hold the negative flat, level, and in position over an opening between the condenser, or diffusing glass, and the enlarging lens (Fig. 460). As it is inserted, the image should be centered within the window of the frame. For the image to print right side up, it must be placed emulsion side down in the negative carrier. Most enlargers can accommodate both a negative carrier whose opening is covered with glass and one that is glassless. Glazed or not, the negative carrier consists of two pieces of metal hinged to close over and hold the negative, and since the device frames the image to reveal it through an opening cut to exact size in the two pieces of metal, a negative carrier of the right size must be used with each negative. One that is too small would cover part of the negative's image; one too large would permit light to escape around the edges and have the effect of veiling highlights. In the event only a large negative carrier is available for use with 35mm film, the gap be-tween the frame and the image could be masked to prevent the extraneous light from exposing the paper and to project all light straight through the negative. Some enlargers, such as the Durst, have negative carriers equipped with masking devices. The glazed negative carrier secures the negative firmly in place and does not allow it to buckle even when heated during long exposures. This ensures sharp focus in the print, which is the main reason for its use, despite difficulties in keeping the glass clean.

Cleanliness throughout all operations is essential to success in photography, but neat working habits are never more imperative than in the handling of negatives during the enlargement process. Like the image itself, fragments of lint, specks of dust, stray hair ends, even if so minute as to escape perception by the naked eye, grow along with the image when projected through the enlarging lens and become recorded in the print as unsightly white spots (Fig. 461). A good way to inspect a negative is to hold it at an angle under a strong light, such as that from the enlarger lens after the lamp has been turned on. The uncovered negative held in a glassless carrier is quite easily cleaned by a soft brush dragged lightly over its surface (Fig. 462). Blowing on the film removes loose dirt but can deposit moisture, and the swollen,

far left: 459. Extract the negative carrier after tilting up the enlarger's lamp housing.

left: 460. Insert the negative, emulsion side down, into the negative carrier, a hinged, framelike device designed to hold the negative flat, level, and in position between the light source and the enlarging lens. Center the image within the window of the negative carrier and close the carrier.

raised spots this causes on the surface of the negative appear in the print as blemishes and distortions. The negative can also be cleaned with compressed gas from an aerosol can (Fig. 463). Such a product (Dust-Off, for example) is free of moisture, and a tube fitted to a tiny hole in the container permits the burst of gas to be easily and accurately directed. When the negative carrier is glazed, both the negative and the carrier should be cleaned before they have been joined in the enlarger. To keep it clean as well as free of scratches, a negative carrier fitted with glass should be stored in a box or envelope. Once inserted into a glazed carrier, the negative becomes more difficult to clean, but this can be accomplished with compressed gas.

When the carrier holding the negative has been placed inside the enlarger, the lamp housing can bc lowered (Fig. 464). This clamps the negative into proper position. Now is the time to turn off the room lights and switch on the enlarger's lamp. In a darkened environment images as projected by light from the enlarger can be seen clearly and thus brought to scale (Fig. 465). If the image is dark, the photographer, taking care not to touch the surface of the lens and soil it with his fingerprints, can bring to the image the greatest amount of light by adjusting the aperture to its largest f-stop (Fig. 466). At

461. Specks of dust on the surface of a negative grow along with the image and, once printed, appear as unsightly white spots.

462. Clean the negative with a soft brush to relieve the surface of lint and dust.

right: 463. Compressed gas from an aerosol can is another way to clean the negative.

far right: 464. Insert the film-loaded negative carrier into the enlarger and lower the lamp housing. Next, switch on the enlarger's lamp and *then extinguish the bright lights in the darkroom,* leaving on the safelight.

far left: 465. Scale the image projected upon the bare surface of the easel by raising or lowering the enlarger head.

left: 466. The largest f-stop the enlarging lens is capable of assures maximum light for focusing.

far left: 467. Compose the image on the easel in relation to the inch marks on the masking slides.

left: 468. Focus the image by turning the control knob to raise or lower the lens.

this time, before printing paper has been inserted, the image falls upon the enlarger's baseboard, which holds the easel. Should the easel not have a white surface suitable for focusing, the photographer can introduce a sheet of plain white paper under the easel's masking slides. Ideal in color and thickness, the nonlight-sensitive underside of photographic paper could serve in this operation.

By raising and lowering the enlarger head, the photographer can arrive at the desired degree of enlargement for his image (Fig. 465). A hand crank (on the Omega enlarger) or an electric motor (on the Besseler enlarger) is the usual means for adjusting higher or lower. If the machine is fitted with a spring mechanism designed to help balance the weight of the lamp housing (which usually is the case), it must be released from a locked state before the enlarger head is moved up or down; otherwise, the mechanism could be broken. While scaling the enlargement, the photographer can also move the easel and use the masking slides, with their inch marks, to compose and frame the picture (Fig. 467).

After scaling the image to the desired size, the photographer should then bring the image into sharp focus by turning the knob control that raises and lowers the lens (Fig. 468). Special focusing devices (Fig. 469), permitting the grain of a thin or

right: 469. Special focusing **devices** can magnify the image and help fix the focus finally.

far right: 470. **Reduce the aperture** to a small f-stop and *switch off the enlarger's lamp, leaving on only the safelight.*

471. **Insert a sheet of printing paper,** emulsion side up, under the masking slides on the easel.

dense negative to be magnified up to 200 times, can help fix the focus finally. In the event focusing has changed the image size, it may be necessary to modify the height of the enlarger head and adjust back and forth between size and focus until both have become satisfactory. When they reach this stage, reduce the aperture of the enlarging lens, by a turn of two or three clicks, to a small f-stop (Fig. 470). The smaller opening can compensate for any slight errors that may remain in the focus.

A final step prior to exposure is the removal from the easel of the blank paper used for focusing.

The best way to determine the correct and most effective exposure for a photographic print is to make a test print (see pp. 244–247). To realize maximum benefit from the test, the photographer should maintain consistency with it by using a timer set to match the time established by the test. The timer typical of enlargers has two switches: one to turn on the light so that the image can be projected for scaling, composing, and focusing; another to illuminate the image for a preset duration of exposure. In the last instance, the light switches off automatically; in the first, the light must be extinguished manually. When-

ever a timer is not available, the photographer can use the switch on the electrical cord for turning the lamp on and off while he observes a clock with a sweep-second hand. Although less efficient than a timer, this is a better way to calculate exposure than some such method as the muttering of "one Mississippi, two Mississippi, etc.," in the hope of equalling the number of seconds needed for the exposure.

With no light on but the safelight, the time has come for the photographer to draw one sheet of printing paper from its box, making certain to close the box. The paper, with its emulsion side up, should be slipped into position under the masking slides of the easel at the enlarger's base (Fig. 471).

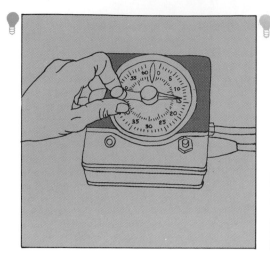

far left: 472. Set the timer for the desired exposure.

far left: 472. Set the timer for the desired exposure.

far left: 473. Make the final exposure by pressing the button to activate the lamp for a preset duration.

Now, all is ready to set the timer (Fig. 472) and switch on the enlarger's lamp for final exposure (Fig. 473). While exposure is taking place, the photographer, rather than just wait for the duration to expire, can do several things to improve the quality of his print. One technique is called *dodging*. Although presented in full on pages 264– 266, dodging can be described here as a process of moving a finger or a tool around over shadow areas in the projected image to block a certain amount of light and thus prevent too much loss of detail through darkening. *Burning-in* offers a reverse process whereby most of the projected image is shielded while highlighted areas receive longer exposure for the purpose of registering the maximum of whatever their detail may be (see pp. 267–272).

Processing the Print

Following exposure of the printing paper, while all illumination but that from a safe-light remains extinguished in the darkroom, the photographer should proceed to develop

474. Fingers contaminated with fixer spoiled this print as it was being placed into developer solution.

right: 475. Develop the print by slipping the paper quickly into the developer solution, controlled at 68°–70°F., and holding it under with the developer tongs.

far right: 476. Agitate by gently rocking the tray throughout the development duration to keep solution flowing over the paper as the picture emerges.

the print with materials and equipment described on pages 218–221 and made ready before the lights went off. As already stated, the process of developing photographic prints resembles that followed for transforming exposed film into negatives. However, like the supplies and arrangements, there are differences relative to film in the way paper must be handled in order to obtain prints. The immersion time for film development lasts from 5 to 20 minutes, but paper, whatever its brand or quality of contrast, develops in no more than 2 minutes.

In the processing of prints through development it would be wise for the photographer to use wood, plastic, or stainless steel tongs for immersing the paper, agitating it in the baths, and moving prints from bath to bath. The chemicals can cause skin irritations and rash; the developer oxidizes to stain fingernails; and fixer chaps skin and even bleaches clothing. Some photographers prefer to wear rubber gloves rather than use tongs, but gloves can prove uncomfortable, and the wearer may have difficulty ascertaining whether they have been wiped clean. Thus, by using his fingers the photographer risks contaminating one solution with another. It was fingers contaminated with fixer that placed a print in the developer and produced the result seen in Figure 474. To avoid such disasters, the photographer must cultivate good working habits from the outset.

Careless use of tongs can also cause the chemicals to contaminate one another. The chemical base of developer is alkaline; that for stop bath and fixer is acidic. Thus, while it would require a large amount of developer to contaminate stop bath or fixer, only a trace of either could ruin the developer. For this reason, tongs used with developer should remain in the developing tray. If by accident they fall into the stop bath or fixer trays, the photographer should rinse them off thoroughly before returning the tongs to the developer. Otherwise, the developer solution could be spoiled. Although the same tongs used for both stop bath and fixer would not ruin the two solutions, it is nonetheless good procedure to reserve one set of tongs for stop bath and one for fixer. Included in the following description of the development processes are methods that can greatly reduce the possibility of chemical contamination.

Developing As soon as the printing paper has been exposed the photographer should use tongs to immerse it quickly but gently and completely in the developer (Fig. 475). To keep fresh solution washing over the print throughout its immersion, he should rock the tray while holding the paper under with tongs (Fig. 476). The

477. Tong-scarred print.

478. Inadequately developed print.

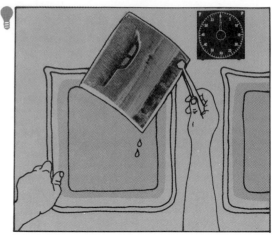

479. Drain the print of excess developer by lifting the print out of the solution and holding it there for a few seconds.

nation of a safelight an image looks darker and could appear fully developed before it is. A good indication of correct development is the evidence of clear detail in both deep shadows and bright highlights. If left in the developer for less than a minute, a print typically looks overexposed and mottled and has a limited range of tones (Fig. 478). Development beyond 2 minutes could cause staining in the print. The print that appears too light after 2 minutes in the developer should be discarded and a new print begun with a longer exposure.

Stopping When developing time has elapsed, the print must be transferred to the stop bath. This can be done by gripping the upper right corner of the print with tongs and holding it above the developer long enough (a few seconds) to allow excess solution to drain back into the developer tray (Fig. 479). The transfer to stop bath is made with the developer tongs, which release the print to slip into the stop-bath solution (Fig. 480). *It is important to return the developer tongs to the developer tray and not lower them into the stop bath* (Fig. 481). Submerge the print in that solution with the stop-bath tongs (Figs. 482, 483).

The stop bath functions to neutralize the developer and halt its chemical action.

agitation must be easy enough not to splash chemicals. Beginners often treat a print brutally and handle the tongs as if they were a harpoon, not realizing that dents made on the reverse side of a print result in ugly black scratches on the surface of the developed print (Fig. 477). The immersion duration should be timed by a clock with a large second hand, according to recommendations made by the manufacturer of the developing materials (usually from 1 to 2 minutes). The photographer can follow the process visually and make a judgment of the effect as it emerges. In the dim illumi-

right: 480. Stop development by allowing the print to slip into the stop bath. *Do not lower the developer tongs into the stop-bath solution.*

far right: 481. Return the developer tongs to the developer tray.

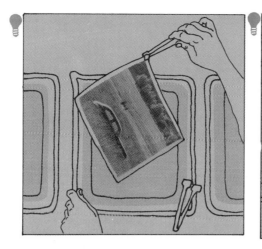

right: 482. Use the stop-bath tongs to press the print under the stop-bath solution.

far right: 483. Agitate the stop bath throughout the time the print remains in it.

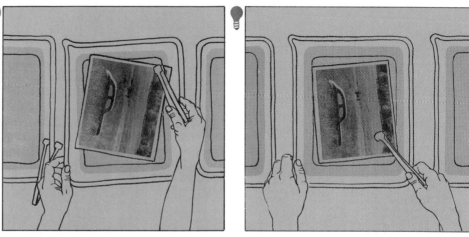

right: 484. Drain the print back into the stop bath.

far right: 485. Fix the image by lowering the print into the fixer solution.

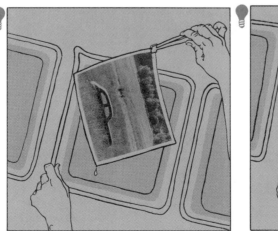
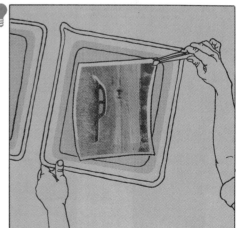

Usually this is accomplished after the developed print has been in the stop-bath solution and agitated slightly for 10 to 15 seconds (Fig. 483). Next, the print is lifted with the tongs and allowed to drain excess solution into the stop-bath tray (Fig. 484). It must then be gripped by the fixer tongs for transfer into the fixer solution or simply conveyed there with the stop-bath tongs (Fig. 485).

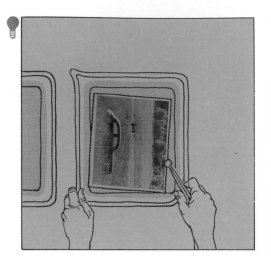

far left: 486. **Agitate the print in fixer** and *turn on the bright lights.*

left: 487. **Examine the print** while holding it in an empty tray.

Fixing After the print has been slipped into the fixer and left there for 1 minute, the strong lights can be turned on in the darkroom (Fig. 486). Immersion time for the fixer stage can last, depending on the brand of the product, from 5 to 10 minutes. It is a good idea for the photographer to agitate the print from time to time while it remains in the fixer.

Two trays of fixer can process the greatest number of prints in a given amount of solution. As prints work through the two trays, the solution in the first becomes exhausted more quickly than that in the second. The second tray then can replace the first while it is supplemented by a tray of fresh solution. The duration for the first immersion of the print should be about 3

488. **Print left too long in fixer.**

right: 489. Wash the print by transferring it to a tray supplied with water circulating from a syphon and hose.

far right: 490. Agitate the print in running water for at least an hour.

below right: 491. Test the washed print's permanence by applying to the border a drop of solution derived from Kodak's HT-2. The paler the stain this leaves, the greater the possibility for permanence.

minutes and for the second immersion about 5 minutes, making total immersion time 8 minutes (for Kodak Rapid Fix). The print exposed to white light before adequate fixing is likely to have veiled highlights and deficient tonal quality. If exposed to white light before fixing, it will immediately turn black. Students sometimes neglect to remove a print from the fixer and return to discover that black particles of silver have bleached out and turned gray areas a pinkish color. Prolonged immersion in fixer solution can destroy a print by causing the image to disappear (Fig. 488). In the fixer, with the lights turned on, is where the finished print can for the first time be given a thorough examination for its ultimate qualities. In a community darkroom, where a number of photographers are working on their prints at various stages in the process of development, it often is not possible to turn on the lights at this point. To examine his work, the photographer can place the print in an empty tray, so as to avoid spilling fixer onto the floor, and take it out of the darkroom and into a fully illuminated area (Fig. 487).

Washing The fixed print should be gripped at a corner with the fixer tongs, lifted from the fixer and allowed to drain over it, and then transferred into the wash (Fig. 489), where it should remain, with water circulating about it, for at least an

hour (Fig. 490). Washing the developed and fixed print in running water serves to cleanse it of all fixing solution and thus ensure the permanence of the image. Photographic prints not thoroughly washed tend to fade and yellow eventually.

After washing, the print's permanence can be tested with a solution derived from Kodak HT-2, itself a residual hypo testing solution. The formula is:

water (distilled)	24 ounces
acetic acid (28 percent solution)	4 ounces
silver nitrate	$\frac{1}{4}$ ounce
water (distilled) to make	32 ounces

Only a tiny amount is needed, applied with an eye dropper to a white area of the print, preferably on the border (Fig. 491). After

492. Squeegee the washed print of excess water. This can be done on a sheet of plate glass or stainless steel or on the bottom of an overturned tray.

493. Dry prints by placing them in the middle of a sandwich of photographic blotters and corrugated cardboard.

494. Blotter rolls offer an efficient means of drying prints.

2 minutes all remaining liquid should be wiped off. The paler the stain that remains, the less the amount of fixer left on the print, and the greater the print's permanence. Characteristic of an archival print is a stain so pale as to be scarcely perceptible.

Drying The washed print can be prepared for drying by using a squeegee or a windshield wiper to remove excess water (Fig. 492). One way to approach this is to place the print facedown on a piece of plate glass or sheet of stainless steel and smooth it out with the fingers to prevent wrinkles. (Wrinkles are more likely to occur in the instance of single-weight paper.) Being careful not to wrinkle the surface, the photographer should squeeze out water by applying the squeegee to the back of the print. Next he turns the print over and follows the same procedure on its face. Once all excess water has been removed, the print is ready for drying.

An uncomplicated way to dry prints is to place them facedown between photographic blotters. Ordinary desk blotters should not be used because they contain lint that could mar the print's surface. Being 19 × 24 inches, photographic blotters can accommodate between layers one 16 × 20 print, two 11 × 14 prints, or four prints measuring 8 × 10 inches. Corrugated cardboard interleaved with layers of blotter provides free circulation of air, thus accelerating the drying process, and prevents wet blotters from adhering to prints and to one another (Fig. 493). It also functions to stiffen the blotters, making it possible to build a stack of layered blotters and prints for the simultaneous drying of a number of prints. Weighted with books, the stack becomes compressed, and after several days drying, prints emerge flat and smooth.

The blotter roll offers another efficient means for drying prints (Fig. 494), providing the photographer can accept prints that, until mounted flat, have a slight curve. The blotter book, made of blotting paper interleaved with tissue paper, can dry prints into flatness, but its limited capacity per-

mits the accommodation of no more than a few prints at a time.

An improvement on the blotter system of drying prints utilizes the blotter within a framed screen (Fig. 495). Here, saran plastic window screening is stretched upon and stapled to a frame slightly larger (24 × 30 inches) than the standard drying blotter (19 × 24). Supported by 1-inch high legs, screens can be stacked one on top of the other to permit free circulation of air for the acceleration of the drying process. The prints are laid facedown on the screen and covered with a blotter, which both absorbs water and holds the prints flat. This method cuts drying time, relative to blotters alone, by about one day. The equipment requires minimum maintenance, only an occasional washing to remove dust.

Electric dryers also exist, but because they dry prints unevenly and thus cause curling, these machines cannot be considered satisfactory. A large drum dryer has the capacity to handle the volume of prints produced in institutional and commercial situations, but it too has disadvantages that must be taken into account. The cloth carrier impresses itself upon the prints it conveys over the drum and leaves them embossed with a cross-hatch pattern that is especially marked in dark areas of the image. The pattern can be removed by adjusting the dryer for less pressure (providing the machine is adjustable) or avoided by adding more hardener to the fixing solution. Should the relief pattern persist, a way to salvage a valuable print is to resoak it and then dry by a different method. Another risk in using the drum dryer relates to fixer that remains despite thorough washing. In the event this soaks into the dryer's cloth apron, it could easily contaminate prints subsequently processed. To prevent such damage, the apron should be changed frequently.

The laundry method of hanging prints with clothespins to a taut line may well be the simplest of all ways to dry prints. After excess water has been wiped away, prints can be gripped at their upper corners and hung back to back with pinch type clothes-

495. Framed screens also provide a good technique for drying prints, which should be placed facedown on the saran plastic screening and covered with blotters.

496. The laundry method dries prints by using clothespins to weight and attach them back to back to a taut line.

pins (Fig. 496). Additional pins fastened to the lower corners weight the prints to make them dry flat and wrinkle-free. Because of the stretching action of the weights, this method seems better suited to prints made on double-weight paper. Dried prints that, despite the weights, persist in curling can be flattened in a warm dry-mount press (see pp. 343–347), once placed there face up between two sheets of paper. Care must be taken that a print surface does not come into contact with the press. When the print has become warm, after at least 15 seconds, it should be removed from the dry-mount press, placed on a clean, smooth surface and covered with a weight. Prints thus cooled remain flat.

497. Values or tonalities—that is, the amount of black present—constitute the graphic means in monochrome photography for reproducing the phenomena visible in reality. These can range, in a single photograph, from dense black through an infinity of grays to clear, sparkling white, as represented in the "gray scale" that accompanies the photograph.

THE TONAL QUALITY OF PRINTS

A graphic process, black-and-white photography records visible phenomena in terms of the value or tonal relationships that exist among the forms photographed, in a range that can extend from dense black through an infinity of grays to clear, sparkling white (Fig. 497). Throughout the printing process, from the moment the developer begins to bring forth the image on blank paper, the photographer must be concerned with the tonal quality of his print. Transparent film cannot register the entire tonal range generated by light rays from objects in a natural scene, but its capability to register tones is one-third greater than that of opaque photographic printing paper. This fundamental limitation requires that the photographer, in order to make the most of the opportunity available to him, engage in a continuous process of manipulating the materials and techniques of photographic printing, of making decisions with regard to the procedures most

likely to yield success for the picture under way. The final product inevitably exhibits both the photographer's sense of what his possibilities were—that is, his interpretation of the subject offered to him—and the control he has been able to exercise for the realization of his intentions. To obtain from the photographic enterprise a convincing interpretation of the tonal character of visible phenomena demands of the photographer not only craftsmanship but also a certain development in aesthetic sensibility.

Beginning photographers frequently are so enraptured with the seemingly magical process of photography that they remain blind to the fact of the technology that makes this visual experience possible. They must, rather, concentrate on mastering the means by which an indifferent print could just as well have been produced as a fine photograph. Once a print has been made, it encourages several questions: Is it too light, or possibly too dark? Does the print seem too flat or sufficiently contrasty? Highly relevant questions, they are best answered from an analysis of the tones registered in the photograph.

Testing for Black By gradually training his eye to distinguish black that is rich from one that is merely dull, the new photographer learns how to avoid making a flat print from a normal negative. To discover the best black that a paper is capable of, the photographer can conduct a test and maintain a record of the results. The procedure is to expose a small piece of photographic paper and develop it for 2 minutes before halting the action in stop bath. Repeat this with slight variations until a black of maximum quality has been obtained. Washed and dried, the specimen black should be kept, along with the record of its production, for comparison with black tones as they emerge in the development process.

Density (Exposure) and Contrast The quality of a print is inextricably related to the quality of the negative it has been made from. However, even when negatives have suffered accidents in exposure or development, the process of printing offers through choices in exposure time, photographic paper, and such special techniques as dodging and burning-in (see pp. 264–272) the means whereby most less-than-perfect situations can be salvaged. This is done by controlled manipulation of the two characteristics that are basic to the negative: *density* and *contrast*. The former term designates the degree to which a negative image is dark. It results from exposure, for an underexposed negative has relatively few of its silver hallide crystals converted into metallic silver; thus, it looks pale, not densely black (Fig. 498). Such a "thin" negative permits much light to pass through to the printing paper, which then develops as a dark photograph (Fig. 499). The over-

exposed negative looks dense from the great quantity of its black metallic silver (Fig. 500); by absorbing much light, instead of passing it, such a negative yields a print of the palest tonality (Fig. 501). It is differences in density that make the value range in a photograph. Such differences are known as *contrast*. Density and contrast form the image and determine the character of its detail, making it crisp or muddy, grainy or smooth. In the printing process, a thin negative, one of low density, requires less exposure than does a negative of high density.

Density

How dark or how light a photograph should be—its exposure—is best decided by the naked eye. A comparison of the mood and visual quality of the three photographs in Figures 502 to 504 can illustrate the principle of this. All three have been printed from the same negative on paper with identical characteristics for contrast, but each had a different exposure time. The print in Figure 502 provides an accurate account of the house and its surroundings; in addition, its general sunniness might well help a real estate broker represent the house to a prospective buyer. The print in Figure 503 received longer exposure and is therefore darker. Here, the clouds have greater definition against the darker background, and the shadows are deeper. In all, the

house seems imbued with a heavier, more dramatic mood than that in Figure 502. For Figure 504 the exposure time was the longest in the series, and the print makes the most extreme visual impact. The clientele identifying with this hostile house and spooky scene might be unusual indeed! Together, the three examples reveal to what degree the character of images can be affected by the exposure decisions made in the printing process. Some situations demand exaggeration; others require a straightforward treatment. Only visual judgment can determine the right exposure. Because of the high cost of photographic paper, the most efficient and economical way to make this determination is by means of test prints.

The Test Print A test print is made with a sheet of photographic paper of the same size as that intended for the final print. Several test prints developed from a sequence of different exposures offer a selection of possibilities from which the final exposure can be determined. The procedure is the following:

By the illumination of a safelight bring the enlarger to sharp focus and set the aperture of the enlarger lens at a small f-stop, to compensate for any slight errors in focus. Turn the enlarger lamp off and extract one sheet of paper from its storage box. Place the paper emulsion side up in the easel and fasten it under the masking

502–504. Density or exposure is best decided by the naked eye, according to the photographer's intentions and his understanding of the photographic process. To demonstrate this principle, the three photographs here were printed from the same negative on the same type of paper, but each print had a different exposure.

502. A literal interpretation of the negative (10 seconds).

right: 503. Increased exposure dramatized the subject (15 seconds).

below right: 504. Prolonged exposure produced an ominous effect (25 seconds).

slides (Figs. 459–471). Practice makes it easier to estimate the initial exposure in the sequence. An image that appears bright on the easel requires less exposure than would a darker one. A timer is needed to make a record of the exposures and to make subsequent exposures consistent with the test (Figs. 472, 473). (The GraLab timer discussed on page 175 can serve, but a more convenient arrangement would be a timer designed for use with paper and connected to the enlarger's light source. Once set, such a device automatically makes accurate exposures each time the button is pressed, and it can be set from a fraction of a second to 1 minute.) Then begin with a series of

5-second exposures, the first of which should be of the entire sheet (Fig. 505). Next, cover three-quarters of the sheet with opaque paper and expose again for another 5 seconds (Fig. 506). Repeat with half the sheet covered, and finally with one-quarter covered (Figs. 507, 508). As a result of its four exposures, each of a different duration, the test print will looked striped (Figs. 509–511). Care must be taken not to move the paper during the process; otherwise, the exposures could overlap and make tonal quality difficult to evaluate.

After the test print has been developed, stopped, and partially fixed (1 to 2 minutes), it can be examined by white light to see if any of the exposures may be the right one.

The important thing to observe is the value relationships. Is there or should there be a complete range of tone from black to white? Which test seems too light; which too dark? Sometimes additional test prints must be made before an acceptable exposure is found.

In Figure 509 even the lightest section of the test print is too dark, indicating the exposure was too long. The example in Figure 510 illustrates the opposite situation, for here inadequate exposure has made the darkest area too light. Figure 511 offers a more promising selection of exposures.

A negative of average density should yield satisfactory prints from exposures of 15 to 20 seconds. Brief exposures of 1 or

509. Dark test print.

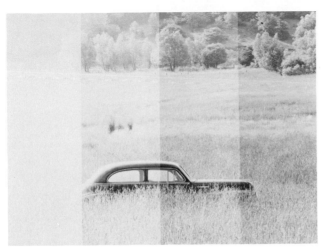

510. Light test print.

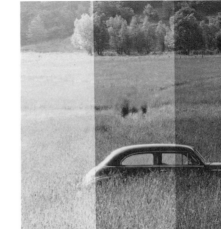

511. Medium test print.

2 seconds allow no time for the photographer to work upon his prints such refinements as can be had from burning-in and dodging (see pp. 264–272). Where necessary, as in the instance of underexposed negatives, the exposure of the printing paper can be lengthened by closing further the diaphragm of the enlarger lens to make a smaller aperture. This would require a compensating extension of exposure time. Like the diaphragm on a camera, that on the enlarger lens increases exposure twice for each f-stop up and reduces exposure by half for each f-stop down. Because of the dim illumination of a darkroom, the lens diaphragm of enlargers generally has been designed to indicate f-stop positions by

clicks that produce tactile and auditory sensations.

Exposure with durations of more than 40 seconds can cause the negative to swell. When this happens, the negative buckles and produces a printed image that is out of focus. A weapon against this danger is the glass negative carrier. Another is the following procedure: Insert the negative in the enlarger and, prior to placing paper on the easel, turn on the lamp and let the negative expand with warmth. While the negative is expanded, refocus the enlarger with the aperture open, close down the aperture, and switch off the lamp. Then quickly, before the negative can contract with cooling, place paper in the easel and expose.

512–529. Contrast has to do with the differences in density from one adjacent area to another within a negative. Film, light, and the relationship between exposure and development of film all affect the contrast factor in a negative's rendition of a scene. As this series reveals, correct exposure and normal development offer the best means of achieving accurate tonal rendition. In other circumstances, the photographer can assume that to increase contrast he should underexpose and overdevelop his film; to reduce contrast, he must overexpose and underdevelop.

**Row A
Overdeveloped
film**

512

513

**Row B
Normally
developed film**

514

515

**Row C
Underdeveloped
film**

516

517

Contrast

Equal to density or exposure in its importance for the production of a fine print is contrast. This characteristic has to do with the differences in density from one adjacent area to another within a negative. Like exposure, it derives its fundamental quality from the negative. One factor influencing contrast is the film. Some films are more contrasty than others. A second influential aspect is illumination. A negative exposed on a bright, sunny day tends to be contrasty, having dark tones in shadow areas and bright tones on sunlit surfaces, whereas film exposed on a cloudy day usually seems flat for the want of marked distinctions between whites and blacks.

The third and most important variable in the contrast factor of a negative's rendition of a scene is the relationship between the exposure and the development of the film. For a correctly exposed negative, the best way to ensure accurate tonal rendition is to follow the development instructions provided by the film's manufacturer. For negatives that have been under- or overexposed, however, adjustments must be made in the

518

519

524

525

520

521

526

527

522

523

528

529

standard development time if normal contrast is to be obtained.

Figures 512 to 529 illustrate what happened when three rolls of film, each with a different exposure, were each developed according to three different durations. Column 1 represents a roll of underexposed film, column 2 film that has been normally exposed, and column 3 an instance of overexposure. Reading across, row A reveals an overdevelopment of 9 minutes for the underexposed, normally exposed, and overexposed films; row B illustrates normal development at 6 minutes for the three

films with different exposures; and row C gives the results of a $4\frac{1}{2}$-minute underdevelopment for underexposed, normally exposed, and overexposed films. Because of the various combinations of exposure and development, each set of negative and print represents a different rendition of highlights and shadows, the brightest and darkest areas that are the polar opposites among values recorded by the negatives. Highlights have their strongest presence in the male mannequin, who was placed next to a window in direct sunlight. The female mannequin, positioned in shade, has its

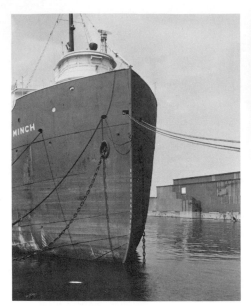

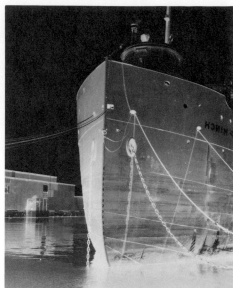

form strongly modeled in shadow. The greatest absence of light can be found in the stair treads and walls.

Figures 520 and 521 are the sole product in the series of normal film exposure and development. Details are visible and well defined in both shadows and highlights, and this makes the print the most factual and pleasing rendition of the scene. In Figure 516, a print from an underexposed and underdeveloped negative, all detail has been sacrificed, and the whole scene is enveloped in the obscurity of impenetrable black shadows. The print in Figure 524 is too white and totally lacking in detail owing to the density of an overexposed and overdeveloped negative. Neither Figure 517 nor 525 is a negative suitable for printing. Different circumstances influenced Figure 528, an example of a print made from a negative that has been overexposed and then underdeveloped. Here, the tonal range is extremely wide, permitting detail to emerge in both light-struck areas and those veiled in darkness. Contrast, however, is muted, the result of underdevelopment, and this might be considered unsatisfactory, since by suppressing the harshness of direct sunlight the veracity of the scene was also sacrificed. However, such reduction of

contrast in an overexposed negative may sometimes be necessary when the photograph has been made in the blazing light of a seaside or snowbound environment. Whatever the technique, the purpose most often is to record and interpret the original scene as faithfully as possible.

The opposite situation prevails in Figure 512, a print taken from an underexposed film that was overdeveloped. Spoiled as the rendition may be, such an increase in contrast frequently is necessary for photographs taken on cloudy, foggy days.

The technique of increasing or reducing contrast in the process of developing film works quite well when the camera employs sheet film, since each sheet can be developed separately. It seems less suitable for roll film, some of whose several subjects might benefit from manipulation in film development while others would suffer. *To increase contrast requires the underexposure and the overdevelopment of film,* with the degree of its feasibility dependent upon the type of film used, the range of contrast in the subject, and the effects sought. A trial effort could be made by underexposing in the amount of one f-number and overdeveloping to the extent of 50 percent. *Contrast can be reduced by*

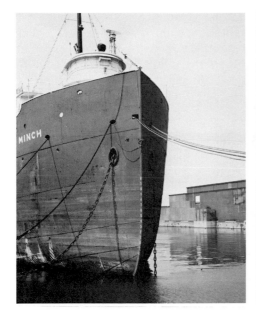

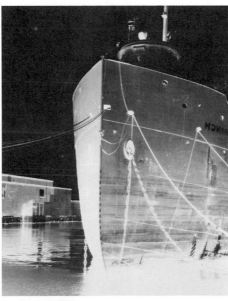

far left: 532. A print of normal contrast taken from a normally exposed and developed negative.

left: 533. The normally exposed and developed negative used for printing the image in Figure 532.

far left: 534. High contrast characterizes a print taken from an underexposed and overdeveloped negative.

left: 535. Underexposure and overdevelopment made the negative that printed the image in Figure 534.

overexposing and underdeveloping film. A safe experiment would be to double exposure and then decrease development by one-quarter. Developers like Acufine or UFG can effectively increase contrast but not reduce it. For the reduction of contrast, Kodak's D-23 or D-76 developers have proved successful.

The examples in Figures 530 to 535 illustrate how the contrast among values in a scene can be variously rendered. All prints were made on paper with the same potential for contrast. The print in Figure 530 came from a negative that was overexposed and underdeveloped (Fig. 531). Its values have been more flatly rendered than those in Figure 532, a print taken from a normally exposed and developed negative (Fig. 533). The product of an underexposed and overdeveloped negative (Fig. 534), the print in Figure 535 exhibits the greatest contrast among the three examples.

Another method promising success in bringing out greater tonal range and detail in a scene marked by extreme contrast is known as the *two-bath developer* technique. It requires that film be developed first in one solution mixed specifically for highlights and then transferred for further processing in a second developer mixed to treat the low values. The photograph in Figures 536 and 537 of a dark interior

536, 537. The two-bath developer technique achieves a greater tonal range in photographs made in situations of high contrast. One solution develops the film for highlights and a second for low values.

536. Normal film development of a photograph made in a high-contrast situation.

537. Two-bath film development improved the rendition of the values seen as high contrast in Figure 536.

538. Fox Talbot. *Sailing Craft.* c. 1845. A print made from the original calotype (paper negative) in the collection of the Science Museum, London. Characteristic is a certain degree of softness and a limitation in tonal range.

flooded with brilliant sunlight was processed in this way. The print in Figure 536 derived from a normally exposed and developed negative. To obtain the print in Figure 537 the photographer followed the advice of Ansel Adams (in *The Negative*) and processed the film in a two-bath developer. In both prints the standard adopted for measuring contrast was the light tone of the sidewalk in direct sunlight. Thus evaluated, the print in Figure 537 would seem definitely to offer a greater range of tones.

Formerly, the limited potential of printing paper made high-quality prints possible only when processing was done with normal negatives (Fig. 538). Flat or high-contrast negatives could yield only prints of lesser quality. Now, modern printing papers, graded for contrast from 0 up through 6, provide the photographer with the opportunity to use the printing process for im-

proving upon the quality of the image found in an abnormal negative. However, to take advantage of such improved and sophisticated materials requires that the photographer be capable of a thorough and accurate analysis of his negatives. Basically, a usable negative can be considered flat, normal, or contrasty. The negative in Figure 531 provides an example of the flat negative. The differences between its light and dark tones are not pronounced, and compared with other examples, this negative seems rather even, therefore flat, in its tonality. Figure 533 can be considered a normal negative, one distinguished by detail in both shadow and strong light. Figure 535 has great and abrupt variation from light to dark and must be seen as a contrasty negative.

When the negative is contrasty its extremes in value variation can be softened

and balanced by printing on low-contrast, or flatter, photographic paper. The best results can be obtained from a flat negative once its narrow range of value dynamics has been expanded by printing on high-contrast paper. In Figures 539 and 541 the negatives of different contrast seen in Figures 542 and 544 have been printed on papers whose capabilities for contrast were exactly the reverse of the contrast charac-

539–544. Extremes in the contrast factor of negatives can be neutralized by printing on paper whose contrast characteristics are the opposite of those present in the negatives used.

below left: 539. High-contrast paper (Kodak grade 5) served for this print made from the low-contrast negative in Figure 542.

below center: 540. Normal-contrast paper (Kodak grade 3) printed the normal-contrast negative in Figure 543.

below right: 541. Low-contrast paper (Kodak grade 1) permitted a normal-looking print to come from the contrasty negative in Figure 544.

542. Flat negative.　　　　**543. Normal negative.**　　　　**544. Contrasty negative.**

545, 546. A low-contrast factor produces great tonal range.

right: 545. High-contrast paper (Kodak grade 5) gave this rendition of a gray scale.

far right: 546. Low-contrast paper (Kodak grade 1) made possible this extension of values in the gray scale.

teristics of the negatives. Figure 539 reveals the result of the flat negative (Fig. 542) having been printed on Kodak's grade 5, a high-contrast paper. The contrasty negative (Fig. 544) became a positive opaque image on Kodak's grade 1, a low-contrast paper (Fig. 541). Meanwhile, the normal negative (Fig. 543) was printed on Kodak's grade 3, whose contrast capability falls in the middle range (Fig. 540).

The flatter the paper's contrast factor, the greater the paper's potential for a wide range of tonal variations. High-contrast paper deepens blacks and brightens whites

and thereby sacrifices the details that gradations in between could bring out. The gray scale in Figure 545 was printed on Kodak grade 5 paper; that in Figure 546 on Kodak grade 1. Notice the greater number of gray tones in the print made on low-contrast paper (grade 1).

The Zone System A very important technique developed by Ansel Adams and called the *zone system* permits the photographer to interpret meter readings of light intensity so as to increase or decrease the value or tonal range of a negative at the

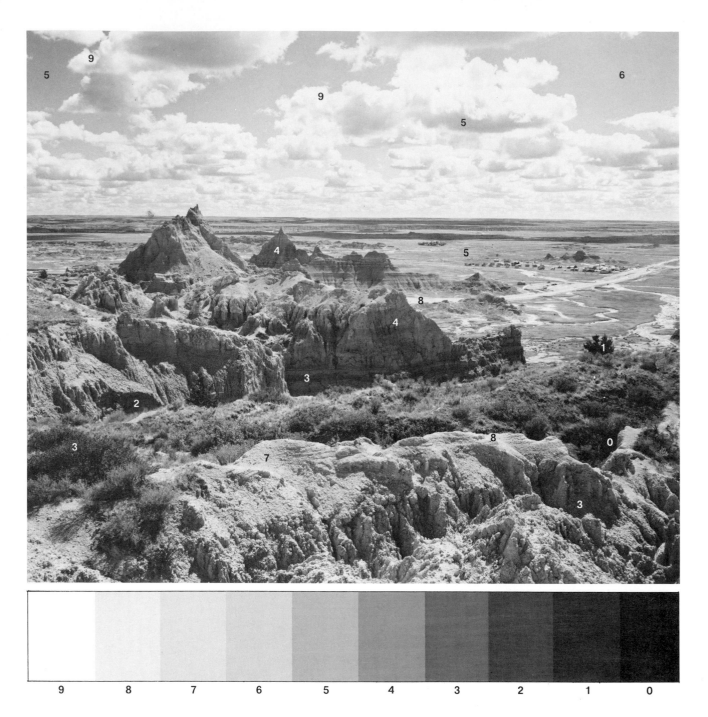

547. The zone system developed by Ansel Adams can help the photographer expose film so as to control the particular translation his photograph makes of full-color visual phenomena into the gray range of a photographic print. Success depends upon an understanding of the "gray scale" and upon an ability to match light intensities radiating from surfaces to tonal values in the gray scale (on which each zone after 0 represents twice the exposure, or an advance of one f-stop, of the immediately preceding zone). In this way, the photographer can use the indications of a reflected-light meter to interpret any degree of light intensity as average gray (zone 5 in the gray scale, or the value of an 18 percent gray card [Fig. 146]), thus to achieve maximum veracity in the rendition of a scene or to emphasize some aspect of a subject by either lightening or darkening the overall tonality of the photographic image. Corresponding values in the gray scale and the photograph are identified by numbers 0 through 9.

moment of its exposure in the camera. Much more than the underexposure and overdevelopment or overexposure and underdevelopment methods discussed on pages 250–255, the zone system offers to the knowledgeable photographer the means to exercise relatively precise control over the process of translating into the gray range of a photographic print the many colors, textures, and forms likely to be present in any subject he may wish to record on film.

To exploit the zone system, the photographer must become sufficiently sensitive in his awareness of the photographic medium to enable him to analyze a subject in terms of its tonal range and how this range can first be recorded on film and then printed as a positive image on paper. To help in this analysis, Adams codified light intensity into a gray scale (Fig. 145) composed of ten zones that rank tonal values from black, which has 0 light, to 9 for white, which is intensity of total saturation (Fig. 547). In a negative, 0 would represent no exposure and would appear as complete transparency; 9 would have the density of maximum exposure. Once printed, zone 9 leaves the paper white, while zone 0 yields pure black. In between, the average tonality of a scene would be comparable to zone 5, the medium or average gray of an 18 percent gray card (Fig. 146)—or the degree of intensity that the reflected-light meter is designed to reproduce when exposure has been made from its indications, whatever the intensity of the light reflections actually measured by the meter (see pp. 86–93).

An important principle of the zone system is that each zone after 0 represents twice the exposure of the immediately preceding zone—that is, an advance of one f-stop. Once the photographer understands this, he can adjust his camera to make it record virtually any light intensity as zone 5 and thereby assure either the most factual rendition possible of a scene or interpret it to emphasize the details of whatever feature may interest him. The photograph in Figure 547 is a full-scale rendition in which the objective was to realize maximum veracity relative to the original scene. To obtain a bit more detail in the deep obscurities of zones 2 and 1, the photographer could have increased aperture by one f-stop to interpret these two zones as 3 and 2. Correspondingly, the printed image would present a lighter tonality overall, and what has been labeled zone 8 in Figure 547 would then appear as whited as zone 9 now is.

To profit by his use of the zone system, the photographer must comprehend very well not only his eye and his camera, but also the exposure meter, film development procedures, printing, and paper. A series of controlled tests offer the best means of gaining such mastery, the purpose being to turn the principles of the gray scale into a personal system assuring the individual photographer a set of standards capable of being manipulated into superior photographic results. For further help in perfecting his employment of the zone system, the reader should consult the books by Ansel Adams, Minor White, and Arnold Gassan cited in the Bibliography that begins on page 352.

Variable-Contrast Paper A special paper, intended for use with enlargers and called *variable-contrast paper,* now offers to photographers in a single sheet the potential for adjusting and controlling contrast within a range equal to Kodak paper grades 1 to 4, but, unlike the regular papers, rising in subtle half-steps. Because coated with a mixture of two emulsions, separately sensitized to yellow and blue-violet light, the paper permits the photographer to vary the paper's contrast by exposure with light projected through a filter of the appropriate color. A yellow filter, for example, yields a low-contrast image characterized by a wide tonal range; a high-contrast image can be obtained with a blue or a violet filter. Graded by Kodak in half-steps from 1 to 4, the filters used in combination with variable-contrast paper provide the range for manipulating contrast that otherwise could be had only from a stock of seven different

grades of paper. The number 2 filter should yield contrast that approaches what could be considered normal.

Variable-contrast paper also promises better results in instances that would seem to require special control over local areas in the image. By masking and remasking the variable-contrast paper so as to expose it sequentially through a series of filters the photographer can bring greater crispness to low-contrast passages and soften the image in contrasty areas. In addition, variable-contrast paper works well with contrasty negatives. Whereas printing on a graded paper for middle and dark tones and then burning-in for white tones (see pp. 267–272) can cause unevenness in the tonal shift from passage to passage, vari-

able-contrast paper allows control of tonal gradation by the simple use of low-contrast filters for white areas (Figs. 548, 549). In this way it is possible for the photographer to realize a desired change in contrast without changing exposure.

Density can vary according to the color of the filter; thus, exposure must be changed to compensate for a change made in the filtration. For example, if the correct exposure for a yellow filter is 15 seconds, a blue filter may require an exposure of 30 to 45 seconds. Eastman Kodak distributes an exposure computer with a scale indicating the correct exposure for each filter. DuPont has eliminated the density variable from the new Varigam and Varilour filters, with the exception of that colored darkest blue.

548, 549. Variable-contrast paper permits the photographer to modify the exposure of specific passages within a single photograph and accomplish this by use of filters.

548. Normal exposure produced a print with an overly light passage in the lower left of the image.

Variable-contrast paper exists in a number of brands; among those available in the United States, DuPont's Varigam and Varilour and Eastman Kodak's Polycontrast are well-known and frequently used products. They can be distinguished by slight differences in color tonality. Varigam's tone, for instance, is cooler than that of Polycontrast.

Because of its sensitivity to a wider range of tones, variable-contrast paper must be worked with under a "safer" light than graded papers require. A light safe enough for graded paper might well cause fogging in variable-contrast paper, but the special safelight needed for variable-contrast paper does not harm graded papers. Thus, the photographer might consider it simply expedient to install a special safelight for general use in the darkroom.

For a variety of reasons, enlargers designed to receive filters above the condensers are more practical than those adapted to hold filters below the lens. Positioned below the lens, the filter holder can obstruct both the passage of light and the photographer's access to the aperture for adjustment purposes. Filters must also be kept scrupulously clean to prevent dust, dirt, or lint from softening the projected image, and such maintenance is more difficult for filters positioned outside the enlarger head.

Disadvantages related to variable-contrast paper are the cost of filters and the need for experience in using the technique.

549. Burning-in by means of filters used with variable-contrast paper yielded a print rich in tonal values smoothly gradated throughout the image.

550–553. Test printing for contrast is as valuable as testing for density. In the illustrations of this principle, the negative used was normal.

550. Low-contrast paper (Agfa grade 1) served for this test for contrast.

left: 551. Normal-contrast paper (Agfa grade 3) printed this version of the test for contrast.

below left: 552. High-contrast paper (Agfa grade 6) yielded this type of test for contrast.

below: 553. A print based on the normal-contrast test print (Fig. 551)—Agfa grade 3 paper exposed for 10 seconds.

554, 555. Contrast and density are often difficult to distinguish.

554. A density test seems very similar to the results obtained in Figure 555, a test made for contrast.

555. A test for contrast, using the same exposure, but more contrasty paper, resembles the results in Figure 554, but nonetheless reveals slightly greater contrast.

Test Prints The test-print technique, very much like that used for density (see pp. 244–247), can also be made for the purpose of evaluating contrast. The negative employed for the illustrations in Figures 550 to 553 was normal. In Figure 550 the print testing occurred on a low-contrast Agfa grade 1, a European paper graded for a contrast range of 1 to 6. This yielded a gray tonality deficient in both brilliant white and dense black, resulting in an overall flat and muddy appearance. For Figure 551 grade 3 paper served for the test exposures, and the normal-contrast factor made possible a balance between honest black and honest white as well as good clear detail throughout the tonal range (Fig. 553). Grade 6 paper was chosen for Figure 552, and the test strips have been rendered contrasty, almost totally devoid of middle values. Such differences often are quite subtle, and comparing tests can help distinguish quality in value ranges.

Sometimes, especially for beginning photographers, it is difficult to differentiate between contrast and exposure, or density. At first glance, the two test prints in Figures 554 and 555 seem similar, but a close ex-

556–558. Contrast in portraiture can be a sensitive issue. Here, the same average-contrast negative served for all three illustrations.

left: 556. Extreme contrast reproduced the subject in a stark, two-dimensional way.

center: 557. Reduced contrast rendered the soft roundness of the child's face.

right: 558. Low contrast appears to have aged the boy prematurely into a man.

amination can reveal that contrast is definitely more marked in Figure 555 than in Figure 554. With a test print as light as these two, the photographer should redo the test and make it darker before determining whether to alter contrast. It is better at first to deal with one variable at a time — contrast or density (exposure) — until experience equips the photographer with the competence to make good decisions based on simultaneous review of both variables.

Contrast in Portraiture The contrast factor is crucial to the rendition of skin tones in portrait photography. The prints in Figures 556 to 558 were all made from the same average-contrast negative. The extreme contrast between light and dark characterizing the print in Figure 556 reproduces the subject in a stark, two-dimensional manner. Not only has detail been suppressed but, in addition, the boy's countenance lacks the roundness of young flesh and bone. The result is a portrait expressing a harsh rather than a pensive mood. Such heightened contrast has proved dramatically efficient in fashion photography, but here it turns a boy into a demonic threat. Figure 557 offers a more normal image, for reduced contrast has softened the flesh and revealed details in the deeper tones. The low contrast of the print in Figure 558 renders the subject in such monotone that he seems aged, almost in a state of 5 o'clock shadow.

There are no absolutes in this type of evaluation, and depending upon the pho-

tographer's tastes and intentions, the preference could be for either a rather flat print of limited contrast or one that is striking by virtue of the sharpness of the contrast it offers between light and dark. The more objective the subject, the more subjective the photographer usually can be in imposing upon his picture the kind of interpretation and expression that contrast factors permit. Who can say which is preferable, the print in Figure 559 or that in Figure 560?

Intensification To yield a satisfactory print, the negative must have the tonal range that only adequate density can provide. Occasionally, some kind of print can be had even when the negative is so light as to leave the image quite faint. The process that could make a print possible

559

560

559, 560. The more objective the subject, the more subjective can be the photographer's interpretation of the photographic image.

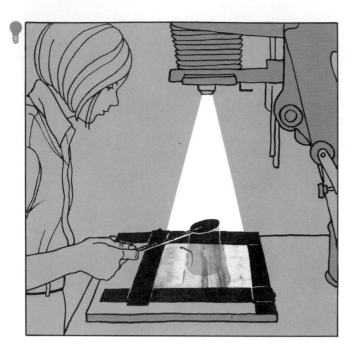

from an underexposed or underdeveloped negative is one called *intensification,* which has been described on page 209 in the chapter on film. The technique for taking a print from a very dense overexposed or overdeveloped negative is *reduction.* A discussion of it can be found also on page 209.

PRINTING MANIPULATIONS

Because film's capacity for recording tones is so much greater than that of paper, detail visible in the negative can appear obscure in a printed photograph. During the exposure phase of the printing process, it is possible to engage in localized manipulation of the exposure for passages that seem too bright or too dark and thus, without harming overall tonal quality, make improvements to bring out detail.

Dodging

Deep shadow areas can be clarified and made less dense by briefly preventing light from striking them during exposure. To make a dodging tool, attach pieces of reasonably stiff, black paper (like that used to package photographic paper) to the end of a wire so that the block can be extended out over the image projected upon the printing paper (Fig. 561). The shape and size should be determined by the passage to be dodged. Reflections from a shiny wire could have an undesirable effect upon the image; thus, the wire must be black. By holding the tool well above the easel and moving it constantly throughout the blocking process, the photographer can make the dodged area blend with the tonal character of the rest of the print. If held stationary, the dodger could produce lines in the printed image. The test print provides an opportunity to make a judgment about the proper duration of the dodging time.

Figure 562 is a print made from a negative in which it was possible to discern quite a lot of detail in the dark interior of the coal chute considered by the photographer to be an important part of his picture. Dodging brought out the detail seen in the print reproduced as Figure 563. Then, in Figure 564 the dodging became excessive and created an unhappy im-

562. Undodged print taken from a negative that revealed considerable detail in the depths of a coal chute.

563. Dodging clarified the detail.

564. Excessive dodging created a discrepancy with the surrounding areas.

balance between the dodged area and the rest of the print.

Pictures shot on very bright days typically have such deep shadows that detail is lost in them. A subject photographed under the high noonday sun will look deformed because of dark shadows under the eyes and chin. Dodging, which would shorten exposure time for the shaded areas, could very well salvage the picture.

565–576. Burning-in offers a technique for adding values and therefore detail to bleached and overexposed passages in a photograph. It entails exposing the whited portions longer while blocking the remainder of the print once it has received normal exposure.

above: 565. A normally exposed print.

left: 566. The tonal character of the sky and the form of the clouds were reinforced by burning-in.

Burning-in

In negatives, even the densest areas often reveal more detail than is present after these have been rendered in a print as light-struck and overly bright passages. To get more value and therefore more detail into such bleached spots, a technique has been devised that is the reverse of dodging. It is called *burning-in* and consists of extending the exposure time for the whited portions while blocking light from the remainder of the print once it has received normal exposure. Landscape photography especially benefits from this procedure, for it makes possible more data in highlights and deeper tones in sky and clouds. The print in Figure 565 received normal exposure; for that in Figure 566 burning-in gave form and definition to the clouds and a strong tonal character to the sky. In this instance, the burning-in could be done with relative ease, for the straight line of the horizon sharply isolates the ground area that had to be blocked.

As in dodging, the black paper block, cut to the shape of the passage to be protected from light, must be kept moving throughout the burning-in process so as to avoid making lines and prevent the print from having an artificial look (Fig. 567). The movement required in Figure 566 was minimal, but to blend the narrow band between sky and earth, it had to be made parallel to the horizon. In pictures that need blending over a wide area of the print, movement must be correspondingly broader.

Although special techniques, dodging and burning-in do not compromise the integrity of photographic printing, for they correct the distortions wrought by "normal" processes and bring pictures closer to the reality of the photographer's experience of the scene he has shot. Figure 566, in which the sky has been burned-in, is a much more accurate record than that provided in Figure 565 of what one would expect to see in an open landscape of this character. In addition, the enhanced tonal rendition has made the picture a more pleasing and successful photograph.

567. To burn-in, cut black photographic paper to the shape of the passage in need of blocking and hold it over the area to be protected from light during the extended exposure, making sure to move the block continually.

568. A hole shaped in blocking paper can make burning-in responsive to more subtle needs.

The technique can be elaborated to make burning-in responsive to more subtle needs. To darken a small area in the print, the photographer should shape a hole of the appropriate size in a sheet of black opaque paper (Fig. 568). Through the opening in the mask light can pass for the extended ex-

569. A normally exposed print in need of greater detail in the window area.

570. Increased exposure for the entire image brought out detail in the window but darkened the brick wall.

posure needed to burn-in. The technique served to solve the problem seen in Figure 569. Here, the bricks have a good tonal definition, but the window area lacks detail. Increased exposure for the entire image clarified the window while simultaneously consuming the brick wall in smoky darkness (Fig. 570). By cutting a doughnut mask to the size and shape of the brick wall and burning-in the light passage, the photographer succeeded in producing a print (Fig. 571) that combined the tonal qualities he considered good in both Figure 570 and Figure 571.

A more extreme variation of the burning-in technique requires the use of raw white light and is called *flashing*. The very bright light source effects a pure black tone in less time than burning-in would take. The instrument that makes this possible is a pen flashlight around which opaque black paper has been wrapped as a means of restricting and directing the beam of light (Fig. 572). In Figure 573 flashing black-

572. Flashing is a variant on the burning-in technique, requiring use of a pen flashlight wrapped in black photographic paper to beam raw white light onto a print during exposure.

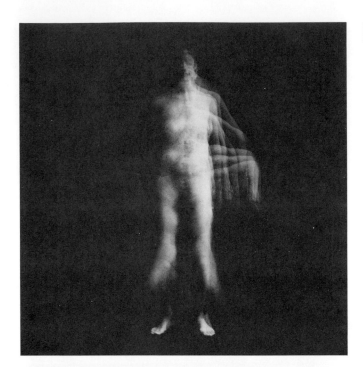

573. Pure black tone can be produced by flashing.

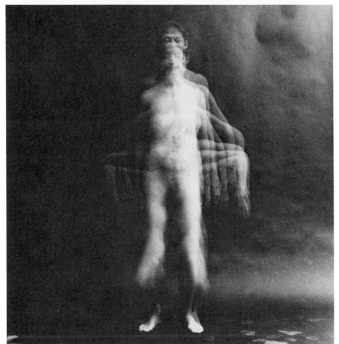

574. The unflashed image reproduced in Figure 573.

ened the print to conceal the model's footprints and the wrinkled surface of the paper backdrop (Fig. 574). Flashing accomplished quickly what burning-in could have done only after a very long exposure.

Vignetting, another variant on the burning-in process, enables the photographer to isolate one part of the total image and print it as an independent photograph. It often works well in portraiture, where the image

of one person is picked out from its background or from a group of people. In Figure 575 the photographer wished to salvage the portrait of one subject in a group spoiled in part by some kind of moisture. Since the negative was not available to him, he copied the old print (see pp. 332–334) and, enlarging from the copy negative, vignetted the single subject by burning-in through a hole cut in a sheet of black opaque paper. The result is a portrait emerging dramatically in soft gradations of tone from a white ground like the image reproduced in Figure 576. The white ground could have been reversed into black by the process of dodging or flashing. One way of accomplishing this is to hold a clenched fist over the exposed image, but close to the lens, and then shake it back and forth for about 5 to 10 seconds

576. **Vignetting,** a variant of burning-in, entails enlarging a single passage while blocking with a doughnut mask the remainder of the image.

as the fist gradually lowers toward the paper's surface.

Chemistry also provides a means enabling the photographer to obtain results similar to those acquired through dodging or burning-in. To lighten a dark, dense area, remove the print from developer, rinse it in running water, and then place it face up on the surface of a stainless-steel tray turned upside down. With a cotton swab apply a solution of potassium ferricyanide to the passage of the print in need of lightening. Care must be taken not to stain other areas with the solution. To darken passages that are too light, a cotton swab saturated with concentrated developer can be applied to the print. Even hot water, which further activates developer already soaked into the paper, can sometimes achieve the effect of burning-in. Both chemical techniques for dodging and burning-in are difficult to master and require some experience before they can be done with ease and success.

Only care, patience, and skill permit a photographer to use dodging and burning-in for the purpose of transforming a mere picture into a successful photograph. Exaggerated or crudely handled, they can spoil the photograph by making it look arbitrary and artificial. The potential of these methods is to endow an image with the details that rightfully belong to it, but it is not possible for them to convert a shadow into a highlight or a pale tone into a detail-rich darkness. (See also pp. 257–259 for the potential that variable-contrast paper offers for dodging and burning-in by means of filtration.)

Color

COLOR: A FUNCTION OF LIGHT

In his normal experience of the world man sees color more quickly than he perceives form, which is all that a black-and-white photograph can record. Without color, life is incomplete, and once the exact image of the forms of life had been recorded by photography, the search was on for the means to give the photographic image the vividness and vitality that only color can provide. The daguerreotype (Figs. 5–7), rich in tonal gradations and accurate in its rendition of perspective, so satisfied the primary conditions of photographic reproduction that it spurred research for a method of taking pictures in natural color.

The desire for color led numerous enthusiasts to experiment, including those who, like Niépce and Daguerre, had pioneered in black-and-white photography, as well as lesser-known amateurs. Levi L. Hill (1816–65), an American Baptist minister, claimed success in producing color pictures as early as 1850, but the Reverend Hill never managed to provide sufficient documentation of his discovery. In 1851, only a year after Hill claimed success, Niépce de St. Victor (1805–70), cousin to Joseph Nicéphore Niépce, began to obtain naturally colored photographs. Like those of his predecessors, St. Victor's method, which he proved repeatedly, was a direct one whereby the photographer employed silver compounds sensitive enough not only to record the intensity of light but

above: 577. Hand-tinted ambrotype of a Civil War soldier. 1860s. Collection the author.

right: 578. Color is a function of the interaction between light and the matter it illuminates. Isaac Newton demonstrated this in 1666 when he broke up a beam of white light into a rainbow array of its components by passing the light through a prism, and then reobtained white light by returning the spectrum through another prism.

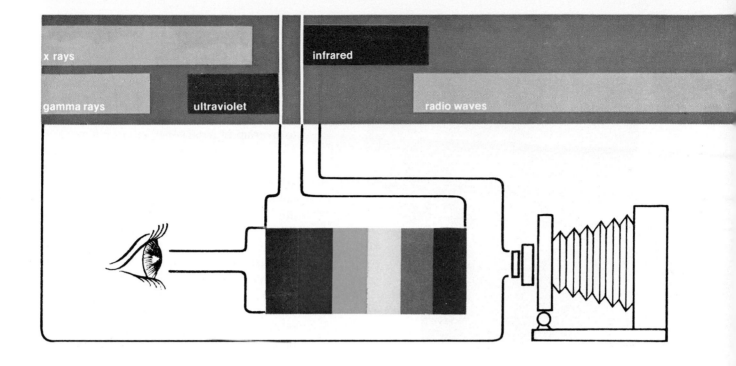

579. The electromagnetic spectrum. The wavelengths of electromagnetic energy radiating from the sun range from .00000000004 inch for X rays and gamma rays to as much as 6 miles for radio waves. Approximately halfway between occur those wavelengths that, because visible to the human eye, are called *light*. Photographic film has the capability to sense all wavelengths from the shortest to some in the infrared group adjacent to the visible spectrum. Light waves radiating from the visible part of the spectrum can be grouped by their lengths into the colors violet, blue, green, yellow, orange, and red, which mixed all together appear to the eye as white light.

also to assume some suggestion of the color of the light striking it. This approach, however, proved fatally flawed in that no means ever evolved for fixing the direct-color coatings once these had been processed. Thus, daguerreotypes were painstakingly hand-tinted with powders so as to dispell the cold, silvery tones of the original images. Eventually, ambrotypes, tintypes, and even paper prints received color by means of paint applied to their surfaces (Fig. 577). Often very crude and destructive of photographic quality, these colored images further convinced photographers of the necessity for a genuine color process.

It was in 1666 that 23-year-old Isaac Newton (1642–1727) conducted the historic experiment demonstrating color to be a function of the interaction between light and the matter it illuminates. This discovery and its scientific proof premised the development of color photography. By directing a ray of sunlight through a glass prism, Newton produced a delineation, in rainbow array, of the various component colors of the visible spectrum; then returning the spectrum through another prism, he obtained the original "white" light (Fig. 578). This last procedure "proved" the experiment conclusively, revealing color to be a quality inherent in light rather than in the matter characterized by color (Fig. 579).

This means that sunlight, or "white" light, contains the elements of all colors, and because it contains them all, each is canceled. An object has a certain color because it reflects those elements of white light that produce the color and absorbs the

580. Specific colors appear because physical materials have the property to reflect the wavelengths of white light that produce those colors and to absorb all others.

others (Fig. 580). An apple, for instance, provides the sensation of red by permitting the reflection of the red element in the spectrum and by absorbing all remaining color elements. The principle by which all colors derive from light can also be seen to function in a rainbow, where droplets of moisture act as so many prisms to capture and bend sunlight into its components.

The term *color* refers to a combination of hue, saturation, and value. *Hue* is the property of a color that gives it a name, that distinguishes one color from another as red, green, violet, etc. Expressed as a rainbow array, the visible spectrum can, in theory, be divided into the hues of red, orange, yellow, green, blue, and violet (Fig. 579). Colors whose beams of light in various combinations can add up to any of the color sensations are called *primary* or spectral hues. Those most generally used for this purpose are red, green, and blue-violet (Fig. 581). (In artists' pigments, which are opaque rather than transparent, the primaries function as red, yellow, and blue.) White results when light beams for the

three primaries are projected separately to overlap in a darkened environment (Fig. 584). Any two colors whose light in a similar situation combines to make white, or all color, are known as *complementary* colors. The complements of primary colors are called *secondary* colors. The secondaries result when two primaries blend. On a color wheel, or circle (Fig. 581), complementaries appear opposite each other, such as yellow and blue-violet. The realization of white light occurs because in red, for example, vibrate the wavelengths for one-third of the visible spectrum, while the blue and green components of cyan have combined in them all remaining wavelengths. Therefore, in a mixture of red and its complement cyan, all hues would be generated to make white light.

Saturation refers to the purity, vividness, or intensity of a color (Fig. 582). A brilliant red is said to be of high saturation, and a soft yellow to be of low saturation. The technical term for shading is *value*, and this distinguishes the property of color that makes it seem light or dark (Fig. 583). Only the values of colors are apparent in black-and-white photographs. Light colors are considered to be high in value, while dark colors are described as low in value.

Colors by Addition

Seen in Figure 584, the method of combining colors to produce the secondaries as well as white functions by virtue of what is known as the *additive color principle,* which forms the basis for one of the two systems for creating colors analogous to those visible in the world. Anyone can prove the principle by covering the lens of each of three slide projectors with a filter of one of the three primary colors. Projected onto a screen, these colors can be made to coincide and yield other colors:

left: 581. Hue is the property of a color that gives it a name. Arranged in a continuous circle, the rainbow array of hues present in white light can be seen as the *primaries* red, green, and blue-violet and the *secondaries* cyan, magenta, and yellow, which on the color wheel appear opposite the primaries. Because together they reflect all light and create white or absorb all light and leave black, depending on the illumination in which they function, a primary color and a secondary color are considered to be the *complements* of each other. Secondary hues occur when two primaries blend.

below: 582. Saturation refers to the purity or vividness of a color. Sometimes this characteristic is referred to as *intensity* or *chroma*.

right: 583. Value distinguishes the relative presence or absence of black.

red + green = yellow
green + blue = cyan (bluish green)
blue + red = magenta (purplish red)

Because each of the three primary colors transmits approximately one-third of the spectrum's wavelengths, the primaries can, in diverse combinations, provide almost all hues. Overlapped in beams of light, all three would appear to the eye as white, the potential of all color. The analysis of full color to discover and separate its components as primary hues and the technique of recomposing these into a rendition of the original full color provided a principle of optics that eventually made color photography a working reality.

Inherent in the *direct* methods pursued by Niépce, Daguerre, Hill, and St. Victor was, and is today, the impossibility of fixing and making stable colors that exist in the reaction of chemicals whose very sensitivity makes deterioration inevitable once they have been reexposed to the light necessary for viewing. Therefore, the future success of color photography lay in an *indirect*

below: 584. The additive principle permits white light to be understood in terms of its three primary components red, green, and blue, which once isolated can be recombined to make other colors or all color (white). Called *additive* because they introduce color where none existed (black), these colors can add up to other colors only when projected separately. Overlapped in white light, two primary colors absorb all wavelengths and cancel each other into blackness.

technique that British physicist James Clerk Maxwell (1831–79) devised for illustrating an 1861 lecture given to hypothesize the nature of color vision. Employing a sequence of three filters, devised as glass containers filled respectively with red, green, and blue dye, Maxwell made three separate exposures of the same subject upon three pieces of black-and-white film. The resulting black-and-white negatives provided in each instance a reasonably accurate record of the values defining the subject as these would have been revealed by red, green, and blue light reflected from the subject. By a process of reversal, he converted the negatives into positive images, called *transparencies*. Projected upon a screen through its original color filter, by means of a strong light beamed from a lantern, each transparency became a light image of values in red, green, or blue. Projected simultaneously and in precise register, the three images combined to add up to and yield a full-color photographic reproduction of the subject recorded by the camera.

Maxwell's demonstration was crude and rather misleading in view of later analysis of his materials. Apparently the *collodion,* the glutinous substance used to coat the film, was overly sensitive to blue light, ignoring the red and green wavelengths reflected by the subject. Fortunately, the equally "untrue" red and green filters allowed blue and ultraviolet rays to pass and record tonal compositions on the emulsion, thereby affording substitute value patterns for the red and green rays. Although Maxwell's color reproduction owed its convincing appearance to chance coordination of minor errors, his method was essentially correct. When, toward the end of the 19th century, black-and-white emulsions were made sensitive to the whole of the visible spectrum, variations on Maxwell's additive process yielded the first practical color photographs.

Colors by Subtraction

Because of the absorption characteristics of the primaries, the colors employed by Maxwell could be made to blend into (add up to) a full-color reproduction only when each was beamed into a darkened environment from a separate lantern to register with the other two on the same plane, or when presented to the eye by means of a specially devised viewing box. The image thus seen was formed by a mixture of colored light and could be experienced only in carefully arranged circumstances requiring relatively complicated equipment.

In their search for the convenience of a color photographic print, two Frenchmen, working independently, introduced an alternate technique for color photography derived from the *subtractive principle* of complementary colors. Louis Ducos du Hauron (1837–1920), in Bordeaux, and Charles Cros (1842–88), in Paris, applied to photography the experience that graphic printers had in superimposing colored inks to achieve color reproductions. Like Maxwell, du Hauron and Cros made separation negatives by exposing black-and-white film through red, green, and blue filters, but instead of converting the negatives to positives for projection through the same filters, they dyed each positive the complementary color of its original filter. Thus, these transparencies became value images of cyan, magenta, and yellow. Precisely overlapped on white paper, the three films fused, as a function of the subtractive principle, into a full color reproduction of the original subject (Figs. 585, 586).

The absorption characteristics of the primary colors are such that red, green, and blue can add up to white, or all color present in the visible spectrum, only when projected separately as colored light beamed into a darkened environment. This is because each of the three primaries, being "pure," can transmit or reflect no more than one-third of the total spectrum while absorbing two-thirds. Therefore, if superimposed, filters for two primary colors would block all light, convey none, and leave the darkened environment black. But since film can be controlled for exposure purposes only in a light-tight container, the primaries proved ideal, in the experiments of Maxwell, du Hauron, and Cros, for transmitting

separately to three pieces of film the wavelengths for red, green, and blue rays (in sum, all the light rays for all the colors) reflected from a subject. However, color could enter the film as nothing more than a black-and-white record of the values of the primary whose light had exposed the film. For the record to appear in color, color had to be reintroduced; the means used by Maxwell was the projection technique already described for the additive primaries.

To create a full-color photographic image in the filtering substance itself (such as dyes laid on the surface of paper), rather than in the light transmitted by the filters, another principle and system of color had to obtain once the additive primaries had served to separate the color reflected from a subject into three independent value records of its primary components. The breakthrough came when du Hauron and Cros realized that the subtractive principle of complementary colors offered the transparency and flexibility needed for printing photographic images in full color.

Because "impure," or the result of a mixture of two additive primaries, the complementaries cyan, magenta, and yellow—

also called the *subtractive primaries*—have the capacity to transmit or reflect a double portion of colored light and to absorb only half as many wavelengths. This is the result of the subtractive primaries sharing the reflection and absorption characteristics

above: 585. The subtractive principle derives from the way the secondary colors cyan, magenta, and yelllow behave in white light to give effect to specific hues. They do this by subtracting from the totality of white light the wavelengths for all colors but the specific color actually made visible. Overlapped, two subtractive "primaries" create a third color. Only when the three subtractive primaries have been superimposed do they subtract all wavelengths from white light and cancel each other into blackness.

left: 586. Louis Ducos du Hauron. *Leaves and Flower Petals.* 1869. Société Française de Photographie, Paris.

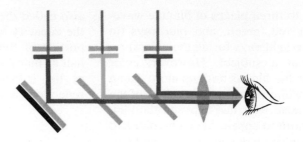

587. Frederic E. Ives, in 1892, designed a camera capable of making simultaneously three exposures of the same subject, with the light for each exposure passing through a red, green, or blue filter. He then mounted the three positives for viewing in a device that caused white light to transmit the images back through filters colored like those used for the exposures and then on, by a set of one-way mirrors, to present to the eye a full-color photographic image.

of two additive primaries. Thus, when filters or films for two complementaries overlap, they do not cancel each other into blackness but, rather, create a third color.

The secondary colors reveal specific hues by subtracting or absorbing from white light all wavelengths but those for the colors revealed (Fig. 585). A cyan filter subtracts from a beam of white light the wavelengths for all colors but green and blue—the two primaries that together make cyan. A yellow filter transmits green and red light waves but absorbs all others. Cyan and yellow are the complementaries of the primaries red and blue; when partially overlapped and projected by white light, filters for these colors subtract from white light the wavelengths for red and blue and transmit the green light rays that are common to both cyan and yellow. Therefore, this simple conjunction of filters yields three colors—cyan, yellow, and green. Add to the mixture a magenta filter and create not only red, blue, and magenta, but also black, the result of the three complementaries combining to subtract from white light the whole of its radiant energy. Because the subtractive principle can apply only where color (white light) already exists, it yields specific colors in an illuminated environment and against the white ground of paper.

In brief, it could be said that the additive primaries convey color in conditions of darkness (such as the interior of a camera or a darkroom), while the subtractive primaries yield color in conditions of illumination (such as daylight and electrically lighted living interiors). The additive and subtractive primaries function in a relationship of positive to negative, like + and −

factors. Being directly opposite in the spectral circle (Fig. 581), a secondary color or subtractive primary is the reverse of an additive primary. Thus, for purposes of exposure to make a negative, the plus factor of an additive color must operate, and for color to be present in a positive image, the minus factor of a subtractive color is needed.

As introduced by du Hauron and Cros, the subtractive principle conclusively established the inherent advantage of the secondary colors for purposes of reproduction. Blending the primary colors requires separate projection, posing a significant handicap in the need for three projectors and perfect coincidence of the images. The subtractive primaries made possible photographic prints whose colors were as natural to the image and the material they were made from as those found in light images formed by the additive primaries. Therefore, it was the subtractive principle that provided the basis for most color photographic processes employed today, even though it took until the 1930s for scientists to work out the many problems of its technology and make the system feasible for practical photography.

REFINING ADDITIVE COLORS

Composite Pictures from Separation Negatives

For quite some time, chromatic print processes, whether additive or subtractive, relied upon the separation negative technique initiated by Maxwell. However, the very complications and slowness of the method severely limited its use. Too, the

collodion error presented a problem until 1873, when Herman Wilhelm Vogel (1834–98) discovered that dyeing the emulsion prior to exposure permitted black-and-white film to record all colors absorbed by those dyes. But with the development of black-and-white materials sensitive to *all* hues, called *panchromatic* films, there nonetheless remained the very serious problem of how to achieve rapid, successive exposure of the negatives. Any alteration, however slight, in the situation being photographed, or any movement of the camera itself, caused deviation among the negatives, thus upsetting the color balance of the composite. The capricious nature of natural light posed a constant threat to photographers wishing to capture outdoor scenes. The vulnerability lay in the time needed to change film and filters for the three separate exposures, because such was the duration that negatives could be rendered inaccurate by shifting cloud patterns and by shadows progressively lengthened or shortened as a result of the earth's movement around the sun.

Eventually, cameras were constructed with prism or mirror systems designed to achieve simultaneous exposure of three negatives. In 1892, Frederic E. Ives (1856–1937) devised an apparatus capable of making on a single plate a total of three negatives, each already filtered for color separation. The positive transparencies obtained from the negatives were refiltered and correctly projected in a viewing device, again with the aid of mirrors, in miniature duplication of Maxwell's original additive system (Fig. 587). The composite picture was then viewed through a small hole in the mechanism. Bulky and undependable, these *one-shot cameras* could manage only long exposures, and their operation proved too complicated to constitute a substantial advance in the technology of color separation.

The two principal processes utilizing separation negatives to produce color prints are known by the terms *carbro* and *dye transfer*. The former derives from a "carbon" printing procedure developed in the 19th century by Alphonse Louis Poitevin

(1819–82). It caused a negative, following exposure, to be registered on paper, in a gelatinous layer composed primarily of powdered carbon. Actual "printing" occurred when, in response to light, certain chemicals in the recording medium triggered a setting reaction in the exposed areas of gelatin. Fixed as insoluble gelatin, the images adhered to the paper while the unexposed areas could be dissolved and removed by washing with hot water. Early versions of this technique failed to yield tonal gradation and produced contact prints only, their size determined by that of the negative. Modified to allow enlargements as well as value retention, the carbro method entails making black-and-white positive prints from each of the color separation negatives in the manner described above and dyeing the developed emulsions the appropriate complements of cyan, magenta, and yellow. These dye images are then gently lifted from their supportive backing and overlapped on another sheet of paper. The handling and registration of gelatin is a tedious operation, one generally considered unfeasible for commercial purposes. Although capable of producing prints with colors distinguished by sharpness, permanence, and accuracy, the carbro process is rarely used today.

The dye-transfer process, while somewhat less complicated than the carbro, also depends upon the transformation that occurs in chemically treated gelatin once it has been struck by light. When a *matrix,* or thick layer of gelatin on a plastic support, is exposed through a separation negative, then developed and subjected to warm water, its surface becomes a three-dimensional relief of the values originally transmitted by the subject. Placed in dye baths of the subtractive colors, matrices obtained from the red, green, and blue separation negatives absorb pigment according to surface modulation. For example, the amount of yellow dye incorporated by any particular area in the matrix of a blue separation negative would be determined by the thickness of the gelatin at that point. Fully saturated, the dye-laden images are regis-

588. The dye-transfer process for making full-color photographic prints consists of the following sequence of steps:

a. Separation negatives made by photographing the same subject or transparency three times through red, blue, and green filters.

b. Gelatin matrices exposed through the separation negatives and developed as positive relief images corresponding inversely to the values in the negatives.

c. Yellow, magenta, and cyan dye absorbed into the matrices proportional to the varying volumes of gelatin in the relief patterns.

d. Dye-laden gelatin matrices for magenta and cyan registered one by one on heavy-duty paper and rolled under pressure to transfer the proportionally dyed images to the absorbent paper.

e. Dye-laden gelatin matrix for yellow combined with magenta and cyan to create a full-color image.

tered one by one on *dye-transfer paper*, a double-weight paper heavily coated with gelatin to absorb the dye. Gentle pressure with a roller after each application of a matrix to the paper assures maximum contact between image and absorbent medium, the transfer of dye being heaviest where the matrix is physically thickest (a dark area in the subject matter). Once the first matrix is removed, the procedure is repeated for the second and third matrices. The ultimate result is a high-quality color photograph with clean whites and good retention of clarity (Fig. 588).

589, 590. The sandwich color negative devised by John Joly in 1873 combined for the first time in a single negative the color filtration capability of three separation negatives. The technique derived from a screen made of alternating microscopic transparent strips colored red, green, and blue and positioned in front of a traditional black-and-white plate. Once exposed through the strips, developed and converted to a positive, and finally projected through the original screen by means of beamed light, the film provided a transparency in which the strips tended to fuse as a full-color rendition of the photographic image.

above: 589. Strip filters used by John Joly to make the first sandwich negative for color reproductions, shown here in magnification.

right: 590. Sandwich-film color reproduction made by John Joly around 1873.

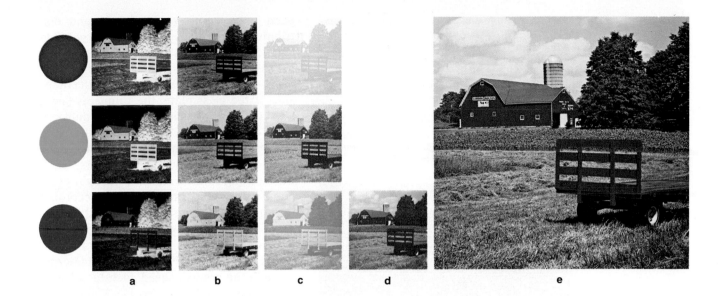

a b c d e

The preceding brief description of carbro and dye-transfer printing considerably simplifies what are, in actuality, extremely complicated processes requiring skill, knowledge, and equipment usually beyond the capabilities of the amateur. Even the separation of colors into individual negatives, the stepping stones of both methods, presents major difficulties. In addition to the two dominant methods, a score of others appeared, most of them more complicated and therefore limited to laboratory situations. A refined technique, one which would be easier to perform, subject to a reasonable price range, and applicable to normal camera equipment, soon became the object of color photography research.

"Sandwich" Negatives

By 1893, John Joly (1857–1933) managed to combine all elements of the additive color process in a single negative that could be used in standard camera models. Joly placed a glass screen imprinted with extremely fine, transparent lines of red, green, and blue in front of the traditional black-and-white plate (Fig. 589). During exposure in the camera, these alternating, microscopic color bands served to break down the subject's transmission of color information to its component parts prior to

value registration, in black and white, on the emulsion. Red, green, and blue wavelengths could therefore pass the screen only at their respective filters, and the resulting negative provided a minutely pieced record of the amounts of red, green, and blue light reflected from the subject. The principle is similar to that used today to create color in television transmission. Following development and the conversion to a positive transparency, which required that the screen be removed, the image appeared in full color once projected through the original screen by means of a light beamed from a lantern (Fig. 590). Joly's "sandwich" negative was by no means perfect, since the picture's color balance depended upon exact replacement of the screen, and substantial enlargement of the image revealed the screen's individual color strips. Nonetheless, it provided the basis for further experimentation.

In 1907, Auguste and Louis Lumière of Lyons (1862–1954; 1864–1948) developed the Autochrome process, which, despite imperfections similar to those in Joly's technique, simplified color photography sufficiently to make it more viable for commercial purposes. Substituting color dots for the lines used by Joly, the Lumière brothers coated one side of a glass plate with a layer of tiny, transparent starch particles dyed red, green, or blue. Next, they ap-

591, 592. Auguste and Louis Lumière of Lyons perfected in 1907 the Autochrome process, which yielded full-color photographic reproductions by means of a filter composed of countless particles of transparent starch dyed red, green, or blue.

below: 591. Varicolored starch filter for an Autochrome, magnified in reproduction.

bottom: 592. Alfred Stieglitz. *Mrs. Selma Schubart* (Stieglitz' sister Selma). 1907. Lumière Autochrome (image reversed), 7 x 5″. Metropolitan Museum of Art (gift of Miss Georgia O'Keeffe, 1955).

plied pressure to pack closely and distribute the particles as evenly as possible (Fig. 591). Lampblack filled the remaining microscopic spaces, and a waterproof varnish sealed the entire surface. On the other side of the glass plate, the Lumières laid a thin coating of panchromatic emulsion. With the starch-covered side of the plate facing the lens during exposure, the grains functioned as minute color filters, each transmitting to the emulsion the light of its hue—red, green, or blue—and recording the image as a mosaic of dots. Once the negative was developed and then reversed into a positive, its image could be projected in full color (Fig. 592). Light filtering through the grains caused each to color its corresponding dot in the black-and-white mosaic. The Autochrome pictures displayed a characteristic spotting or color blotching, not found in the Joly images, and this slightly marred the visual effect. Normally invisible, the starch grains had a tendency to cluster in one-color groups large enough to be seen in the final reproduction.

By 1913 the Lumières were manufacturing 6,000 Autochrome plates a day, and the process continued in use until the early thirties. The Lumière firm remains one of the largest producers of film in France.

SUBTRACTIVE COLOR FILMS

Shortly before World War I, German chemist Rudolf Fischer (1881–1957) patented the principle of *dye coupling*, which would do much to streamline the subtractive method of producing color photographs. Formerly, standard dyes were introduced into the process only after developed negatives had been converted into black-and-white positives. The immense difficulty of this technique lay in controlling the rate at which each dye diffused through two and three layers of film. What helped solve the problem was Fischer's proposal that dye-producing elements, called *dye couplers,* be incorporated into the emulsion right along with the light-sensitive silver compounds. These chemicals would then generate color, by turning into dyes, when

activated by the developer during the processing of the black-and-white image. Thus coupled to black-and-white development, color production not only submitted to control but was considerably simplified. Fischer foresaw dye coupling as a benefit for the manufacture of color separation negatives. In the 1920s, innovators perceived the validity of the principle for coloring the new *multilayer films,* but this became a working reality only in the succeeding decade.

Multilayer films consist of very thin, individually color-sensitized sheets of black-and-white emulsion, sandwiched to form an integral unit far more compact than the photographic plates of Joly or the Lumière brothers. Usually sensitive to the primaries red, green, and blue, the emulsions capture wavelengths at the appropriate levels as light penetrates the film. By this means, the entire process of color separation is compressed onto a single piece of film. Foremost among those experimenting with the multilayer approach were Leopold Mannes (1899–1964) and Leopold Godowsky (b. 1900) two professional musicians who also happened to be passionate amateur photographers. Their early research led to the development of a subtractive color system based on film made with two layers of emulsion, one sensitive to the green and blue-green wavelengths of the spectrum and the other to the red wavelengths. Once exposed and developed, the negative was converted to a black-and-white positive and its images infused with dyes. As explained above, accuracy depended upon careful regulation of the speed at which each dye diffused through the film layers. After learning of Fischer's ideas on dye coupling, Mannes and Godowsky temporarily abandoned their complicated procedures in favor of experimentation with dye couplers in triple-layer, or *integral tripack,* films.

COLOR TRANSPARENCY FILMS

Kodachrome

Five years of collaboration between Mannes, Godowsky, and Eastman Kodak in

593. Kodachrome color photographic reproduction. 1936. View of Yellowstone Falls, Wyoming.

Rochester, New York, resulted in a commercially feasible color positive film. Early in 1935 Kodachrome went on the market for use in home movie cameras, then was modified to make color still photographs. Having failed to confine the dye couplers to specific emulsion layers, which confinement would have been necessary for good color balance, Mannes and Godowsky returned to the diffusion method for their Kodachrome system, but used as the coloring agent couplers contained in the developing solution. Thus, the techniques for developing Kodachrome remain so complicated that even today most photographers forward their exposed film for processing at Eastman Kodak Laboratories.

While still incapable of yielding inexpensive color prints, Kodachrome nevertheless represented a culmination of color theory and technique. The integral tripack film joined with selected characteristics of previous color processes to provide a practical system making color photography available to the general public. Most important, the color was realistic and pleasing (Fig. 593).

594. Modern color film consists of 9 layers, which all together measure about .00065 inch in thickness.

a. Hard gelatin coats the top to insolate the emulsion against scratches.
b. The blue-sensitive emulsion records the image in values of blue.
c. The yellow filter, made of colloidal silver, does not record an image but absorbs any blue light rays leaking beyond the blue layer.
d. The green-sensitive emulsion registers a latent image in values of green.
e. Gelatin separates the green layer from the red.
f. The red-sensitive emulsion responds to the value variations in the red light rays reflected from the subject.
g. The subbing layer, a special gluelike gelatin, adheres the emulsion to its support below.
h. The support provides a strong but flexible plastic base for all other component layers of film.
i. The antihalation backing prevents reflections that could create halos around bright areas of the images.

Ektachrome

Soon after the advent of Kodachrome, German researchers at the Agfa company did manage to adapt dye couplers for inclusion in a multilayer film. During World War II, following takeover by the Allies of an Agfa plant, the secrets behind Agfacolor became known, permitting yet another general advance for chromatic technology.

The introduction of Kodachrome marked a new era in color photography. A roll of film could be purchased, exposed, and mailed to Kodak where it was quickly processed and returned as a group of color transparencies. Enlargement of these transparencies on a projection screen did not reveal colored lines or starch particles to spoil the quality of the imagery. Available in 8mm and 16mm sizes for motion pictures as well as in 35mm for slides, Kodachrome capitalized on the well-established success of those two popular modes of expression, home movies and slide shows. In 1942, Ansco marketed a film named Ansco-Color (later Anscochrome and now GAF). Shortly thereafter, Kodak announced Ektachrome. Both films contain the dye couplers.

As slides projected for home entertainment or as the expression of a highly for-

malized art, color transparencies are an end unto themselves. They also make possible the first step—the composite from which the primaries can be separated—leading to commercial reproduction of color by industrialized photomechanical means.

Even in modern films, color reproduction commences with the separation of light waves reflected from a subject into records of its values in the additive primaries. Fundamentally, this occurs when the film is exposed in a camera. Integral tripack film contains in a single sheet stratified layers of three different emulsions—one sensitive to red, one to green, and the third to blue—which alternate with separating materials and rest upon a supportive base (Fig. 594). Despite its greater complexity, color transparency film has a thickness only slightly greater than that of black-and-white film. The top emulsion is sensitive to blue light and captures those wavelengths. Directly below the blue-sensitive emulsion is a yellow filter (made of colloidal silver) that, as the complement of blue, absorbs any blue light rays that may have leaked through the blue layer. While permitting green and red wavelengths to penetrate to their respective layers, the yellow filter performs a vital screening function. Since blue is fundamen-

tal to all silver halide emulsions, the color inheres in the sensitivity of the green and red layers, and its wavelengths could affect them sufficiently to make accurate color separation impossible. Barring the fortuitous coordination of errors that gave success to James Clerk Maxwell's experiment, an unfiltered composite film system could not generate realistic color reproduction. No filter is required between the green and red layers.

The routine of processing color transparency film requires not only patience but also adherence to established guidelines. Even minor deviations can severely alter a film's representation of color, resulting in barely recognizable tones. Colors can, of course, be deliberately distorted for the purpose of attaining desired aesthetic effects, but this entails highly specialized modifications in methodology.

Reversal Images Because it demands great amounts of time, expensive equipment, and elaborate procedures, color processing usually must be done in commercial laboratories. For that reason, only a brief description is given here of Kodak's E-4 method, which, although designed to serve the specific needs of Ektachrome, could be taken as representative of the ways that color film can be processed. Ektachrome, owing to the dye couplers included in its emulsion, provides a relatively simple model of color processing.

The diagram in Figure 596 represents the colors of the light waves reflected from a subject (Fig. 595). Once the film has been exposed to make a record of the image and its colors, it must be handled in total darkness until the processing has advanced through the stop bath. First, the processor conditions the exposed film in a prehardener and then in a neutralizing solution. Next, he places it in the developer, which causes the light-sensitive silver particles, or halides, in the three emulsion layers to blacken in proportion to their exposure. The result is three black-and-white separation negatives sandwiched into a single sheet of film (Fig. 597). Following its first

development, the integral tripack negative must be subjected to a stop bath, to halt the action of the developer, and then rinsed to remove chemical residues. Now rendered insensitive to light, the film can for the remainder of the processing be handled in an illuminated environment.

At this point, the film consists of three black-and-white negatives, each reproducing the value record of one of the additive primaries. The next step is to reverse these value images from negative to positive transparencies. For this to be accomplished, earlier processes (E-1, E-2, and E-3) required that a flash from a bright light source reexpose the film. Reexposure and a second development cause previously unaffected silver halides in the light or thin passages of the transparency to turn black (become metallic silver) and assume the image. This renders the film completely black and opaque (Fig. 598). With the E-4 process, the same effect can now be achieved by chemical action. Once developed the second time, the film must be immersed in stop bath and then rinsed briefly.

For the image to appear in color, the positive value records in the three emulsion layers must be dyed and the whole transparency relieved of the blackness that now possesses it. As the color developer reverses the image from negative to positive, it oxidizes and then activates the dye couplers present in the positive portions of the three emulsions (Fig. 599). The color the dye couplers release in each of the emulsion layers is the complementary, or subtractive primary, of the additive primary that created the value record at the time of exposure. The result of this is a film composed of three positive black-and-white images combined with three color images.

To make the color image visible, black must be removed from the film. A bleaching solution serves to weaken the silver compounds and make them soluble. A fixing bath can then dissolve not only all metallic silver formed during the two developments but also the yellow filter stratified between the blue-sensitive and green-sensitive emulsions. It also bleaches away any

595

596

597

598

595–601. **Color reversal film** makes possible the photographic reproduction of images in positive transparencies whose full color is a function of the subtractive primaries yellow, magenta, and cyan.

595. Subject.

596. Exposure causes the film layers sensitive to blue, green, and red light to record as latent images the wavelengths for those colors emanating from the subject. Where the subject is black, no exposure occurs at any layer; where it is white, all three layers are exposed.

597. The first development produces black-and-white (metallic silver) negative images in the three light-sensitive layers, the density of each negative corresponding to the quantity of blue, green, or red in the subject.

598. Reversal of the negative to a positive occurs as a result of a second exposure or of chemical action in the second development. By this process the previously unaffected silver halides in the thin or clear passages of the three film layers become metallic silver and assume the image. The film now appears completely black.

dye not solidified by prior exposure and development. After a final rinse, the film is placed in a stabilizer to fix the permanence of its hues.

What remain after all the processing are three positive images formed of hardened gelatin whose colors are, respectively, yellow, magenta, and cyan (Fig. 600). Because exposed and processed simultaneously in a single piece of tripack film, the three images overlap in perfect registration. A beam of white light projected through the three images causes their colors to combine in various mixtures and re-create the original colors of the light reflected from the subject whose image the camera recorded on film (Fig. 601). Since the transparency's colors

function by the subtractive principle, each subtracts (absorbs) from white light the wavelengths of its complementary opposite and allows the others to pass through. Thus, where red should appear, images have formed on the yellow and magenta layers to subtract their complementaries blue and green from the white light. This serves to block the passage of all but the wavelengths of red light, thus permitting the eye to perceive the image as red. Other combinations occur to re-create by subtraction of their opposites all the colors present in the subject. Where the image should appear white, no color has formed at any level of the tripack positive, and the clear, featureless film transmits all wavelengths of white light.

599. Color appears in the three layers as oxidizing developer activates dye couplers in the three emulsions to dye the positive black-and-white images yellow, magenta, and cyan—the colors complementary to the blue, green, and red light waves that exposed the three film layers.

600. Bleaching solution removes all silver compounds and unsolidified dye to leave a film composed only of the superimposed and perfectly registered yellow, magenta, and cyan images.

601. The positive transparency reproduces a photographic image whose natural colors are a function of the way the subtractive principle permits some colors to combine and simulate all colors. To make black, yellow, magenta, and cyan fuse to subtract from white light all its wavelengths. To create green, yellow and cyan combine to transmit their wavelengths while subtracting all others. For white to appear, the transparency remains clear and passes all wavelengths.

Black is reconstituted by the presence of an image at all three strata, which together subtract all light and result in the eye perceiving black. In as many proportional relationships as there are subjects to photograph, the yellow, magenta, and cyan images can combine to reinforce and cancel one another until they have realized a convincing representation of the whole range and variety of the spectral world.

Color Prints from Transparencies

Requiring projection by light from a lantern, transparencies could not satisfy the popular demand for self-revealing color reproductions. Thus, manufacturers of color film began to make prints from transparencies. Kodak introduced Kodachrome prints, which consisted of color images imposed upon a plastic material. The quality of the early prints was poor, mainly because printing made the contrasty character of Kodachrome film even more pronounced than in the transparent state. Owing to the intricacies of Kodachrome development, prints from this process could be obtained only at the Eastman Kodak facilities in Rochester, New York. Ansco's Printon process also yielded color reproductions on plastic supports. A simpler technique, Printon could be accomplished in any well-equipped black-and-white darkroom. The high gloss and glare of the plastic surfaces

made Printon and Kodachrome opaque reproductions difficult to view, and their quality prevented these prints from satisfying any but amateur snapshot needs.

Some improvement was realized in paper-backed prints taken from Kodachrome transparencies when Eastman Kodak devised a special internegative film. This required that a color transparency be copied onto a color negative, which could then be printed by a process resembling that described on pages 299–302. The internegative is now employed by photofinishers on occasions specifying a quality print of an image found only in a developed positive transparency. This and a reversal method (Ektaprint R) have largely replaced the Kodachrome print and Printon systems.

The dye-transfer method (see pp. 281–283), altered only slightly by modern technique, continues to produce some of the most impressive color prints now to be seen. Instead of old-fashioned color separation negatives, a color transparency or a color negative supplies the source for the matrices. Three black-and-white exposures of a color transparency are made through red, green, and blue filters. These copies are then used to prepare the dye-transfer matrices. Any change in print size requires complete recasting of the matrices. Unfortunately, the high quality that distinguishes dye-transfer prints also makes imperative the high cost of the process (approximately $100 to $175 for an 8×10 print). As with most color transparency printing, dye transfers normally can be achieved only in well-equipped color laboratories.

Brands of Color Reversal Film

The following are generally distributed color transparency films that can be purchased in 35mm and/or 120 film sizes:

Agfachrome CT 18 (50)
Ektachrome Professional, daylight type (50)
Ektachrome Professional, type B (32)
Ektachrome-X (64)
High Speed Ektachrome, daylight (160)
High Speed Ektachrome, tungsten (125)

Fujichrome R-100
GAF 64 Color Slide Film
GAF T/100 Color Slide Film, tungsten type
GAF 200 Color Slide Film, daylight type
GAF 500 Color Slide Film, daylight type
Kodachrome II, daylight type (25)
Kodachrome II Professional, type A (40)
Kodachrome-X (64)

Exposure for Color Slides

Since the time of Newton's experiment, it has been known that color is a function of the interaction between light and the matter it illuminates. Thus, in photography, which is a product of light, ultimate color balance results from the quality of the light making the exposure and the color quality in the light-sensitive materials exposed by the light. A transparency consists of the actual film that was exposed in the camera. For a color positive image to be realized, the developed negative has only to be reversed to a black-and-white positive, which is first dyed the subtractive colors and then bleached of all black elements. The photograph remains in the original film; its viewing state does not emerge only after the image has been transferred to another medium, such as paper in the instance of photographic prints. Thus, the principal opportunity the photographer has for controlling color balance in color transparencies is at the time of exposure. To exercise control, he must match the color of the light source with the color sensitivities peculiar to the film used. The technique is to choose a film to match the available light, or choose a light to match the available film, or use filters to alter the color balance in the light so that it can affect the film's color balance in a desired way.

Exposure of color reversal transparencies involves neither detailed preparation nor complicated procedure, but it does require careful evaluation of the amount and quality of light by which the film is to be exposed. A small error in exposure can drastically change color rendition (Figs.

602. Normal exposure.

603. 1 f-stop overexposure.

604. ½ f-stop overexposure.

605. ½ f-stop underexposure.

606. 1 f-stop underexposure.

602–606. Exposure of color reversal transparencies must be accurate, for a small error can drastically change color rendition.

602–606). The tints of an overexposed transparency have a pale, washed-out appearance (Figs. 603, 604). Underexposure produces a dark transparency characterized by little detail and subdued colors (Figs. 605, 606). The exposure latitude for color transparency film is considerably narrower than that for black-and-white film (Fig. 607). An apparent change in color occurs with an alteration in exposure of no more more than a single f-stop or even with half that amount. Black-and-white film tolerates modifications within a range of two f-stops for increased exposure and one f-stop for decreased exposure. Such sensitivity to light makes the exposure meter an imperative in color photography.

Also, slight variations in processing can alter density, or the capacity of exposed and developed film to stop the light beamed or projected through it. Altered density affects tones in much the same way as do exposure variations. A good color processor can control tolerance to no less than one-half an f-stop in either direction. Thus, even when exposure is correct, processing may cause color distortions. To compensate for variables in exposure and development, the photographer can practice *bracketing*. This increases the probability of acceptable color by allowing for three different exposures of the same view: one determined by the meter's indications; a second at an increase of one-half an f-stop; and a third at a decrease by the same amount.

Light Source The light source itself is a major determinant of the color tonality of transparencies. Most types of illumination transmit all wavelengths of light, but with

607–609. Color balance in reversal emulsions has been adjusted to render colors as human vision expects them to appear, whatever the color balance in the light source.

607. The exposure latitude for color transparency film is considerably less wide than that for black-and-white film.

608. Daylighted tungsten-type film records an excess of blue lightwaves.

609. Tungsten-lighted daylight-type film proves overly sensitive to red lightwaves.

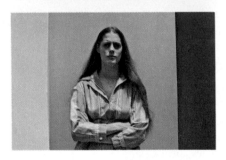

610. Conversion filters can correct film sensitized to artificial light for use in daylight. Here, a filter has converted tungsten type B film to balance with the color of daylight. Compare this photograph with the unfiltered version in Figure 608.

cause of the way the brain processes the information conveyed to it by the senses, human vision perceives white as white whether illuminated by the blue coolness of daylight or by the red warmth of tungsten light. Photographic emulsions, having no such overall compensator, record light exactly as it is reflected, not necessarily as the photographer may see the light.

Film Type Color films are each designed to function in light with a particular color temperature. The sensitivities of the emulsions in each are balanced to reproduce colors as human vision has been prepared by experience to see them. Color films can be had with emulsions adjusted for use in three standard types of illumination.

daylight and electronic flash
professional studio equipment (type B)
photoflood (type A)

Both intended for use with incandescent light, type A film is adjusted for a color temperature of 3400°K., while type B has a sensitivity of 3200°K. If tungsten-corrected type B film is used in daylight, the photographic reproduction will appear bluish (Fig. 608). Daylight film exposed under tungsten illumination will render the scene with an orange cast (Fig. 609).

The color temperature of a light source should not, as a rule, differ by more than 100°K. from the sensitivity of the film used. A color temperature meter permits accurate analysis of a particular light source, and helps the photographer maintain balance between his film and the illumination he works by. Most moderately priced meters measure blue and orange light waves as an indication of the source's total color composition. At a higher cost, tricolor metering systems are available.

Filtration Because color films have been sensitized to correspond to the color temperature of no more than three types of common light sources (daylight and two varieties of incandescent lamps), color filters of optically clear glass or gelatin must be employed to correct the available films for

the range dominated by those for one or a few hues, which give the light a characteristic color. Some artificial lights, having concentrated in them the wavelengths of one or a few spectral hues, display a *discontinuous spectrum* (Figs. 630–632). Since objects reflect the wavelengths that the light source throws upon them, they assume the color balance of that source. Abundant in rays from the "warm" section of the spectrum, incandescent light lends a reddish tinge to whatever it illuminates. Predominantly blue daylight tends to "cool" the hues of outdoor scenes.

The color "temperature" of light can be measured in degrees Kelvin (see p. 351). In light of high temperature, red and yellow predominate, while blue and green prevail in light of low temperature. Be-

exposure by light whose color composition is different. By providing a favorable medium for the energies of certain light rays, color filters can control which wavelengths reach the photographic emulsion. In theory, a blue filter passes blue light and absorbs all red and green light (Fig. 179). Actually, the phenomenon is not quite so simple. A wavelength is stopped only if it finds in the filter receptive molecules capable of incorporating its energy. This energy may then be released almost immediately by filter molecules, but usually as heat rather than light. Now, the receptivity of a particular filter can be chemically structured to absorb several wavelengths or merely a few. Since filters reduce the amount of light reaching the film, exposure must be increased proportionately. Determining the corrected exposure requires an understanding of the *filter factor,* or degree of compensation, which is discussed on pages 342 and 343 in the Appendices.

Conversion filters, or Kodak Light-Balancing Filters, can, by their bluish or yellowish color, correct film sensitized to one type of artificial light for use by another type of artificial light, or for service in daylight (Fig. 610). The filter designed to correct daylight-type film for use in artificial light is so dark that the required exposure may not be practical. Table 10.1 identifies filters capable of making standardized accommodations between two films and their light sources. The ASA ratings vary according to filtration, and instructions provided with film usually indicate in detail the proper employment of conversion filters.

Color compensation (CC) filters, also produced by Kodak, enable the photographer to modulate tones under more specific conditions. These are available in such

611. Color compensation (CC) filters are available in a range of colors and concentrations. They offer the photographer a means for making subtle modifications in the color balance of exposure light.

colors as red, green, blue, yellow, magenta, and cyan, and concentrations ranging from extremely pale (CC025) to very dark (CC50). Singly or combined, compensation filters are the implements of interpretive color (Fig. 611).

Daylight color transparency film is designed for exposure between 10 A.M. and 2 P.M., the hours when sunlight is "whitest" owing to the perpendicular angle at which light rays travel earthward from a sun located high in the sky or even directly overhead (Fig. 612). Because at this angle all rays enter the earth's atmosphere more or less simultaneously, all wavelengths are present in the generally balanced mixture

Table 10.1 Conversion filters

Type of film	Daylight	Color temperature 3400°K.	3200°K.
A	85*		32A
B	85B	81A	

* Kodak Wratten Filter number.

612. The "whitest" daylight, from 10 A.M. to 2 P.M., offers exposure conditions most favorable to the color balance designed into daylight-type color transparency film.

613. The color of daylight varies according to the distance the sun's rays must travel in order to enter the earth's atmosphere. At high noon, daylight is "whitest" because the sun's angle perpendicular to the earth permits all wavelengths of light to arrive simultaneously. The earth's atmosphere then scatters and redirects the wavelengths, and since those for blue are the shortest, they scatter more pervasively, giving the effect of blue to the sky. At sunset, the angle of the sun is such that some of its rays must travel a greater distance than others. Since the longer red lightwaves travel faster, it is their color that gives the evening sky its characteristically rich tonality and creates the brilliant, chromatic sunsets that color photographers find irresistible.

that makes white light (Fig. 613). Once light rays enter the earth's atmosphere, they are scattered by molecules of air, water particles, and bits of dust. The shorter wavelengths are those most easily refracted; thus, they predominate in daylight to give the sky its characteristic blue tonality.

Color Balance Often, amateur photographers associate noon light with the entire day. In actuality, however, the color temperature of light fluctuates quite considerably as the sun moves from horizon to horizon, and the results of both black-and-white and color photography vary as the quality of light changes from early morning to late afternoon. At sunset, the angle of the sun is such that some of its rays must travel much farther through the earth's atmosphere (Fig. 613). Being less subject to dispersal, the longer wavelengths of red come to predominate and create the rich, russet hues typical of spectacular sunsets. The longer reach of early and late sun rays gives the atmosphere more light to scatter, which brightens the sky and reduces the contrast between it and direct sunlight (Fig. 614). Many photographers prefer this suffused lighting to the strong light-and-dark contrasts produced by the noon sun.

Clouds refract light still further, and color photographs made on cloudy days have soft pastel hues and an overall bluish cast (Fig. 615). Shadows exist where no direct sunlight falls, but forms and colors within shaded areas receive illumination from the

614. Early and late sun rays brighten the sky, reduce contrast, and provide a suffused lighting that many photographers prefer.

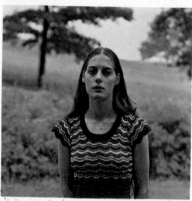

615. Clouds refract light, yielding photographs with soft pastel hues and an overall bluish cast.

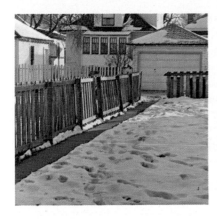

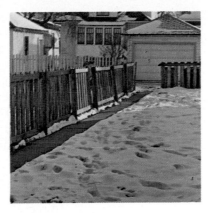

616, 617. Color emulsions respond to the light actually reflecting from surfaces, whereas human vision perceives colors as the brain has learned to expect them to appear.

far left: 616. Blue shadows register in photographs of snow scenes made with daylight-type color reversal film.

left: 617. Ultraviolet filtration (UV) can screen out the wavelengths that make snow shadows appear purple.

atmospheric scattering of blue-dominated light. Blue shadows are especially present in photographs made of snow scenes with daylight color transparency film (Fig. 616). An ultraviolet filter (Kodak 1A) can warm the color rendition of outdoor shadows and diminish the atmospheric haze evident on very bright days (Fig. 617).

The intensity of hue in a particular sunrise or sunset depends upon a variety of factors, including the amount of water vapor, dust, dirt, smoke, and smog in the air. The color transparency in Figure 618 renders the reflection from building and snow of red-dominated late afternoon sunlight. The memory system of human vision easily accepts the tones of yellow and red that give a warm, pleasant quality to the weatherbeaten wood. Not congruent with our sensibilities, however, are the pink-tinged snow and the deeply blued depres-

618. The color of light affects the color appearance of all that it illuminates, and color-sensitized film registers this, even though human visual perception may filter it out.

sions in the drifted snow. Since we perceive snow as white, whatever the color of light reflecting from it, many viewers may have difficulty accepting the uncompromising realism in the response made by the photographic emulsion. At the same time, we cannot reject the possibility that distortion

619, 620. Color reflects from object to object.

far left: 619. Red reflects onto white and somewhat less onto flesh tone.

left: 620. Blue lightwaves affect the adjacent white and even the flesh tone.

621. Sunlit scene.

622. Leaf-filtered light provides cool, greenish illumination.

623. Atmosphere-refracted light suffuses shadow with a cool, blue, low-contrast tonality.

the reflection but transmits the respective hues less vividly than does white.

Light filtering through semitranslucent colored material tints a scene with the hue of that material more distinctly than human vision would perceive. In Figure 621 the image glows with the direct illumination of late afternoon sunlight. Greenish tones, filtering through the leaves overhead, prevail in Figure 622. The cool tinge of the subject in Figure 623 derives from refracted blue lightwaves that provide indirect illumination even of shaded areas.

Smooth surfaces so modify the behavior of light that the vibrations normal to light waves are contained within a single plane (Fig. 624). Known as *glare,* such polarized light can be screened, or produced, by a *polarizing* or *pola filter.* To prevent the glare from entering the lens, the filter's axis must be positioned perpendicular to the plane of the light's vibration (Fig. 625). At other orientations, the filter slices the light into parallel bands as it passes through the lens. In Figure 626, light reflecting from the pond surface reduces detail and pales the color of the water, flowers, and leaves. At its best, a pola filter can relieve glare, enhance color, and sharpen detail—even reveal the bottom of the shallow pool in Figure 627. Figures 628 and 629 illustrate the pola filter's ability to minimize the harsh concentration of light reflecting from a metal roof and bring out details otherwise lost in the cloud pattern.

Figures 630 and 631 demonstrate the result of tungsten film (type B) and daylight film exposed under fluorescent illumination. Neither transparency even approximates a color balance that would seem correct to human visual expectations, since both emulsions have recorded the abundance of green wavelengths characteristically present in fluorescent light sources. In fluorescent illumination, the photographer encounters one of the most serious challenges to any hope he may have of achieving uniform quality in color rendition. Tungsten and daylight sources transmit a full, if unbalanced, range of wavelengths, but fluorescent light generates a

may be significant to the quality of this photograph, and routine corrective filtration could actually have spoiled the effect.

Colored objects affect one another by reflection, and this is apparent in color reproductions of more confined scenes. Figures 619 and 620 reveal red and blue panels that have a decided effect upon the color of the blouse. Facial tone is also colored by

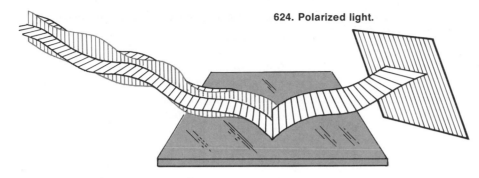

624. Polarized light.

624–629. Glare is light whose behavior has been so modified by a smooth surface that its vibrations become polarized into a single, two-dimensional plane.

left: 625. A pola filter can absorb glare provided the filter's axis has been positioned perpendicular to the plane of the light's vibrations.

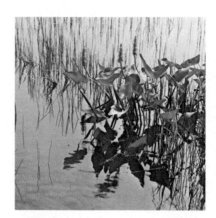
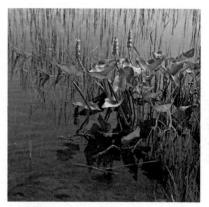

right: 626. Light-reflecting pond surface reduces detail and pales all color.

far right: 627. Pola-filtered light reveals color, clarity, and detail.

right: 628. Harsh, concentrated light obscures detail on a metal roof.

far right: 629. Pola filtration brings out color and detail in the roof.

630–632. Fluorescent light generates a discontinuous spectrum of lightwaves in which there is a concentration of blue and green lightwaves.

right: 630. Tungsten (type B) film and fluorescent illumination.

far right: 631. Daylight film and fluorescent illumination.

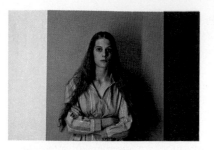

632. Filtered fluorescent illumination and daylight film.

Table 10.2 Filtration for fluorescent illumination

Film	Type of fluorescent illumination Daylight	Warm white	Deluxe cool white
Daylight	20M + 20Y 2/3 stop	20C + 20M 2/3 stop	10C 1/3 stop
Type B	85B* + 30M + 30Y 1 stop	20M + 20Y 2/3 stop	10M + 30Y 2/3 stop
Type A	85* + 30M + 30Y 1 stop	30M 1 stop	20M + 20Y 2/3 stop

* Kodak Wratten Filter number.

B (Y)
G (M)
R (C)

secs. 5 10 15 20 25 30

633, 634. Reciprocity failure, resulting from overexposure, is critical in color films, since it causes chemicals producing the three subtractive colors to react in an uncoordinated way.

left: 633. Unequal response among the color emulsions results after 30 seconds of exposure, causing the red-sensitive layer to yield a cyan image less dense than the yellow and magenta images recorded by the blue and green light waves striking the film.

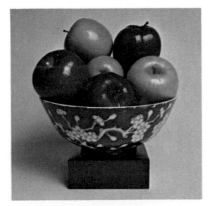

634. Inadequate cyan, resulting from reciprocity failure, causes this transparency to appear too red.

discontinuous spectrum. Some wavelengths are omitted in favor of heavy concentrations of those for blue and green. In addition, fluorescent lighting exists in six different types, and since each is characterized by only a slight difference in color emphasis, proper identification of a specific type often is difficult. To complicate things further, fluorescent color changes as tubes age, which produces a multitude of aberrations within each type of fluorescent lighting. On top of all this, tubes of diverse coloration often can be found within a single fixture.

Because of such factors, filters cannot compensate sufficiently to yield consistent results in color photography done under fluorescent illumination. Thus, photographers should work by fluorescent lighting only when more dependable and accurate illumination cannot be had from a tungsten source. However, the filtrations suggested in Table 10.2 may help the amateur find a way to realize acceptable color reproductions even when the light source derives from fluorescent tubes (Fig. 632). Testing the suggestions for suitability is the best technique for obtaining good results. In using filters, the photographer must remember that inevitably they reduce the amount of light admitted into the lens. Thus, an increase in exposure has been indicated for each filtration cited in the table.

Only a multitude of specifically tinted color compensation filters could adequately prepare the photographer for all unforeseen lighting conditions. As an alternative to such cumbersome equipment, the Decamired System has been devised whereby eight filters in various intensities of red and blue can be combined to yield a wide range of color filtrations. The name of the system derives from the Greek term for 10 and from *mired,* a standardized color temperature value. Thus, the filter strength in this system is measured in units of 10 mired.

Not only have color transparency films been formulated for exposure by no more than three common types of illumination, but, in addition, their exposure must occur within designated durations. Exposures exceeding those specified result in *reci-*

procity failure (see p. 100). In black-and-white film, the effect of reciprocity failure is underexposure, a mistake that may be correctable in printing. In color films, reciprocity failure is more critical, because it alters the action of the color-producing chemicals. The graph in Figure 633 plots the exposure pattern of one film's color components. After 5 seconds, light affects the three emulsions equally relative to one another. After 30 seconds, the red-sensitive emulsion has failed to keep the desired equilibrium. The developed transparency would reveal a significant change in color balance (Fig. 634).

Even when working by dim light, the photographer should not expose color film beyond the duration suggested by the manufacturer, unless he deliberately seeks the effect of color imbalance. For whatever compensation that filters may be able to make for reciprocity failure, the manufacturer supplied the information in Table 10.3 with a box of 4 × 5 Ektachrome daylight film, whose emulsion requires only a CC05 Red for an exposure of 30 seconds. When the necessary filtration is excessive, it greatly reduces the film's effective ASA. Manufacturers assume that certain films will not be used in situations likely to incur reciprocity failure. In employing such color film, the photographer must test to discover the material's performance characteristics and what corrections may be possible.

When released by the manufacturer, color film meets certain strict requirements, but shipping and subsequent storage can change its color balance. In an attempt to maintain consistent balance in color transparency film, photographers often purchase large quantities with the same emulsion number and store it in the refrigerator or, for maximum preservation, in the freezer. Subsequently, they make a series of tests with representative rolls to check the accuracy of the indicated ASA number and the relative color balance. These tests then provide an exposure norm for the film batch, which simultaneously serves to establish the point at which reciprocity failure could become a problem.

The ASA speeds for color transparency film have increased steadily over the years. The speed can be augmented further by extending the first development. Table 10.4 indicates the alterations in the E-4 process necessary to effect an increase in the speed of Ektachrome. The highest ASA-development combination listed in the table may produce transparencies with a slight color imbalance. Faster films tend to have flat, less saturated color. The degree of distortion varies with the emulsion number, and only testing can gauge the exact exposure range. Extending the first development is feasible for those who process their own film. Commercial labs can make the necessary modifications in procedure, but this entails extra time and special handling, for which they must charge a premium fee.

COLOR NEGATIVE FILM

Beginning in 1941, with Kodacolor, Eastman Kodak introduced color print techniques which by now have been so simplified that the present Ektacolor print process enables amateur photographers to realize, with minimum equipment and

Table 10.3 Filtration to prevent reciprocity failure

| | Emulsion No. 6116–987 | |
Exposure time	Effective speed	Suggested Kodak filter
1/2 second	ASA 32	None
5 seconds	ASA 20	None
30 seconds	ASA 16*	CC 05 Red

* This speed includes the exposure increase required by the suggested filter.

Table 10.4 Alterations to increase ASA for Ektachrome

| | Effective ASA speed | | | |
| Camera exposure | Ekta. X | High Speed Ekta. | | 1st developer time |
		Daylight	Tungsten	
2 stops under	250	640	500	Increase 75%
1-1/3 stops under	160*	400*	320*	Increase 50%
1 stop under	125	320	250	Increase 35%
Normal	64	160	125	Use normal time

* These ASA speeds available from Kodak.

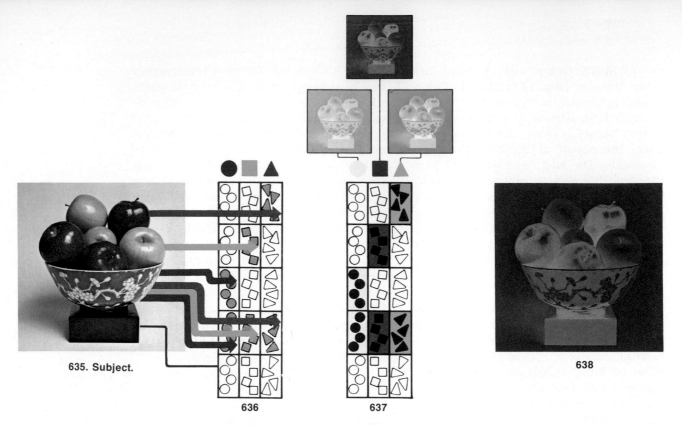

635. Subject.

635–643. Color negative film for prints: exposure, development, and printing.

636

637

638

636. Exposure of the film registers blue, green, and red light waves as latent images on three emulsion layers individually sensitized to those levels of energy. Where the subject is black, it reflects no light to expose the film; where it is white, light rays expose all emulsion layers.

637. During development the three latent images emerge as black-and-white negatives representing the subject in its blue, green, and red values. Color is introduced as dye couplers, activated by oxidizing developer, color the three negative images yellow, magenta, and cyan.

638. An orange mask covers the developed negative to compensate for color distortions that otherwise would occur in printing the negative.

trouble, color reproductions of quite commendable quality. Including Ektacolor, there are currently available some five major brands of color negative film, all in 35mm, 120, and/or 126 film sizes:

Agfacolor CNS (80)
Ektacolor Professional Type S (100)
Fujicolor N-100
GAF Color Print Film (80)
Kodacolor-X (80)

Agfacolor comes from the German company Agfa; Eastman Kodak sponsors Ektacolor and Kodacolor; Fujicolor is a Japanese product; and GAF, the successor of Ansco, manufactures GAF Color Print

Film. Each firm distributes a kit composed of all chemicals, materials, and instructions necessary for processing its film into printed images. In addition, Rapid Access and Unicolor are systems designed to print the color negative films of almost any manufacturer.

Film designed to make color prints functions essentially in the same way as the reversal film made for transparencies, except that it must be developed as a negative transparent image, rather than a positive one. When exposed, color negative film, like color positive film, separates and records light reflected from a subject on three layers of emulsion that individually are sensitive to blue, green, or red wavelengths

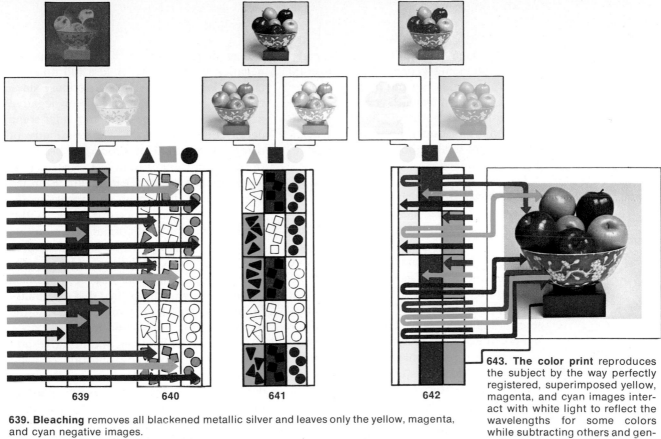

639. Bleaching removes all blackened metallic silver and leaves only the yellow, magenta, and cyan negative images.

640. Exposure of the tricolor-sensitive paper by means of white light beamed through the negative reverses the image to latent positive images recorded by wavelengths of red, green, and blue light transmitted by the negative's subtractive colors.

641. Development of the paper print raises positive black-and-white images in the paper's three color-sensitive emulsion layers. Color enters the three paper images in amounts of cyan, magenta, and yellow proportional to the density of black-and-white positives.

642. Blackened metallic silver is bleached out of the print, leaving only the three color images.

643. The color print reproduces the subject by the way perfectly registered, superimposed yellow, magenta, and cyan images interact with white light to reflect the wavelengths for some colors while subtracting others and generally fuse to simulate all colors. For example, magenta and cyan combine to absorb green and red and to reflect blue. Where all three colors are coincident, all light is absorbed and the image appears black. The absence of all three color images reveals the white paper.

(Figs. 635, 636). During the first development, the latent image in each emulsion emerges as a black-and-white negative representing values in blue, green, or red (Fig. 637). As the developer oxidizes it activates dye couplers to color the negative images the hues of their complementary opposites —yellow for blue, magenta for green, and cyan for red (Fig. 637). Next, the metallic silver must be bleached from the film, which leaves the tripack a composite of superimposed images in yellow, magenta, and cyan —the "negative" colors of the original blue, green, and red separated from the light bouncing off the subject at the time of exposure (Fig. 639). The fully processed negative has an orange cast to it whose presence on the film is intended to compensate for distortions that were found to occur in printing tripack color negatives (Fig. 638).

The negative is printed on paper coated with three layers of emulsion whose light-sensitivity corresponds to the three color images in the film. Since the transparency's colors are the negative complementaries yellow, magenta, and cyan, they convey the image to the paper, by means of white light beamed through the negative, and expose it with the wavelengths for specific additive primary colors while subtracting from the white light the wavelengths for all other colors (Fig. 640). Where the negative is clear, it transmits red, green, and blue light to expose all three emulsions on the paper;

where it is magenta, the film subtracts green (the complementary opposite of magenta) while transmitting red and blue light waves to expose the emulsion layers sensitive to those colors; and where yellow, magenta, and cyan are all superimposed in the negative, all light is absorbed and the paper remains unexposed.

The process for developing the print resembles that for the negative. Each layer of emulsion emerges as a black-and-white positive image corresponding to the values of the red, blue, or green light that exposed it (Fig. 641). Development also causes dye couplers to color the images with the complementaries of the additive primaries that exposed them (Fig. 641). Thus, where red, green, and blue light exposed all three layers, the three images become dyed, respectively, cyan, magenta, and yellow. The overlapped layers exposed by red and blue light waves turn cyan and yellow. That part of the image left unexposed, owing to the presence in the negative of superimposed layers of yellow, magenta, and cyan, has the whiteness of the paper support. When the metallic silver deposits have been bleached out of the print, only the three color images remain (Fig. 642). Perceived in full light, these complementaries once again mix and function by the subtractive principle to reconstitute the original colors present in the subject photographed (Fig. 643). Overlapped yellow, magenta, and cyan subtract all of white light and reflect none, and where this occurs, human vision perceives black. Yellow and cyan absorb all but the wavelengths for green, which causes the image to reflect green. The white passages reflect all colors, which mix in the eye as paper white.

Exposure of Color Negatives

Relative to the color transparency system, the color negative and print process allows a greater margin for error in exposure. Because printing provides an opportunity for correction, a slight under- or overexposure proves less critical. Underexposure, however, is less desirable than overexposure.

The inadequate density of an underexposed negative could fail to yield a full range of color. Overexposure is less serious, since even the darkest areas of a color negative can, when printed, be made to render some detail (Figs. 644, 645). The possibility of using the printmaking process to bring out the detail present even in overexposed negatives makes color negative film seem especially attractive to photographers working with multiple exposures, slow shutter speeds, and such abnormal situations as fluorescent lighting, which precludes accurate exposure calculations. Here, color transparency film could offer less promise of success, owing to the fact that the quality of its result is largely determined at the moment of the film's exposure.

The very flexibility of the negative and print system raises the question of what constitutes correct color balance. The issue does not exist in color positive photography, since the manufacturer generally sets the color norm, and to achieve that standard, the photographer has only to work as prescribed. To judge color quality in prints, the photographer must look elsewhere for an instrument of evaluation. Usually, he refers to a neutral 18 percent gray card (Fig. 146), or to white and/or flesh tones present in the image.

This technique requires that film exposure be established by a meter reading taken from the gray card placed in the scene to be photographed. It also entails photographing the gray card in the scene so as to make a *master negative* whose very subject —the gray card—provides a standard by which to determine a paper exposure likely to yield a properly balanced color print (see pp. 312, 313). Some subjects permit the test card to be included in the final exposure; where this is not possible, the card can be photographed separately at the same session. The latter procedure is described here.

The first exposure on a roll of film could be used for the gray card test. The photographer should determine exposure by metering the light incident to the card (Fig. 646), set the camera's lens at infinity, and expose the film at close range to the card

right: 644. An overexposed negative and normal development produced this print.

far right: 645. Corrected color balance was realized in the printing of the image in Figure 644.

644, 645. Color correction can occur in printing color negatives, because the selection and exposure of paper provide an opportunity for the photographer to exercise skill and judgment in modifying whatever the color balance may be in the negative.

right: 646. A master negative is made by placing the gray card in the scene to be photographed, metering the light incident to the card, and photographing the card out of focus and at close range. Once a print from this exposure has been processed to balance in color against the subject, the particulars of paper and exposure can be used to color correct all other prints from camera exposures made at this session.

far right: 647. The gray-card test can control film exposure, paper selection, and paper exposure so as to realize prints characterized by optimum color balance.

646, 647. An objective standard for evaluating color balance in color prints can be found in the standard 18 percent gray card (Fig. 146).

(Fig. 647). Photographing the gray card out of focus eradicates from the image any dirt or scuff marks that could otherwise influence the rendition of its color. Next, remove the gray card from the scene, and use the light reading taken from it for all succeeding exposures, provided illumination remains constant. In the event lighting shifts noticeably, another gray card exposure would be called for. A new test would also be required for each roll of film having a different emulsion number. Acquiring quantities of film with the same emulsion number helps to reinforce the photographer's control over the quality of his color photographic prints.

The gray card establishes a reliable standard against which to evaluate color balance in a photographic print. Its implacable objectivity avoids analysis based on the subjective preconceptions that many people have of the tonal character that should be present in color renditions of such commonly photographed surfaces as Caucasian flesh. The gray card maximizes the possibility of realizing a color balance that is true to the subject. Without such a standardized unit of measure to guide it, critical analysis can become confused to the point of approving technically unacceptable color for the sake of making the rendition fit unrealistic conceptions.

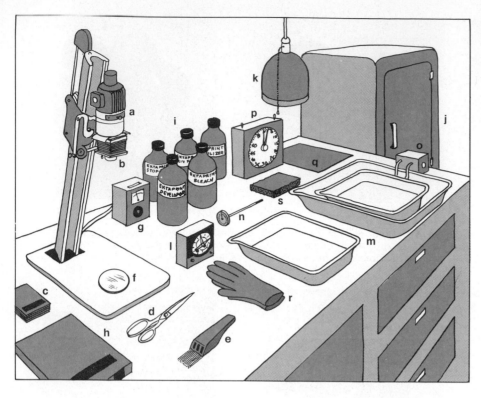

648. The equipment, tools, and materials needed for printing color negatives should be assembled and put in order before processing commences. Since color printing resembles in its fundamentals the procedures for printing black-and-white negatives, the photographer may wish to refer to Figures 435 and 436.

a. **Enlarger with a color head.**
b. **Color-corrected enlarging lens.**
c. **Color filters.**
d. **Scissors.**
e. **Antistatic brush.**
f. **Heat-absorbing glass.**
g. **Voltage regulator.**
h. **Color printing paper**
i. **Chemicals.**
j. **Refrigerator.**
k. **Safelights.**
l. **Exposure timer.**
m. **Processing device** (here, two 8 × 10 trays, one 11 × 14 pan).
n. **Thermometer.**
o. **Hot water regulator.**
p. **Processing timer.**
q. **Gray card.**
r. **Waterproof gloves.**
s. **Viscose sponge.**

Equipment Needed for Printing Color Negatives

Color negatives can be printed and the prints processed in any well-equipped darkroom, but so complex, expensive, and time-consuming is the technology of color photographic printing that to avoid failure and disappointment the photographer should endeavor to meticulously control its variables. The equipment, tools, and materials cited in Figure 648 are those needed for printing color negatives. The photographer should assemble all items—including any he may require from the materials discussed in Chapter 9 on black-and-white printing (Figs. 435, 436)—order them, and make certain they are ready to use before commencing to work with negatives and paper.

Enlarger with a Color Head So delicate is the balance among hues in color printing that it can be controlled only by means of filtration during exposure. Thus, the head of the enlarger employed for printing color negatives should have in it, just above the condensers, a drawer or slot where filters can be placed. Elements to be coordinated and controlled for color balance are the negative itself, the paper, and the light source in the enlarger. This last is usually tungsten, whose color temperature can vary from bulb to bulb, from session to session, and with the length of the session. If the enlarger head does not accommodate filters, these can be placed in a holder and positioned beneath the enlarger lens.

Enlargers designed specifically for color printing incorporate filters in their actual structure. Because it protects the filters from dust and dirt, this type of equipment assures a high degree of consistency in filtration. Some color enlargers (Chromega, for one) control light by diffusion, while others (such as the Beseler) do it with condensers. The softening effect of diffusion tends to deemphasize the grain natural to color negatives, which critical photographers may prefer to avoid or to exploit for aesthetic purposes.

Color-Corrected Enlarging Lens The less expensive lenses suitable for black-and-white work often are inadequate for color printing. A color lens must be carefully designed and ground to exquisitely precise tolerances to ensure that the light passing through it and the negative conveys to the printing paper an image whose detail and colors have not been distorted. Although manufacturers do not specify them, lenses corrected for color enlargement can be distinguished by the sharper image they project, as well as by their higher cost.

Color Filters The filtration system used for printing color negatives can be based either on the additive primaries red, green, and blue or on the subtractive primaries (really "secondaries") yellow, cyan, and magenta. By their nature, the primaries can add up to full color only when projected separately; thus, the system based on them requires three different exposures of the printing paper. This complication usually reserves the tricolor filtration method for the automated equipment employed by commercial photofinishers. The subtractive primaries function in such a way that filters in these colors can be combined in a filter pack for a single exposure of the paper.

If the enlarger head accommodates filters between the lamp and the negative, so that they screen light before it enters the enlarging lens, the relatively less costly acetate Color Printing, or CP, filters can be used. When the filters must be attached below the enlarging lens, only Color Compensating, or CC, gelatin filters can serve, since they are optically corrected to prevent distortion when used in this position, and the CP filters are not. Because of their critical location, CC filters must be absolutely clean and scratch-free. Minor blemishes on the CP filters do not, owing to their placement above the negative, threaten the image or its color. CP and CC filters are available in densities varying from .025 (pale) to .50 (rich).

An ultraviolet, or UV filter (Kodak CP-2B), must be in the filter pack at all times, to guard against any ultraviolet lamp radiation. Although rarely stated on the package, some paper emulsions are unusually sensitive to ultraviolet rays. In such an instance, color balance could not be attained with filtration composed of subtractive colors only. A clear filter, the UV requires no additional exposure. Along with the UV, the filter pack generally includes yellow and magenta, since together they compensate for any imbalance in the primaries transmitted by the subtractive colors.

Heat-Absorbing Glass Like the color filters, the heat-absorbing glass is a special requirement in color photographic printing. Since both negatives and filter materials are sensitive to heat, the glass must be introduced to prevent their being damaged by warmth from the enlarger's light source. The glass' greenish hue also helps to correct color in the light conveyed to the paper. The glass should be installed in the enlarger head between the bulb and the filter drawer. In some enlargers, this can be done by lifting up the housing and laying the glass on top of the condenser lenses.

Voltage Regulator From time to time, normal household current varies in power, and even a small change of 5 volts can affect the color of the lamp sufficiently to result in a print whose color rendition is incorrect. Plugged into the wall outlet and with the enlarger plugged into it, the voltage regulator can compensate for deviations in electrical current. Black-and-white printing is not so sensitive a process that it requires this supplementation.

Color Printing Paper Most manufacturers offer color printing paper suitable for use with their processes and capable of yielding good prints. Variations in the color rendition obtained with these processes and materials can, for the most part, be isolated as either color saturation or contrast. Color differences among papers may be a matter of preference, but contrast can by means of comparison be reduced to objective analysis. Through testing, the photographer can identify the contrasty papers and choose

649, 650. Color printing papers can be distinguished one from another by their properties of saturation and contrast.

left: 649. A low-contrast color negative printed on low-contrast paper.

650. A contrasty paper can benefit a low-contrast negative like that in Figure 649.

one likely to benefit a print made from a low-contrast color negative (Figs. 649, 650). He could also avoid papers so high in contrast they would render the printed image too harsh. In addition to objectives of color and contrast, wise and wary photographers typically consider cost and availability in their selection of paper.

The *white light data* (for the light beamed from the enlarger's lamp) noted on each box of paper is a rough filtration guide provided by the manufacturer for that particular batch of paper (Fig. 651). He does this to help the photographer prepare filtration appropriate to correct the variations in color sensitivity that occur in paper from batch to batch. The photographer should refer to the data each time he commences on a new batch of paper. Storage also affects the color response of printing paper, and only preliminary testing can account for this.

Chemicals Modern developments make possible some choice among combinations of chemistry, paper, and equipment, but in most instances, photographers process their prints in the chemical system devised by the manufacturer of the film they have chosen to use.

Refrigeration Because of its sensitivity to heat and excess moisture, color printing paper must be stored in a refrigerator. Prior to use, however, it needs to be warmed to room temperature.

Safelights Since color printing paper must respond to light of all colors, it can be worked with only when illumination derives from a special light so dark some photographers do not bother to turn it on. Thus, the darkroom and all in it must be organized to permit use under conditions of minimum illumination. Fluorescent tape glowing in the dark can help locate essential things once it has been placed strategically at the hot water faucet, light switch, easel, etc.

Exposure Timer Precision in all aspects of color processing requires the use of an accurate timer. One attached to the enlarger ensures consistency of exposure.

Processing Device Trays, drums, and even "canoes" are among the devices designed to contain exposed color printing paper and the various chemicals through which prints must be processed and agitated. The selection of a particular device depends upon such factors as the film and chemical system used, the availability of an adequate amount of water controlled at a specific temperature, the need for speed, and the liabilities of working in total darkness throughout a certain duration.

Thermometer Color processing solutions, especially the developer, demand exact temperature control. At a retail price of approximately $15, Eastman Kodak distributes a model of its Process Thermometer that can record temperature quickly and in

degree indications spaced to facilitate accurate reading.

Hot Water Regulator Hot water in plentiful supply and controlled to maintain critical temperatures in solutions, rinses, and washes is imperative to success in color print processing. In winter, when water temperature drops to 40°F., household heating equipment may not be adequate to produce the quantities of hot water needed to gain and control temperatures. The problem can be solved by investment in a regulating device capable of furnishing water as required at a temperature that is specific to within a half degree, the maximum tolerance for developer. It can actually save water by eliminating the need to run water until it has mixed to the desired temperature. The price of such equipment is about $150.

Processing Timer Accurate and easy to set, a GraLab timer, like that illustrated in Figure 318, can ensure the precise timing essential for processing a color print once the paper has been exposed.

Gray Card The standard 18 percent gray card described on pages 87, 302, and 303

651. **White light data** appear on each box of color printing paper and represent the manufacturer's estimate of the filtration needed to achieve color balance in prints made with this batch of paper. The sensitivity of paper emulsions varies from batch to batch, and to help control this variable, manufacturers test each batch of paper and label the containers with indications like those reproduced here. The label illustrated calls for magenta to be reduced by .05 (-05M) and yellow increased by .05 (+05Y). Had the indication been 00Y, any yellow in the basic filter pack would not require modification. The Ex. Factor establishes a figure to be used with a formula supplied by the manufacturer for computing a new exposure time to compensate for a variation from the norm in the paper's sensitivity to light.

is a necessary tool that will be referred to on several occasions during the discussion of color printing techniques.

Color Analyzer Several methods and types of instrumentation exist for determining what exposure could obtain proper color balance, given such specific factors as the enlarger's source, the negative, and the paper selected. Some resemble filters, while others take the form of electronic densitometers and probes.

Color Printing Processes

Exposure The procedures for exposing photographic paper by projecting upon it light beamed through a negative have been discussed step by step in Chapter 9, on black-and-white prints. Here, our consideration will be limited to those aspects of exposure that relate specifically to the needs and objectives of color photographic prints.

Because full color exists in photographs only when a few colors can be brought into some kind of equilibrium that makes them fuse and function as all color, we inevitably speak in any consideration of color about the nature and importance of color balance. And in printing color negatives, it is at the time of exposure that the most can be done to correct color balance so as to make it achieve the effect expected of the color print. The technique is filtration.

Filtration Filtration is central to success in the photographer's attempt to balance colors, because of the three basic elements determining the final color quality of a photographic print, filtration is the one most subject to the kind of close, individual control that can stamp the photographer's work with his own special personality. The other two factors—film and paper—derive from the standardized dye chemicals invested in the materials by industrial manufacture. But the color balance of a print results just as much from the color of the light used to make the exposure as it does from the negative and the paper. And not only does each lamp have a slightly different color, but,

652. Tricolor filtration depends upon the additive primary colors red, green, and blue. The absorption characteristics of these colors require that a separate exposure be made for each filter. To avoid disrupting the image's registration during filter changes, the filters must be mounted below the enlarging lens. In this position, only optically corrected materials can serve, maintained in a dirt- and scratch-free state.

653. Subtractive filtration relies on the secondary colors cyan, magenta, and yellow that are complementary to the primaries red, green, and blue. The absorption and reflection characteristics of these colors permit filters to be superimposed for a single exposure. Thus, the filter pack can be placed in the enlarger head, where optically corrected materials are not essential. Acetate subtractive filters are available in strengths graduated as .025, .05, .10, .20, .30, .40, and .50.

Table 10.5 Tricolor filtration

If the print color is too . . .	make this change in filtration:
blue	increase blue
green	increase green
red	decrease green and blue equally
yellow	decrease blue
magenta	decrease green
cyan	decrease red

also, the lamp's color changes both with age and with the length of the darkroom session. Thus, the color of the beam projected by the enlarger's light source must be filtered to balance with the color factors in the film and paper selected for a specific print.

The filtration method based on the additive primaries, called by Kodak the Tricolor process, uses only three filters, for red, green, and blue (Fig. 652), and the nature of the primaries is such that a separate exposure must be made for each. Correction to color balance occurs in the modification of the exposure period for each filter. The blue filter absorbs from the white light beamed through it all wavelengths but those for blue. It transmits these to the negative, which passes them on to the paper except where the image is present on the negative's yellow layer. Yellow being the complementary of blue, it blocks the passage of blue. Thus, by action of blue light, the yellow image in the negative has been reversed to a positive image on the paper, for the emulsion layer exposed by the blue wavelengths will, during development, be dyed yellow to transform a latent image into an actual one. Similar exposures through green and red filters result in positive images developing on the paper's magenta and cyan emulsion layers.

Approximate exposures are 5 seconds for the blue filter, 10 seconds for green, and 6 for red. Since these are variable, depending upon the correction needed for the individual print, Table 10.5 suggests guidelines. These would indicate, for example, that a negative likely to print as too red should have exposure arranged as 3 seconds for blue, 8 for green, and 6 for red.

The tricolor method, although capable of providing sensitive and subtle filtration, imposes certain disadvantages. Without automation, changing filters for serial exposures through the additive primary colors is tedious and time-consuming, and even a slight dislocation of the enlarging equipment between exposures could result in a print with its color images poorly registered. To minimize this possibility, it is best to introduce the red, green, and blue

filters into the exposing light, not in the lamp housing, but below the enlarging lens. Here, only optically corrected glass or sheet gelatin (CC filters) can serve, for acetate would cause image distortion. Since the glass filters are expensive, photographers often prefer to use gelatin for tricolor filtration.

Because cyan, magenta, and yellow create some colors by subtracting others from white light, these colors can be combined in a filter pack for simultaneous projection, which allows a single exposure, instead of three separate ones. The subtractive primaries preclude poor registration, and, overall, they give the photographer a more promising opportunity to work flexibly toward a subtle and refined balance in photographic color. The acetate substance of the subtractive filters now in general use tends to permit fading toward the center, where heat from the beamed light is more intense, and this, of course, could create distortion in the color print. Recently introduced are *dichroic filters,* which not only remain stable in coloration but also offer a still wider range of possible color filtration. Eventually, when a price problem has been solved, dichroic filters should become usable in more than commercial situations.

Subtractive filters are manufactured in graduated densities designated as .025, .05, .10, .20, .30, .40, and .50 (Fig. 653). Used singly or combined, they provide a substantial density span. 120M indicates magenta filtration that could be composed of filters with strengths of .30, .40, and .50. The principle of the system holds that a .30 filter creates twice the density of the negative layer for that color. Thus, exposure should be doubled for every .30 increase in filtration. Contrary to the principle, however, is yellow. A 60Y filter requires only a slight increase in exposure, not four times that needed for an unfiltered negative. Useful as such rules may be, testing by trial and error can better serve to determine the exact filtrations needed for specific exposures.

A combination of filters adds up to several layers of plastic, which could dim light sufficiently to require a fractional increase

654, 655. To correct color balance requires either removing from the filter pack the color complementary to the color cast of the unbalanced print or adding to the filtration the same color as the print's color cast.

left: 654. A filter pack of magenta, yellow, and the UV element yielded an overly red print.

right: 655. Additional magenta and yellow filtration realized a print in which red and blue seem acceptably balanced.

in exposure. A filter pack made up of all three subtractive primaries in equal density would be so perfectly balanced as to constitute neutral density. Thus, it would only complicate things by requiring increased exposure (which could cause reciprocity failure) without in any way affecting the color balance of the print.

Color Balance The nature of the negative-positive reversal relationships of the additive and subtractive colors has already been discussed in this chapter. An understanding of the principle by which they function is essential to any analysis of a color print made for the purpose of correcting color balance by means of revised filtration. For those who think of color in terms of the primaries red, blue, and green, the filtration equivalents are listed here:

10 red = 10 magenta + 10 yellow
10 blue = 10 magenta + 10 cyan
10 green = 10 yellow + 10 cyan

To demonstrate, let us assume a color print made with the typical filter pack composed of magenta, yellow, and the UV element. If the print appears too red (Fig. 654), the photographer would be justified in suspect-

656. 40R. **657.** 40M. **658.** 40Y.

659. 20R. **660.** 20M. **661.** 20Y.

662. 10R. **663.** 10M. **664.** 10Y.

 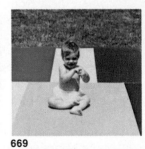

665 666 667 668 669

665. Correct filtration and underexposure by one-half normal exposure.

666. Correct filtration and underexposure by one-quarter normal exposure.

667. Correct filtration and normal exposure.

668. Correct filtration and overexposure by one-quarter normal exposure.

669. Correct filtration and overexposure by one-half normal exposure.

left: 670. 10B.

671. 10G. **672.** 10C.

673. 20B. **674.** 20G. **675.** 20C.

676. 40B. **677.** 40G. **678.** 40C.

ing that the difficulty may lie in an overly dense cyan layer in the negative, for the more dense the negative, the greater its power to block the passage of light and to prevent it from exposing the paper. The weaker the exposure, the thinner the image once the exposed paper has been developed. In other words, whatever the characteristics of the negative, they become reversed in the positive. A positive cyan image that is weaker than the positive images dyed magenta and yellow lacks the saturation necessary to produce the blues and greens capable of competing with the red generated by magenta and yellow. Such a color balance could be improved by either removing a color from the filter pack or by adding to it. For the example cited, reducing cyan in the filtration would reinforce cyan density in the positive, but this possibility is voided by the absence of cyan from the filtration used. The alternative is to increase the filtration already there. Reinforcement of the magenta and yellow in the filter would reverse in the positive to thin the density for these colors. This then reduces red to make it balance with the print's blue element (Fig. 655).

In sum, to correct color balance, either remove the filter for the color complementary (opposite) to the color cast of the unbalanced print or add to the filtration the same color as the print's color dominance. The former is preferable, wherever possible, for adding filters entails both increased exposure and the risk of reciprocity failure. Table 10.6 aligns standard problems in color balance with the solutions possible in either the addition of color to or the removal of color from the filter pack.

Initially, only visual analysis and trial and error can determine the amount of fil-

679. Notebook format for recording data as color prints are exposed.

tration needed to make a satisfactory correction in color balance. A color print with a familiar subject can help the photographer develop his judgment and discover workable solutions (Figs. 656–678). For instance, if a photographer knows that a pale pink passage in a print should in fact look white, he might understand that the color balance is almost correct, requiring perhaps no more than an increase of .05 or .10 in the filter strength of the color dominating the print or a decrease of an equal amount for its complement. If the printed passage is actually red, then a correction of .30 or .40 might be in order.

Correcting color balance can become more efficient sooner for the photographer who maintains a record of his experience. He might proceed by keeping a notebook based on the format in Figure 679. Here,

Table 10.6 Filtration for color balance

When the overall color balance of print is . . .	remove these filters, if possible:	Otherwise, add these filters:
yellow	magenta + cyan (blue)	yellow
magenta	cyan + yellow (green)	magenta
cyan	magenta + yellow (red)	cyan
red	cyan	yellow + magenta (red)
blue	yellow	magenta + cyan (blue)
green	magenta	cyan + yellow (green)

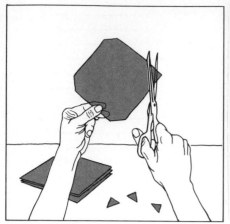

680, 681. The assembly of a filter pack is the first step in preparations made for an exposure designed to correct color balance.

far left: 680. Select colors and cut the acetate sheets to fit the size and shape of the filter drawer. Prepare enough filter packs to permit at least three variants, such as 50M + 40Y + 2B; 40M + 30Y + 2B; and 30M + 20Y + 2B.

left: 681. Place the first pack in the drawer and slide it into position inside the enlarger head. See Figures 459–473 for proper exposure technique.

the negative number helps identify the information with a specific print. If the number is also noted on the back of the print, mistakes in reprinting and comparison can be avoided. The paper number establishes the batch from which the print was made. Magnification derives from the distance between the enlarger lens and the paper on the easel. This can be read and controlled by reference to the scale on the enlarger or, if it does not have one, to an ordinary tailor's tape measure fixed to the enlarger's supporting column. The yellow, magenta, and cyan entries serve to designate the filtration used, and the final line the exposure in terms of aperture and duration.

Testing and Analysis With the test print the photographer enters actively into the real process of making color photographic prints. The test print gives him maximum opportunity to develop skill and experience in visual analysis and in the control of materials, equipment, technique, and final product. As indicated in the chapter on black-and-white prints (see pp. 244–246), the test print is a genuine photograph, but even more so, for it incorporates into a single print a wide range of the effects possible from printing a specific negative. The photographer should commence by selecting filters sufficient to assemble packs for three variants of one color composition, such as magenta, yellow, and, of course, the element for absorbing ultraviolet rays. The

variants could be 50M + 40Y + 2B; 40M + 30Y + 2B; and 30M + 20Y + 2B. The acetate sheets must be cut with scissors to fit the size and shape of the enlarger's filter drawer (Fig. 680). After arranging the filters in their respective packs, storing the scissors and materials, and discarding the remnants, the photographer places the first pack (50M + 40Y + 2B) in the filter drawer and slides it back into position inside the enlarger head between the light source and the negative (Fig. 681).

When the negative and the enlarger have been prepared, the photographer slips a sheet of color-sensitive paper under the easel's masking slides and in segments makes several different exposures, such as 3, 6, 9, and 12 seconds. The technique for masking the paper segmentally for the purpose of creating test prints is illustrated in Figures 505–511. After completing similar tests with fresh paper and the other two filter packs, the photographer can obtain through development an array of some twelve or fifteen combinations from which to select the filtration and exposure most likely to yield a successful color print (Fig. 682).

After long search, easier methods are being found for the testing and analysis of color photographic prints. Among them are such inexpensive devices as the Mitchell Unicube and the Caltura Color Matrix. Photofinishers requiring rapid methodology utilize a densitometer to compare the color

682. **Ernst Haas.** *Untitled.* 1958. Courtesy Magnum, New York.

characteristics of one negative with another. This system depends upon a master negative that has been printed until the filtration provides a correct rendition of the gray card or of flesh tones and/or white (Fig. 647). Once fed this information, the densitometer can indicate what filtration will be needed for an unknown negative. A fairly expensive photoelectric machine, the densitometer measures the light-stopping capability of a negative. Since the machine is not attached to a single enlarger, it can issue comparative information for groups using separate facilities — provided the characteristics of the individual enlarger are taken into account.

The *analyzer,* another piece of relatively expensive professional equipment, func-tions only with a specific enlarger. Once programmed with information yielded by trial-and-error printing of the master negative, this machine analyzes, by means of a probe placed on the easel, the red, green, and blue light that the subtractive colors in the negative filter from the enlarger's beam. Comparing its understanding of the light projected by the master negative to the light passed by an unknown negative, the analyzer can determine the filtration needed to correct color balance for prints made from the new film. In commercial photo-finishers, the prevalence of human sub-jects establishes a common denominator in flesh tonality that enables the analyzer to realize great economies in production time.

above: **683. Tanks or sinks designed to process and agitate color prints** through developer and other solutions controlled at a desired temperature.

left: **684. Baskets contain exposed color paper and bear it for immersion in solutions** maintained in a sequence of sink tanks.

Color is the product of light, and in any analysis of the color balance in prints, consideration must be given to the lighting conditions under which the prints are likely to be viewed. Where the processor, the photographer, and the client all use the same type of illumination, no problem exists. However, the hues of a color photograph made under tungsten illumination appear quite different once viewed in an environment illuminated by the fluorescent tubes common to public buildings. The greenish

685. A bluish tonality veils the image in freshly processed Ektacolor prints. The blue cast disappears once the prints have dried.

character of fluorescent light (Figs. 630, 631) tends to cool the warmth of such prints, rendering their tones less pleasing. When color consistency is critical, a source of light standard to all parties must be used. A pioneer manufacturer that now distributes several types of standardized viewing equipment is the Macbeth Corporation. Because of the prevalence of fluorescent lighting, the individual photographer may be wise to print for it, and generally preferable to an overly cool tonality is the effect produced by a fluorescent-adapted print when viewed under normal tungsten lighting.

Processing Prints from Color Negatives

The methodology outlined in Chapter 9 for the processing of black-and-white prints provides the fundamental steps for developing color prints. The techniques special to color printing, such as bleaching out all silver deposits, vary according to the particular process used, and since these are always being refined and improved in the light of new chemical and technical advances, the student of photography should acquire his experience and skill by following the manufacturer's instructions prepared for the materials he has chosen to use.

Color Print Systems First devised for commercial use, Eastman Kodak's Ektacolor was gradually simplified into a system that could be managed in a home darkroom. Initially, the system required expensive color sinks (Fig. 683) to control temperature within the small tolerance the solutions could support (within $\frac{1}{2}$°F. for the developer). Improvisations intended to avoid the expense were very time-consuming. As in all early systems, the prints processed by Ektacolor were inserted in baskets of plastic screening for transport from one solution to another (Fig. 684). Lowered into the solutions, the prints were agitated as a plenum or gas distributor at the bottom of the tanks intermittently released pressure to cause a cyclical rise and fall in the solution level. The distributor consisted of

plastic "spaghetti" tubing perforated by tiny holes and connected to an automatic timer. It discharged nitrogen into the developer; in the other solutions and in the washes it released oil- and moisture-free compressed air. The tanks themselves, usually made of stainless steel, rested in larger containers called *water jackets,* which, when filled with water of the proper temperature, served to control the temperature of the processing liquids. The tube fixtures made the tanks and sinks expensive, and eventually sets of baskets with the plenum directly attached reduced the photographer's investment in equipment.

In the early Ektacolor process it took over 40 minutes of working through many solutions for extended durations before the photographer could see the results of a test strip. Gradually, raising the processing temperature first from 75°F. to 85°F. (Ektaprint C) and then to 100°F. (CP-5) reduced the total processing time until now only $7\frac{1}{2}$ minutes are required. The sink and basket method and the lower temperature of the Ektaprint C process enable commercial photofinishers to handle large quantities of prints all at once, as many as 250 8 × 10 prints, arranged 35 to 50 to a basket, in a row of tanks measuring 16 × 20 inches. Because the tanks hold such large volumes of chemicals, a replenishing system is employed to ensure consistency. Depending upon the solution, replenishers either have an entirely separate chemical makeup or they are diluted in a ratio different from that used to prepare the original solution. Manufacturers provide full instructions for all the variables possible in the use of replenishing chemicals. The CP-5's 100°F. method will be taken up again in a discussion of processing devices.

During the simplification of the Kodak system, two European processes, Agfacolor and Gevacolor, became available. After buying out Gevaert, Agfa combined characteristics of both systems to make a new Agfacolor offering two advantages over the Ektacolor system. First, the Agfa paper lacks the blue veiling that hinders accurate judgment of color in a wet Ektacolor print (Fig. 685). Although the veiling disappears as soon as the print dries, the delay, now very slight, could pose a problem in certain circumstances. Agfa paper allows evaluation of a print before it has been fully processed. Second, the Agfacolor procedure permits greater flexibility in temperatures and immersion times. Limited hot water could curtail printing by the high-temperature Ektacolor process.

Two recent American products, Rapid Access and Unicolor, compete with Agfacolor in omitting the blue veiling and in offering a wide latitude for processing temperatures. Both systems are in some respects compatible with each other and with those of Agfacolor and Ektacolor. The Unicolor process has its own paper, plus a set of chemicals for Agfacolor paper and another set for Ektacolor paper. Unicolor and Agfacolor papers can be used with Rapid Access chemistry. In all, they make possible a broad choice among combinations of chemistry, paper, and equipment.

Processing Devices The first devices offered for developing Ektacolor paper prints at 100°F. were the Kodak Rapid Color Processors, models 11 and 16. Figure 686 illustrates the less expensive model 11. These color drums consist of an electric motor, a stainless steel drum, a net arrangement, a tray, and a hose with a piece of plastic pipe at the end. Presoaked in water, the exposed print is placed emulsion side down on the drum, where the net holds it stationary. When the device has stabilized the developer solution in the tray at the proper temperature, the motor can be turned on to activate the drum. As the drum rotates it passes through the solution in the tray, where the drum's rippled surface picks

686. The color drum (Kodak's Rapid Color Processor) with exposed paper attached to it rotates through a tray of solution to develop the print's image.

687. The Heath Color Canoe is a tray whose shape permits exposed paper to be rocked back and forth in developer solution.

688. The Premier Daylight Color Processor is a light-tight cylinder that can be loaded with solution and exposed paper and then floated in a pan of water heated to control temperature.

up a film of liquid that flushes across the print's emulsion surface. Because of its economical use of chemicals, the drum system permits the photographer to forego replenisher and control the strength of the developer by discarding the exhausted solution.

Other products also utilize the 100°F. (CP-5) process. The Heath Color Canoe is a stainless-steel tray that takes its name from the shape of the tray's profile (Fig. 687). After an exposed print has been placed inside the canoe, emulsion side up, and the developer poured in with it, the canoe is lowered into a tray containing water heated to the control temperature of 100°F. and then rocked back and forth so as to agitate the solution evenly across the print's emulsion surface. Following a speci-

fied duration, the canoe must be drained of the developer and refilled with another solution. Available in sizes 8×10, 11×14, and 16×20, the Heath canoe is both inexpensive and simple to use.

The Premier Daylight Color Processor offers a stainless steel cylinder whose leak-proof lid permits the cylinder, loaded with an exposed print and developer solution, to float in a pan of water heated to control temperature (Fig. 688). Once the exposed print is inside the light-tight cylinder, total darkness must prevail only when solutions are poured in or drained.

Prints can also be processed with developer solution poured into an ordinary 8×10 photo tray once this has been floated in a larger pan filled by a constant flow of water heated to maintain a control temperature of 100°F. (Fig. 689). For the inner tray, stainless steel is preferable, since this material conducts heat, but a plastic one will suffice. The exposed paper should be placed in the tray emulsion side up. The chemicals are then poured on top. Next, the photographer gently rocks the tray to agitate the print and solution throughout development. This method consumes about 4 ounces of solution per 8×10 print, as opposed to the 2 ounces normally required in the canoe and cylinder systems.

The color drum, the color canoe, the Premier Daylight Color Processor, and the tray method all demand total darkness at least during the transfer of chemicals if not throughout development. The next two devices are designed and constructed in such a way that processing can occur under normal illumination once the print has been loaded into the light-tight tank. The Unidrum II Color Print Processor offers a light trap that allows chemicals to be poured in and drained without risk of further exposure to the print's unfixed image (Fig. 690). A similar device is the FR One-Shot Drum Processor, whose lid reservoir permits it to be simultaneously filled and drained (Fig. 691). Since both these processors depend upon preheated and temperature-stabilized chemicals, neither requires a hot water bath.

689. The tray method calls for exposed paper to be agitated in a solution-filled tray placed inside a larger pan containing water heated to control temperature.

690. The Unidrum II Color Print Processor is among the devices whose light-tightness permits color prints to be processed under normal illumination. Through a light trap chemicals can be poured in and drained without risk to the processing print.

Because the Unicolor and the Premier Daylight Color Print devices were designed for use with the lower temperature range of Rapid Access process, both may present problems if required to function with Kodak's CP-5 chemistry. The difficulties could develop in the event of a rapid drop in temperature from 100°F.

Wherever the supply of hot water is abundant, as in school laboratories, the directness and simplicity of the tray method may actually make it the most suitable means of processing color prints. However, to ensure that the number of prints processed in trays does not exceed the solutions' capacity, the photographer should maintain some record of his activity. The tray method can also serve for solutions controlled at lower temperatures, but this so extends the processing time as to make working in total darkness seem unsatisfactory to many photographers.

Some of the other methods require more practice before results can be made consistent, and all are inherently more time-consuming, since in these systems solutions must be prepared and brought to correct temperature, the processor loaded with exposed paper, and then alternately filled with and emptied of solutions. In addition, those devices intended to function within a lower temperature range inevitably extend the total processing time. But where a deficiency of hot water complicates handling by the tray method, the photographer may prefer to work with one of the processors.

Drying Color Prints

Like all other aspects of color photography, drying color prints demands a technique more meticulous than that used for black-and-white prints. When wet, the delicate surface of color prints tends to stick to everything it touches. Owing to the stickiness, the blotter roll or screen (Figs. 493–495) usually proves to be an unsatisfactory means of drying such materials. When dried by expensive electric devices, the surface takes on a high gloss, called *ferrotype,* that many photographers find objectionable.

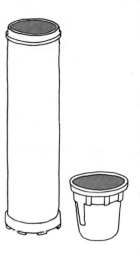

691. The FR One-Shot Drum Processor has a lid reservoir that permits it to be simultaneously filled with one solution while another is draining. This eliminates the possibility of unwanted exposure of the print processing inside the drum.

The simplest and most direct method for drying prints is to attach them with clothespins to a line so that they hang in pairs back to back (Fig. 496). A clothespin clipped to each of the two bottom corners weights the print and helps to prevent its curling. Plastic clothespins are not likely to damage emulsion surfaces, but wherever the white borders are to be trimmed, even wooden clothespins can be used. The dry mount press (Fig. 750) flattens curled paper, but for color prints, both the press and the cover sheet must be preheated to prevent the print surface from adhering to the cover sheet. To avoid affecting the print's color, the press must be kept at a lower temperature than is suitable for black-and-white prints. Thirty seconds in the press is sufficient (see pp. 343–350). Less precaution is required with Kodak's new resin-coated papers, which have durable surfaces and less tendency to curl.

Special Techniques

ASA Acceleration The ASA speed for color negative film (Kodacolor and Ektacolor) is not very high, relative to other films. Not only are color transparency films (Kodachrome and Ektachrome) faster, but, in addition, special development can push them still higher. With Ektacolor and Kodacolor, such techniques are only moderately effective. Nonetheless, a method does exist whereby a higher ASA rating can be attained for these films, albeit a procedure not recommended by Eastman Kodak, owing to the possibility of reduced factuality in the colors produced. Treated in this way, some emulsions yield better results than others, and the photographer has no way of analyzing the potential of each situation. Thus, the method is best employed when the desire for faster color film can justify the risk to color rendition.

692–695. Burning-in and dodging are special exposure techniques that permit the photographer to darken or lighten limited areas of an image so as to deepen tones to reveal detail (see pp. 264–272).

692. Overly light coloration in skies can be enriched by means of burning-in.

693. Extended exposure, or burning-in, reinforced the color of the sky that seemed too light in the normally developed print reproduced in Figure 692.

color to ASA 300–400 for a flat scene and 500–600 for a contrasty scene.

The negative produced from Ektachrome lacks the orange color mask that covers Ektacolor negatives (Fig. 638). Therefore, filtration of an odd sort may need to be devised. A piece of unexposed but processed Ektacolor sheet film placed in the filter pack often can provide sufficient supplementation of yellow and magenta to make the filtration realize normal color balance in the print. This type of filtration is possible only in enlarger heads equipped to receive filters in a position above the condensers.

The photographer must take particular care to dispose of and never use again the Kodacolor or Ektacolor developer solution employed to process an Ektachrome negative. Reaction with the Ektachrome film so alters the chemical nature of the developer that it can no longer process a color negative properly. All solutions other than developer are, however, interchangeable.

Techniques exist for reducing the contrast in the Ektachrome negative, and one of these is the addition of citrazinic acid (175 grains per gallon) to the developer. A Kodak product, citrazinic acid costs $20 a pound, the minimum quantity sold. Another procedure entails developing the film for 9 minutes in fresh solution or up to $11\frac{1}{2}$ minutes in used solution. The developed negative is then immersed in a solution of 1 teaspoon of Epsom salt mixed with 16 ounces of water controlled at 75°F. Next, $\frac{1}{2}$ ounce of the developer should be carried over to the Epsom salt solution. Film immersed 4 to 6 minutes in this solution should reveal more detail in shadows. Thereafter, processing continues normally.

The technique consists of processing exposed High Speed Ektachrome film in chemicals normally used for Kodacolor or Ektacolor film. This produces a rather contrasty color negative, which could in some instances prove undesirable. However, to photographers accustomed to the inherent flatness of Kodacolor and Ektacolor, the added contrast may offer a welcome aesthetic variation. Mixing processes in this way jumps the ASA rating of 80 for Ekta-

Burning-in and Dodging These techniques darken or lighten local areas so as to suppress or bring out values and details. They are described in the chapter on the processing of black-and-white prints (see pp. 264–272). Figure 692 illustrates a color print with the potential for enhancement by means of burning-in. In Figure 693 selective reexposure has strengthened subtleties of tone and pattern in the sky. Dodging by means of filtration (see pp. 257–259) produces an actual color change, a phenomenon illustrated in Figures 694 and 695.

Spotting and Coloring Occasionally a good color print needs to be retouched by the nonphotographic technique of spotting and coloring. Kodak's Retouching Colors offer dyes that can be mixed with water to color white spots created by dust and dirt particles that, left on the surface of the negative, prevented exposure. These colors can even be made to alter the tint of an entire area in a print. To apply them, the photographer gently rubs across the print's surface a bit of cotton moistened with the appropriate blend, using a circular motion to produce an even coat. Repeated applications, with a rest of 1 or 2 minutes in between, intensify the hues. Should these become too saturate, cotton moistened with undiluted Photo-Flo can remove the coloring. Where the waxy Retouching Colors produce a surface different from the normal gloss of a photographic print, steam vapor or even human breath offers the best means to make the wax soak into the emulsion and thus reveal the surface's original gloss. Retouching Colors are versatile materials capable of range and subtlety in effect. In the Eastman Kodak Handbook *Printing Color Negatives* can be found detailed instructions and guidance for their practical application.

POLACOLOR

A unique process, Polacolor combines the principles of modern color photography with those of the black-and-white Polaroid system (see p. 80). All components needed for producing a developed color print in less than a minute are sandwiched within eleven layers upon a single sheet of Polaroid film (Fig. 696). Resting on the base are paired layers of silver halide emulsion and developer-dye. Each of the emulsions responds to the lightwaves for one color only —blue, green, or red—thus, no filter is required between layers. Instead, the developer layer below each emulsion sheet contains dye that is bonded to the developer and complementary in color to the sensitivity of the emulsion directly above. In these layers exposure generates a reaction that results in a positive being developed on paper, which itself has three different color-sensitized layers, by means of an alkaline chemical called *goo* that is contained in a pod occupying yet another layer.

To develop the negative and print the positive, the photographer pulls the film tab to bring film and paper together. As these move forward they pass between two rollers that squeeze the elements sufficiently to break the pod and disperse the alkaline solution (Fig. 697). As the goo penetrates to all layers it activates the other chemicals. These move upward, developing the image as a negative and trapping the dye wherever exposure has occurred in the adjacent emul-

694. Color resulting from multiple exposures.

695. A hue change was produced by dodging the print in Figure 694 by means of filtration (see pp. 257–259).

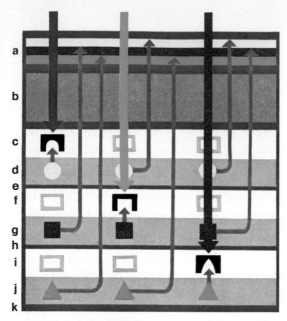

right: 696. Polacolor film-print sandwich consists of 11 different layers.
a. Printing paper with three emulsions separately color-sensitized to yellow, magenta, and cyan.
b. Goo, or an alkaline chemical, spreads throughout these layers as the exposed film and paper are pulled from the camera.
c. Blue-sensitized film emulsion.
d. Yellow dye-developer.
e. Spacing layer.
f. Green-sensitive film emulsion.
g. Magenta dye-developer.
h. Spacing layer.
i. Red-sensitive film emulsion.
j. Cyan dye-developer.
k. Support.

Exposure affects the silver halides in the film's emulsion layers. As the photographer draws the film-paper sandwich from the camera, a pod of alkaline goo spreads across the film and diffuses down through the layers to activate the developer-dye molecules. This releases the latter to move upward. Those encountering exposed silver grains convert them to blackened metallic silver, produce a negative image, and lodge there. The remaining developer-dye molecules diffuse all the way to the color-sensitive paper emulsion, in which they blend by the subtractive principle to form a full-color positive image.

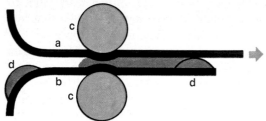

right: 697. Goo is an alkaline solution that activates the developer-dye molecules to move from the exposed film's emulsion layers to form in the paper's color-sensitized emulsions a full-color positive image. Pulling the film-paper sandwich from the camera squeezes it through rollers that break the pod, causing its goo content to spread across and diffuse throughout all film layers.

below: 698. The Polacolor print reveals soft and subtle coloration and good detail in shadows.

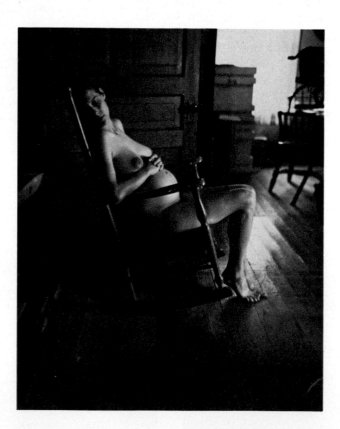

sion layer (Fig. 696). Elsewhere, the volatile developer-dye molecules are free to move all the way to the paper, there to form a positive image in each of three emulsion layers sensitized to accept dye colored cyan, magenta, or yellow. At the end of the process, alkaline solution finally attains acid molecules present in one of the positive layers. This encounter produces water to rinse away all remaining alkali, thus halting development. The dye molecules expand to seal the surface and make the image permanent with a low-gloss finish.

Thus, Polacolor derives from a complex diffusion system rather than from the dye couplers employed in other color processes. Its color is soft and subtle, the detail in shadows good, and the rendition of skin tone quite pleasing (Fig. 698). Disadvantages lie in the impracticality of duplicates and the limited print size. The camera designed to hold the Polacolor pack produces relatively small prints, measuring only $2\frac{7}{8} \times 3\frac{1}{2}$ inches.

Appendices

Owing to the slow speed of their materials, the first photographers could expose film only on bright, sunny days. Today, fast films and lenses allow photographers to make pictures whenever and wherever they may wish. One of the first successful solutions to the problem of generating enough light to permit photography to occur under conditions other than full sunlight was a disk of lime heated to brilliant incandescence by a flaming jet of oxygen and hydrogen. The device entered the English language as "limelight," for its use in spotlighting actors on the stage in 19th-century theatres. After 1850, photographers produced powerful light, almost like daylight, by burning a magnesium wire. Despite its choking emissions of white smoke, magnesium made it possible for such murky interiors as those of coal mines and the Great Pyramid of Cheops to be recorded on film. From the 1880s, *flash powder*—a compound of magnesium, potassium chlorate, and antimony sulfide—provided effective artificial lighting for photographic purposes. Potentially explosive, flash powder not only threatened fire on all occasions but accidentally exploded from time to time to burn or blind photographers and their associates.

STUDIO LIGHTING

Eventually, electricity gave photographers a safe and dependable source of artificial light. The light most typically deployed in today's photographic studios derives from flood and spot lamps. A floodlight consists of a bulb in a reflector, an arrangement that permits wide and even distribution of light. Normally attached to the front of floods made for commercial use are metal doors, called *barn doors,* that make it possible for the photographer to control the direction of the light emitted by the flood. In addition, such lights often have placed in front of them a diffusion screen made of translucent plastic or fiber glass, which is yet another device for controlling the character and distribution of the artificial light. Altogether, the quality of light a flood lamp can produce closely approximates sunlight. Usually, the flood lamp provides the main source of the photographer's light, and it is important that he work by a main source, for in the absence of one, no source dominates among several, and the subject appears in the photograph with as many as twelve shadows, a situation often seen in television pictures.

Instead of diffusing light generally, a spot lamp condenses light and projects it as a narrow, intensely focused beam. Adjustable by a lever or knob, the beam's diameter can be reduced and tightened further by means of a "snoot," a sheet of metal that, once placed over the spot, transmits its light only through a small circular opening. It too may have barn doors, which permit the spot's beam to be shaped. The quality of light projected by a spot lamp is such that it is often used to create highlights on a subject or strong shadows to emphasize texture.

The best way, usually, to simulate sunlight is to illuminate the subject in its space with a large, main floodlight and then to lighten the shadows from secondary sources, such as flood lamps positioned farther away, or with their light diffused, or set at angles designed to brighten shadows. Principally, light is controlled by the angle from which it strikes the subject, by the distance between the subject and the source that lights it, or by the position of the light, which could be in front of, behind, above, or below the subject. In addition to diffusion screens, barn doors, and "snoots," the photographer can also employ shields, shades, or color filters for controlling the character of studio lighting. Once the flood has been set up, a spot can be made to produce a highlight. Classically designed lighting models the subject in gradations of light and dark so that its planes and volumes have a palpable, three-dimensional quality. The highlights should sparkle, while the shadows are richly dense but clear enough to reveal their detail. Such lighting is ideal for rendering a subject with the clarity needed for purposes of illustration.

An infinity of arrangement is possible in studio lighting. Lighting can be made to create mood, dramatize form, or reproduce a subject as a literal reality. But whatever the arrangement, it should be made with the kind of taste, judgment, and respect for materials, their potential and limitations, that only experience provides. Above all, the photographer must learn to see in terms of light, which is the fundamental medium of photography, and to see as the camera does—with sensitivity and selection.

Direction of Light

A single light source and a subject can demonstrate the degree to which it is possible for the

photographer to control the direction of light and, ultimately, the kind of picture light's direction is capable of producing. From picture to picture in this series (Figs. 699–702) the texture, color, and quantity of the subject's hair change, the shape of her face is altered, even the relation of the face to the hands seems to have a different character.

Front Lighting For the example in Figure 699, the photographer positioned the light source in front of the camera. This permitted the flood of light to wash the face so thoroughly that it eliminated small, local shadows and reduced roundness, making the face look flat and two-dimensional. This arrangement, however, provided the basic information about the face, almost as would a portrait for the police files! Such shadows as there are lack shading—that is, a range of tonal values from black to light gray. So little have the hands and face been separated that they seem like a continuous flat surface. The rendition of the hair has its normal tonality, and the absence of highlights makes it seem soft, flowing, and tactile. This type of frontal lighting is familiar from photographs made with a flashbulb source attached to the camera.

Side Lighting In Figure 700 a single strong side light has rendered the subject in a totally different way. The shape of the face now seems long and thinner than in Figure 699. Its parts have been distinctly separated, giving roundness to the planes of the cheeks and forehead, and there is a sense of interaction among them. An element of seduction is introduced by the strong shadow veiling one eye, which is contrasted to the partial shadow over the other eye. Here, the brunette of the first picture could have become a blond, and the illuminated hair is strikingly set off from the background.

Bottom Lighting Owing to the drastically unnatural appearance that results, subjects are seldom lighted from below, and then it is done to achieve a specifically calculated effect—usually of horror or the bizarre. In Figure 701 bottom lighting has endowed the subject with a slightly sinister character. This type of lighting produces form and texture and exaggerates them. as in the lips and planes of the face. Relative to the first two examples, the face appears smaller and more withdrawn. The nose is changed; it has an upward tilt, and the nostrils seem expanded. The hair almost dissolves into shadow, and it is not such an important element as in the first two

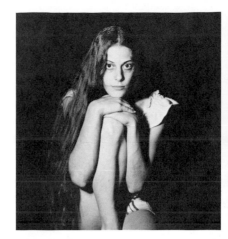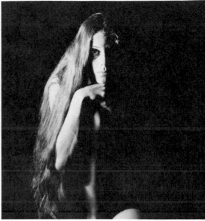

left: 699. Front lighting requires that the light source be positioned in front of the camera. While providing basic information about the subject, such lighting eliminates small, local shadows and causes the subject to look flat. Here, the hair has its normal tonality, and the absence of highlights makes it seem soft, flowing, and tactile.

right: 700. Side lighting has set the subject's features off in contrast with one another, giving roundness to the planes of the cheeks and forehead. The strongly shadowed left eye introduces a seductive element, and the brunette hair, strikingly silhouetted against the dark background, now seems blond.

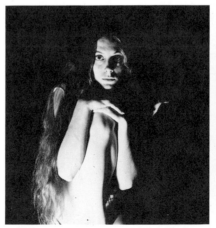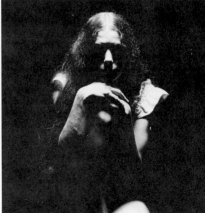

left: 701. Bottom lighting exaggerates both form and texture and creates a horrific or bizarre effect. Here, the face appears small and withdrawn, the nose tilted upward, and the nostrils flared. The hair seems dissolved and less dominant over the face than in Figures 699 and 700.

right: 702. Top lighting serves mainly to add highlights to a subject, since, as here, it creates shadows so pervasive they obscure personal identity. The face seems skull-like, and the luxuriant hair looks thin and wiry.

699–702. Artificial light can be controlled by the angle from which it strikes the subject. Also important are the distance from the subject to the source lighting it and the position of the light relative to the subject it illuminates. The arrangement most likely to simulate sunlight consists of one main flood lamp for general illumination of the subject, with shadows brightened from a source in a second flood positioned at a different angle and farther away.

Artificial Light **323**

703 704 705 706 707

703–707. Five basic types of lighting can be arranged for illuminating subjects posed for photography in a studio. The subject in this sequence is a small, silver-plated abstract sculpture.

703. Point source means illumination from a single source, such as a flood lamp. It causes the subject to cast a strong shadow and the tonality of the form to appear exaggerated. Had other objects been present, as in nature, they would have absorbed and reflected light to make the rendition seem less hard.

704. Diffusion means a directionless light that does not reveal its source or permit a shadow to be cast. Here, the metal sculpture gleams with reflections of the white paper used to refract the light and of the dark ceiling overhead.

705. Silhouetting results when light is projected upon a white background so that no light falls on the subject. This permits only the basic form to be revealed and suppresses whatever surface characteristics the form may have.

706. Edge lighting derives from sources on either side of the subject. It emphasizes any imperfections in the subject's shape, such as the sculpture's blunted tip.

707. Cast-shadow lighting imposes on the subject the appearance of changed form. The technique is to place a patterned screen between the subject and its light source.

examples. Here, the emphasis has moved from the hair to the shape of the face.

Top Lighting Equally seldom are subjects lighted solely from above. Most often, top lighting serves to add highlights to the hair in female portraiture. In Figure 702 the shadows so dominate the subject that her particular identity is

lost. Since neither eye is clearly visible, the face has little opportunity to express personality. The lighting exaggerates the forehead and nose and gives the face the character of a skeleton. Of the four images in this sequence, this one is perhaps the least flattering. The luxuriant fall of hair now seems thin and rather like wire. Raw light concentrated directly on the hands makes them look more like stone than flesh.

Types of Lighting

Basically there are five types of lighting that can be arranged in a studio. To illustrate them here, a small sculpture, made of polished metal, has served as the subject.

Point Source The example in Figure 703 is of the subject illuminated by a single source of light, as if it were the sun. Placed above and to one side, it cast a shadow. In the resulting picture, the tonal character of the forms seems exaggerated, owing to the absence of other objects, which would have, as in nature, acted as reflectors to help lighten the shadows. Here, the light source was a flood lamp; had it been a spot, the rendition would be still harder.

Diffusion To light the sculpture for Figure 704, a diffusion technique was employed, made possible by a tent of white translucent paper

placed around the subject. (Frosted plastic or muslin would have worked.) A small hole in the tent permitted the camera's lens to be inserted. The paper refracted and diffused the light beamed upon it, thus making the sculpture's surface gleam with reflections of the luminous white paper and, at the top, of the dark ceiling overhead. Sometimes undesirable in photographs of silver, here the small black reflection helps to define the elongation of the form. This type of light has no real direction; therefore, its source is impossible to distinguish.

Silhouetting Illuminating a white background and allowing no light to fall on the subject renders the subject as a silhouette (Fig. 705). In this example all surface differentiation has been lost, which makes it impossible to determine what the subject is made of. Only its basic form has been revealed.

Edge Lighting Sources from either side created the outline highlights along the edges of the sculpture in Figure 706. Barn doors prevented the light from striking the camera's lens. This type of lighting emphasizes any imperfections in shape, such as the sculpture's blunted tip. Here, the polished material permitted flood lamps to produce the effect sought, but for materials with less reflectance, spot lights might be necessary.

Cast-Shadow Lighting The horizontal lines of a screen placed between the subject and the spot illuminating it cast shadows upon the sculpture that give the appearance of a changed form (Fig. 707). The spot lamp made the shadows more focused; a less shiny surface would have created a still more telling effect.

REFLECTORS

Light radiating from the sun is directional, at the same time that it is scattered and bounced about by dust and moisture particles in the atmosphere and by objects in the environment. Scattered light helps to fill shadows with reflected light, and this gives nature its familiar appearance. Conditions for scattering light in a bare, clean studio do not exist. Too, the less intense light source generates less light to scatter. To compensate, the photographer can use secondary lights and reflectors for filling in shadows.

Usually the reflectors are one with a smooth white surface and another covered with crumpled and flattened foil (Fig. 708). For the picture in

Figure 709 the photographer lighted the subject with a single photoflood positioned to the left and slightly above. This illuminated only part of the subject, for the right side is hardly distinguishable from the dark background.

Using the same light source, the photographer obtained the result in Figure 710 by adding a smooth white surface to the right of the subject. This served as a reflector for returning some of the light to the subject on its dark side. The quality of this lighting is soft, without strong highlights of any sort. The gradations of tone make the mannequin appear more dimensional than in Figure 709.

The crumpled foil surface replaced the smooth white surface as the reflector for the image in Figure 711. This bounced considerably more light into the shadows on the mannequin's dark side. There, it also gave a subtle edge to

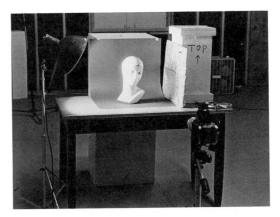

708–711. Scattered light is the condition normally encountered in nature, where the sun's directional rays are bounced about by dust and moisture particles in the atmosphere and by objects in the environment. This permits shadows to receive sufficient illumination for objects and surfaces in them to be visible. Reflectors are the means that enable the photographer to scatter studio lighting in a way to simulate natural illumination.

above: 708. Reflectors usually are of two types: one with a smooth white surface and another covered with foil (propped against the white block).

top right: 709. Side lighting without reflectors.

center right: 710. A smooth white reflector on the right supplemented the side lighting seen in Figure 709.

right: 711. A crumpled foil surface on the right supplemented the side lighting seen in Figure 709.

the form's contours, thus separating it from the background. Too, the right eye reveals more detail, and there is greater modeling of the hair, eye, and cheek, which creates more dimensionality overall.

The subtleties possible in lighting with reflectors are best worked out when the photographer can observe the composition of the scene on the ground glass of a view camera while an assistant shifts the reflectors. The impression changes as the photographer moves back and forth from the camera to the scene and its reflectors, and he may have difficulty remembering effects from one position to another. In such a situation, the photographer could try using a Polaroid as a means of determining the effect his arrangement of lights and reflectors may make.

Out-of-doors, reflectors have been used less for still photography than for work in motion pictures, which require reflectors of huge size. Still photographers normally exploit such "found" reflectors as concrete walls and white buildings.

FLASHBULBS

In the 1930s the flashbulb introduced simplicity and safety into flash photography. Filled with crumpled aluminum foil and pure oxygen and coated on the outside with lacquer, to prevent splintering, the flashbulb generated an intense light when ignited by a powder primer charged by battery-produced electricity. Dependable and inexpensive, modern flashbulbs—miniaturized and filled with a ribbon of zirconium—are easily the most popular source of artificial light for whole populations of amateur photographers. A flashbulb that has been accidentally cracked may explode when fired. To help prevent this, most manufacturers place a colored dot on each bulb that changes color in the event the bulb is cracked. Each bulb provides only one flash, but the *flashcube* contains four individual bulbs, each with its own reflector, and this permits a sequence of pictures to be made one right after the other.

Classified according to the time they require to attain peak brilliance, flashbulbs exist in three different categories, the differences measured in milliseconds: fast, medium, and slow peak.

Now seldom required, *fast-peak flashbulbs,* by igniting instantly (in 1 to 2 milliseconds), help stop action when shutter speed is inadequate to accomplish this. Producing a flash of light for 1/200 of a second. the fast-peak bulb

has the effect of accelerating a shutter speed of 1/30 of a second to 1/200.

Medium-peak bulbs create brilliance for a longer duration, taking about 15 to 20 milliseconds to reach maximum intensity. Thus, when this type of flashbulb is used, the camera's shutter speed must control exposure.

The greater duration of brilliance created by *slow-peak bulbs* serves well the needs of 35mm cameras with focal-plane shutters. Because of its movement across the picture plane (Figs. 104–109), the focal-plane shutter is in operation longer than the speed of the exposure it provides. Slow-peak bulbs ignite in about 20 milliseconds but remain bright for 40 milliseconds.

Once peaked, flashbulbs have different degrees of brightness, and the photographer should select a flashbulb for the brightness needed in order to illuminate a particular subject. A small bulb—that is, one capable of limited brilliance—would be adequate to obtain good exposure of two people standing in a small room, but a larger bulb offering more powerful light would be needed to photograph a group gathered in a large room.

Originally, flashbulbs were clear, but the trend now is toward blue bulbs. Without affecting the light sensitivity of black-and-white films. the blue color helps to standardize the color balancing in color reversal films and in the printing processes for color negatives.

Synchronization The camera's shutter must be synchronized with the flashbulb so that it opens the exact instant the bulb ignites. Most cameras offer both M and X synchronization.

M synchronization delays the shutter's opening by about 12 milliseconds, which permits it to be open when the minimum-peak bulbs attain maximum brilliance. Without this delay, a shutter speed factor *more* than 1/30 of a second would be impossible. owing to the time it takes a minimum-peak bulb to reach its climax. M synchronization therefore allows a wide range of shutter speeds, which greatly increase the versatility of the camera under conditions requiring the use of flashbulbs.

X synchronization serves primarily for electronic flash, which provides instantaneous brilliance, does not peak, and requires no delay. Thus, when used with a flashbulb, X synchronization has the effect of allowing a shutter speed no faster than about 1/30 of a second.

As we saw in the discussion of slow-peak flashbulbs, the type of shutter fitted into a camera must be taken into account in the selec-

tion of flashbulbs and synchronization. Traveling as it does across the focal plane, exposing segments of the film equally but in sequence, the focal-plane shutter requires a flashbulb whose peak has a duration equal to the time it takes for the shutter to complete its journey. Thus, *FP bulbs* are manufactured to function with focal-plane shutters. They permit the shutter to work at a wide variety of speeds. Only at slower speeds can the focal-plane shutter be used with faster-peaking bulbs at M synchronization and with electronic flash at X synchronization. The leaf shutter, which is located in the lens (Figs. 97–103), does not involve such complications, and when the leaf shutter is used, shutter speeds do not have to be reduced for either medium-peak bulbs (M synchronization) or electronic flash (X synchronization).

The differences between bulbs and synchronizations are such that it is important for them to be matched. When in doubt about the proper combinations, the photographer should adopt X synchronization at 1/30 of a second, which can function both for electronic flash and for all types of flashbulbs.

Lighting by Flash Illumination from flashbulbs fixed in a reflector is very directional and intense. Usually, the photographer has found it quick and convenient simply to photograph with the flash unit mounted on the camera. The result probably is a correctly exposed subject isolated against an underexposed background and an overexposed foreground. Such harsh lighting flattens contours and makes the subject look two-dimensional; it also causes the subject to cast a dark shadow over any near wall or object. Photographers have learned to improve on this and to achieve attractive and subtle lighting effects by using flashbulbs in a variety of orientations relative to the camera and its subject. A flashbulb held higher and away from the camera casts large shadows out of the viewing field and introduces smaller ones in the subject to create a sense of relief and three-dimensionality.

Heightened film sensitivity and brighter flashbulbs now permit such techniques as bounced light. In this arrangement, the flash is directed toward ceiling or wall, which then acts as a reflector for distributing light generally over a broad area. The effect approaches that of a photograph made by daylight, offering the image of a subject softly modeled in a diffusion of light. Bouncing also makes the experience of flash lighting more comfortable for the subject.

ELECTRONIC FLASH— "STROBE LIGHT"

Introduced in the 1930s, electronic flash releases a powerful burst of light, colored somewhat like daylight, as a result of electrical energy built up from a normal outlet or from batteries and stored in the circuits of the flash unit. Switched on, the stored energy leaps between electrodes inside a glass tube filled with a mixed selection of gases. Fired by the electrical discharge, the gases glow brilliantly for a duration so brief (about 1/1000 of a second) that photographically it can stop fast action. Widely and incorrectly called *strobe*—for its early use as a stroboscope, a repeating flash applied to the study of rotations in machinery— this type of flash illumination permits photographs to be made of movements too rapid to be seen by the naked eye, such as a bullet in its trajectory or the fluttering of a hummingbird (Fig. 65).

A strobe light is good for thousands of flashes, which makes for economy, but the effect of its quick burst of light is difficult to visualize, therefore to control. It may, however, prove practical for complicated situations, and it can be oriented for reflected light in the way described for flashbulbs. It is their potential for greater lighting power that enables some strobes to stop faster action than can other lights. Originally heavy and expensive, electronic flash no longer imposes either problem.

Exposure for Flash Exposure for flash is determined mainly by the distance between the flash and the subject. for at $8\frac{1}{2}$ feet from its light source the subject receives half as much light as it would at a distance of 6 feet.

Guide numbers for correct exposure can be found in charts included by manufacturers with film and flash equipment. Film speed and shutter speed must be correlated to the appropriate guide number in the chart. The guide number should then be divided by the distance from light source to subject. A distance of 10 feet divided into a guide number of 160 would indicate f/16 for correct exposure.

Other factors, however, must be considered in a decision on exposure. For example, a room painted white reflects more light and generally creates greater luminosity than does a space enclosed by dark, light-absorbing walls. A highly polished reflector intensifies the brilliance of the flash, while a reflector with a matte finish makes the flash somewhat softer.

Once the image formed on the film inside the camera is larger than one-tenth the subject's actual size, it has been brought into focus from a distance of no more than 1½ to 3 or 4 feet in front of the camera's lens. The photograph made from the film record of such an image is a *closeup*. Closeup images formed on film can be as large as the subject itself, making an image-subject ratio of 1:1, or have a magnification as great as 50 or more times the subject's actual size. Photographic images taken from such close-range focusing reveal in the subject textures and surface details that would never be apparent in images recorded at a more conventional distance. Closeup photography submits subject matter to the most searching and critical scrutiny, and such photographs can offer the viewer unexpected and thrilling discoveries even in familiar and commonplace material (Fig. 712).

The term *closeup,* as used here, refers to an image derived from a camera-subject distance of less than the normal lens' minimum focusing distance of from 1½ to 3 or 4 feet. *Macrophotography* or *photomacrography* also describes closeup photography. A *macrophotograph* has recorded the subject in an image that is as much as 5 to 15 times lifesize. Some *photomacrographs* so magnify a subject that its film image can even be greater than 50 times actual size.

The photographer's approach to closeup photography is inevitably determined by the equipment available to him, but whatever the camera-lens system used, several basic principles must be observed if successful closeup photographs are to be obtained. First, the photographer must realize that the closer the focus, the more critical all factors become. For instance, the shorter the camera-subject distance, the more shallow the depth of field. And the very critical nature of closeup work demands precision in every aspect of the operation, for the fineness of the focus would magnify not only the image but also any error or miscalculation made in recording the image. Usually, closeups are made specifically to reveal more detail than the eye could observe. Therefore, the lens should be good enough to permit sharp focus and then corrected appropriately to allow sharp focus at close range. Lighting must be appropriate to reveal the detail sought, and this entails extremely accurate metering of the illumination. To prevent the blurring that even the slightest movement would cause, it is imperative that the camera be stabilized throughout exposure, often by means of a tripod.

Fundamentally, there are two ways to achieve closeup focusing, one optical and the other mechanical. Mounted on the front of the camera's normal lens (Fig. 713), an element called a *closeup lens* (a positive lens) can magnify the image formed inside the camera, relative to the subject's size, and permit a closeup photograph to be realized by what is an optical means. This is the least costly technique for making closeup photographs. Such supplementary lenses exist in a range of magnification whose various degrees are designated as *diopters* (+1, +2, +3, etc.). They can be combined to obtain extreme magnification. Because supplementary lenses function by the same principle as the magnifying glass and are made of inexpensive optical glass, their presence on a camera tends to reduce image sharpness. Although supplementary lenses do not require exposure compensation, they should be used with the aperture closed down to f/8 or f/11.

712. Closeup photography submits subject matter to the most searching scrutiny, which can offer the viewer thrilling discoveries even in familiar and commonplace material.

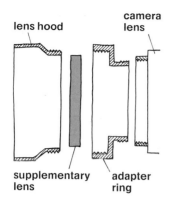

lens hood

camera lens

supplementary lens

adapter ring

713. Two techniques exist for making closeup photographs, one optical and the other mechanical. A closeup lens added to the camera's lens (left) can so magnify the image striking the film that a closeup photograph is obtained by what is an optical means. Increasing the focal distance (the distance between the lens and the focal plane), by "racking out" the lens, enlarges the image of the subject projected upon the film (right). However, the greater focal distance results in a loss in the amount of light striking the film, and to assure a sufficiently bright image, exposure must be compensated.

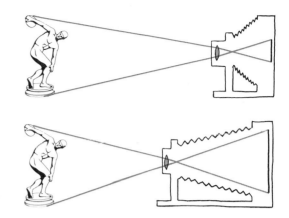

Information provided in a chart by manufacturers of closeup lenses indicates the field of vision, the camera-subject distance, and the setting on the camera's distance scale that would be possible once a normal lens has been corrected by supplementation with a closeup lens. For example, the photographer desires to photograph an area measuring 5×8 inches with a 50mm lens installed in a 35mm camera. The chart would tell him that to achieve this he should employ a +3 diopter closeup lens, position his camera $11\frac{1}{2}$ inches from the subject, and set the camera's distance scale at 8 feet.

The mechanical technique is known to the photographer from his experience of the normal lens, whereby the shorter the distance between the camera and its subject the more the photographer must adjust the camera's lens for sharp focus by "racking it out." The effect of racking out the lens is to increase the focal distance, which is the distance between the lens and the focal plane where the image forms inside the camera. All the many accessories designed to make closeup photography possible derive from the fact that the closer the photographer works to his subject the more something must change in order to keep the subject in focus. Either the lens must move farther away from the film or the lens itself must become optically smaller. And as the photographer would know from his use of a normal lens, the farther light must travel inside the camera before striking the focal plane, the greater the loss of light and the dimmer the image cast upon the film. Therefore, the mechanical technique of achieving a closeup image by extending the distance from lens to film introduces another factor, that of exposure compensation sufficient to assure a bright image.

Some types of camera permit closeup photography much more readily than do others. Where viewing occurs through the camera's picture-taking lens, as in single-lens reflex and view cameras, the photographer has only to equip his camera with the appropriate lens or lens supplement in order to bring a near subject into sharp focus. Viewfinder, rangefinder, and twin-lens reflex cameras, however, usually allow accurate sighting only up to within 3 or 4 feet of the subject. At shorter distances, the discrepancy between what the eye sees and what the lens sees, known as parallax (Fig. 86), must be accounted for.

One device for remedying parallax is the *focal frame* (Fig. 714), which must be constructed to indicate the working closeup distance and the field peculiar to the capability of the individual camera's lens system. This can be tested by means of a small piece of ground glass introduced for viewing purposes at the film plane. To do this, the photographer opens the camera back and lays the glass, frosted side toward the lens, across the film tracks. The photographer can then view the image that forms there as he adjusts the lens for focus. Since focus is proportionately more critical relative to the closeness of the subject, the focusing frame performs a useful and necessary function, but once fixed, the frame cannot be adapted to any other focus or field.

714–716. Parallax poses a problem for closeup photography (Fig. 86). It exists in viewfinder, rangefinder, and twin-lens reflex cameras.

714. The focal frame remedies parallax once it has been constructed to indicate the working distance and the field peculiar to the capability of the individual camera's lens system.

Closeup Photography **329**

left: 715. A closeup string, knotted at the near and far limits of the lens' range for sharp focus on near objects, offers a simple and inexpensive way to solve the problem of parallax.

below: 716. Cardboard cut to the right measure can also help solve the viewing problem posed by parallax.

The lens' range for focusing on a near subject can also be identified by a length of string in which knots have been tied at the near and far limits of focus. Once the string has been tied to the camera and then stretched out in front of the lens (Fig. 715), any subject falling between the two knots would probably photograph in sharp focus. Although not very precise, this method is inexpensive and easy to assemble.

A method offering the greater accuracy of the focusing frame and the simple, lightweight adaptability of the knotted string is that illustrated in Figure 716. After determining the lens-subject distance and the field for his closeup, the photographer cuts a piece of cardboard to the shape illustrated and to the dimensions necessary to bring the subject into sharp focus when the subject has been framed by the notch in the far end of the board. The fact that a separate board must be made for each situation constitutes both the method's advantage and its disadvantage.

Parallax can be avoided in some cameras by means of accessories that make closeup photography both possible and easy to accomplish. In certain instruments, for instance, the twin-lens reflex camera has a normal focusing range no closer than $3\frac{1}{2}$ feet. Supplemented with sets of closeup lenses, such a camera can focus at distances as slight as 1 foot. One set of lenses permits photographs to be made at a range of from 19 to 34 inches. A second set brings focus into a range of 13 to 19 inches from the camera, while a third set provides sharp focus for a subject present within 10 to 13 inches of the camera. Each of these sets contains two lenses, one (a thick lens) to supple-

ment the viewing lens and the other (a thin lens) to supplement the picture-taking lens. The differences between the two supplementary lenses must never be confused, and the viewing supplement can be identified by a dot meant, for parallax correction, to be oriented to the top. To prevent the supplementary lens from reducing the sharpness of the image, it is suggested that aperture be closed down to f/8 or f/11.

Accessories also exist for converting the more expensive 35mm rangefinder cameras into single-lens reflexes. Such a device is called *reflex housing*. Attached to the camera in place of the lens and then to the lens, the reflex housing makes a rather cumbersome arrangement.

Overall, the best solution to the problems of closeup photography lies in the single-lens reflex camera or in the view camera. Their systems of viewing through the picture-taking lens eliminate the difficulties of determining camera-subject distance and the degree of magnification, as well as the problem of parallax. Shallow as depth of field may be in closeup photography, these cameras actually reveal to the eye the very depth of field the lens sees. Such visual experience of reality permits far better results than could any chart devised by manufacturers of closeup accessories.

For 35mm single-lens reflex cameras that permit an interchange of lenses, special lenses have been made to supplant rather than supplement the normal lens. Two such *macrolenses* are the Micro Auto-Nikkor and the Macro Kilar. These lenses have a much greater range of focus; thus, they achieve closeup focusing by the mechanical extension of the focal distance. Focusing at extremely close range entails such extension of the focal distance that there must be a compensating increase in exposure. For easy and fast reference, the exposure factor is indicated on the focusing scale next to the distance scale. Correct exposure is automatically fixed in cameras equipped with a built-in exposure meter.

A camera whose lens can be removed also allows the use of extension tubes (Fig. 717) or a bellows. The effect of these is increased focal distance and a much-expanded capability for closeup photography. When the lens has been removed from the camera, the tube is inserted in its place. Next, the lens must be attached to the tube. Extension tubes exist in a variety of lengths and can be used singly or in combination according to the degree of coverage and magnification desired. Some tube sets even pro-

vide for preserving the automatic diaphragm feature of the camera system, despite the removal of the camera's lens from the instrument's main body.

Also an extension device, a bellows unit offers, over the tube system, the convenience of fewer operations necessary to convert the camera to the magnification sought (Fig. 718). In addition, its light-tight coupling from camera to lens can be collapsed or expanded like an accordion, thus providing continuous adjustment for closeness to the subject. The lens is held by the "front standard" of the bellows, and this rides upon lightweight rails. Adjustment usually occurs by turning a small knob. It is also usual for the rails to be engraved to indicate magnification and even exposure compensation for various lenses at various positions along the rail. A number of units actually preserve the camera's automatic diaphragm feature, despite the intervention of the bellows between lens and camera body.

A bellows extension permits closeup ratios ranging from 1:1 to 4:1. The former indicates a 35mm film image of a size that fills the 1 × 2½ inch format of the film and, in addition, is the same size as the subject. The latter means a film image 4 times the size of the subject. But the focal length of the lens is a factor that affects the closeup ratio. A 35mm (wide angle) lens yields ratios of approximately 2.5:1 to 6:1; a 50mm (normal) lens produces ratios ranging from 1.5:1 to 4:1; while a 90mm (medium long) lens results in a ratio range of 1:1 to 2.5:1. Often, these ratios are too extreme, for what is needed is a lens capable of yielding a 1:1 ratio, perhaps even a slightly smaller image, while permitting a somewhat greater distance from camera to subject. In this instance, a lens with the focal length of 125mm or 135mm should prove preferable.

Because they increase the distance that light must travel in order to expose the film, such extension devices as tubes and bellows require exposure increases so as to assure a bright image. The exposure factor provides a number by which normal exposure must be multiplied in order to obtain the correct exposure. For example, an exposure factor of 2X indicates that twice the normal exposure is needed. The shorter the extension tube, the smaller the exposure factor. The relevant factor usually is inscribed on the extension device or included with the instructions accompanying it. It is important to take account of the exposure factor, for otherwise underexposure could result.

717, 718. Tubes and bellows extend focal distance and thus permit closeup photography to occur. This type of supplement is normally inserted between the lens and the camera's body.

left: 717. Extension tubes increase focal distance at specific intervals measured by each tube's length.

below: 718. The bellows unit provides continuous adjustment for closeness to the subject.

The view camera, offering both through-the-lens viewing and focusing and a bellows for extended focusing range, makes the ideal instrument for closeup photography. But here too, bellows extension requires exposure compensation, and view cameras do not have engraved upon them scales indicating exposure increases. In their stead, this formula can help the photographer calculate the exposure needed.

$$\frac{\text{focal length}^2}{\text{bellows extension}^2} = \frac{\text{normal exposure}}{\text{correct exposure}}$$

An example could be a 4 × 5 view camera with a 5½ inch lens focused on a near object. The bellows extension is 12 inches, and the meter indicates exposure of 1 second at f/16. Placed in the formula, these factors appear thus:

$$\frac{5.5^2}{12^2} = \frac{1}{X}$$

$$\frac{30.25}{144} = \frac{1}{X}$$

$$30.25X = 144$$

$$X = 4.75$$

In the instance of fractions, such as 4¾ seconds, it is best to overexpose rather than underexpose. Thus, 5 seconds at f/16 would be the new and corrected exposure.

The following procedure accomplishes the same result without the photographer's having to use pencil and paper. He can derive the correct exposure simply by using f-number and shutter-speed dials on the exposure meter

(Fig. 719). Here, we can again assume the factors just used in the formula:

1. Obtain the exposure in the normal manner (1 second at f/16).
2. Measure the bellows extension (12 inches).
3. Place the shutter speed of 1 second opposite 5.6 on the f-number scale as representative of the focal length.

4. On the f-number scale find the f-number corresponding to the bellows extension of 12 inches.
5. Opposite this number would appear the exposure — 5 seconds.

Because the numbers do not always round out, the technique allows slight inaccuracies to occur, but such discrepancies usually are too slight to affect exposure. At the same time, the simplicity of this practical procedure enables the photographer to calculate quickly and easily the exposure necessary to compensate for bellows extension.

Appendix C
COPYING

Copying is the recording on film of an image that exists in two dimensions, such as a painting, a drawing, or another photograph, and obtaining a photographic record that recapitulates virtually one-for-one all that the eye sees, including fine detail of line, tone, and/or color, in the original subject, usually referred to as *copy*. Because the subject/copy exists in a single plane, depth of field is of no consequence, and the photographer need be concerned only for good, sharp focus all over the subject's flat surface. In most instances, copying constitutes a form of closeup photography, which, as we saw in the immediately preceding discussion, can be accomplished with relative ease when the camera is of the single-lens reflex or view type, both of which permit viewing through the camera's picture-taking lens and therefore eliminate the possibility of parallax error. The only additional equipment necessary, other than that to correct the lens for closeup work, consists of a tripod for steadying the camera, a cable release for maintaining the camera's stability at the time of exposure, and two photoflood lamps for illuminating the copy.

The formal literalness in this type of photography requires that the subject be as firmly secured as the camera and that the camera-subject angle be calculated with exactitude. Usually, the copy is fixed absolutely flat to a wall or to a horizontal surface, by some means other than pins capable of casting undesirable shadows onto the copy surface. A copyboard designed specifically to hold the subject can be used. To avoid distortion in the image of the subject's forms, the camera should be positioned center and parallel in relation to the subject — that is, the copy should be centered relative to the lens' axis. Surrounding the copy with black paper, or placing black paper over the copyboard before securing the copy to it, reduces the possibility of flare.

The best lighting, for purposes of copying, usually is even and diffused. Thus, the two lamps should be placed symmetrically at a 45° angle on either side of the copy (Fig. 720), with the distance between the light source and the copy short enough to flood the surface with strong light yet sufficiently great not to illuminate the subject's edges more than its center. The evenness of the light's distribution can be checked with an exposure meter, or by the simple technique of holding a pencil perpendicular to the copy at its center and then comparing the shadows cast by the pencil's slender shaft. Two equal shadows signify balanced illumination (Fig. 721).

Some subjects, however, such as paintings, may demand lighting arranged irregularly to dramatize, by means of highlights and shadows,

the textures of a richly impasto surface. In a circumstance of this character, one of the photofloods could be beamed from a slightly closer range so as to rake the raised portions of the surface with strong light and cause these to cast small shadows. The second light source, projected from a somewhat greater distance, could then be made to illuminate the shadows sufficiently to keep them from appearing too dark.

Paintings with varnished surfaces may create glare and require certain adjustments in the lighting. Changes in the angle of the light source can sometimes eliminate glare. Should this fail, the photographer may need to attach polarizing filters to the photofloods and to the camera's lens.

Glass covering a framed subject can give off troublesome reflections; it may even mirror the image of the camera, the photographer, and the surrounding area. A polarizing filter cannot eliminate such reflections, owing to the 90° angle of the relationship between camera and copy. To focus and compose his image, the photographer opens the diaphragm wide, and the increase this causes in depth of field makes such reflections less apparent. To check for their presence, he can close down the aperture and then observe the image conveyed through the lens. A technique for blocking out the reflections is to stretch a sheet of black cotton cloth from one light stand to the other across the front of the camera. The camera's lens is then inserted into a hole cut in the black wall (Fig. 722).

Because it reads incident light only, the incident-light meter is ideal for copy work. However, if the copy is darker or lighter than average, exposure compensation may be required. The reflected-light meter should be read from an 18 percent gray card held over the copy (Figs. 146, 646, 647). An exposure from this reading will reproduce an average range of tones. But again, unusually light or dark copy requires compensation in exposure.

Black-and-white films used for copying colored subjects must be panchromatic in order for them to render all tones properly. Copying photographs of normal tonal range can be beautifully realized with Kodak's Professional Copy Film, a film made especially for this purpose. Copy of extreme black-and-white contrast, such as ink and pencil drawings, calls for a film likely to render the image in good "separation" —that is, in black-and-white contrast as strong and emphatic as that in the original. Here, a film like Kodak's Tri-X Ortho could be effective, for its blindness to red makes this film unusually

right: 720. Copying is best done when the camera and subject have both been firmly secured and positioned center and parallel relative to each other, and the subject has been illuminated by two lamps placed symmetrically at a 45° angle on either side of the copy.

center right: 721. The evenness of the light's distribution can be checked by observing the shadows cast from a pencil placed perpendicular to the subject's center. Two equal shadows signify balanced illumination.

below right: 722. To eliminate mirror reflections on the glass covering a subject, the photographer can stretch a sheet of black cloth from one light stand to another, across the front of the camera, and photograph through a hole cut in the black wall.

contrasty. Underexposure and overdevelopment (Figs. 534, 535) offer another technique for realizing good separation in photographic images made of strongly contrasted subject matter.

Kodalith is a film so high in contrast that it renders the subject only in stark black and white (Fig. 57). Kodalith works well for copying such "line art" as maps, mechanical drawings, charts, diagrams, and typography. Printers use it primarily in making photomechanical reproductions. However, this film may not be ideal for the reproduction of drawings, because it eliminates all tonal values, even that of the paper's texture.

The exposure of Kodalith is fairly critical, for if underexposed, the negative is inadequately dense in its black areas, which may even be interrupted by "pinholes," tiny clear spots capable

of printing as black points. On the negative, these can be covered with *opaque,* a brush-applied waterbase paint. An overexposed negative yields a print in which black reduces separation by filling in and obscuring areas of fine detail. Such black filling could diminish the legibility of a word.

Kodalith film must be processed in its own developer chemicals, prepared as solution A and solution B. Stored separate from each other, the two solutions have a long shelf life. Once mixed, however, oxidation destroys their effectiveness after about an hour. Because safelights (Kodak filter OC) do not expose it further, Kodalith can be handled in a printing darkroom. Its thin-base emulsion requires less washing (about 5 minutes) than do ordinary films. For the same reason, Kodalith also dries rapidly.

Appendix D
VIEW CAMERA MOVEMENTS

Photography's first camera, the view camera remains the photographer's most versatile instrument (Fig. 135). Not only does this camera allow the photographer to change lenses and see in large format the image actually present on the focal plane, but, in addition, the long bellows connecting lens and focal plane permits both front and back of the camera to rise and fall and slide and shift independently of each other, enabling the photographer to swing and tilt the camera until he has manipulated perspective and depth of field to his complete satisfaction. All this plus the individualized processing of the large negative provide the photographer with maximum control over the final image.

A view camera can be swiveled on the lens axis both vertically and horizontally (Figs. 723, 724). Swinging the back horizontally or tilting it vertically determines the perspective of the image that forms on the ground glass at the focal plane. As long as the ground glass is parallel to the subject, the image formed there will be parallel to the subject. Meanwhile, the front can be positioned in a proper relationship to the subject for sharp focus. *The principle basic to the design of view cameras is that the back of the camera controls perspective while the front controls depth of field.*

Raising and Sliding the Camera's Front By raising and sliding the camera's front, the photographer often can center the subject without having to move the large camera mounted on a tripod. In Figure 725 the camera had been placed as desired, but the view revealed much of the street below and too little of the building's upper portion. To bring his main subject, the building, entirely into the field of vision, the photographer raised the camera's front (Fig. 726). In many situations this manipulation would have solved the problem. Here, however, it proved to be beyond the lens' capability, and the black corners at the top of the picture reveal the limitation of the lens' coverage. Often, this type of deficiency is difficult to see on the ground glass. Raising the camera's front can be used to make moderate changes in composition, but to accomplish extreme movements requires a different maneuver, based on tilts and swings.

Sliding the front to left or right helps to center the subject on a horizontal plane in the camera's field of vision (Figs. 727, 728). Such facility serves a good purpose when conditions, such as street traffic, prevent the camera's being placed directly in front of the subject. For extensive coverage, the camera's back can also be made to slide.

Tilts and Swings Tilts and swings are manipulations of the view camera that permit it to make a photographic image of architecture in which the lines of the subject have been distorted. Rarely is it possible to get far enough away from a build-

723–736. The principle basic to the design of view cameras is that the back of the instrument controls the perspective while the front controls depth of field.

above left: 723. Vertical swiveling on the lens axis is possible in the view camera.

left: 724. Horizontal swiveling on the lens axis is also possible in the view camera.

725, 726. Raising and sliding the camera's front permits the photographer to center the subject without moving the large camera mounted on a tripod.

right: 725. Correct camera placement but imperfect view recorded the subject cut off at the top.

far right: 726. A raised camera front brought the building into full view—only to reveal the limitations of the lens' coverage, evident in the black corners at the top of the picture.

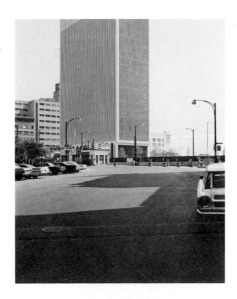 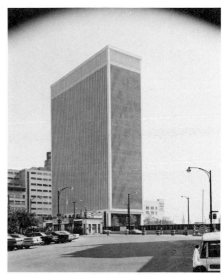

727, 728. Sliding the view camera's front to left or right helps center the subject on a horizontal plane.

right: 727. Subject's image too far to the right, owing to an obstruction that prevented placement of the camera on axis with the subject.

far right: 728. Subject brought into full view by sliding the camera's front to the left.

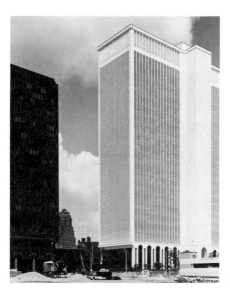 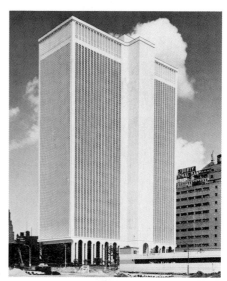

View Camera Movements **335**

left: 729. Camera parallel to the ground plane and the camera front and back parallel to the subject's vertical lines.

right: 730. Entire camera pointed up.

left: 731. Back of upward-pointed camera tilted to a position parallel with the subject's vertical lines.

right: 732. Camera pointed up and camera front and back both tilted parallel to the subject's vertical lines.

729–732. Tilts and swings are view camera manipulations that make possible distortion-free photographs of such monumental forms as skyscraper architecture.

ing to see it without looking up. The angle of vision created by looking up results in a perspective that causes the building's vertical parallels—the orthogonals—to seem to converge toward a single point. Optically, we see the building this way, but human vision corrects the experience so that, despite the appearance of convergence, we perceive the orthogonals as absolutely parallel. Such psychological correction does not occur, however, when the image has the two-dimensional character of a photographic print. In photography the only correction possible is optical, not psychological. Tilting and swinging the view camera can make the physical modifications needed in the image.

Photographed with the front and back of the camera parallel to the subject's vertical lines, the building appears only in its lower portion (Fig. 729). For the photograph in Figure 730 the camera was pointed up, which rendered the building in steep perspective, giving it the appearance of falling backward. For Figure 731 the photographer tilted the rear of the camera until it was parallel to the building's perpendicular lines. This eliminated the converging orthogonals but introduced a focusing problem. To such a degree was the building's upper half out of focus, even closing the aperture all the way down could not bring that part of the subject into sharp focus. The photographer could then solve this problem by making the camera's front parallel to the subject's vertical lines. The rendition this produced in Figure 732 makes the building seem as solid, sound, and clearly defined as it would in the viewer's direct experience of it.

To gain depth of field on either a horizontal plane or on a vertical one, the photographer can swing or tilt the camera's front. The images in Figures 733 and 734 were both made with a wide-open aperture. For the second of the two pictures the photographer gained considerable depth of field by tilting the camera's front.

This technique works well for subjects, such as ploughed fields, whose lines run parallel to the ground. It would, however, photograph a vertical subject out of focus. To gain sufficient depth of field to accommodate vertical subjects, the camera's front can be swung. This principle is illustrated in Figures 735 and 736, both made with the aperture wide open. For the first of the two pictures the camera was focused on the first picket in the fence accented by a round-top finial. This yielded shallow depth of field. Swinging the camera's front for the second illustration extended depth of field quite significantly.

733–736. Depth of field can be gained by tilting or swinging the view camera's front.

left: **733. Camera pointed down and aperture wide open** to photograph a subject whose lines run parallel to the ground.

right: **734. Front of downward-pointed camera tilted toward the subject** and the aperture wide open for the subject photographed in Figure 733.

Appendix E
FILTERS

Filters, like lenses, diaphragms, and shutters, help the photographer control light in a way that its behavior can make possible a photographic image of a particular sort. Fabricated of glass, sheet gelatin, or acetate in various colors and densities and placed in front of a lens, filters exclude light rays of a certain character from the camera while admitting other light rays. They are, in fact, selective in their effect on light.

Filters designed for use in black-and-white photography are of several general types: *Correction filters* control light so that a film can render all colors in value relationships that human vision could accept as normal. *Contrast filters* modify the light admitted into the camera in a way to cause different colors, which otherwise would be rendered in the same tonal value, to have strongly contrasting brightnesses in the photographic image. *Haze filters* clarify the atmosphere in a photographic image by allowing film to respond to electromagnetic radiation that penetrates atmospheric haze to reflect off the scenery. *Neutral-density (ND) filters* reduce brightness generally, while *polar-*

above: **735. Limited depth of field** resulted from focus on the first strongly accented post in the fence, a vertical subject.

736. Camera front swung toward the subject extended the depth of field beyond that recorded in Figure 735.

737. Filters must match physically and optically the lens they supplement. Vignetting results from a filter that corresponds to the lens' physical size but optically is too small to cover the lens completely.

izing filters absorb glare, thereby clarifying imagery, darkening skies, and unifying colors.

Since the purpose of all filters is to absorb a portion of the light reflected from the subject, filters actually reduce the brightness of the image conveyed by the filtered light to the film. Thus, when the photographer adds a filter to his lens, he must simultaneously increase exposure so as to assure a sufficiently bright image inside the camera. The degree to which exposure must be compensated is called the *filter factor.*

The method for attaching filters to a lens resembles that for closeup lenses (Fig. 713). Their size designation derives from their diameter; thus, a number 4 filter would be taken from a series in which a number 8 filter represents a larger size. Filters must match physically and optically the lens they are intended to supplement. In certain situations, a filter may suit a lens in physical size at the same time that optically it is too small to cover the lens completely. Such a discrepancy results in a vignetted image (Fig. 737). To guard against filters that may vignette, the photographer should carefully check the information offered by filter manufacturers and test the filter-lens combinations suggested.

Filtration for Correction and Contrast Filters alter the photographic rendition of a scene by modifying the way the lens interprets the value relationships among colors. For example, a yellow filter, being the complementary opposite of the color blue, absorbs much of the blue light but transmits to the film light rays for yellow and neighboring colors in the visible spectrum. When the scene is a landscape, the effect of this is to underexpose the blue element,

which makes the sky print very much darker than it would otherwise, thus setting off the white clouds in dramatic contrast (Figs. 738, 739).

Filters can cause specific colors to be rendered either lighter or darker. To raise the tonal value of an object, the photographer should adopt a filter of the same color as the object. To lower the value, a filter of the opposite color should be added to the lens, as in the instance of the yellow filter to obtain a dark rendition of sky. In monochrome photography, the colors most typically employed for filtration are yellow, red, orange, and green.

Red filtration absorbs blue and green light-waves and darkens the sky drastically; used with infrared film it renders the sky as black and as white such subject matter as grass and leaves.

Blue filtration lightens the tonal value of blue objects. Since its effect is to whiten the sky, this filtration is seldom used in landscape photography.

Yellow filtration, as noted above, serves mainly to darken the value rendition of sky, and it would do the same for water.

Orange filtration also gives sky and water a deeper tonal value; in addition, it helps to clarify a scene affected by atmospheric haze.

With these as general guides to filter characteristics, the beginning photographer may find it beneficial and interesting to try the following combinations of Kodak filters for the typical situations described:

Clouds against a blue sky

natural appearance	Wratten 8 yellow
darker than natural	Wratten 15 orange
very dark	Wratten 25 red

Water and blue sky

natural appearance	Wratten 8 yellow
darker than natural	Wratten 15 orange

Distant landscape (haze penetration)

natural appearance	Wratten 8 yellow
reduction of haze	Wratten 15 orange, or Wratten 25 red
elimination of haze	infrared film with Wratten 25 red

Foliage

natural appearance	Wratten 8 yellow

Beaches, snow

natural with texture	Wratten 8 yellow
enhanced texture	Wratten 15 orange, or Wratten 25 red

738–741. Filtration can correct or reinforce the tonal rendition of a scene by modifying the way the lens interprets the value relationships among colors. A filter of the same color as the object lightens the photograph's tonal rendition of the object; one of the opposite color darkens the rendition. In this sequence the subject matter consists of a light-gray building and brilliant blue sky articulated by white clouds.

above right: 738. An unfiltered photograph reveals only subtle separation between sky and clouds.

above far right: 739. A Wratten 8 filter set the sky off from the white clouds.

right: 740. A red filter darkened the sky quite distinctly.

far right: 741. A glare-reducing pola filter supplemented the red filter to yield the most striking contrast of all between dark sky and light clouds.

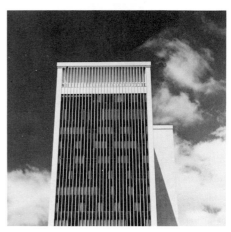

Figures 738 to 741 illustrate the effect that various filtrations can have on the rendition of a scene. Here, the subject matter consists of a light-gray building and brilliant blue sky punctuated by white clouds. The photograph in Figure 738 was made without filtration, and it reveals only a subtle separation between sky and clouds. Photographed with a Wratten 8 yellow filter, Figure 739 offers a darker sky, which sets it more distinctly off from the white clouds. The third example (Fig. 740) derives from a red filter, which has darkened the sky still more emphatically. The filtration for Figure 741 combines a red filter with a glare-reducing pola filter (Figs. 624, 625), and this yielded the most striking contrast between the dark sky and its light clouds of any photograph in the series.

Despite the fact that films are designed and manufactured to have sensitivities corresponding to the color balance in the illumination by which photographers typically work, even panchromatic film, which in theory is sensitive to all colors in the visible spectrum, cannot record with complete fidelity the tonal range of a scene whose illumination has a distinct imbalance toward either the cool end of the spectrum or toward the warm. In daylight, for instance, the blue light rays dominate, but artificial illumination from a tungsten source presents a dominance of red light rays. Panchromatic film has been corrected to accommodate a situation somewhere in between; therefore, it normally is used without filtration. Nonetheless, the photographer adopting panchromatic film and eager to achieve a more sensitive rendition of the tonal values in a tungsten-illuminated scene should supplement his lens with a green filter (11), which would absorb some of the wavelengths for red. Out-of-doors, it would, as we have seen, be a light-yellow filter (8) that could correct the imbalance toward blue.

Infrared radiation consists of light waves whose lengths are just slightly greater than those for red in the visible spectrum. Thus, they

742, 743. Infrared radiation consists of light waves too long to be visible to the eye, but infrared film is sensitive both to some visible light waves and to wavelengths generated by the infrared segment of the electromagnetic spectrum. Different from visible light in its reflection and absorption behavior, infrared energy can produce strange and wondrous photographic effects.

below: 742. Normal panchromatic film recorded this image of a landscape.

bottom: 743. Infrared film supplemented by a deep red filter rendered the scene in surreal fashion.

744, 745. Haze filtration can be realized with infrared film and a red filter, since infrared radiation, unlike visible light, is not scattered by smoke or water particles but passes through to reflect off the scenery.

top: 744. Panchromatic film exposed in a sequence of different durations recorded a totally featureless sky in the lightest segment and obscured foreground detail in the darkest segment.

above: 745. Infrared film filtered by red clarified the atmosphere and gave contrast to sky and clouds, but rendered the trees in an unduly light tonality.

are not perceptible to the naked eye, but infrared film sees both some of the visible wavelengths and, in addition, the wavelengths generated by the infrared segment of the electromagnetic spectrum. Infrared energy is emitted by incandescent bulbs as well as by the sun. Because its behavior in absorption and reflection is different from that of visible light, infrared energy can produce strange and wonderful photographic effects (Fig. 763), making ordinary sunlit scenes look like surreal landscapes (Figs. 742, 743). In Figure 743 the foliage and grass appear white because their subsurfaces strongly reflected the wavelengths of infrared magnetic

energy, as did the large water particles in the clouds. As is usual with infrared film, this photograph was made with a deep red filter, which blocked the blue lightwaves and caused the sky to be recorded as very dark—almost black in areas.

Haze Filtration Infrared film, supplemented by red filtration, can also penetrate atmospheric haze and record the details of objects present in the far distance. This occurs because infrared radiation, unlike visible light, is not scattered by smoke and water particles; rather, it passes through to reflect off the scenery. The print in Figure 744 was made by giving unfiltered panchromatic film a sequence of different exposures. The lightest segment has rendered the sky as totally featureless, while the darkest segment reveals greater detail in the sky at the same time that it has obscured in darkness the finer elements of the foreground. In general, the scene appears to be a sunrise or a sunset, neither of which is the case. The photograph in Figure 745 was made at the same session, but with infrared film. This clarified the atmosphere and gave contrast to the sky and clouds; it also made the trees look much lighter in value than they should.

Neutral-Density and Polarizing Filters Neutral-density and polarizing filters have no inherent color, but they function—when all other factors fail, such as film speed and exposure—to help the photographer realize the most out of certain types of photographic opportunities.

A neutral-density filter appears gray and absorbs all the light-rays of all colors. It serves for both color and black-and-white film as a means of reducing the amount of light of all wavelengths entering the camera through the lens. Such service is useful when, for instance, the photographer is on the beach and has fast film in his camera. In this situation the camera's shutter-speed and f-number systems may not be able to control the brightness sufficiently to prevent overexposure. A neutral-density filter added to the lens could absorb enough of the excess illumination to make good photography possible.

Neutral-density filters are available in a graduated range of strengths (.30ND, .60ND, .90ND, etc.). To compensate for the amount of light a neutral-density filter excludes from the camera, exposure must be increased. A .30ND filter requires, for example, four times the normal exposure, and a .90ND filter eight times normal exposure.

Neutral-density filters can also be used to limit depth of field when this is not possible by other means, such as a slower film. A camera loaded with medium-speed film may not on a bright day be capable of a shutter speed fast enough to compensate for the f-number needed to restrict depth of field (Fig. 746). The ND filter could slow down the film sufficiently to allow the wide aperture essential to limited depth of field, yet not produce an overexposed photograph (Fig. 747).

Reflections from glass or water, but not from metal, consist of light that is polarized, whose waves are oriented at one angle rather

746, 747. Neutral-density filters reduce the number of light rays of all wavelengths entering the camera. Thus, they can slow down film too fast for the brightness of the available light and by this means limit depth of field when shutter capability is not fast enough to compensate for the f-number needed to restrict depth of field.

right: 746. Depth of field is too great here to make this an effective portrait.

far right: 747. A neutral-density filter permitted the wide aperture necessary to limit depth of field and thus isolate the face for an intensified portrait image.

748, 749. Polarized light is glare—that is, light from surfaces of high reflectancy whose waves are oriented at one angle rather than many. Because of its singleness of direction, glare can be controlled by a filter capable of blocking light rays bounced from one direction (Figs. 624–629).

than many. This is glare (Fig. 748), and because of the singleness of its direction, polarized light can be controlled by a filter capable of blocking those particular reflections. A polarizing filter, despite its appearance of transparency, contains submicroscopic crystals whose alignment is parallel like the pickets in a fence. Lightwaves parallel to the rows of crystals pass through; those of a different orientation are blocked (Figs. 624, 625). By turning the filter. the photographer can orient it to absorb the waves of the polarized light, and since this orientation affects only the waves arriving from one angle, all other lightwaves pass through to make the exposure (Fig. 749).

The photographer orients the pola filter to absorb polarized light by rotating the filter as he looks through it, watching until the glare has disappeared. He must then place the filter on the lens so that it retains the orientation. If his camera is a single-lens reflex, the photographer can place the filter on the lens and then view through it to orient the filter for glare correction.

The pola filter proves especially useful in color photography, for once glare has been reduced or eliminated, colors appear very much richer (Figs. 626–629).

By virtue of the fact that it excludes a certain amount of light from the camera, the pola filter makes exposure compensation essential, by a factor of 2.5. In conditions of low illumination, this factor may actually prevent the filter's being used.

Table E.1 Filters and filter factors for black-and-white film

Filter	Color	Filter factor Daylight	Tungsten
Wratten 8	Yellow	2X	1.5X
Wratten 11	Green	4X	3X
Wratten 25	Red	8X	4X
Wratten 15	Orange	3X	2X
Pola	Gray	2.5X	

Filter Factor Their very nature as light-absorption agents causes filters to reduce sufficiently the brightness of the image projected upon the film that, to compensate, the light image must be allowed to fall on the film for a longer duration. This exposure compensation is known as the *filter factor,* the number by which normal exposure must be multiplied in order to obtain correct exposure. Owing to the relative color balance of each light source, the filter factor for daylight is not the same as that for tungsten illumination. Table E.1 relates the most commonly used filters to their respective filter factors for black-and-white film.

Table E.2 Filter factors in relation to increased f-number

Filter factor	1.2	1.5	2	2.5	3	4	5	8
F-number increase	$\frac{1}{3}$	$\frac{2}{3}$	1	$1\frac{1}{3}$	$1\frac{2}{3}$	2	$2\frac{1}{3}$	3

A 2X filter factor indicates that the requirement is for compensation equal to twice normal exposure. Thus, if normal exposure is 1/50 at f/8, the addition of a filter with a factor of 2X would entail exposure augmentation to 1/50 at f/5.6 or to 1/25 at f/8. The choice of slowing the shutter speed or of expanding the aperture depends upon the subject to be photographed and the photographer's intentions. Often, the most convenient modification is to change the f-number. The information in Table E.2 can help the photographer relate filter factors to f-number adjustments needed to realize exposure compensation.

Appendix F
TONING

Toning is a chemical process for altering the "color" of a black-and-white print. It adds to the metallic silver of the photographic image another chemical so that the two form a new compound producing a different color. Once toned, a black-gray-and-white photograph may present its value range in sepia tones, or even in blue, green, or tan ones. The technique must be employed with taste and discrimination, for, fundamentally, it is justifiable only when the quality and interest of a good picture can be enhanced by a change in tonal color.

Toning was practiced even by the early photographers. It can make warm blacks become cool, or reverse this effect. Often, toning causes the blacks to seem richer without affecting the other values in the image. Frederick Sommer and Ansel Adams are among the great modern photographers who have used toning for this purpose, as well as to give the images more archival permanence. The best results are realized when the negative has been printed on warm-toned paper.

To prepare for toning, the photographer should print the image slightly darker than usual. The print must be thoroughly washed before it is toned, for any residual hypo would create a stain. Once washed, the print is bleached slightly in a dilute solution of potassium ferricyanide, which is pale yellow in color. After a second wash of 30 minutes duration, the print is immersed in a dilute solution of selenium toner (1 part chemical to 16 parts water). There, it must be agitated for about 2 minutes. Upon removal, the print may appear to be a shade too dark, but it will lighten during the hour's wash that should follow.

A simplified variant of the technique entails only the toning of a washed print in dilute solution of selenium toner and then a wash for 60 minutes.

Appendix G
PRESENTATION

Photographic prints curl because the emulsion side has dried at a rate different from that of the paper support. Not only is a curled print difficult to view, but, in addition, an attempt to increase visibility by flattening the print may actually cause the hardened emulsion to crack. The best solution to this problem, and the most respectful way to treat a good, successfully processed photograph, is to fasten the print soon after it has dried upon a firm, rigid, flat surface, such as a thin sheet of mount board. And the best way to mount a print is by a "dry" process requiring that heat be applied from a special press. "Wet mounting" with ordinary glue, paste, or rubber cement can create as many problems as it solves, since the adhesives deteriorate with time and may contain ingredients capable of staining or discoloring the prints.

Dry Mounting Dry mounting offers a relatively neat and simple method for giving prints the ultimate finish and permanence that good work deserves. In dry mounting the bonding agent is a shellac-impregnated tissue. Once a sheet of the tissue has been placed between the print's paper support and the mount board and then heat applied to the sandwich, the tissue melts, thereby bonding all elements together.

In some brands of dry-mount tissue a sheet of paper separates sheets of tissue. To distinguish the paper from the tissue, Eastman Kodak

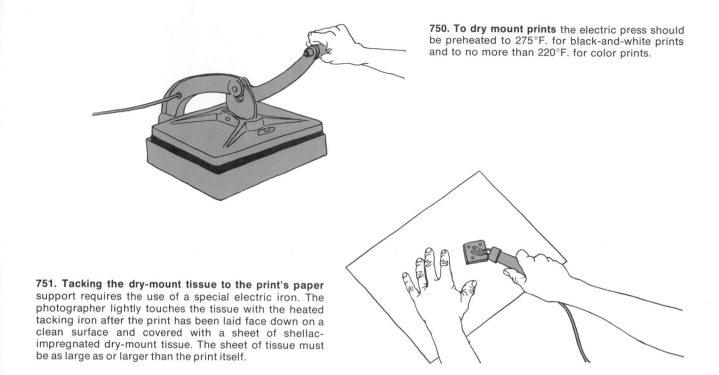

751. Tacking the dry-mount tissue to the print's paper support requires the use of a special electric iron. The photographer lightly touches the tissue with the heated tacking iron after the print has been laid face down on a clean surface and covered with a sheet of shellac-impregnated dry-mount tissue. The sheet of tissue must be as large as or larger than the print itself.

colors the paper pink, and photographers using such a product must understand the difference. Dry-mount tissue is manufactured in sizes that correspond to the dimensions of most papers; for large prints, rolled tissue exists. The tissue should be the same size as the print. Smaller pieces spliced together often produce distortions in the print's surface, especially in prints made on single-weight paper. Where splicing cannot be avoided, care must be taken against overlapping sheets of tissue, for this can result in a ridge on the print's emulsion side. The opposite situation—a space between sheets—may create the appearance of a crack in the mounted print. When the photograph has been printed on double-weight paper, such defects are less likely to have a visible effect.

To dry mount, the photographer should turn on the electrically powered heating press and set it at 275°F. for black-and-white prints or at no more than 220°F. for color prints (Fig. 750). Leaving the press closed without clamping it shut permits the rubber base pad to warm up. At this point the photographer might also consider ways to handle prints without leaving them spoiled by dirt and fingerprints. Hands not light, sure, and dextrous in their touch should perhaps be covered with the sort of

film editor's white gloves that can be obtained in motion picture supply stores.

Next, the photographer places the print face down on a smooth, clean surface and over it lays a sheet of dry-mounting tissue, squaring the tissue on top of the print as perfectly as he can. He then touches the tissue at the center with an electrically heated tacking iron, applying just enough light pressure to cause the tissue to adhere at this point to the back of the print (Fig. 751). To verify that tissue and print have been secured to each other, the photographer can lift the tissue. If the tissue fails to carry with it the weight of the paper, the photographer should recenter the two sheets and tack them again, continuing to use only a very light stroke.

Any tissue that extends beyond the print's edge must be trimmed, for otherwise the excess would stick to the cover sheet once the lid of the dry mount press has closed down on the sandwich. Should any shellac be transferred to the cover sheet, the sheet must be replaced, to prevent its spoiling the emulsion surface of prints subsequently placed in the press.

Now also is the moment for the photographer to trim the print in whatever way he may intend. Prints whose image will be framed by a superimposed mat need only to be trimmed for any

excess mounting tissue. Those to appear as "bleeds"—that is, with both white borders and mounting board cropped flush with the edges of the image—must also be trimmed for little more than the excess tissue. If, however, the print's presentation is to be as mounted upon its board support, the photographer should at this time trim the print to exact size.

Prints are best cropped of borders and tissue with a mat knife and a metal straight-edge rule. Because its blade rotates, the Nikor trimmer cuts a very neat edge, even when the paper is heavy weight. In addition, a light attachment ensures an accurate trim by permitting the photographer to see through the print. The blade of the guillotine type cutter often is not sharp enough to trim prints without breaking the emulsion along the cut edge. The technique is to turn the print face up and position it so that the tacked tissue rests against a hard, flat surface not likely to be damaged by the trimmer's blade. The straight edge should go on top of the print's image with the rule's outer edge aligned precisely where the cut is to occur. With the thumb and first two fingers of one hand pressing the rule firmly against the print, the photographer should grasp the trimmer with the other hand and, bearing down sufficiently for

the blade to penetrate both print and tissue, draw the trimmer flush up against the metal straight edge for the full extent of the materials being cut (Fig. 752).

The type of mount board can affect both the print's permanence and its presentation. It must be heavy enough to give the print firm support and have the color and finish needed to enhance the image. A white, smooth-surfaced board seems most often to provide success. One with a cream or yellow cast could dull the print's light tones, and a textured board might cause a photograph printed on single-weight paper to acquire a rough appearance. The larger the print, the thicker the mount board must be in order for both print and board to remain flat.

The trimmed print is ready to be positioned face up on the mount board. To make it suitable for final presentation as mounted on the board, the photographer should take care to center the print perfectly within the board's perimeter. A printer's pica stick is an efficient tool for centering the print. A hook at one end stabilizes the stick at the board's edge and makes possible a quick and accurate reading of the proper measure (Fig. 753).

Holding the print securely in position with the last two fingers of one hand, the photog-

754. To tack the print and its dry-mount tissue to the mount board, the photographer holds the print in position with the last two or three fingers of one hand and with the thumb and forefinger lifts a corner of the print. With the other hand he then lowers the tacking iron to stroke lightly the dry-mount tissue lying flat on the mount board.

755. Inside the press the sandwich consisting of print, dry-mount tissue, and mount board should be placed face up and covered with a sheet of clean, dry, and warmed paper.

756. Weight the dry-mounted print facedown on a clean surface and let it cool for a few minutes.

rapher uses thumb and forefinger to lift one corner of the print only, not the tissue. With the other hand he lowers the tacking iron onto the tissue and touches it lightly to make the tissue stick at this point to the mount board (Fig. 754). It is imperative that the tacking iron not touch the print's emulsion, for such contact could irrevocably spoil the print. Once the tissue has been tacked both to the print and to the mount board, the whole sandwich is ready to be inserted into the dry-mount press.

By this time the press should have heated to 275°F. for black-and-white prints and to no more than 220°F. for color. While warming, the rubber mat and cover sheet will have developed moisture. To dry them, the photographer has only to remove pad and sheet and let them cool briefly in the open air. Moisture in the press

could cause the cover sheet to stick to the print's surface, giving it a slightly spotted appearance. In humid atmosphere, the mount board itself collects moisture. This can be checked by placing the board in the press for a few seconds. If the board feels damp, it should be alternately warmed and cooled until the surface seems dry to the touch.

Inside the press the print should be placed face up on the rubber pad and covered with the warmed, dry sheet of clean white paper (Fig. 755). Next, the press is closed and clamped down. How long to leave the print in the press depends upon the weight and thickness of the materials used, as well as on the brand of the dry-mount paper. Normally, the duration extends from 15 to 40 seconds, but the photographer should experiment a bit in order to determine the press time most likely to make a good bond without adversely affecting the print. Color prints must be heated in a cooler press for an even briefer period. A successful bond has occurred when immediately on removal from the press the print proves to be firmly fastened to the mount. The photographer should try gently to buckle the mount board. If the print separates from it, the indication is that the sandwich needs additional time in the press.

Subjecting the print to heat in a dry-mount press can also raise blisters that are pockets of air trapped between the bonded surfaces of the print and its mount board. Often, it is possible to flatten such a bubble by re-pressing the print under a thicker cover sheet. In extreme cases, the air can be released through a pinhole made from the back of the board. In using this technique, the photographer should take care to penetrate the board only, not the print itself.

The warm print mounted on its board support should be placed facedown on a smooth, clean surface and covered with a weight (Fig. 756). If a weight manufactured for this purpose is not available, a heavy book or a brick covered with paper could serve. Thus cooled for a few minutes, the mounted print tends to remain flat. And dry-mount tissue is such that generally it makes a permanent bond and prevents removal of the print even when this might be desired.

Only the most meticulously clean conditions and procedures should prevail in dry mounting prints, for any dirt permitted to remain either under or on top of the print will, once bonding has occurred, have an undesirable physical effect. Small but annoyingly visible sharp-pointed lumps usually result from dirt particles trapped

right: **757. White spots** result from lint and dirt particles collected on the negative at the time of exposure.

below: **758. Spotting** involves dyeing selected passages of emulsion a deeper tonality so as to obscure and eliminate white spots (Fig. 757).

under a mounted print. Sometimes, the photographer can use the convex side of a spoon, or some such smooth object, to gently press the lump into the board, but he must work carefully so as not to break the emulsion surface or leave a depression in lieu of a raised spot. Dirt particles on the press can make dents and dimples on the print's surface, which may actually prove irreparable.

Heat applied for the purpose of dry mounting should cover the entire area of the print all at once. For this reason, a clothing iron is not recommended as a means for dry mounting prints, except possibly for those measuring no more than 4×5 inches. The iron's dial should be set between silk and wool. Once used, the iron must be thoroughly cleaned, for any shellac that may have adhered to its surface could subsequently be transferred to clothing. So that heat can cover the print adequately, dry-mount presses are manufactured in a range of sizes. If the photographer must use a small press to mount a large print, he should shift the print around in the press from time to time to avoid the crease that develops when such a print has been left too long in one position.

Dry mounting is a delicate and somewhat tedious procedure, but if followed with care and respect, it can do much to enhance the value of a good print. However, slipshod workmanship can at this stage compromise or totally dissipate all the investment of time, energy, and genius that the photographer has made in obtaining a beautiful, perfectly realized image from the processes of photographing, developing, and printing.

Spotting A dried and mounted print is so smooth and flat that it may now reveal in the image certain imperfections called *white spots*. These, of course, detract from the overall quality of the print's appearance and should therefore be eliminated. The retouching of color prints was discussed in Chapter 10 (see p. 319); therefore, the comments made here are limited to finishing appropriate for black-and-white photography.

White spots are exposure failures that result from the presence on the negative of such foreign particles as dust, dirt, and lint (Fig. 757). They can be assimilated into the image's adjacent tonal quality by a technique known as *spotting* (Fig. 758).

Spotting is done with dyes (Spotone) that become absorbed into the gelatin of the print's emulsion. Since the dye does not rest upon the print's surface, but is integral with the substance of the emulsion, the treated passage retains the surface quality of the print itself. Such dye is a toning medium; therefore, it attains deeper value only gradually as repeated applications and time permit the gelatin to absorb a sufficient quantity of dye. For the same reason, the dye can yield dark gray, but not black. Also, a brush loaded with dye produces a dark tone

759. Materials for spotting are Spotone dye, a container of water, a fine watercolor brush, a palette, bits of blotter, and the prints in need of treatment.

begins, thus to avoid applying medium that would only darken the image and make it contrast even more noticeably with the white spot. It is also better to begin with a light tone and build toward a darker one, for once absorbed, Spotone proves very difficult to lighten. As the photographer proceeds, he can blend dye and water on the palette as needed, soaking the brush each time and then blotting it almost dry. To deepen tonality, he should pause between applications and then treat the spot again with a freshly moistened brush. To match really dark areas, a somewhat wetter brush charged with full-strength dye should be poised on the emulsion surface for a few seconds with each stroke. The emulsion can absorb only so much moisture at any one time, and to build up tone, the photographer must be patient enough to let the absorption process take place, which seems to occur better when the emulsion is dry.

Also exposure failures, *black spots* are produced by clear, transparent areas in the negative, such as those caused by scratches and air bubbles. Owing to its small size, the negative usually cannot be treated with Spotone. Thus, it is in the print that a remedy must be sought. The technique of lightening a print, instead of darkening it in spots, is relatively complicated and hazardous. Black spots must be bleached with a concentrated solution of potassium ferricyanide or with an ordinary laundry bleach, such as Clorox. An instrument suitable for accomplishing this is a toothpick with cotton wrapped around its tip. After dipping the cotton tip into the bleach and blotting all excess solution on absorbent paper, the photographer can touch briefly the loaded instrument to the black spot, taking care not to let bleach come into contact with any other area of the print. Several such applications will render the black spot white. The whitened area can then be spotted in the usual way.

Matting A print that has been dry-mounted and spotted is a finished product ready for exhibition. The photographer's objective should now be to preserve this condition. Of most concern is the print surface, for the relatively soft material of the emulsion can be easily scratched. Even the sliding of the back of one mounted print across the surface of another often is sufficient to scuff the dried emulsion. Such marks, of course, detract from the print's appearance. Tissue paper placed between prints provides some protection, but under no circumstance should the photographer use for this purpose the pink

only if moved slowly across the print's surface or made to rest momentarily on the white spot.

The photographer should assemble his materials on a cleared table and arrange a good, strong white light from a source not likely to produce glare on the surface of the print being spotted. He must have a bottle of dye in a color matched to that of his prints, a small jar of water, a fine watercolor brush (possibly number 4 in size), a glazed and fired saucer or some such hard, sealed surface suitable to serve as a palette for mixing dye and water, bits of blotter, paper towels, or tissues for wiping the brush, and the prints in need of spotting (Fig. 759). Spotone is available in pure black or in black tinged with red (to make it warm or brownish) or blue (to effect a cold tonality). The exact tonality of the dye should, of course, be selected to harmonize with the color quality of the black-and-white photograph, which derives from the type of paper it was printed on and/or from any chemical toning that may have occurred following development.

The photographer mixes the dye and water by dipping the brush first in the dye and depositing the medium in a series of little puddles on the palette. He next dips the brush into water and mixes it in graduated amounts with the several pools of dye, to provide a range of dye tonalities, from light to dark. This leaves the brush charged with a dilute of toning medium. It should then be stroked over the blotter of absorbent paper until almost dry on the surface and pointed at the tip. To test the value of the toning dilute, the photographer can apply the moistened brush to a remnant of white border trimmed from the print. If the tonality of the mark made by this stroke matches that of the area surrounding a white spot, he can then begin to work on the print.

It is better to use just the tip of the brush and paint out in small dots from the center of the white spot to the edge where the print's tonality

760–763. Matting a print is one of the best ways to protect its emulsion surface against scuffs and scratches.

left: 760. Cutting out the center of the mat board should be done with a mat knife and a straight-edge metal rule. Cover a table top with an oversize sheet of corrugated cardboard and on top of this align the mat board so that cuts can follow the corrugations.

above: 761. Bevelling the cut gives an elegant finish to the edges of the mat board's window.

left: 762. A tape hinge is a good way to attach the mat to the mount board supporting the print.

sheets with which Eastman Kodak separates sheets of dry-mount tissue. Shellac could linger on this material and become transferred to the photograph.

Storing prints in boxes the same size as their mount board prevents their shuffling back and forth across each other's surfaces. Prints should not be stored in empty photographic paper boxes, since these are made of paper containing considerable amounts of sulfur, which in time can damage prints. Boxes low in sulfur content are available and should be used for print storage.

Even properly stored prints remain vulnerable, especially when handled by someone insensitive to the value of good photographs. Possibly the best way to ensure the print's safety at all times is to frame the image with a mat whose surface is raised sufficiently above that of the print to provide protection for the print's emulsion.

The mat board should be cut to match the size and shape of the board the print has been mounted on. From the mounted print the photographer takes the measure of the opening needed in the mat and lightly marks in pencil the four corners of this area on the mat board. He then places the mat board on an oversize piece of corrugated cardboard, which should rest on a firm table or counter top, and aligns the intended cut on parallel sides of the opening with the structural ridges in the cardboard. This precaution both assures a good, clean, penetrating cut and protects the supporting surface. For the second pair of parallel cuts the cardboard must, of course, be shifted to make its ridges align with the new cuts.

As cutting tools, it is a good idea to use both a mat knife and a straight edge. The straight edge should be placed on the margins of the mat so that any mistakes made with the knife will affect the center area of the mat board that is to be cut away. Once the metal rule has been

aligned with two of the pencil marks noting the image's corners, the knife can be drawn along its straight edge (Fig. 760). To make the corners sharp and free of stray tufts of board fiber, the photographer should cut precisely up to the desired corner. With the more simple knives, the photographer can make an ordinary vertical cut or angle the knife's blade to realize a bevelled edge. The latter technique requires a degree of practiced skill. He can also employ a cutter designed specifically to give the edge a bevelled effect (Fig. 761).

The cut mat board must now be attached to the print's mount. This is best done by means of a hinge. The photographer lays the mounted print face up on the work table and adjacent to it places the mat board facedown. The two boards should be aligned at their top edges and flush with each other. Over the full length of the line separating the two boards the photographer fastens down a strip of cloth tape. He can then lift the mat up and swing it back down upon the mount board to which it has been hinged (Fig. 762). In this final position, the mat frames the print's image and reveals it as through a window (Fig. 763).

763. The photographer's finished product—an image photographed, developed, printed, and mounted for respectful display through the window of a mat and frame. EDWARD STEICHEN. *U.S.S. Lexington: Getting Set for the Big Strike on Kwajalein,* 1943. Infrared photography. Museum of Modern Art, New York.

Appendix H
COLOR TEMPERATURE

The "white light" produced by such energy sources as the sun and an incandescent bulb has present within it light waves of all the lengths that make up the visible portion of the electromagnetic spectrum (Fig. 579). Because they contain all wavelengths, daylight and incandescent illumination offer a "continuous spectrum," even though the overall distribution of the various wavelengths may be such that some predominate over others. The quality of light resulting from a particular balance among wave-

lengths bears the term *color temperature,* and the instrument used for measuring color temperature is the Kelvin scale (see pp. 291–299, 307–314). Expressing color temperature as Centigrade plus 273, the Kelvin scale, or degrees Kelvin (°K.), represents the extent to which a black radiator (which could *reflect* no light) would have to be heated in order for it to *emit* light of the same color as the source being measured. The lower its color temperature, the richer a light source would be in the long wave-

lengths for red and yellow; and the higher the color temperature of a light source, the greater its dominance by the shorter wavelengths for blue. It is by understanding the nature of color temperature that manufacturers have been able to offer films sensitized to match the color of the light most typically available for exposing film— daylight and tungsten incandescence. And matching the color sensitivity of film to the color of its exposing light is fundamental to any success in realizing by photographic means a plausible representation of color balance as human perception would expect it to appear. The mired scale (for microreciprocal) offers an alternative system for expressing color temperature (in degrees Kelvin divided into 1,000,000), one normally employed for assessing the light-balancing capabilities of color filters (see p. 298). In degrees Kelvin, the chart reproduced in Figure 764 illustrates the relative warmth or coolness of the light sources commonly serving to effect exposure of photosensitive materials.

764. The Kelvin scale provides an absolute measure by which to rate the color temperature of light sources typically available for exposing photosensitive materials. The lower its position on the scale, the "warmer" the source and the richer it is in red light rays; the higher the light source's position on the scale, the "cooler" it is and the greater its dominance by the longer wavelengths for blue rays.

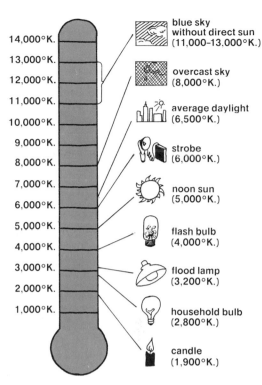

blue sky without direct sun (11,000–13,000°K.)

overcast sky (8,000°K.)

average daylight (6,500°K.)

strobe (6,000°K.)

noon sun (5,000°K.)

flash bulb (4,000°K.)

flood lamp (3,200°K.)

household bulb (2,800°K.)

candle (1,900°K.)

Appendix I
TIME-TEMPERATURE CHART

After film has been exposed, the two variables in the development process that ultimately determine the quality of the negative—its characteristics of density and contrast (see pp. 160, 162, 167, 168, 242–264)—are time and temperature. Manufacturers distribute charts indicating time-temperature combinations for given materials, but photographers themselves can make charts based on their own experience and objectives. The time-temperature chart reproduced in Figure 765 suggests a format for the record each photographer might wish to keep of the results of his work with certain materials and his use of certain techniques. The chart assumes an unvarying system of agitation, which for each photographer would be governed by the processing device available to him. For purposes of demonstration, a selection of commonly used Eastman Kodak products have been cited, but the individual photographer would list in his chart the materials he knows and prefers. The second line for each film in the column provided for developer strength concerns 35mm film, since a thin negative (produced by weakened solution) yields a denser, richer print when the image has been projected across the relatively great distance necessary to enlarge from a very small negative.

A time-temperature chart exists to acknowledge the fact that in the development process temperature is a variable that must be balanced by compensating variations in time. However, it should be stated that the optimum temperature generally is considered to be 68°F., even though consistent results can be obtained for black-and-white film when processing occurs within the rather broad latitude of 65–75°F.

765

TIME-TEMPERATURE CHART

The following data apply to _____ film developer.

Film	Size	Strength of developer solution	Minutes of developing time at various temperatures				
			65°F.	68°F.	70°F.	72°F.	75°F.
Panatomic-X (roll)	____						
	35mm						
Plus-X (roll)	____						
	35mm						
Tri-X (roll)	____						
	35mm						
Verichrome (roll)	____						
	35mm						

BIBLIOGRAPHY

The following bibliography is intended to serve as no more than an initiation to the vast literature now compiled on the art and science of photography. For a thorough listing of individual publications, the reader should consult the two-volume *Photographic Literature* edited by Albert Boni (Hastings-on-Hudson, N.Y.: Morgan & Morgan, 1970). Because they provide comprehensive coverage of the major categories of photographic information, the several volumes comprising the *Life Library of Photography* (New York: Time-Life Books, 1970–71) are identified here:

The Camera, Light and Film, The Print, Color, Photography as a Tool, The Great Themes, Photojournalism, Special Problems, The Studio, The Art of Photography, The Great Photographers, Photographing Nature, Photographing Children, Documentary Photography, Frontiers of Photography, Travel Photography, Caring for Photographs. Supplements: *Series Index, A Photographer's Handbook, Camera Buyer's Guide, Buyer's Guide to Darkroom Equipment.*

A complimentary copy of the useful *Index to Kodak Information* can be obtained by writing to the Eastman Kodak Company in Rochester, N.Y. An annual publication, the index enumerates the more than seven hundred technical pamphlets, "how to," and data books prepared by Kodak.

History

American Heritage, Editors of. *American Album.* New York: American Heritage, 1968.

Bensusan, A. D. *Silver Images: History of Photography in Africa.* Cape Town: Howard Timmins, 1966.

Braive, Michel F. *The Photograph: A Social History.* New York: McGraw-Hill, 1966.

Coke, Van Deren. *The Painter and The Photograph: From Delacroix to Warhol.* Albuquerque: U. of New Mexico Press, 1964.

Darrah, William Culp. *Stereo Views: A History of Stereographs in America and Their Collection.* Gettysburg, Pa.: Times and News, 1964.

Doty, Robert. *Photo-Secession; Photography as a Fine Art.* Rochester, N.Y.: George Eastman House, 1960.

French Primitive Photography. Introduction by Minor White. New York: Aperture, 1970.

Gassan, Arnold. *A Chronology of Photography.* Rev. ed. Athens, Ohio: Handbook, 1972.

Gernsheim, Helmut. *Creative Photography: Aesthetic Trends, 1839–1960.* London: Faber & Faber, 1962.

————. *The History of Photography.* New York: McGraw-Hill, 1970.

————, and Alison. *A Concise History of Photography.* New York: Grossett and Dunlap, 1965.

Lacey, Peter, and Anthony LaRotonda. *The History of the Nude in Photography.* New York: Bantam, 1964.

Mees, C. E. Kenneth. *From Dry Plates to Ektachrome Film: A Story of Photographic Research.* New York: Ziff-Davis, 1961.

Moss, George H. *Double Exposure.* Sea Bright, N.J.: Ploughshare Press, 1971.

Newhall, Beaumont. *The Daguerreotype in America.* Rev. ed. Greenwich, Conn.: New York Graphic, 1968.

————. *The History of Photography from 1839 to the Present Day.* Rev. ed. New York: Museum of Modern Art, 1964.

————. *Latent Image: The Discovery of Photography.* Garden City, N.Y.: Doubleday, 1967.

Newhall, Beaumont and Nancy. *Masters of Photography.* New York: Abrams, 1969.

Pollack, Peter. *The Picture History of Photography.* Rev. ed. New York: Abrams, 1970.

Rinhart, Floyd and Marion. *American Daguerreian Art.* New York: Clarkson N. Potter, 1967.

Rudisill, Richard C. *Mirror Image: The Influence of the Daguerreotype on American Society.* Albuquerque: U. of New Mexico Press, 1971.

Scharf, Aaron. *Creative Photography.* London and New York: Studio Vista, Van Nostrand Reinhold, 1965.

Taft, Robert. *Photography and the American Scene: A Social History.* 1938. New York: Dover, 1964.

Wall, E. J. *E. J. Wall's the History of Three-Color Photography.* New York: Amphoto, 1970.

Technique

Adams, Ansel. *Artificial-Light Photography, Basic Photo Series.* Hastings-on-Hudson, N.Y.: Morgan & Morgan, 1968.

————. *Camera and Lens, Basic Photo Series.* Hastings-on-Hudson, N.Y.: Morgan & Morgan, 1970.

————. *Natural-Light Photography, Basic Photo Series.* Hastings-on-Hudson, N.Y.: Morgan & Morgan, 1965.

————. *The Negative, Basic Photo Series.* Hastings-on-Hudson, N.Y.: Morgan & Morgan, 1968.

————. *Polaroid-Land Photography Manual.* Hastings-on-Hudson, N.Y.: Morgan & Morgan, 1963.

————. *The Print, Basic Photo Series.* Hastings-on-Hudson, N.Y.: Morgan & Morgan, 1968.

Black-and-White Processing for Permanence. Rev. ed. Publication #J19. Rochester, N.Y.: Eastman Kodak, 1968.

Coote, J. H. *Colour Prints.* New York and London: Amphoto, Focal, 1956.

Davis, Phil. *Photography.* Dubuque, Iowa: Wm. C. Brown, 1972.

De Maré, Eric. *Colour Photography.* Baltimore: Penguin, 1968.

Dmitri, Ivan. *Kodachrome and How to Use It.* New York: Simon & Schuster, 1940.

Eaton, George T. *Photo Chemistry in Black-and-White and Color Photography.* Rochester, N.Y.: Eastman Kodak, 1957.

————. *Photographic Chemistry.* Hastings-on-Hudson, N.Y.: Morgan & Morgan, 1965.

Edgerton, Harold E. *Electronic Flash, Strobe.* New York: McGraw-Hill, 1970.

Evans, Ralph M. *Eye, Film and Camera in Color Photography.* New York: John Wiley, 1959.

Feininger, Andreas. *The Complete Photographer.* Englewood Cliffs, N.J.: Prentice-Hall, 1966.

————. *Successful Color Photography.* Englewood Cliffs, N.J.: Prentice-Hall, 1969.

The Focal Encyclopedia of Photography. New York: McGraw-Hill, 1969.

Gassan, Arnold. *Handbook for Contemporary Photography.* Athens, Ohio: Handbook, 1970.

Hedgecoe, John, and Michael Langford. *Photography: Materials and Methods.* London: Oxford U. Press, 1971.

Jacobs, Lou, Jr. *Electronic Flash.* Rev. ed. New York: Amphoto, 1971.

James, Thomas H., and George C. Higgins. *Fundamentals of Photographic Theory.* Hastings-on-Hudson, N.Y.: Morgan & Morgan, 1968.

Kemp, Weston D. *Photography for Visual Communicators.* Englewood Cliffs, N.J.: Prentice-Hall, 1973.

Langford, Michael J. *Basic Photography.* New York and London: Amphoto, Focal, 1965.

————. *Advanced Photography.* New York and London: Amphoto, Focal, 1972.

Latham, Sid. *Filter Guide.* New York: Amphoto, 1962.

Mees, C. E. Kenneth, and T. H. James. *The Theory of Photographic Process.* 3rd ed. New York: Macmillan, 1966.

Neblette, Carroll B. *Photographic Lenses.* Hastings-on-Hudson, N.Y.: Morgan &

Morgan, 1955.

_____. *Photography: Its Materials and Processes.* 6th ed. New York: Van Nostrand Reinhold, 1962.

Pittaro, Ernest M., ed. *Photo-Lab-Index.* Hastings-on-Hudson, N.Y.: Morgan & Morgan, 1973.

Procedures for Processing and Storage of Black-and-White Photographs for Maximum Possible Permanence. Rev. ed. 1970. Published and distributed by the East Street Gallery, 1408 East Street, Grinnell, Iowa 50112.

Professional Printing in Black-and-White. Rochester, N.Y.: Eastman Kodak, 1968.

Stroebel, Leslie. *View Camera Techniques.* New York: Hastings House, 1967.

Sussman, Aaron. *The Amateur Photographer's Handbook.* 8th ed., rev. New York: T. Y. Crowell, 1973.

Todd, Hollis N., and Richard D. Zakia. *Photographic Sensitometry.* Hastings-on-Hudson, N.Y.: Morgan & Morgan, 1969.

White, Minor. *The Zone System Manual.* Hastings-on-Hudson, N.Y.: Morgan & Morgan, 1968.

Zakia, Richard D., and Hollis N. Todd. *101 Experiments in Photography.* Hastings-on-Hudson, N.Y.: Morgan & Morgan, 1969.

Related Books and Catalogues

American Photography: The Sixties. Exhibition catalogue. Lincoln: Sheldon Memorial Art Gallery, U. of Nebraska, 1966.

Anderson, Sherwood. *Home Town: Photographs by Farm Security Photographers.* New York: Alliance Book, 1940.

Andrews, Ralph W. *Picture Gallery Pioneers: 1850 to 1875.* Seattle: Superior, 1964.

Arnheim, Rudolph. *Art and Visual Perception.* Berkeley and Los Angeles: U. of California Press, 1965.

California Photographers 1970. Exhibition catalogue. Davis: Memorial Union Art Gallery, U. of California, 1970.

Collier, John, Jr. *Visual Anthropology: Photography as a Research Method.* New York: Holt, Rinehart & Winston, 1967.

Collins, Leonora, ed. *London in the Nineties.* London: Saturn, 1950.

Conrot, Maisie and Richard. *California Historical Society,* 1972.

Copeland, Alan, ed. *People's Park.* New York: Ballantine, 1969.

Faber, John. *Great Moments in News Photography.* New York: T. Nelson, 1960.

The Family of Man. Intro. by Edward Steichen. New York: Museum of Modern Art, Simon & Schuster, 1955.

Figure in Landscape. A portfolio. Rochester, N.Y.: George Eastman House, 1971.

Five Photographers. Exhibition catalogue. Lincoln: U. of Nebraska Art Galleries, 1968.

Garver, Thomas H. *12 Photographers of the American Social Landscape.* Exhibition catalogue. Waltham, Mass: Brandeis U., Rose Art Museum, 1967.

Graphic/Photographic. Exhibition catalogue. Fullerton: California State College, 1971.

Harper, Russell J., and Stanley Triggs, eds. *Portrait of a Period: A Collection of Notman Photographs, 1856–1915.* Montreal: McGill U. Press, 1967.

Hattersley, Ralph. *Discover Your Self Through Photography.* Hastings-on-Hudson, N.Y.: Morgan & Morgan, 1970.

Hicks, Wilson. *Words and Pictures: An Introduction to Photojournalism.* New York: Harper, 1952.

Hood, Robert E. *12 at War: Great Photographers Under Fire.* New York: Putnam, 1967.

Image of America: Early Photographs, 1839–1900. Exhibition catalogue. Washington, D.C.: Library of Congress, 1957.

Into the Seventies. Exhibition catalogue. Akron, Ohio: Akron Art Institute, 1970.

Ivins, William M., Jr. *Prints and Visual Communication.* 1953. Reprint. Cambridge, Mass.: M.I.T. Press, 1969.

Just Before the War. Exhibition catalogue. Washington, D.C., Newport, R.I., and New York: Library of Congress, Newport Harbor Art Museum, October House, 1968.

Kepes, Gyorgy. *Language of Vision.* Chicago: Theobold, 1944.

Kroeber, Theodora, and Robert F. Heizer. *Almost Ancestors, The First Californians.* San Francisco: Sierra Club, 1968.

Leverant, Robert. *Zen in the Art of Photography.* San Francisco: Images, 1970.

Levitas, M., and Magnum Photos. *America in Crisis.* New York: Holt, Rinehart & Winston, 1969.

Levitt, Helen. *A Way of Seeing.* Essay by James Agee. New York. Viking, 1965.

Lyons, Nathan. *Photography in the Twentieth Century.* New York and Rochester, N.Y.: Horizon, George Eastman House, 1967.

_____, ed. *Contemporary Photographers: The Persistence of Vision.* New York and Rochester, N.Y.: Horizon, George Eastman House, 1967.

_____. *Contemporary Photographers: Toward a Social Landscape.* New York and Rochester, N.Y.: Horizon, George Eastman House, 1966.

_____. *Photographers on Photography.* Englewood Cliffs, N.J.: Prentice-Hall, 1966.

_____. *Vision and Expression.* New York: Horizon, 1969.

Lyons, Nathan; Syl Labrot; and Walter Chappell. *Under the Sun.* New York: George Braziller, 1960.

McLuhan, Marshall. *Understanding Media.* New York: McGraw-Hill, 1971.

Memorable "Life" Photographs. New York: Museum of Modern Art, 1951.

The Multiple Image. Exhibition catalogue. Kingston: U. of Rhode Island Arts Council, 1972.

Newhall, Beaumont. *Airborne Camera.* New York: Hastings House, 1969.

Niece, Robert Clemens. *Photo-Imagination.* Philadelphia: Chilton, 1966.

Not Man Apart. San Francisco: Sierra Club, 1965.

Peace on Earth: Photographs by Magnum. New York: Magnum Photos, 1964.

Photographers Midwest Invitational. Minneapolis: Walker Art Center, 1973.

Photographic Portraits. Exhibition catalogue. Philadelphia: Moore College of Art, 1972.

Photography at Mid-Century. Exhibition catalogue. Rochester, N.Y.: George Eastman House, 1959.

Photography 1970. Portfolio. Lexington, Ky.: Lexington Camera Club, 1970.

Photography 63. Exhibition catalogue. Rochester, N.Y.: New York State Exposition, George Eastman House, 1963.

Photography 64. Exhibition catalogue. Rochester, N.Y.: New York State Exposition, George Eastman House, 1964.

Reflections on a Capital: 12 Ottawa Photographers. Exhibition catalogue. Ottawa: Public Archives of Canada, 1970.

Refocus 70. Exhibition portfolio. Iowa City: U. of Iowa, 1970.

Studies of the Human Form by Two Masters: John Rawlings and Edward Weston. Great Photography Series 1. New York: Maco Magazine Corporation, 1957.

Studio 1968. Exhibition catalogue. New York: Studio, 1968.

Szarkowski, John. *Looking at Photographs.* New York and Greenwich, Conn.: Museum of Modern Art, New York Graphic, 1973.

_____. *The Photographer and the American Landscape.* New York: Museum of Modern Art, 1963.

_____. *The Photographer's Eye.* New York and Garden City, N.Y.: Museum of Modern Art, Doubleday, 1966.

The Visual Dialogue Foundation. Exhibition catalogue. Carmel, Calif.: Visual Dialogue Foundation, 1972.

Ward, John L. *The Criticism of Photography as Art, The Photographs of Jerry Uelsmann.* Gainesville: U. of Florida Press, 1970.

Whiting, John R. *Photography Is a Language.* New York: Ziff-Davis, 1946.

The Wisconsin Heritage in Photography. Catalogue of an exhibition by Bennett, Steichen, and Metzker. Milwaukee: Mil-

waukee Art Center, 1970.

Young Photographers. Exhibition catalogue. Albuquerque: University Art Museum, College of Fine Arts, U. of New Mexico, 1968.

Young Photographers '68. Exhibition catalogue. Lafayette, Ind.: Purdue U., 1968.

Photographers

Abbott, Berenice

Abbott, Berenice, and H. W. Lanier. *Greenwich Village Today and Yesterday*. New York: Harper, 1949.

———, and E. McCausland. *Changing New York*. New York: Dutton, 1939.

Berenice Abbott. New York: Horizon. 1970.

Adams, Ansel

Adams, Ansel. *These We Inherit: The Parklands of America*. Rev. ed. of *My Camera in Yosemite Valley*. San Francisco: Sierra Club, 1962.

———, and Nancy Newhall. *Death Valley*. 3rd ed. Los Angeles: 5 Associates, Ward Ritchie, 1963.

———. *Fiat Lux, The University of California*. New York: McGraw-Hill, 1967.

———. *The Tetons and the Yellowstone*. Los Angeles: 5 Associates, Ward Ritchie, 1970.

———. *This Is the American Earth*. San Francisco: Sierra Club, Ballantine, 1968.

Newhall, Nancy. *The Eloquent Light*. San Francisco: Sierra Club, 1963.

Aigner, Lucien

Clark, Glenn, and Lucien Aigner. *Windows of Heaven*. New York: Harper, 1954.

Allen, Harold

Allen, Harold. *Father Ravalli's Missions*. Chicago: Goodlion, 1971.

Atget, Eugène

Abbott, Berenice. *The World of Atget*. New York: Horizon, 1964.

Atget, Eugène, and Marcel Proust. *A Vision of Paris*. New York: Macmillan, 1963.

Avedon, Richard

Avedon, Richard and James Baldwin. *Nothing Personal*. New York: Atheneum, 1964.

———, and Truman Capote. *Observations*. New York: Simon & Schuster, 1959.

Beaton, Cecil

Beaton, Cecil. *The Glass of Fashion*. Garden City, N.Y.: Doubleday, 1954.

———. *The Wandering Years*. Boston: Little, Brown, 1961.

The Best of Beaton. New York: Macmillan, 1968.

Bellocq, E. J.

Szarkowski, John, ed. *E. J. Bellocq: Storyville Portraits*. New York: Museum of Modern Art, 1970.

Binzen, Bill

Binzen, Bill. *Tenth Street*. New York: Grossman, 1968.

Bischof, Werner

Bischof, Werner, and Manuel Gasser. *The World of Werner Bischof*. New York: Dutton, 1959.

———, and Robert Guillain. *Japan*. New York: Simon & Schuster, Bantam, 1961.

Farova, Anna, ed. *Werner Bischof*. New York: Grossman, 1968.

Blair, James P.

Blair, James P., and Samuel Hazo. *Listen with the Eye*. Pittsburgh: U. of Pittsburgh Press, 1964.

Blumberg, Donald

Blumberg, Donald. *Twenty Daily Photographs 1969/1970*. Available from Light Impressions, Rochester, N.Y.

Bourke-White, Margaret

Bourke-White, Margaret. *Dear Fatherland, Rest Quietly*. New York: Simon & Schuster, 1946.

———. *Eyes on Russia*. New York: Simon & Schuster, 1931.

———. *Portrait of Myself*. New York: Simon & Schuster, 1963.

———. *Purple Heart Valley, A Combat Chronicle of the War in Italy*. New York: Simon & Schuster, 1944.

———. *Shooting the Russian War*. New York: Simon & Schuster, 1942.

———, and Erskine Caldwell. *North of the Danube*. New York: Viking, 1939.

———. *Say, Is This the U.S.A.?* New York: Duell, Sloan and Pearce, 1941.

———. *You Have Seen Their Faces*. New York: Modern Age, 1934.

Brown, Theodore M., and Sean Callahan. *The Photographs of Margaret Bourke-White*. Greenwich, Conn.: New York Graphic, 1972.

Brady, Matthew

Horan, James D. *Matthew Brady: Historian with a Camera*. New York: Crown, 1955.

Meredith, Roy. *Mr. Lincoln's Contemporaries: An Album of Portraits by Matthew B. Brady*. New York: Scribner's, 1951.

Brandt, Bill

Bill Brandt. New York: Museum of Modern Art, 1969.

Brandt, Bill. *Camera in London*. London: Focal, 1948.

———. *Perspective of Nudes*. With preface by Lawrence Durrell. New York and Lausanne, Switz.: Amphoto, Héliographia, 1961.

———. *Shadow of Light*. New York: Viking, 1966.

Brassaï (Gyula Halász)

Brassaï. Intro. by Lawrence Durrell. New York: Museum of Modern Art, 1968.

Brassaï. *Camera in Paris*. London: Focal, 1949.

———. *Graffiti*. Stuttgart: Schwarzweiss Fotos, 1960.

———. *Picasso & Co*. Garden City, N.Y. and London: Doubleday, 1966.

———. *Seville en fête*. New York: T. Y. Crowell, 1956.

Morand, Paul. *Paris de Nuit*. Paris: Arts et Métiers Graphiques, 1933.

Bravo, Manuel Alvarez

Parker, Fred R. *Manuel Alvarez Bravo*. Pasadena: Pasadena Art Museum, 1971.

Brook, John

Brook, John. *Along the Riverrun*. 1970. Available from Light Impressions, Rochester, N.Y.

Bullock, Wynn

Bullock, Wynn, and Richard Mack. *The Widening Stream*. Santa Barbara, Calif.: Peregrine, 1965.

Wynn Bullock. Exhibition catalogue. San Francisco: San Francisco Museum of Art, 1969.

Burden, Shirley

Burden, Shirley. *God Is My Life*. New York: Reynal, 1960.

———. *I Wonder Why* Garden City, N.Y.: Doubleday, 1963.

Burri, René

Burri, René. *Les Allemands*. Paris: Private press, 1963.

Callahan, Harry

Callahan, Harry. *The Multiple Image*. Chicago: Press of the Institute of Design, 1961.

Harry Callahan. Intro. by Paul Sherman. New York: Museum of Modern Art, 1967.

Photographs: Harry Callahan. Exhibition catalogue. Santa Barbara, Calif.: El Mochaelo Gallery, 1964.

Cameron, Julia Margaret

Gernsheim, Helmut. *Julia Margaret Cameron*. 1948. Reprint. New York: Da Capo, 1968.

Capa, Cornell

Capa, Cornell, ed. *The Concerned Photographer*. New York: Grossman, 1968.

Huxley, Matthew, and Cornell Capa. *Farewell To Eden*. New York: Harper & Row, 1964.

Capa, Robert (André Friedman)

Capa, Robert. *Images of War*. New York: Grossman, Paragraphic, 1964.

———. *Slightly Out of Focus*. New York: Holt, Rinehart & Winston, 1947.

Farova, Anna, ed. *Robert Capa*. New York: Grossman, Paragraphic, 1969.

Caponigro, Paul

Paul Caponigro. Aperture Monograph 13:1. New York: Aperture, 1967.

Carroll, Lewis

Gernsheim, Helmut. *Lewis Carroll, Photographer*. 1949. Reprint. New York: Dover, 1967.

Cartier-Bresson, Henri

Bresson. New York: Viking, 1952.

Cartier-Bresson, Henri. *The Decisive Moment*. New York: Simon & Schuster, 1952.

_____. _The Europeans_. New York: Simon & Schuster, 1952.

_____. _The People of Moscow_. New York: Simon & Schuster, 1955.

_____. _The World of Henri Cartier-Bresson_. New York: Viking, 1968.

Delpire, Robert, ed. _From One China to the Other_. Text by J. P. Sartre. Paris and New York: Burns & MacEachern, Universe, 1956.

Kirstein, Lincoln, and Beaumont Newhall. _Photographs by Cartier-Bresson_. New York: Grossman, 1963.

_____. _The Photographs of Henri Cartier-Bresson_. New York: Museum of Modern Art, 1947.

Clark, Larry

Clark, Larry. _Tulsa_. New York: Lustrum, 1971.

Coburn, Alvin Langdon

Coburn, Alvin Langdon. _A Portfolio of Sixteen Photographs_. Intro. by Nancy Newhall. Rochester, N.Y.: George Eastman House, 1962.

Gernsheim, Helmut and Alison, eds. _Alvin Langdon Coburn: An Autobiography_. New York: Praeger, 1966.

Cosindas, Marie

Marie Cosindas: Polaroid Color Photography. Exhibition catalogue. Cambridge, Mass.: Polaroid, 1966.

Cumming, R.

Cumming, R. _Picture Fictions_. Fullerton, Calif.: Private press, 1972.

Cunningham, Imogen

Imogen Cunningham. Aperture Monograph 11:4. New York: Aperture, 1964.

Imogen Cunningham Photographs. Seattle: U. of Washington Press, 1970.

Daguerre, Louis Jacques Mandé

Daguerre. Intro. by Beaumont Newhall. New York: Winter House, 1971.

Gernsheim, Helmut and Alison. _L.J.M. Daguerre: The History of the Diorama and the Daguerreotype_. 1956. Reprint. New York: Dover, 1969.

Dain, Martin J.

Dain, Martin J. _Faulkner's County: Yoknapatawpha_. New York: Random House, 1963.

Davidson, Bruce

Davidson, Bruce. _East 100th Street_. Cambridge, Mass.: Harvard U. Press, 1970.

Talese, Gay, and Bruce Davidson. _The Bridge_. New York: Harper & Row, 1964.

Doisneau, Robert

Robert Doisneau's Paris. New York: Simon & Schuster, 1956.

Dorr, Nell

Dorr, Nell. _In a Blue Moon_. New York: Putnam, 1939.

_____. _Mother and Child_. New York: Harper, 1954.

_____. _Of Night and Day_. Greenwich, Conn.: New York Graphic, 1968.

Duncan, David Douglas

Duncan, David Douglas. _Picasso's Picassos_. 1958. Reprint. New York: Ballantine, 1968.

_____. _Self-Portrait U.S.A._ New York: Abrams, 1969.

_____. _This Is War!_ 1951. Reprint. New York: Bantam, 1967.

_____. _War Without Heroes_. New York: Harper & Row, 1970.

_____. _Yankee Nomad: A Photographic Odyssey_. New York: Holt, Rinehart & Winston, 1966.

Eakins, Thomas

Eakins, His Photographic Works. Philadelphia: Pennsylvania Academy of the Fine Arts, 1969.

Eastman, George

Ackerman, C. W. _George Eastman_. Boston: Houghton Mifflin, 1930.

Emerson, Peter H.

Emerson, Peter H. _Naturalistic Photography_. London: Sampson Low, Marston, Searle & Rivington, 1889.

Evans, Walker

Evans, Walker. _American Photographs_. New York: Museum of Modern Art, 1938.

_____. _Many Are Called_. Boston: Houghton Mifflin, 1966.

_____. _Message from the Interior_. New York: Eakins, 1966.

_____, and James Agee. _Let Us Now Praise Famous Men_. 1941. Boston: Houghton Mifflin, 1966.

Walker Evans. New York and Greenwich, Conn.: Museum of Modern Art, New York Graphic, 1971.

Fenton, Roger

Gernsheim, Helmut. _Roger Fenton, Photographer of the Crimean War_. London: Secker & Warburg, 1954.

Fernandez, Benedict J.

Fernandez, Benedict J. _In Opposition: Images of American Dissent in the Sixties_. New York: Da Capo, 1968.

Frank, Robert

Frank, Robert. _The Americans_. New York: Aperture, 1969.

_____. _The Lines of My Hand_. Los Angeles: Lustrum, 1972.

Freed, Arthur

Freed, Arthur. _Eight Photographs_. A portfolio. Garden City, N.Y.: Doubleday, 1971.

Freed, Leonard

Freed, Leonard. _Black in White America_. New York: Grossman, 1969.

_____. _Made in Germany_. New York: Grossman, 1970.

Friedlander, Lee

Friedlander, Lee. _Self Portrait_. New York: Haywire, 1970.

_____. and Jim Dine. _Work from the Same House_. London: Trigram, 1969.

Gardner, Alexander

Gardner's Photographic Sketch Book of the Civil War. 2 vols., 1865–66. Re-

printed as 1 vol. New York: Dover, 1959.

Genthe, Arnold

Genthe, Arnold. _As I Remember_. New York: Reynal & Hitchcock, 1936.

_____. _The Book of the Dance_. Boston: International, 1920.

_____. _Impressions of Old New Orleans_. New York: George H. Doran, 1926.

_____. _Pictures of Old Chinatown_. New York: Moffet Yard, 1909.

Gibson, Ralph

Gibson, Ralph. _Déjà-vu_. New York: Lustrum, 1973.

_____. _The Somnambulist_. New York: Lustrum, 1970.

Goro, Herb

Goro, Herb. _The Block_. New York: Random House, 1970.

Griffiths, Philip Jones

Griffiths, Philip Jones. _Vietnam Inc._ New York and London: Collier Books, Collier-Macmillan, 1971.

Groebli, René

Groebli, René. _Variation 2, Possibilities of Color Photography_. New York: Hastings House, 1971.

Grossman, Sid

Grossman, Sid, and Millard Lampell. _Journey to the Cape_. New York: Grove, 1959.

Gruber, Fritz

Gruber, Fritz. _Famous Portraits_. New York: Ziff-Davis, 1960.

Haas, Ernst

Haas, Ernst. _The Creation_. New York: Viking, 1971.

Halsman, Philippe

Halsman, Philippe. _Halsman On the Creation of Photographic Ideas_. New York: Ziff-Davis, 1961.

_____. _Jump Book_. New York: Simon & Schuster, 1959.

Haskins, Sam

Haskins, Sam. _Cowboy Kate & Other Stories_. New York: Crown, 1965.

Heath, David

Heath, David. _A Dialogue with Solitude_. Culpeper, Va.: Community Press, 1965.

Heartfield, John

Heartfield, John. _Life and Work_. Dresden: Veb Verlag Der Kunst, 1961.

John Heartfield. London: Institute of Contemporary Arts, 1969.

Hegg, E. A.

Morgan, Murray, and E. A. Hegg. _One Man's Gold Rush_. Seattle and London: U. of Washington Press, 1967.

Heinecken, Robert F.

Heinecken, Robert F. _Are You Real 1964–1968_. A portfolio. Rochester, N.Y.: George Eastman House, n.d.

_____. _The Photograph: Not a picture of, but an object about_. Los Angeles: UCLA Press, n.d.

Henles, Fritz

Henles, Fritz. _Figure Studies_. New York and London: Studio, 1945.

Heyman, Ken
Heyman, Ken, and Michael Mason. *Willie.* New York: Ridge, 1963.
Hill, David Octavius
Schwarz, Heinrich. *David Octavius Hill.* New York: Viking, 1931.
Hill, David Octavius, and Robert Adamson
David Octavius Hill, Robert Adamson: Inkunabeln der Photographie. Essen: Museum Folkwang, 1963.
Michaelson, Katherine. *A Centenary Exhibition of the Work of David Octavius Hill and Robert Adamson.* Edinburgh: Scottish Arts Council, 1970.
Himmel, Paul
Himmel, Paul, and Walter Terry. *Ballet in Action.* New York: Putnam, 1954.
Hine, Lewis W.
Gutman, Judith Mara. *Lewis W. Hine and the American Social Conscience.* New York: Walker, 1967.
Hine, Lewis W. *Men at Work.* New York: Macmillan, 1932.
Lewis Hine Portfolio. Rochester, N.Y.: George Eastman House, 1970.
Holmquist, Anders
Holmquist, Anders. *The Free People.* New York: Outerbridge & Dienstfrey, 1969.
Horst, Horst P.
Horst, Horst P. *Photographs of a Decade.* New York: Augustin, 1962.
Huffman, L.A.
Brown, Mark H., and W. R. Felton. *Before Barbed Wire; L. A. Huffman, Photographer on Horseback.* New York: Bramhall House, 1955.
———. *The Frontier Years, L. A. Huffman, Photographer of the Plains.* New York: Bramhall House, 1956.
Huie, Crystal K. D.
Huie, Crystal K. D. *Dark Hollow.* Private press, 1972.
Jackson, William Henry
Jackson, Clarence S. *Picture Maker of the Old West: William Henry Jackson.* New York: Scribner, 1947.
Time Exposure: The Autobiography of William Henry Jackson. New York: Putnam, 1940.
Jay, Bill
Jay, Bill. *Views on Nudes.* New York: Amphoto, 1971.
Kalisher, Simpson
Kalisher, Simpson. *Railroad Men.* New York: Clarke & Way, 1961.
Kennedy, Clarence
Clarence Kennedy. Exhibition catalogue. Northampton, Mass.: Smith College Museum of Art, 1967.
Keppler, Victor
Keppler, Victor, *Man + Camera.* New York: Amphoto, 1970.
Kertész, André
André Kertész. New York: Grossman, Paragraphic, 1966.
André Kertész: Photographer. Intro. by John Szarkowski. New York: Museum

of Modern Art, 1964.
Davis, George, ed. *Day of Paris: Photographs by André Kertész.* New York: Augustin, 1945.
Klein, William
Klein, William. *Moscow.* New York: Crown, 1964.
———. *New York.* New York: Crown, 1965.
———. *Rome, The City and Its People.* New York: Viking, 1959.
Krause, George
George Krause-1. Haverford, Pa.: Toll & Armstrong, 1972.
Krims, Leslie
Krims, Leslie. *Eight Photographs.* A portfolio. Garden City, N.Y.: Doubleday, 1970.
———. *Four Limited Edition Folios; The Deerslayers; The Incredible Case of the Stack O'Wheats Murders; The Little People of America; Roadside Deaths.* Buffalo, N.Y.: Private press, 1972.
———. *Making Chicken Soup.* New York: Private press, 1972.
Lange, Dorothea
Dorothea Lange. Intro. by George P. Elliott. New York and Garden City, N.Y.: Museum of Modern Art, Doubleday, 1966.
Lange, Dorothea. *The American Country Women.* Fort Worth and Los Angeles: Amon Carter Museum, Ward Ritchie, 1967.
———, and Paul Schuster Taylor. *An American Exodus.* New Haven and New York: Yale U. Press, 1969.
Lartigue, Jacques Henri
Lartigue, Jacques Henri. *Boyhood Photos of J. H. Lartigue.* Lausanne, Switz.: Guichard, 1966.
———. *The Photographs of Jacques Henri Lartigue.* New York: Museum of Modern Art, 1963.
Laughlin, Clarence John
Laughlin, Clarence John. *Ghosts Along the Mississippi.* New York: Scribner, 1948.
Leen, Nina
Leen, Nina. *Women, Heroes, and a Frog.* New York: Norton, 1970.
Leydet, François
Leydet, François. *Time and the River Flowing: Grand Canyon.* San Francisco: Sierra Club, 1964.
Liebling, Jerome
Liebling, Jerome, and Don Morrison. *The Face of Minneapolis.* Minneapolis: Dillon, 1966.
Link, Richard
Link, Richard. *Fossils.* Buffalo, N.Y.: Private press, 1972.
Lyon, Danny
Lyon, Danny. *The Bikeriders.* New York: Macmillan, 1968.
———. *Conversations with the Dead.* New York: Holt, Rinehart & Winston,

1969.
———. *The Destruction of Lower Manhattan.* New York: Macmillan, 1969.
Man Ray
Man Ray. Exhibition catalogue. Los Angeles: Los Angeles County Museum of Art, 1966.
Man Ray. *Photographs, 1920–34: Paris.* New York: Random House, 1934.
———. *Self Portrait.* Boston: Little, Brown. 1963.
Mandel, Mike
Mandel, Mike. *Myself: Timed Exposures.* Los Angeles: Private press, 1971.
Meatyard, Ralph Eugene
Gassan, Arnold, ed. *Ralph Eugene Meatyard.* Lexington, Ky.: Gnomon, 1970.
Meatyard, Ralph Eugene, and Wendell Berry. *The Unforseen Wilderness.* Lexington, Ky., and New York: U. of Kentucky Press, Ballantine Books, 1971.
Michals, Duane
Michals, Duane. *The Journey of the Spirit After Death.* New York: Winter House, 1971.
———. *Sequences.* Garden City, N.Y.: Doubleday, 1972.
Miller, Wayne
Miller, Wayne. *The World Is Young.* New York: Ridge, 1958.
Minick, Roger
Minick, Roger, and Dave Bohn. *Delta West: The Land and People of the Sacramento-San Joaquin Delta.* San-Francisco: Scrimshaw, 1969.
Mitchell, Margarette
Mitchell, Margarette. *Gift of Place.* San Francisco: Scrimshaw, 1969.
Moholy-Nagy, László
Cummings, Paul, ed. *Moholy-Nagy, Documentary Monographs in Modern Art.* New York: Praeger, 1970.
László Moholy-Nagy. Chicago: Museum of Contemporary Art, 1969.
Moholy-Nagy, László. *Painting, Photography, Film.* Cambridge, Mass.: M.I.T. Press, 1967.
———. *Vision in Motion.* 1947. Chicago: Theobald, 1965.
Morgan, Barbara
Morgan, Barbara. *Summer's Children.* Hastings-on-Hudson, N.Y.: Morgan & Morgan, 1951.
Morris, Wright
Morris, Wright. *God's Country and My People.* New York: Harper & Row, 1968.
———. *The Home Place.* Lincoln: U. of Nebraska Press, 1968.
———. *The Inhabitants.* New York: Scribner, 1946.
Muybridge, Eadweard
Muybridge, Eadweard. *Animals in Motion.* 1899. Reprint. New York: Dover, 1955.
———. *The Human Figure in Motion.* 1901. Reprint. New York: Dover, 1957.
Nadar (Gaspard Félix Tournachon)

Nadar. Exhibition catalogue. Paris: Bibliothèque Nationale, 1965.
Prinet, J., and A. Dilasser. *Nadar.* Paris: Armand Colin, 1966.

Nègre, Charles
Jammes, André. *Charles Nègre, Photographer, 1820–1880.* Paris: Private press, 1963.

O'Sullivan, Timothy
Horan, James D. *Timothy O'Sullivan: America's Forgotten Photographer.* New York: Doubleday, 1966.
Newhall, Beaumont and Nancy. *T. H. O'Sullivan, Photographer.* Rochester, N.Y., and Fort Worth: George Eastman House, Amon Carter Museum, 1966.

Paine, Wingate
Paine, Wingate, et al. *Mirror of Venus.* 1966. Reprint. New York: Bantam, 1970.

Parks, Gordon
Parks, Gordon. *In Love.* Philadelphia and New York: Lippincott, 1971.

Penn, Irving
Penn, Irving. *Moments Preserved.* Intro. by Alexander Liberman. New York: Simon & Schuster, 1960.

Porter, Eliot
Porter, Eliot. *Baja California and the Geography of Hope.* San Francisco: Sierra Club, 1967.
———. *Forever Wild: The Adirondacks.* New York: Harper & Row, 1969.
———. *In Wildness Is the Preservation of the World.* New York: Sierra Club, Ballantine, 1967.
———. *The Place No One Knew—Glen Canyon on the Colorado.* New York: Sierra Club, Ballantine, 1966.
———. *Summer Island.* New York: Sierra Club, Ballantine, 1968.

Rawlings, John
Rawlings, John. *100 Studies of the Figure.* New York: Bonanza, 1951.

Renger-Patzsch, Albert
Albert Renger-Patzsch: Der Fotograf der Dinge. Essen: Ruhrland und Heimatmuseum, 1966.
Junger Ernst. *Bäume.* Ingelheim: Boehringer, 1962.
Renger-Patzsch, Albert. *Gestein.* Ingelheim: Boehringer, 1966.

Riboud, Marc
Riboud, Marc. *Face of North Vietnam.* New York: Holt, Rinehart & Winston, 1970.

Riis, Jacob A.
Riis, Jacob A. *How the Other Half Lives.* 1890. Reprint. New York: Dover, 1971.

Rothstein, Arthur
Rothstein, Arthur. *Creative Color in Photography.* Philadelphia: Chilton, 1963.
———. *Photojournalism.* 2nd ed. Philadelphia: Chilton, 1965.

Ruscha, Edward
Ruscha, Edward. *Crackers.* New York: Wittenborn, 1969.
———. *A Few Palm Trees.* New York: Wittenborn, 1971.
———. *Nine Swimming Pools and a Broken Glass.* New York: Wittenborn, 1968.
———. *Records.* New York: Wittenborn, 1971.
———. *Some Los Angeles Apartments.* New York: Wittenborn, 1965.
———, and Billy Al Bengston. *Business Cards.* New York: Wittenborn, 1968.

Salomon, Erich
Salomon, Erich. *Celebrated Contemporaries.* Stuttgart: J. Engelhorns Nachfolger, 1931.

Sander, August
Sander, August. *Men Without Masks.:* Greenwich, Con.: N.Y. Graphic, 1973.

Schulthess, Emil
Schulthess, Emil. *China.* New York: Viking, 1966.

Seymour, Daniel
Seymour, Daniel. *A Loud Song.* New York: Lustrum, 1971.

Seymour, David ("Chim")
Farova, Anna, ed. *David Seymour ("Chim").* New York: Grossman, Paragraphic, 1966.

Sheeler, Charles
Charles Sheeler. Monograph. Culpeper, Va.: *Contemporary Photographer,* 1969.
Charles Sheeler. Exhibition Catalogue. Washington, D.C.: Smithsonian, 1968.

Siskind, Aaron
Aaron Siskind. Rochester, N.Y., and New York: George Eastman House, Horizon, 1965.
Aaron Siskind, Photographs. New York: Horizon, 1959.

Skrebneski, Victor
Skrebneski. New York: Ridge, 1969.

Slavin, Neal
Slavin, Neal. *Portugal.* New York: Lustrum, 1971.

Smith, W. Eugene
W. Eugene Smith: His Photographs and Notes. Aperture Monograph. New York: Aperture, 1969.

Sommer, Frederick
Frederick Sommer. Exhibition catalogue. Philadelphia: Philadelphia College of Art, 1968.
Frederick Sommer, 1939–1962 Photographs. New York: Aperture, 1963.

Soule, Will
Belous, Russell E., and Robert A. Weinstein. *Will Soule: Indian Photographer at Fort Sill, Oklahoma 1869–74.* Los Angeles: Ward Ritchie, 1969.

Steichen, Edward
Sandburg, Carl. *Steichen the Photographer.* New York: Harcourt Brace, 1929.
Steichen, Edward. *A Life in Photography.* Garden City, N.Y.: Doubleday, 1963.
———, ed. *The Bitter Years: 1935–1941.* New York and Garden City, N.Y.: Museum of Modern Art, Doubleday, 1962.
Steichen the Photographer. New York and Garden City, N.Y.: Museum of Modern Art, Doubleday, 1961.

Stieglitz, Alfred
Bry, Doris. *Alfred Stieglitz: Photographer.* Boston: Museum of Fine Arts, 1965.
Exhibition of Photographs by Alfred Stieglitz. Exhibition catalogue. Washington, D.C.: National Gallery of Art, 1958.
Frank, Waldo, et al., eds. *America and Alfred Stieglitz: A Collective Portrait.* Garden City, N.Y.: Doubleday, 1965.
Norman, Dorothy. *Alfred Stieglitz.* New York: Duell, Sloan and Pearce, 1960.

Stock, Dennis
Stock, Dennis. *California Trip.* New York: Grossman, 1970.

Strand, Paul
Newhall, Nancy. *Paul Strand: Photographs 1915–1945.* New York: Museum of Modern Art, 1945.
Paul Strand: A Retrospective Monograph. New York: Aperture, 1972.
Strand, Paul. *Un Paese.* Turin: Einaudi, 1954.
———, and James Aldridge. *Living Egypt.* New York: Aperture, Horizon, 1969.
———. and Basil Davidson. *Tir A'Mhurain.* 1962. New York: Grossman, 1968.
———, and Nancy Newhall. *Time in New England.* New York: Oxford U. Press, 1950.

Swedlund, Charles
Swedlund, Charles. *Charles Swedlund Photographs.* Cobden, Ill.: Anna, 1973.
———. *My Wife Is Pregnant.* Cobden, Ill.: Anna, 1971.
———. *A Portfolio of Color Prints.* Cobden, Ill.: Anna, 1973.
———. *Stereo Photographs.* Cobden, Ill.: Anna, 1973.
———. *We Have a Daughter.* Cobden, Ill.: Anna, 1971.

Szarkowski, John
Szarkowski, John. *The Face of Minnesota.* Minneapolis: U. of Minnesota, 1958.

Talbot, William Henry Fox
Booth, Arthur. *William Henry Fox Talbot, Father of Modern Photography.* London: Arthur Barker, 1965.
Talbot, William Henry Fox. *The Pencil of Nature.* Facsimile of 1864 edition, with introduction by Beaumont Newhall. New York: Da Capo, 1969.

Thompson, John
Thompson, John, and Adolphe Smith. *Street Life In London.* 1877. Reissued. New York and London: Benjamin Blom, 1969.

Tice, George A.
Mendoza, George, and George A. Tice. *Goodbye, River, Goodbye.* New York: Doubleday, 1971.
Tice. George A. *Paterson.* New Brunswick, N.J.: Rutgers U. Press, 1972.

Trager, Philip

Trager, Philip. *Echoes of Silence.* New York: Scroll, 1972.

Turner, Alwyn Scott

Turner, Alwyn Scott. *Photographs of Detroit People.* Detroit: Private press, 1970.

———. "Portraits of American People — A Monumental Portfolio of Photographs." *Avant Garde* Special Issue, Spring, 1971.

Uelsmann, Jerry N.

Jerry N. Uelsmann. Aperture Monograph. New York: Aperture, 1970.

Uelsmann, Jerry N. *Eight Photographs.* Portfolio. Garden City, N.Y.: Doubleday, 1970.

Ulmann, Doris

The Appalachian Photographs of Doris Ulmann. Penland, N.C.: Jargon Society, 1971.

Van der Elsken

Van der Elsken, ed. *Bagari.* New York: 1961.

———. *Love on the Left Bank.* Holland: W. Vonk, n.d.

———. *Sweet Life.* New York: Abrams.

Vroman, Adam Clark

Mahood, Ruth I., ed. *Photographer of the Southwest, Adam Clark Vroman, 1856–1916.* Los Angeles: Ward Ritchie, 1961.

Walker, Todd

Portfolio by Todd Walker. Thumbprint. 1968.

Webb, Todd

Todd Webb: Early Western Trails and Some Ghost Towns. Fort Worth: Amon Carter Museum, 1965.

Todd Webb Photographs. Exhibition catalogue. Forth Worth: Amon Carter Museum, 1965.

Weegee (Arthur Fellig)

Harris, Mel, and Weegee. *Naked Hollywood.* New York: Pellegrini & Cudahy, 1953.

Weegee. *Naked City.* New York: Essential, 1945.

———. *Weegee, An Autobiography.* New York: Ziff-Davis, 1961.

———. *Weegee's People.* New York: Duell, Sloan and Pearce, 1946.

Weston, Brett

Armitage, Merle. *Brett Weston Photographs.* New York: Weyhe, 1956.

Newhall, Nancy. *Brett Weston: Photographs.* Fort Worth: Amon Carter Museum, 1966.

Weston, Edward

Armitage, Merle. *Edward Weston.* New York: Weyhe, 1932.

Newhall, Nancy. *Edward Weston.* New York: Museum of Modern Art, 1946.

———, ed. *The Daybooks of Edward Weston: Vol. 1. Mexico.* Rochester, N.Y.: George Eastman House, 1961.

———. *The Daybooks of Edward Weston: Vol. II. California.* Rochester, N.Y., and New York: George Eastman House, Horizon, 1966.

———. *Edward Weston: Photographer.* Aperture monograph. New York: Aperture, 1965.

Weston, Charis Wilson and Edward. *California and the West.* New York: Duell, Sloan and Pearce, 1940.

Weston, Edward. *My Camera on Point Lobos.* 1950. New York: Da Capo, 1968.

White, Clarence H.

Photographs of Clarence H. White. Exhibition catalogue. Lincoln: U. of Nebraska, 1968.

White, Minor

White, Minor. *Mirrors Messages Manifestations.* Aperture Monograph. New York: Aperture, 1969.

Winningham, Geoff

Winningham, Geoff. *Friday Night in the Coliseum.* Houston: Allison, 1972.

Winogrand, Garry

Winogrand, Garry. *The Animals.* New York: Museum of Modern Art, 1969.

Periodicals

Album. Aidan Ellis and Tristram Powell, 70 Princedale Road, London, W. 11, England.

Aperture. Aperture, Inc., 276 Park Avenue, New York, N.Y. 10017.

Artforum. Artforum, Inc., 667 Madison Avenue, New York, N.Y. 10021.

Art News. Newsweek, Inc., 444 Madison Avenue, New York, N.Y. 10022.

British Journal of Photography. Henry Greenwood & Co., London, England.

Camera. C. J. Bucher, Ltd., Lucerne, Switzerland.

Camera 35. U.S. Camera Publishing Corp., 132 West 31st Street, New York, N.Y. 10001.

Camera Work (1903–17). Alfred Stieglitz, New York, N.Y. Back copies of this publication are in the collection of the Department of Photography at the Museum of Modern Art, 11 West 53rd Street, New York, N.Y. 10019, and may be viewed by appointment.

Color Photography Annual. Ziff-Davis Publishing Co., 1 Park Avenue, New York, N.Y. 10016.

Creative Camera. International Federation of Amateur Photographers, 19 Doughty Street, London, England.

Image. A monthly publication of the George Eastman House, 900 East Avenue, Rochester, N.Y. 14607.

Image Nation. The Coach House Press, Montreal, Canada.

Modern Photography. The Billboard Publishing Co., 165 West 46th Street, New York, N.Y. 10036.

Photographis. An international annual of advertising photography published by Walter Herdeg, The Graphis Press, Zurich, Switzerland, and distributed in this country by Hastings House, Publishers, Inc., 10 East 40th Street, New York, N.Y. 10016.

Photo Reporter. Modernage, 319 East 44th Street, New York, N.Y. 10017.

Popular Photography. Ziff-Davis Publishing Co., 1 Park Avenue, New York, N.Y. 10016.

U.S. Camera World Annual. U.S. Camera Publishing Corp., 132 West 31st Street, New York, N.Y. 10001.

GLOSSARY

Terms *italicized* within the definitions are themselves defined in the glossary.

aberrations Optical defects in a *lens* that cause it to render subject matter in *images* marred by blurring or some other type of distortion. Types are *astigmatism, barrel distortion, chromatic aberration, coma,* and spherical aberration.

absorption In photography, the as-similation of *light* rays by the medium they strike, the effect of which is to block light so that it travels no further. The complete absorption of light results in black. The opposite of *reflection.*

accelerator Alkali that in *developer* increases the *speed* of chemical action.

acetic acid The acid used in diluted form for *stop bath,* which halts or neutralizes the action of *developer* in the *processing* of *film* and *prints.* Also used in *fixing baths* as an *emulsion hardener,* and in the *dye-transfer* process to prevent blurring between dyes.

acutance *Film* sharpness as distinguished by the degree of *tonal gradation* separating light and dark areas in a photographic *image.*

additive colors In *light,* those *hues*

known as the *primaries* — red, green, and blue — that when blended in a dark environment can, theoretically, add up to *white light* (all light), since each contains approximately one-third of the total number of *wavelengths* in the visible portion of the electromagnetic *spectrum.* On this principle is based the additive system of simulating full color in photographic *images.*

additive principle or **system** See *additive colors.*

agitation The technique of causing the *processing* liquids to flow freely and continuously over all surfaces of *film* and paper throughout their immersion periods.

ambrotype An early *wet-plate* photographic *process* that produced a faint *negative image* upon a glass plate coated with *collodion.* When backed with black, it appeared as a *positive.*

analyzer An electronic device for determining the *filtration* needed to obtain a *print* of good color balance from a specific *negative* projected by *light* from a specific *enlarger.*

antihalation backing A coat of dye or pigment on the back of the film support whose purpose is to *absorb* extraneous *light* rays passing through the *emulsion* and thus prevent their *reflecting* back onto and affecting the light-sensitive material.

aperture The *lens* opening that admits controlled amounts of *light* into a *camera,* its size variable but regulated by an iris *diaphragm* and expressed as an *f-number.*

archival The quality of permanence or durability.

ASA For American Standards Association, a system designed to rate the *speed* or *light* sensitivity of photographic materials.

astigmatism A *lens aberration* that prevents equal *focus* for lines that lie at right angles to each other on the same plane.

barrel distortion Magnification of an *image* at its center, caused by a *lens aberration.*

bellows An accordion-pleated, *light-tight,* and collapsible unit — made of leather, cloth, or plastic — that in certain *cameras* connects the *lens* to the back of the camera. Its to-

and-fro movement permits the lens to be *focused.*

between-the-lens shutter See *leaf shutter.*

bleed In color *processing,* the seepage of dyes beyond *image* boundaries. Also, an image trimmed at the edge of the page or mount board supporting it.

blocked up An extremely *dense* area in an *overexposed* and possibly overdeveloped *negative* whose *opacity* prevents the passage of *light.*

blowup Photographic vernacular for enlargement.

box camera The first hand-held roll-film *camera,* introduced in 1888 by George Eastman, consisting of a *light-tight* box fitted with *lens, shutter,* and *viewfinder,* as well as rollers for advancing and registering the *film.*

bracketing As a margin for error, the technique of making in addition to a "normal" *exposure* several exposures that are both over and under the norm.

bromide See *halide.*

bulb A *camera exposure* setting (B) allowing the *shutter* to remain open as long as its release is depressed.

burning-in A printing technique for allowing restricted areas of an *image* to receive longer *exposure* while the remainder of the *print* surface is shielded from the *enlarger's light.* See also *dodging, flashing,* and *vignetting.*

cable release A long, flexible, cable-like plunger that as a *camera* accessory permits the photographer to release the *shutter* without touching the camera.

cadmium sulfide (cds) cell A receptive agent of available *light* that, by resisting a battery-generated electrical current, functions as a light indicator in some *exposure meters.* See also *selenium.*

calotype A paper *negative process* introduced by Fox Talbot in 1840 and later called a "talbotype."

camera From the Latin for "room," a *light-tight* box fitted with a *lens* to admit, by the action of a released *shutter,* a selection of *light* rays so as to cause them to form an *image* on a field of light-sensitive material.

camera obscura From the Latin for "darkroom," a *light-tight* box or room with a tiny hole in one wall

that *projects light* rays upon the opposite wall to form there an upside down and reversed *image* of the scene outside. Long used by artists for viewing and sketching, the camera obscura developed into the modern *camera* once materials of suitable light sensitivity had been invented.

cartridge A roll-*film* carrier, sometimes called "cassette," that completely encloses the *light*-sensitive material.

cassette See *cartridge.*

CC filters Color Compensation *filters* that are made of *gelatin,* optically corrected, and produced in six colors of various intensities for use in balancing the color of the *light* available for *exposing film* and photographic paper.

chloride See *halide.*

chromatic aberration A defect of simple *lenses* that causes the *light* rays of different colors to *focus* at different planes, resulting in blurred black-and-white *images* and color images that are fringed or haloed with extraneous color.

circle of confusion A tiny, round cluster of *light* rays projected upon a *focal plane* by a point of light *reflected* from a subject outside the *camera.* The tighter such clusters, the sharper the *image* they form.

closeup A photograph in which *focus* has occurred, by optical or mechanical means, at a distance of no more than $1\frac{1}{2}$ to 3 or 4 feet in front of the *camera.*

coating A thin, *transparent* film of magnesium fluoride, or other material, applied to *lens* elements to *absorb* extraneous *light,* reduce *flare,* and thereby brighten the *image.*

collodion A *transparent* and glutinous solution, consisting of pyroxyl, alcohol, and ether, used as a vehicle for *light*-sensitive *silver* particles and coated onto *emulsion* supports in the 19th-century *wet-plate* process.

color head In an *enlarger,* a drawer or slot above the *condenser lenses* designed to contain the *filters* that affect the color of the *exposing light.*

color sensitivity The effective response of a photographic *emulsion* to different *wavelengths* of *light.*

color temperature A means of de-

scribing the color of *light* in terms of its relative warmth (dominance of red *wavelengths*) or coolness (dominance of blue *wavelengths*), which can be measured in degrees *Kelvin*. Applicable only to light sources, such as the sun or a *tungsten* lamp, emitting a *continuous spectrum*.

coma A *lens aberration* that causes *light* rays passing diagonally through a lens to form unsymmetrical *image* points on the *film*.

complementary colors Any two *hues* of *light* that when combined in the *additive system reflect* all *wavelengths* to produce white; in the *subtractive system*, any two hues that combine to *absorb* all *wavelengths* and yield black or neutral gray.

composite The photographic *image* created when two or more *negatives*, or parts of negatives, have been *printed* as one.

condenser system In an *enlarger*, a pair of convex (positive) *lenses* whose interfaced relationship enables them to gather rays beamed from the *light* source and direct them to spread uniformly over the *negative* for *projection* through it.

contact print A *print* made by interfacing the *emulsion* sides of a *negative* and a sheet of photographic paper and by *exposing* the paper with raw *light* beamed through the negative.

continuous spectrum *Light* containing measurable quantities of all *wavelengths*, such as the light emitted by the sun or a *tungsten* filament.

contrast In black-and-white photography, the differences in the brilliance or *density* from one passage to another that make possible the visibility of an *image*. A contrasty *negative* or *print* is characterized by drastic differences in brilliance or density.

conversion filters *Filters* designed to help correct *film* sensitized to one type of *light* (daylight, for instance) for use in a different type of light (*tungsten*, for example).

covering power The capability of a *lens* to give, at the largest *aperture* possible, a sharply defined *image* out to the edges of the *film* it is designed to cover.

CP filters Color Printing *filters* used to balance, in relation to the *negative*, the color of the *light exposing* the photographic paper. Because made of acetate, CP filters are not optically corrected and must therefore be inserted above rather than below the *enlarger*'s *lens*.

curvature of field A *lens aberration* causing the plane of *focus* to be curved so that the center and edges of an *image* cannot be focused simultaneously.

daguerreotype The first successful photographic *process* and its product (1839), which employed vapors from heated mercury to form an *image* on a copper plate coated with polished silver.

definition The fineness and clarity of detail in an *image* or the capability of a *lens* or an *emulsion* to yield fine detail.

densitometer An instrument for measuring the *silver* deposits in any portion of a *developed* photographic *image*.

density In a *negative*, the light-stopping power of a blackened *silver* deposit relative to the light beamed toward the negative.

depth of field The zone extending in front of and behind the point of sharpest *focus* throughout which focus seems acceptably sharp and unblurred.

depth of focus The small zone in which the *focal plane* (*film*) can be moved away from a focused *lens* without incurring a perceptible loss of *focus* in the *image*.

develop and **development** See *developer*.

developer A chemical solution that acts to change *silver halides* affected by *light* to black metallic silver, thereby converting an invisible *image* latent on *film* into a visible image.

diaphragm In a *camera*, usually placed in the *lens* barrel or *shutter* mechanism, a device for regulating the size of the *light*-admitting *aperture* by means of leaves that overlap to expand and contract in circular order.

diffraction The optical phenomenon of *light* rays bending around the edge of an *opaque* object.

diffusion The scattering of *light* rays in all directions, as a result of their reflecting off a rough surface or passing through a *translucent* medium.

diffusion system In an *enlarger*, a sheet of frosted glass that diffuses rays beamed from the *light* source to spread them generally over the *negative* for *projection* through it.

DIN For Deutsches Industrie Norm (German Standards Organization), a system common in Europe for measuring the *speed* or *light* sensitivity of photographic materials.

diopter A unit of measure employed in optics to express the power of a *lens*; usually applied to supplementary *closeup* lenses to indicate their capability for magnification.

discontinuous spectrum *Light* in which certain *wavelengths* are not present, such as fluorescent light, where blue and green wavelengths predominate.

dodging The technique of lightening part of the *image* in a photographic *print* by briefly shielding that part during the *exposure* of the photographic paper.

double exposure Two or more *images* recorded on one *film* or sheet of photographic paper, the record made either deliberately or inadvertently.

dry mounting A technique of mounting a *print* by applying heat to a sandwich of thin tissue of thermoplastic material interleaved with the print and its mount board.

dye couplers Chemicals present in the three *emulsions* of color *film* that react with *developer* to release dyes and thus color the developed *images*.

dye transfer The technique of making a color photographic *print* by *registering* on one sheet of paper three *gelatin matrices* prepared to represent the subject in *value images* individually dyed yellow, magenta, and cyan.

easel A flat board at the base of an *enlarger* designed to support paper during *exposure*, and usually fitted with masking strips to hold the paper flat and in proper position and to frame the *image* inside white borders.

electromagnetic spectrum See *spectrum*.

emulsion A coating of *gelatin* in which are suspended the *silver* salts

that make *film* and paper *photosensitive*.

enlarger An apparatus for *projecting light* through a *negative* so as to *expose* light-sensitive paper and *print* the *image* at a *scale* either larger or smaller than the negative.

expose See *exposure*.

exposure The effect that *light* has on *photosensitive* material; also the product of light's intensity and the time during which it affected the *photosensitive* material.

exposure latitude The degree of *exposure* variance possible without detriment to *image* quality. See *reciprocity law*.

exposure meter An instrument for measuring the intensity of the *light* falling on or *reflecting* from a subject and for indicating this in terms of *camera exposure* settings for the *speed* of the *film* used.

extension tubes *Light-tight* tubular rings designed to extend the distance between the *lens* and the *focal plane* inside the *camera* and thus to effect *image* magnification.

fast *Film* or paper that is highly sensitive to *light;* also a *lens* with a small *f-number*, one capable of admitting a great deal of light into the *camera*.

ferrotype For the iron in the highly polished plates used for the *tintype* process (1860s); now the technique of giving a glossy finish to the *emulsion* surfaces of photographic prints by *squeegeeing* them to dry with the emulsion side flat against a polished metal surface, often stainless steel.

film A sheet or strip of thin, flexible, *transparent* material (acetate or polyester plastic) coated on one side with a *light*-sensitive *emulsion* capable of recording an *image* as a result of *exposure* in a *camera*.

filter A piece of *transparent* material, *gelatin*, glass, or acetate, that when placed in front of the *light* source can, through its color or structure, affect the *exposure* of *photosensitive* materials by blocking some *wavelengths* while passing others.

filter factor The number by which correct *exposure* prior to filtration must be multiplied in order to maintain the same effective exposure once the *filter* has been added. The factor increases exposure to compensate for the *light* withheld by the filter.

fisheye An extremely *wide-angle lens*, covering a field of about 180° and reproducing a circular *image* with pronounced *barrel distortion*.

fix In *film* and *print processing*, to render a photographic *image* stable by desensitizing the *emulsion* in a fixing bath or *hypo*, which dissolves all *silver halides* not converted by the *developer* to black metallic silver.

fixer or **fixing bath**. See *fix*.

flare Haloes around photographic *images* and other types of bright patches caused by extraneous *light reflections* inside the *lens* or along the edge of the *lens hood* or mount.

flash A *light* source that is coordinated with the camera's *shutter* mechanism to provide, for purposes of *exposure*, a brief intense flash of light.

flat A term describing a photographic *print image* in which *value contrasts* are low.

f-number The numerical expression of the relative size of the *light*-admission opening in the *lens*, an expression derived from the lens' *focal length* divided by the effective diameter of the lens. Each lens is capable of a series of *apertures*, often termed "f-stops."

focal distance The extent measured from the *lens* to the plane where the *image* has been *focused*.

focal length The distance from the *lens* to the plane of *focus* when the lens has been focused at *infinity*.

focal plane The surface where *light* rays fall and come together to form an *image;* the *film* inside the *camera*.

focal-plane shutter A *light*-controlling mechanism installed along and just forward of the *camera's focal plane* that allows *film* to be *exposed* progressively through a slit of adjustable size formed by one or more roller blinds moving parallel to the focal plane.

focus The point inside the *camera* where *light* rays converge to form a clear and sharply defined *image* of the subject in front of the camera. To adjust the camera to achieve this result.

fog A veil-like *density* in the *nega-*tive or *print* deriving not from the subject but from extraneous *light* or chemical action.

f-stop See *f-number*.

gelatin A jellylike protein substance isolated by boiling the hides, horns, bones, and hooves of animals and used as a binder for the *silver* salts contained in *light*-sensitive *emulsions*.

glare See *polarized light*.

goo Slang for an alkaline chemical used in the *diffusion* process by which *developer* is activated in Polacolor *film*.

gradation A range of *values* or *tones* from white through gray to black.

grain Particles and clumps of black metallic *silver* that form a *developed* photographic *image* and become visible under a microscope or in an enlargement.

gray card The Kodak Neutral Test Card prepared to offer a standard, in the form of an average gray (one with 18 percent *reflectance*), by which reflected *light* can be measured or color balance compared for the purpose of controlling the *tonal* or color quality of photographic *images*.

gray scale A printed rendition of a standardized *scale* of *tonal values* arranged in a *gradation* of ten zones representing the degrees of *reflectance* possible in nature, from lighter to darker around a median or average gray (see *gray card*).

ground glass In *view* and reflex *cameras*, a plate of glass frosted on one side to provide a *translucent screen* capable of stopping *light* rays to reveal an *image* formed on the *focal plane* that is visible on the other side of the ground glass.

halation Blurring or haloes around *images* produced by excess *light* passing through the *film* and *reflecting* back from the film support. See *antihalation backing*.

halftone A term used by engravers and printers for a process that simulates the continuous *tone* or tonal *gradation* characteristic of photographic *images*, and life itself, by means of a regularly patterned *screen* of dots whose size is proportional to the *density* of the original image. Also often used as a synonym for "photograph."

halide A compound of one of the

halogens, such as bromine, chlorine, and iodine, with *silver* that provides the *light*-sensitive material fundamental to photographic processes.

hardener A chemical, such as potassium or chrome alum, used in one of the *processing* solutions, or separately, to firm and toughen the *gelatin* of a photographic *emulsion* after it has been *developed*.

highlights The brightest portions of a photographic *image,* which appear *dense* or dark in the *negative* and light gray or white in the *positive*.

hue The property of a color that distinguishes it from another color as red, green, blue, etc.

hyperfocal distance The distance in front of the *camera* from the *lens* to the nearest limit of *depth of field* when the lens has been *focused* on *infinity*.

hyperfocal focusing A technique for extending *depth of field* by *focusing* on the *hyperfocal distance,* which enlarges the scope of focus to an area extending from one-half the hyperfocal distance to *infinity*.

hypo Photographic slang for sodium thiosulfate (discovered in 1819 by Sir John Frederick William Herschel), a chemical compound used in *fixing baths* to dissolve the undeveloped *silver* salts remaining in an *emulsion* after *development*.

image A two-dimensional representation of an object or subject in nature realized by photographic means.

incandescent light Illumination generated by a heated substance, such as the glowing filament of a *light* bulb, which derives its energy from electric current.

incident light *Light* falling on a subject before it has been *reflected* by the subject.

infinity (∞) In photography, the area furthermost from the *camera* in which objects are seen by the *lens* in sharp *focus*. This usually commences at 40 or 50 feet in front of the camera and continues into the distance as far as some 300 yards. Infinity focusing derives from the phenomenon of *light* rays seeming to travel parallel to each other over great distances rather than at angles to one another as in the near environment.

infrared A band of *wavelengths* in the electromagnetic *spectrum* adjacent to and longer than those for red and too long to be visible, but so long that the greater heat they generate makes it possible for these wavelengths to be detected by specially sensitized photographic materials.

intensification A "last resort" chemical means of increasing *density* or *contrast* in *negatives*.

iodide See *halide*.

iris See *diaphragm*.

Kelvin For W. T. Kelvin (1824–1907), who devised a system now used for measuring the *color temperature* of *light* sources. Its units, called "degrees," are numerically equal to degrees Centigrade plus 273.

lamp Artificial *light* source, usually generated by electric current.

lamp housing The *light-tight* and ventilated chamber containing the *light* source in an *enlarger* or projector.

latent The invisible state of the *image* formed in *light*-sensitive *emulsion* by *exposure* until such time as it has been acted upon by *developer*.

leaf shutter A mechanism for controlling *exposure,* usually located in the *lens* or just behind it, whose assembly is a concentric arrangement of overlapping metal leaves that, when activated, rotate toward the outer rim of the circle, thus admitting *light,* and then close. Sometimes called *diaphragm shutter*.

lens A solid, shaped piece of *transparent* material, or an assembly of such pieces, capable of gathering and selecting *light* rays *reflected* from a subject and of modifying their behavior so that they enter the *camera* and travel toward the *focal plane* to form there an *image* of the subject from which they emanated.

lens hood A detachable accessory for the *camera* designed to shield the *lens* from the extraneous *light* capable of creating the problem of *flare*.

lens mount The part of the *camera* housing the *lens* and all its elements.

light Energy, emitted in wavelike pulsations from the sun, that forms the visible part of the electromagnetic *spectrum*. Illumination.

light-tight Capable of excluding all *light*.

macrolens A *lens* capable of extending *focal distance* so as to achieve the *image* magnification required for *closeup* photography.

mat A cardboard frame serving to border, isolate, enhance, present, and protect a photographic *image*. See also *matte*.

matrix In the *dye-transfer* process, a relief *image* in *gelatin* corresponding to the *values* of red, green, or blue light *reflected* from the subject. Once dyed the color *complementary* (yellow, magenta, or cyan) to the exposing *light* and then transferred by superimposition and *registration* upon a suitable paper base, such *matrices* create a full-color photographic image of high quality.

matte In photographic paper, an *emulsion* surface textured to be dull and non*reflective*.

mirror optics An optical system employing curved mirrors, rather than glass elements, to form *images*. Converging *light* by the play of internal *reflection,* rather than through *refraction,* mirrors eliminate *chromatic aberrations*.

monobath A single solution containing both *developer* and *fixer* for the rapid *processing* of photographic materials.

monochrome A single color.

negative A *developed* photographic *image* in which the subject's *value tonalities* have been reversed from light to dark and dark to light. Usually, the image on *transparent film* from which a *print* is made. In optics, a concave *lens*.

negative carrier A frame for holding the *negative* inside an *enlarger* so that it can be *printed*.

neutral-density filter A colorless *filter toned* a uniform gray and designed to reduce the brilliance of the *exposing* light without altering its color.

opaque The characteristic of matter that makes it resist the passage of *light*. Also, a tempera paint that once applied to a *negative* can block the passage of light.

orthochromatic Sensitive to the *wavelengths* for all colors but red.

overexposure Too much *light* strik-

ing *photosensitive* material.

pan Swing the *camera* during *exposure* to follow a moving subject.

panchromatic Sensitive to the *wavelengths* for all colors in the visible *spectrum*.

parallax The discrepancy between the view presented to the eye through a *camera's* sighting device and that recorded by the camera's *lens*.

perspective The representation of a three–dimensional subject in the two dimensions of a flat surface.

photon A unit of *light*. In reaction with other matter, light behaves in one or both of two characteristic ways: either as waves or as particles called "photons."

photosensitive Chemically responsive to the action of *light*.

pinhole camera A *camera* whose *aperture* is not a *lens* but a tiny hole in an *opaque* material such as aluminum foil.

pola filter A *filter* that by means of its structure, not its color, can block *polarized light* to prevent its entering the *camera* or can actually polarize light before admitting it into the *lens*.

polarized light The phenomenon of glare, or *light* whose vibrations emanate from highly *reflective* surfaces and occur in a single plane, instead of in several planes.

positive A photographic *image* whose colors and/or *tonal values* correspond to those in the original subject. The opposite of a *negative*. Also, a convex *lens*.

primary colors In *light,* red, green, and blue, or the *hues* that together add up to create *white light* (all color) in darkness, where no light existed, and that in various combinations are capable of creating any other hue.

print The photographic *image* in its final, *positive* state when it has been reproduced on sensitized paper by means of *light projected* through a *negative*. Also, the photographic *process* of making such a print.

prism A solid triangular box made of *transparent* material and bounded on two sides by polished surfaces whose straight planes are inclined toward one another so that a beam of *white light* entering the

form on one side is *refracted* or bent by the angle of the second side to exit the form as a rainbow array of the component *wavelengths* of white light. The capability of shaped transparent material to affect the behavior of light constitutes one of the principles fundamental to the photographic *process*.

process In photography, the sequence of steps by which *light* and light-sensitive materials can be caused to reproduce an *image* of a subject.

projection Controlling *light* so as to shape its beam and direct it toward a specific target, the *focal plane,* where could be conveyed the colors and/or forms present in any *transparent* medium introduced into the beam.

rangefinder An optical device permitting the photographer to view a subject as the *camera's lens* will record it. Consists of a system of two lenses whose individual views of the subject can be made to coincide.

real image An *image* capable of being *projected,* as by a *positive lens,* upon a surface, such as the *ground-glass screen* at the back of a *view camera,* and there made visible to the naked eye. See *virtual image.*

reciprocity failure See *reciprocity law.*

reciprocity law The principle holding that *exposure* is the product of *light* intensity and time, which means that exposure changes in proportion to changes in either intensity or time. Thus, if in the second of two exposures intensity is doubled and time halved, the black metallic *silver* produced on *development* should be the same in both *negatives*. However, reciprocity failure occurs in disproportionate combinations, such as the long times required for low light or the high intensities needed for exposures of very brief duration.

reducer A chemical solution capable of reducing the *density* of a *negative* or *print* by dissolving some of the *silver* forming its *image.*

reducing agent A *developer* ingredient that converts a *latent image* in *film* or paper by supplying additional electrons to the ions of ex-

posed *silver halides* in the *emulsion* to lessen their positive charge.

register In photography, to superimpose *images* so that they coincide and align perfectly either as a single image or in whatever way may be desired.

reflect, reflectance, and **reflective** See *reflection.*

reflection The rebounding of *light* rays as a result of their having struck a surface. Also, the *image* seen by reflection in such gleaming surfaces as those on mirrors and water.

reflector A surface used to control rays from a *light* source and direct them with minimum loss to fall on the subject to be illuminated.

refraction The bending of *light* rays caused by their passing obliquely from one *transparent* medium through another of different density.

replenisher A relatively concentrated chemical solution added to *developer* to restore the strength exhausted by *processing.*

resolving power The ability of a *lens* to record or of an *emulsion* to reproduce fine detail.

reticulation A wrinkled surface of processed *emulsion* resulting from the expansion and contraction that drastic temperature changes or strong chemical action can cause.

reversal The process of converting a *negative image* to a *positive* one, as well as the contrary, the principle of which is basic to all photography, but especially to color photography.

safelight Darkroom illumination whose color and intensity are not likely to affect, within an allowable period, the sensitivity of the photographic materials being *processed.*

saturation The intensity and/or purity of a color, its relative brilliance (high saturation) or softness (low saturation).

scale A sequential arrangement of *values* from light to dark or small to large; the relative size of an object or *image*. Also, to make an image larger or smaller than its *negative* by adjusting the distance between the *light* source in an *enlarger* and the *focal plane* where the image has been *projected.*

screen A sheet of glass or plastic bearing a regular pattern of dots or

lines designed to break up an *image* for photomechanical reproduction as a *halftone;* the *ground glass* at the back of a *view camera* on which *focusing* and viewing occur; and a surface upon which images can be *projected* for viewing.

secondary colors In *light,* yellow, magenta, and cyan, or the *complementaries* of the *primary colors* blue, green, and red; distinct *hues* each containing equal portions of two primaries; and hues that themselves are primary in the *subtractive system* of color reproduction.

selenium Like *cadmium sulfide,* an agent in some *exposure meters* for providing an electrical measure of available *light.*

separation The *process* of analyzing the colors of a subject into three black-and-white records, one each for the *values* of red, green, and blue, made by photographing the subject through *filters* of those colors. Also, the qualities that differentiate elements in an *image,* such as dark forms against a light ground.

shutter A mechanical system for controlling the time variable of the *exposure.*

silver See *silver halide.*

silver halide A compound of silver with one or more of the halogens (chlorine, bromine, and iodine), particles of which provide the *light* sensitivity of photographic *emulsions.*

slow *Film* or paper that has relatively low sensitivity to *light.* Also, a *lens* with a large *f-number,* one relatively incapable of admitting a great deal of light into the *camera.*

sodium thiosulfate See *hypo.*

soft A term for *prints* and *negatives* low in *contrast* or for printing papers manufactured to yield low-contrast *images.*

soft focus A blurred or slightly out-of-*focus* photographic *image,* often a quality deliberately sought.

solarization The *reversal* of *tones* that occurs as a result of extreme *overexposure.* More often the so-called "Sabattier effect," the partial reversal produced when a *negative* has been exposed to a very strong and unsafe *light* in the darkroom during *development.*

spectrum The systematic arrangement of electromagnetic *wavelengths* from short X and gamma rays to radio waves measuring as much as 6 miles in length; more specifically, the array of colored bands composing the visible portion of the electromagnetic spectrum known as *light.*

speed A term for the relative *light* sensitivity of photographic materials; also for the light-admitting capabilities of *lenses.*

spot meter A special-purpose *exposure meter* for measuring *light* as this is *reflected* from a small portion of the subject.

spotting Painting over and bleaching out defects in a photographic *print* so as to improve its appearance.

stock Chemical *processing* solution in concentrated form intended to be diluted for use. Also, the material, such as paper or plastic, used as the support for photographic *emulsion.*

stop bath A dilute solution of *acetic acid* that chemically neutralizes the *developer,* thus stopping its action, in *negatives* and *prints* prior to their transfer into a *fixing bath.*

stop down To reduce *exposure* by adjusting the *camera* to a smaller *aperture.*

strobe For stroboscopic, an electronic *flash* whose capability to fire repeatedly and rapidly, for the purpose of producing a high-intensity *exposure light,* derives from energy stored in a charged condenser.

subbing In a sheet of *film,* an adhesive *gelatin* securing the *emulsion* to its backing.

subtractive colors In light, those *hues* known as the *secondaries* — cyan, magenta, and yellow, or the *complementaries* of the *primary colors* red, green, and blue — that give the effect of specific color by subtracting from the totality of *white light* all *wavelengths* but those for the color revealed. Because they function in white light — unlike the *additive primaries,* which create color only in darkness where no color existed — the subtractive "primaries" provide the principle by which modern processes of color reproduction function.

subtractive principle or **system** See *subtractive colors.*

talbotype See *calotype.*

telephoto lens A "long" *lens,* one whose *focal length* exceeds 200 millimeters, which causes it to produce a larger *image* on the *negative* than would a normal lens and optically to reduce the depth of the space separating objects located in the field before the *camera.* Such a lens has the capability to render a clear and large image of subjects relatively distant from the camera.

test print A *print* exposed segmentally so that each succeeding strip-like section receives a constant multiple of the *exposure* allowed the immediately preceding one. From the visual evidence this provides, the photographer can determine the correct exposure for the final print.

time exposure *Exposure* made with the *shutter* set at T, which causes the shutter to remain open after the photographer has pressed it for release and until he has pressed the release a second time. This permits exposures of durations longer than those made by the *camera's* automatic settings.

time and temperature The two variables by which it is possible to control the results obtained in the *film development process.* Manufacturers distribute charts indicating time-temperature relationships for given materials. Photographers can themselves make charts based on their own experience and objectives.

tintype A photographic process (*ferrotype*) introduced in 1852 that recorded *images,* usually portraits, on wet *collodion emulsion* coated on a japanned metal plate and *processed* in an iron *developer.*

tonality The overall quality of gray in a photograph, its range of *values,* or the quality of its color.

tone, tonal See *tonality* and *toning.*

toning Altering by chemical means the tint or color of the *silver* image in a black-and-white *print.*

translucent The character of a medium that makes it neither clear or *transparent* nor altogether *opaque,* which quality permits the material to pass *light* but to scatter its rays and create a *diffusion* of light.

transmission The passage of *light* through a *transparent* or *translu-*

cent medium.

transparency A photographic *image* in a medium, such as *film,* whose transparency permits it to be *projected* by means of *light* beamed through the medium.

transparent Capable of *transmitting light* without scattering its rays.

tripod A three-legged support for stabilizing the *camera* while permitting it to be tilted, turned, raised, or lowered.

tungsten In photography, a general term for artificial illumination; specifically, the material in the filament that heats to *incandescence* the bulbs familiar from everyday use.

ultraviolet A band of *wavelengths* in the electromagnetic *spectrum* adjacent to and shorter than those for blue-violet and too short to be visible, but detectable by specially sensitized photographic materials.

underexposure Too little *light* admitted to the *camera* to form a sufficiently bright *image,* resulting in a thin, pale *negative* and a *dense,* dark *print.*

value The presence of black, in whatever degree or relative amount. Values can be rated on a *scale* ranging from white (the absence of black, or the *reflection* of all *light*), through gray, to black (the *absorption* of all light).

view camera A large, basically professional *camera* so-called for the *ground-glass* viewing *screen* whose location on the same plane as the *film* permits it to receive *light* directly from the picture-taking *lens,* thus revealing to the photographer precisely what the film will record.

viewfinder A device on or in a *camera* for sighting and framing the *image* to be photographed.

vignetting A *dodging* technique for isolating an *image* detail inside *soft* borders that fade into the white of the paper support.

virtual image The *image* formed in a *negative lens* and, although clearly visible, perfectly *focused,* and oriented like the original subject, not capable of being registered on a flat surface. See *real image.*

visible spectrum See *spectrum.*

wavelength The characteristic that distinguishes each type of energy within the electromagnetic *spectrum.* It is the varying lengths of their waves that cause light rays to appear red, green, or blue, etc.

wet plate The *collodion* processes of the *ambrotype* and *tintype* in which the *light*-sensitive chemical had to be coated onto the plate and then both *exposed* and *developed* while still wet.

white light In general, illumination, such as daylight and *tungsten incandescence,* in which all *wavelengths* of the visible *spectrum* are present and by which normal *exposure* of photographic materials can occur.

wide-angle lens A *lens* of short *focal length* that allows both broad viewing coverage and, in addition, great *depth of field.*

working solution Photographic chemicals appropriately mixed. diluted. and ready for use.

zoom lens An adjustable *lens* capable of continuously variable *focal length,* often used in cinematography for tracking and recording a moving subject.

INDEX

References are to page numbers, except for black-and-white and color illustrations, which are also identified as figures.

Photo credits for sources not identified in the legends accompanying the works provided by the sources. The number, or numbers, cited after each credit refers to the figure number given to the reproduction in this book: Dan Bailey (248–252): Oscar Bailey (502–504, 556–560, 563, 564); Bibliothèque Nationale, Paris (12); George Eastman House, Rochester, N.Y. (81); Rapho Guillumette Pictures, New York (109); Museum of Modern Art, New York (27); Service Commercial des Monuments Historiques, Paris (16); Société Française de Photographie, Paris (5); Charles Swedlund (51, 67, 72, 98–103, 108, 114, 116, 118, 119, 121–123, 147–159, 161, 181, 183, 185, 206, 216–224, 232–236, 238–247, 254–258, 261–271, 276, 277, 283–286, 290, 292, 294, 296–305, 307–311, 346, 351, 428, 429, 434, 435, 451, 457, 458, 461, 474, 477, 498–501, 509–537, 539–544, 547, 550–555, 562, 565, 566, 569–571, 573, 574, 584, 585, 588, 602–606, 608–610, 612, 615–623, 626–632, 656–678, 693–696, 699–712, 725–749, 757, 758); David Vine (548, 549, 580, 595, 611, 614, 635, 638, 643–647, 649, 650, 652–655, 686).
Special thanks to Georgia O'Keeffe and the Estate of Alfred Stieglitz for permission to reproduce Figures 26, 28, and 29.